ANCIENT ART FROM CYPRUS

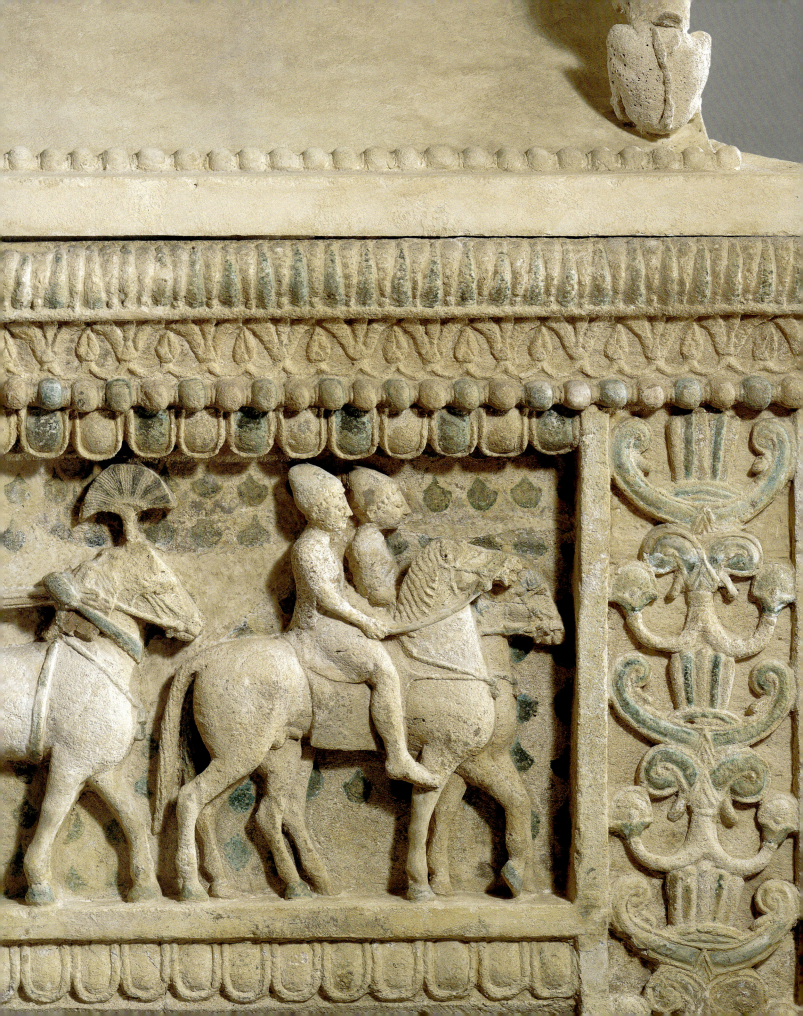

ANCIENT ART FROM CYPRUS

The Cesnola Collection in The Metropolitan Museum of Art

Vassos Karageorghis

in collaboration with
Joan R. Mertens and Marice E. Rose

THE METROPOLITAN MUSEUM OF ART, NEW YORK

DISTRIBUTED BY HARRY N. ABRAMS, INC., NEW YORK

This publication is made possible in part by a grant from the Government of the Republic of Cyprus.

Additional support has been provided by The Adelaide Milton de Groot Fund, in memory of the de Groot and Hawley families.

Published by The Metropolitan Museum of Art, New York

John P. O'Neill, Editor in Chief
Teresa Egan and Jane Bobko, Editors
Tsang Seymour Design Inc., Design
Peter Antony and Megan Arney, Production

New object photography by Joseph Coscia, Jr., Paul Lachenauer, and Oi-Cheong Lee, the Photograph Studio, The Metropolitan Museum of Art, New York; figs. 1–5, 7–13 The Metropolitan Museum of Art, New York; figs. 6, 14, 15 courtesy of Vassos Karageorghis

Separations by Professional Graphics Inc., Rockford, Illinois
Printed and bound by CS Graphics PTE Ltd., Singapore

Map of the eastern Mediterranean by The Metropolitan Museum of Art, New York; map of Cyprus and chronology adapted from Veronica Tatton-Brown, *Ancient Cyprus,* 2nd ed. (London, 1997), pp. 12, 91, copyright © the British Museum, British Museum Press

Jacket/cover illustration: Colossal head of a bearded figure wearing a conical helmet. Beginning of the 6th century B.C. (cat. no. 171)

Frontispiece: Sarcophagus. ca. 475 B.C. (cat. no. 330, detail)

Library of Congress Cataloging-in-Publication Data
Metropolitan Museum of Art (New York, N.Y.)
 Ancient art from Cyprus : the Cesnola collection in the Metropolitan Museum of Art / Vassos Karageorghis in collaboration with Joan R. Mertens and Marice E. Rose.
 p. cm.
 ISBN 0-87099-944-3 — ISBN 0-87099-945-1 (pbk.) — ISBN 0-8109-6552-6 (Abrams)
 1. Art, Ancient—Cyprus—Catalogs. 2. Art, Cypriote—Catalogs. 3. Cyprus—Antiquities—Catalogs. 4. Cesnola, Luigi Palma di, 1832–1904—Art collections—Catalogs. 5. Metropolitan Museum of Art (New York, N.Y.)—Catalogs. 6. Art—New York (State)—New York—Catalogs. I. Karageorghis, Vassos. II. Mertens, Joan R. III. Rose, Marice E. IV. Title.
N5430.M48 2000
709'.39'370747471—dc 21

99-056516
CIP

CONTENTS

DIRECTOR'S FOREWORD

The Metropolitan Museum of Art is renowned for the diversity and depth of its holdings. Yet the presence here of the richest representation, outside Cyprus, of Cypriot antiquities may seem unexpected. The Museum's acquisition of the Cesnola Collection in the mid-1870s reflects, quintessentially, New York and, in a broader sense, the United States during the optimistic, opportunistic years directly following the Civil War. The Metropolitan Museum was founded in 1870 in order to provide New York with an institution worthy of the city's wealth and significance. "The Metropolitan Museum of Art should be based on the idea of a more or less complete collection of objects illustrative of the History of Art from the earliest beginnings to the present time. We consider this definition important," said the report of the committee establishing the policies of the Museum, in February 1870. Thus, in 1872, when the American consul on Cyprus, General Luigi Palma di Cesnola, opened negotiations with John Taylor Johnston, Junius Spencer Morgan, and Museum trustees over the sale of Cesnola's impressive collection of antiquities from Cyprus, such an acquisition seemed appropriate to the young institution's mission. After the purchase, when Cesnola organized and displayed the pieces with the same command that he had shown as a cavalry officer during the Civil War, he was offered the position of the Museum's first director.

As the institution developed and directors such as Edward Robinson and Herbert E. Winlock widened its archaeological perspectives to ancient Greece, Rome, and Egypt, interest in the Cesnola Collection waned, though its most significant works, such as the limestone sarcophagi from Amathus and Golgoi, remained continuously on exhibition. The thoroughgoing reinstallation of the Greek and Roman galleries initiated in 1990 has provided the opportunity to reconsider the Museum's Cypriot holdings and to present them in a way that makes sense both for the object and for the visitor. As of the spring of 2000, highlights of the Cesnola Collection are displayed in four galleries located on the second floor, just above those devoted to Greek and Roman art and in immediate proximity to those for ancient Near Eastern art. The A. G. Leventis Foundation has generously led the way in supporting the Cypriot galleries' renovation. We are also indebted to the New York City Department of Cultural Affairs and to the National Endowment for the Arts for supporting conservation work on the objects.

The preparation of this book, the first devoted to the Cesnola Collection since 1914, is due to the initiative of Vassos Karageorghis, former director of the Department of Antiquities of the Republic of Cyprus and the recognized authority on the archaeology of Cyprus. We are indebted to him for his expertise and energy. The publication of the volume has been made possible by a generous grant from the Government of the Republic of Cyprus. Support within the Museum has been provided by The Adelaide Milton de Groot Fund, in memory of the de Groot and Hawley families.

—*Philippe de Montebello*

PREFACE

This volume presents the finest works from The Metropolitan Museum of Art's vast and historic Cesnola Collection of Cypriot art. The Cesnola Collection, purchased by subscription in the mid-1870s, constituted the first group of Mediterranean antiquities to enter the nascent Museum. It seems only fitting, therefore, that this should be the first of several handbooks of the Classical collections to be published in conjunction with the refurbishment and reinstallation of the galleries of Greek and Roman art, an ongoing project since 1990. The book is a comprehensive survey of Cypriot art from prehistoric to Roman times, as represented by the Museum's rich holdings, and it serves as a guide to the four permanent galleries now devoted to Cypriot works from the Cesnola Collection. Pieces of prehistoric, Greek, and Roman art that were imported into Cyprus can be found in the galleries for Greek and Roman art, on the main floor. In the future, additional objects from the Cesnola Collection will be exhibited in the study galleries of the Department of Greek and Roman art.

The Museum is deeply indebted to Vassos Karageorghis, former director of the Department of Antiquities on Cyprus and for the past four years the Museum's consultant on the reinstallation of the Cypriot galleries. He has spearheaded this publication with great efficiency and flair, and he is responsible for the selection of objects both for this book and for the galleries housing the Cesnola Collection exhibits. I am profoundly grateful to Dr. Karageorghis for his impeccable scholarship and boundless energy, as well as for his cheerful collaboration with every member of the Department of Greek and Roman Art involved in this important project.

— *Carlos A. Picón*
Curator in Charge
Department of Greek and Roman Art

ACKNOWLEDGMENTS

I express my gratitude to the director of The Metropolitan Museum of Art, Philippe de Montebello, and to the curator in charge of the Department of Greek and Roman Art, Carlos A. Picón, whose support has made possible the reinstallation of the Museum's Cypriot galleries. They offered every assistance during my frequent visits to the Museum to prepare this book. Joan R. Mertens, Curator, Department of Greek and Roman Art, collaborated in the most efficient and cordial manner throughout my study of the Cesnola Collection and coordinated conservation and photography of the objects as well as preparation of this publication. Marice E. Rose, Research Associate, worked with me throughout the project and offered precious technical advice. I am grateful to Joan R. Mertens; Marice E. Rose; Joan Aruz, Acting Associate Curator in Charge, Department of Ancient Near Eastern Art; and Christopher S. Lightfoot, Associate Curator, Department of Greek and Roman Art, who agreed to write entries for this book.

I have profited greatly from the expertise of Stuart Swiny (prehistoric metalwork), Antoine Hermary (sculpture), Hartmut Matthäus (Iron Age metalwork), Christine Lilyquist (stone vases), and Elizabeth Hendrix and Günter Neumann (cat. no. 307). Joanna Smith helped prepare the text during the initial stages of my work. Maria Georghiou readied the final manuscript.

Members of the staff of the Metropolitan Museum have been involved in all aspects of assembling the material for this book. Numerous individuals deserve specific mention. In the Department of Greek and Roman Art, gallery supervisor William M. Gagen and technicians Jennifer Slocum Soupios and John F. Morariu, Jr., made the objects available for study and photography. Oi-Cheong Lee; Joseph Coscia, Jr.; and Paul Lachenauer deserve credit for the exceptionally fine photographs. Editors Teresa Egan and Jane Bobko devoted their superb skills to transforming a complex manuscript into a publication. Jean Wagner edited the bibliography. Patrick Seymour was responsible for the book's design, Peter Antony and Megan Arney for its production; their expertise and effort have made this a beautiful book. Deanna D. Cross and Lucinda K. Ross were essential intermediaries in the Photograph and Slide Library. Conservation was performed by Dorothy H. Abramitis, Lorna Barnes, Linda Borsch, Fred A. Caruso, Shinichi Doi, Elizabeth Hendrix, Sarah McGregor Howarth, Lisa Pilosi, Kendra Roth, Ellen Salzman, Dylan Smith, Karen Stamm, Richard E. Stone, Alexandra Walcott, Wendy Walker, George Wheeler, Susan White, and Mark T. Wypyski.

The Anastasios G. Leventis Foundation, Nicosia, supported my research both in New York and on Cyprus. The Institute for Aegean Prehistory (INSTAP), New York; the Samuel H. Kress Foundation, New York; the International Coordinating Committee, Justice for Cyprus, New York; and the Foundation for Hellenic Studies, Washington, D.C., also sponsored my travel to New York to study the Cesnola Collection.

—*Vassos Karageorghis*

CONTRIBUTORS
TO THE CATALOGUE

The text of this volume is by Vassos Karageorghis, with the exception of catalogue entries signed with the following initials:

JA Joan Aruz
Acting Associate Curator in Charge
Department of Ancient Near Eastern Art

CL Christopher S. Lightfoot
Associate Curator
Department of Greek and Roman Art

JRM Joan R. Mertens
Curator
Department of Greek and Roman Art

MER Marice E. Rose
Research Associate
Department of Greek and Roman Art

NOTE TO THE READER

In the headings of the catalogue entries, dimensions are abbreviated as follows: h., height; w., width; d., depth; l., length; diam., diameter. The objects were measured in centimeters. Dimensions are given in centimeters followed by inches, which have been rounded off to the nearest eighth of an inch.

While the order of objects in the book is chronological, pieces that have a particularly strong iconographical or functional connection are occasionally grouped together, regardless of their date.

All of the objects in this catalogue are in the Department of Greek and Roman Art, with the exception of the cylinder seals (cat. nos. 102–7), which are in the Department of Ancient Near Eastern Art.

Citations are abbreviated throughout the book; full references are provided in the bibliography.

The parenthetical reference that follows the accession number of each object is to J. L. Myres's *Handbook of the Cesnola Collection of Antiquities from Cyprus*, still the basic guide to the Cesnola Collection as a whole. Unless otherwise indicated, the credit line for each object is: The Cesnola Collection, Purchased by subscription, 1874–76.

CHRONOLOGY

CYPRUS

PRE-NEOLITHIC PERIOD: CA. 10,000 B.C.
 Akrotiri culture (CA. 8800 B.C.)
 First hunter-gatherers

NEOLITHIC PERIOD: CA. 8500–CA. 3900 B.C.
 Khirokitia culture (CA. 7000/6500 B.C.–5700/5500 B.C.)
 Arrival of first settlers from the Near East
 Sotira culture (CA. 4600/4500 B.C.–4000/3900 B.C.)
 First handmade pottery produced

CHALCOLITHIC PERIOD: CA. 3900–CA. 2500 B.C.
 Erimi culture
 Earliest metal objects

BRONZE AGE
EARLY CYPRIOT I (EARLY BRONZE AGE I): CA. 2500–CA. 2075 B.C.
 Philia culture (CA. 2600/2500–2300 B.C.)
 ? Arrival of settlers from Anatolia

EARLY CYPRIOT II (EARLY BRONZE AGE II): CA. 2075–CA. 2000 B.C.

EARLY CYPRIOT III (EARLY BRONZE AGE III): CA. 2000–CA. 1900 B.C.

MIDDLE CYPRIOT I (MIDDLE BRONZE AGE I): CA. 1900–CA. 1800 B.C.

MIDDLE CYPRIOT II (MIDDLE BRONZE AGE II): CA. 1800–CA. 1725 B.C.

MIDDLE CYPRIOT III (MIDDLE BRONZE AGE III): CA. 1725–CA. 1600 B.C.

LATE CYPRIOT I (LATE BRONZE AGE I): CA. 1600–CA. 1450 B.C.
 Significant trade with Egypt, the Near East, and the Greek world

LATE CYPRIOT II (LATE BRONZE AGE II): CA. 1450–CA. 1200 B.C.

LATE CYPRIOT III (LATE BRONZE AGE III): CA. 1200–CA. 1050 B.C.
 Major wave of Greek immigration (CA. 1100 B.C.)

MEDITERRANEAN WORLD

Minoan civilization on Crete
 (CA. 3000–1100 B.C.)

Mycenaean civilization in Greece
 (CA. 1600–1100 B.C.)

The "Sea Peoples" active in eastern
 Mediterranean (late 13th–early
 12th century B.C.)

CYPRUS

MEDITERRANEAN WORLD

IRON AGE

CYPRO-GEOMETRIC I: CA. 1050–CA. 950 B.C.
Earliest evidence for the Greek language (11th century B.C.)

CYPRO-GEOMETRIC II: CA. 950–CA. 850 B.C.
Phoenician colony founded at Kition (mid-9th century B.C.)

CYPRO-GEOMETRIC III: CA. 850–CA. 750 B.C.

Homer (CA. 750 B.C.)

CYPRO-ARCHAIC I: CA. 750–CA. 600 B.C.
Assyrian rule (CA. 707–612 B.C.)

CYPRO-ARCHAIC II: CA. 600–CA. 480 B.C.
Egyptian rule (CA. 570–526/5 B.C.)
Persian rule (CA. 526/5–333 B.C.)
Persian siege of Cypriot cities (498/7 B.C.)

Persian control of Ionia (by CA. 540 B.C.)

CYPRO-CLASSICAL I: CA. 480–CA. 400 B.C.
Struggle of Evagoras I of Salamis (r. 411–374/3 B.C.) against
Persian rule

Greek victory over the Persians (479 B.C.)
Completion of Parthenon in Athens
(432 B.C.)

CYPRO-CLASSICAL II: CA. 400–CA. 310 B.C.
Submission of Cypriot cities to Alexander the Great (333 B.C.)

Alexander's victory over the Persians at
Battle of Issus (333 B.C.)

HELLENISTIC PERIOD: CA. 310–CA. 30 B.C.
End of city-kingdoms
Annexation of Cyprus by Ptolemy I of Egypt (294 B.C.)
Cyprus becomes province of Rome (58 B.C.)
Cyprus in possession of Cleopatra VII (CA. 47–30 B.C.)

Romans sack Corinth (146 B.C.)
Greece becomes part of the Roman
Empire

ROMAN PERIOD: CA. 30 B.C.–CA. A.D. 330
Cyprus integrated into the Roman Empire (30 B.C.)
Saints Paul and Barnabas establish Christian community
(CA. A.D. 47–49)
Revolt of Cypriot Jews (A.D. 116)

Byzantium (Constantinople) becomes
capital of the Roman Empire (A.D. 330)

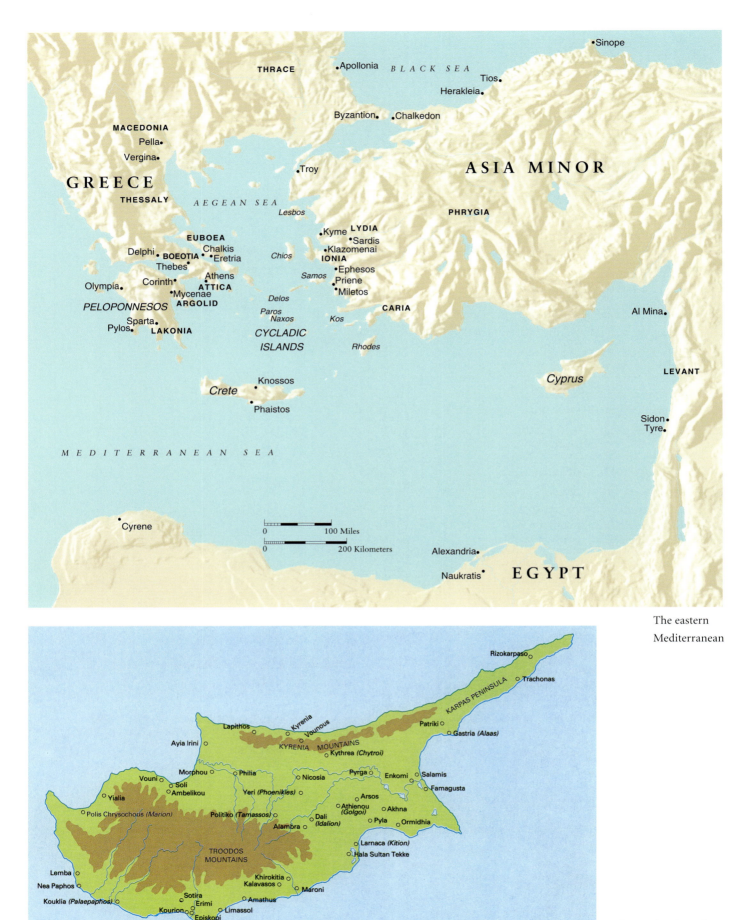

The eastern
Mediterranean

Cyprus (ancient place
names are italicized)

ANCIENT ART FROM CYPRUS

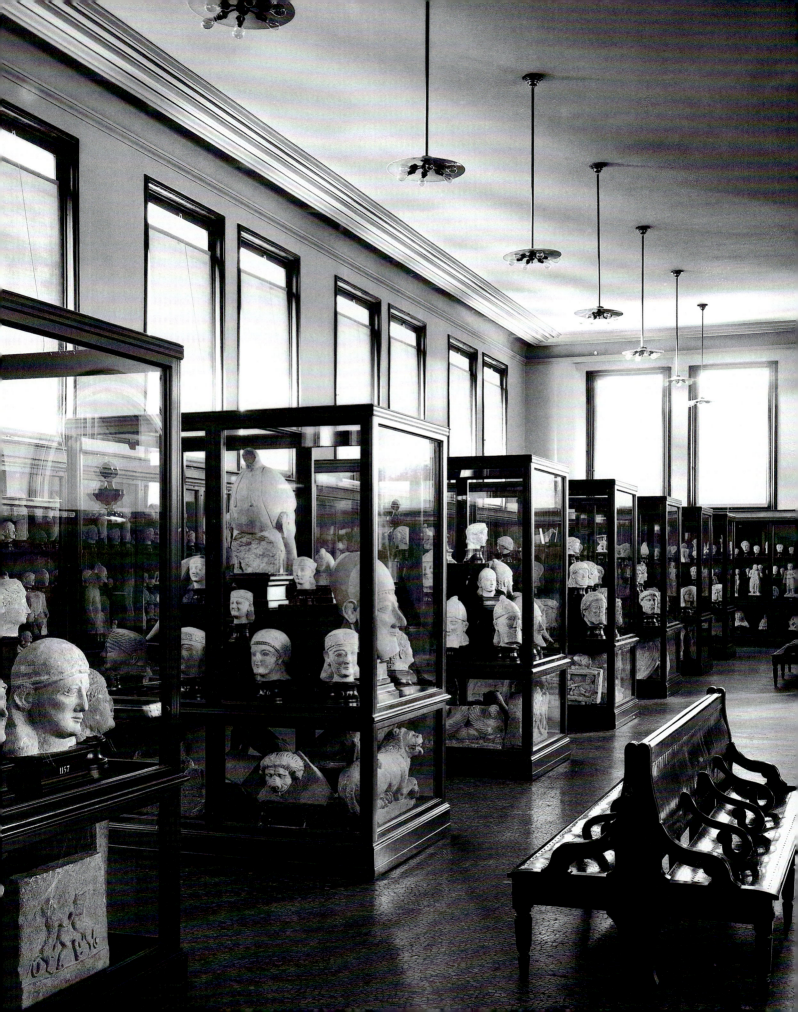

INTRODUCTION

Since the Middle Ages, European travelers, particularly pilgrims to the Holy Land, have visited Cyprus. In their accounts they refer to the island as the birthplace of Aphrodite, the land where Saints Paul and Barnabas preached Christianity, and the place where Shakespeare set *Othello*. There are occasional references to the ruins of specific monuments, such as those at Salamis and Paphos—still the two most important archaeological sites on the island.

During the first half of the nineteenth century, foreign scholars, mainly French, came to the island and showed the first serious interest in Cypriot antiquities, especially inscriptions. Local antiquarians formed private collections of antiquities, notably the Pierides Collection, begun by Demitrios Pierides toward the end of the century. Cypriot peasants began to provide material for collectors, digging wherever they could. Cyprus was then under Ottoman rule, and there were no laws to protect objects and monuments.

The second half of the nineteenth century witnessed the first excavations organized by amateur archaeologists—foreign consuls and bankers who vied with one another in making archaeological discoveries and publishing reports about them. R. Hamilton Lang, for example, was a Scottish banker who lived in Larnaca in the 1860s and 1870s and developed an interest in the antiquities of Idalion and Pyla. Scholarly investigations continued, by men such as Melchior de Vogüé and William Waddington. In 1863, as a result of the activities of French scholars on the island, 173 Cypriot antiquities were removed to the Musée du Louvre, Paris, generating interest outside Cyprus in Cypriot archaeology. Studies, mainly of inscriptions found on Cyprus, began to appear in foreign archaeological journals.

Luigi Palma di Cesnola was the first American consul on Cyprus. Born in Rivarolo Canavese, in the Piedmont region of Italy, in 1832, he became an officer of the kingdom of Savoy and, after brief service in the Crimean War, emigrated to America in the late 1850s. In 1862 he volunteered for a New York cavalry regiment and served in the Civil War until 1864, including ten months in a Confederate prison. After being discharged, in both New York and Washington he applied his considerable energy, initiative, and skills at self-promotion to obtain the position of American consul on Cyprus. He arrived there with his pregnant wife and young daughter on Christmas Day, 1865.

Cesnola established himself in Larnaca, which was then Cyprus's most cosmopolitan town, where foreign consuls, bankers, and businessmen resided. His social contacts with foreign residents of Larnaca who had already developed an interest in archaeological activities persuaded him to follow their example. He had time to spare from his consular duties, as well as intellectual

Figure 1 (opposite). Limestone and terracotta sculpture from the Cesnola Collection on display at The Metropolitan Museum of Art, 1907

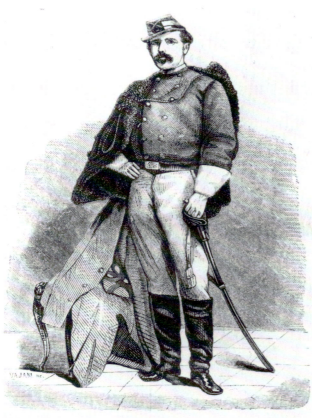

IL COLONNELLO PALMA.

Figure 2. Cesnola as colonel of the Fourth New York Cavalry during the Civil War. Archives, The Metropolitan Museum of Art, New York. Gift of Mrs. J. Bradley Cook, 1997

curiosity and a material interest in unearthing and collecting antiquities. The lack of any laws that might hinder such a pursuit and the ease of finding expert diggers among the local inhabitants provided ideal conditions for the development of a hobby that was destined to become a passion and make Cesnola internationally famous.

Cesnola's archaeological activities on Cyprus have already been described in detailed studies of both a popular (McFadden 1971) and a scholarly nature (Masson 1961). Cesnola did not have any formal education as a historian or classical scholar that might have helped him to interpret and to publish the results of his discoveries, but he had easy access to experts in distinguished museums in Europe, such as the British Museum, London, and the Antiquarium, Berlin; he was also helped considerably by influential friends in New York, particularly the hotelier Hiram Hitchcock, whose Fifth Avenue Hotel,

which opened in 1859, was a gathering spot for everyone of social, political, or financial consequence. Hitchcock helped Cesnola unstintingly and unflaggingly with money, advice, and other assistance; his papers are now in the collection of Dartmouth College in New Hampshire.

Cesnola was fascinated by the limestone sculpture of Cyprus. He compared it to the works of Classical Greek sculpture, undoubtedly in an effort to enhance its value and importance. But he probably did so chiefly because sculpture was his most important discovery, in the temple of Aphrodite at Golgoi-Ayios Photios, which he unearthed in 1870. Statues of gods, goddesses, heroes, and priests, some over-lifesize, were brought up in large numbers. Ironically, it was sculpture that caused Cesnola's troubles with critics, chiefly the French dealer Gaston Feuardent. In his effort to present complete works Cesnola did not hesitate to put heads and limbs on bodies to which they did not belong. These irregularities notwithstanding, the collection of limestone Cypriot sculpture in The Metropolitan Museum of Art is the finest and richest of its kind, even by comparison with the collections in museums on Cyprus. Two unique limestone sarcophagi, one from Golgoi and the other from Amathus (cat. nos. 330, 331), are the centerpieces of the Cesnola Collection.

It is not certain how the Golgoi sculptures were found. A proper excavation report recording where the sculptures were situated in the sanctuary and describing accompanying artifacts did not interest Cesnola; nor did he provide plans, measurements, or other information about the architectural remains, if any, within which his discoveries came to light. It is even doubtful that he was present throughout the excavation. If one judges Cesnola and his methods by modern procedures, one must condemn him, but it should not be forgotten that in his day the main goal of archaeological activity was merely the discovery of works of art. Stratigraphy, architectural documentation, and the collection of scientific data are considerations that have evolved more recently. It is to Cesnola's credit that he preserved his Golgoi finds together—or so one hopes. But there is no defending the overenthusiasm with which he manipulated fragments in order to create complete statues.

Cesnola did not hesitate to use other unorthodox methods, which have added to the shadow cast over his work. He was active when the German archaeologist

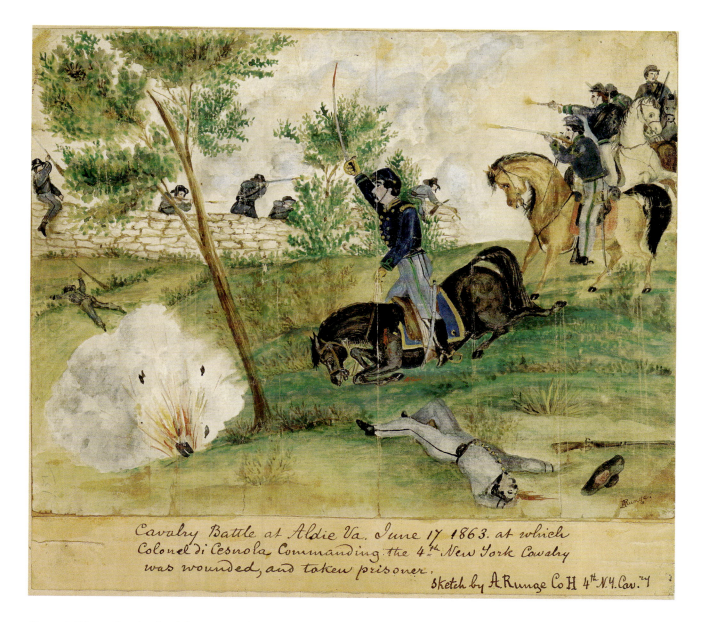

Cavalry Battle at Aldie Va. June 17 1863. at which Colonel di Cesnola Commanding the 4th New York Cavalry was wounded, and taken prisoner.

Sketch by A. Runge Co H 4th N.Y. Cav. "1

Figure 3. Watercolor sketch of the 1863 cavalry engagement at Aldie, Virginia, in which Cesnola was taken prisoner. Archives, The Metropolitan Museum of Art, New York. Gift of Mrs. J. Bradley Cook, 1997

Heinrich Schliemann was making headlines with his discoveries at Troy (1871–90) and Mycenae (1871–94) and was publishing the results of his excavations in what may justifiably be considered scholarly papers, providing as much information as possible and taking into consideration the archaeological context and the architectural remains associated with his finds. Schliemann's excavations appealed enormously to classical scholars because they had an immediate relation to Homeric epic, at a time when the existence of ancient objects directly pertinent to literary sources was a novelty. No doubt Cesnola envied Schliemann's achievements and their acclaim throughout the scholarly world. He wished to emulate Schliemann by making a great discovery at an important site from one specific period rather than just accumulating objects, however precious, from dozens of sites or tombs. Thus Cesnola claimed to have found at Kourion, near the southwestern coast of Cyprus, subterranean vaults that contained priceless treasures, including gold and silver jewelry. Ignorant of

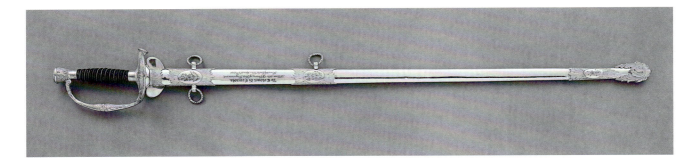

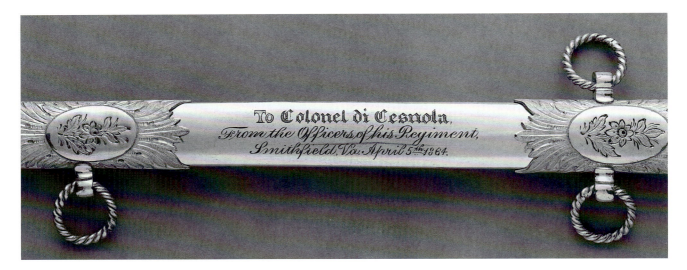

Figure 4 (top). Sword presented to Cesnola after his release from a Confederate prison and return to active duty. The Metropolitan Museum of Art, New York. Gift of Mrs. J. Bradley Cook, 1997.

Figure 5 (bottom). Detail of figure 4, showing inscription

the typology and chronology of ancient Cypriot artifacts, he described objects of widely disparate periods as having been found together. In order to gain credibility, he provided a ground plan with measurements of the subterranean vaults. This is the only plan with measurements that exists for any of Cesnola's architectural discoveries. The so-called Kourion Treasure kindled the public's imagination and elicited admiration and envy internationally. Cesnola himself confessed that his main concern was to rival Schliemann, stating that "when I publish my last discoveries, they will throw forever into shade those of Schliemann" (McFadden 1971, p. 161). The "Kourion Treasure" certainly impressed the trustees of the Metropolitan Museum and allowed Cesnola to inflate the price at which he sold his collection to the Museum. But the truth could not be hidden for long, and when it was disclosed Cesnola's reputation was damaged considerably (cf. McFadden 1971, pp. 157–65).

Recent archaeological excavations at the necropolis at Kourion may throw some light on the "Kourion Treasure." Cesnola evidently happened upon some very rich tombs in the necropolis, on the southeastern side below the acropolis, where he found silver and bronze bowls, alabaster vases, and bronze and iron tripods, besides jewelry and other artifacts. Some of these tombs may have been built chamber tombs with barrel-vaulted roofs, similar to one that was recently excavated by Demos Christou for the Cyprus Department of Antiquities. It was found half looted, but even so it yielded numerous pieces of gold jewelry, including beads that correspond exactly to the gold beads of a necklace now in the Metropolitan Museum (cat. no. 382). This tomb may have been opened first by Cesnola or his workers. It is situated in the same area where Cesnola is depicted, in a drawing published in his book *Cyprus: Its Ancient Cities, Tombs, and Temples* (New York, 1877), seated

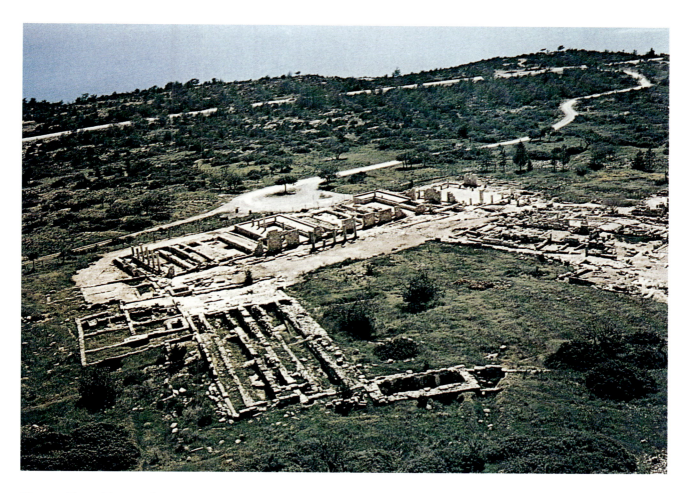

Figure 6. View of the site of Kourion

under a tree and looking through his binoculars at the acropolis of Kourion. He may have excavated more than one such built tomb, which "inspired" him to imagine a series of subterranean vaults.

The year 1872 was a pivotal one for Cesnola's collection and his relation to The Metropolitan Museum of Art. Faced in 1871 with a ban on the export of antiquities from Cyprus, Cesnola succeeded in having the major pieces in his collection, notably the sculpture, shipped to England by mid-January 1872. He spent the rest of the year haggling with representatives from Saint Petersburg, Berlin, London, Paris, and New York over the sale of his collection. In December, John Taylor Johnston, president of the Metropolitan Museum, and fellow trustees approved the purchase. The collection reached New York in 275 crates, some nearly nine feet long, and in February 1873 Cesnola was allocated a salary

of $500 per month and an appropriation of $10,000 for the repair and installation of the Cypriot finds. They went on public view a month later. Cesnola returned to Cyprus at the end of the year with a contract from the Museum to pursue his excavations, which he did until 1876. The "Kourion Treasure" was the major result of this second campaign. In 1877 he returned to New York and very quickly was appointed secretary of the Metropolitan Museum. In 1879 he became the first director, a position that he held until his death in 1904.

As the primary display of archaeological material in the newly established museum, the Cesnola Collection attracted considerable attention. During his years of seeking a buyer for his finds, Cesnola enlisted the services of the firm Rollin & Feuardent, well-known art dealers in Paris. In August 1880, Gaston Feuardent launched a fierce attack on the restorations and alterations

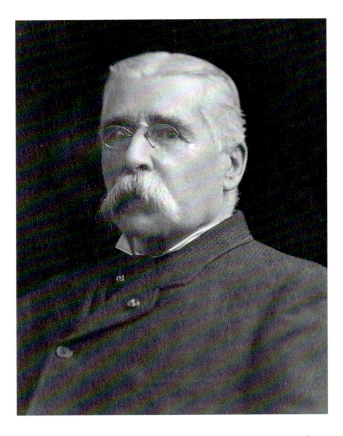

Figure 7. Cesnola during his tenure as director of The Metropolitan Museum of Art

to which objects in the Cesnola Collection had been subjected; he targeted one limestone figure (cat. no. 343) in particular. The controversy escalated into a court trial that ended in early 1884 with a vindication of Cesnola.

Even before this episode, Cesnola was aware that he had an obligation if not to vindicate then at least to explain his archaeological activities and discoveries. His *Cyprus: Its Ancient Cities, Tombs, and Temples* provides a dramatic and anecdotal account of his activities on the island. His most important publication, however, is the catalogue of his collection (or the majority of it), published in Boston and New York between 1885 and 1903 in three large volumes (with text and plates in each volume). Entitled *A Descriptive Atlas of the Cesnola Collection of Cypriote Antiquities in The Metropolitan Museum of Art, New York*, it remains a basic tool and source of information for students of Cypriot art.

In 1914 the British archaeologist J. L. Myres published a scholarly catalogue of the Cesnola Collection, based on a more accurate typology and chronology of the objects, but with only a few small-scale illustrations. This catalogue, entitled *Handbook of the Cesnola Collection of Antiquities from Cyprus* (New York, 1914), provides a conspectus of all of the pieces now in the Cesnola Collection. Myres may be considered the first credible scholar of Cypriot archaeology. His *Handbook* remained for many years a fundamental work in the study of Cypriot art, though its commentary is too summary or outdated to be particularly useful today.

After Myres, scholarly study of the Cesnola Collection languished. Individual objects occasionally appeared in monographs or studies and in specialized catalogues published by Gisela M. A. Richter, curator of classical art at the Metropolitan Museum. In 1928 a large portion of the Cesnola Collection was auctioned by the Museum and scattered among other museums and private collections in the United States—and perhaps elsewhere: there is no complete record of the destination of the pieces. A catalogue with some illustrations was published by the Anderson Galleries in 1928 (*Cypriot and Classical Antiquities: Duplicates of the Cesnola and Other Collections, Sold by Order of the Trustees of The Metropolitan Museum of Art*). Two thousand three hundred objects were bought by the John and Mable Ringling Museum of Art, Sarasota (Florida). A large number had earlier gone to Stanford University. Before the Anderson auction, additional pieces had also been disposed of through "over-the-counter" sales at the Museum; the purchasers were predominantly private individuals. Of the thirty-five thousand objects that Cesnola removed from Cyprus, about six thousand remain in the Metropolitan Museum.

Cesnola left Cyprus for good in 1876, two years before the annexation of the island by Great Britain and the prohibition of all unauthorized archaeological activity. Cesnola's brother Alexander, who at the invitation of Luigi operated in Cyprus in 1877 and 1878, mainly in the area of Salamis, did not make any outstanding discoveries. Part of his collection was confiscated by the island's new rulers, part of it was acquired by the Antiquarium, Berlin.

One of the first archaeological visitors to Cyprus after its annexation by Great Britain was Max Ohnefalsch-Richter, a Prussian classical scholar who came to the island at the end of 1878. In 1879 he began his archaeological activities at Kition, afterward continuing at

Greek culture in general, however, penetrated deeply and influenced Cypriot artistic production. Works of art were imported from Greece, often in exchange for copper. Alexander the Great's conquest of Cyprus put an end to Persian rule, and the island became subject to the Ptolemys in Alexandria. The artistic production of Cyprus during the Ptolemaic period was part of the Hellenistic koine, a style that prevailed throughout the Mediterranean world.

The Romans' domination entailed heavy taxation, but emperors such as Trajan and Hadrian favored the cities of Salamis and Paphos and adorned them with fine public buildings that continue to be unearthed. The excellence of Cypriot mosaics and the luxury of the Roman villas are also apparent from recent work at Nea Paphos, the capital of Cyprus during the Late Hellenistic and Roman periods.

The Classical, Hellenistic, and Roman periods are well represented in the Cesnola Collection. Noteworthy and little-known are a series of Hellenistic and Roman heads (see cat. nos. 404–11). Special mention should also be made of the gold and silver jewelry in the collection, most of which is now displayed.

Since 1960, when Cyprus gained its independence, the Department of Antiquities of the Republic of Cyprus has followed a liberal policy toward foreign missions, aimed at accelerating the development of Cypriot archaeology, particularly in obscure areas, such as the early prehistoric periods and some phases of the Late Bronze Age. This policy has brought to Cyprus missions from Europe, the United States, and Australia. Since the amendment of the Antiquities Law in 1964, all antiquities discovered in Cyprus belong to the state, and there is no division of finds with excavators. About fifteen to twenty foreign missions are active in various parts of the island each year. The professional staff of the Department of Antiquities has increased, and new museums have been created and the old ones expanded. The government's policy is not only to promote culture but also to link archaeology with economic development through cultural tourism.

More than 130 years after Cesnola's arrival in Cyprus, Cypriot archaeology remains a lively and challenging field for the student of cultures of the ancient world, because the island served throughout its past as a stepping-stone between the orient and the occident. Cesnola's methods of excavation deprive the collection of much of its archaeological or historical value. Nevertheless, it contains objects that are among the finest examples of Cypriot art. Cypriot sculpture, pottery, and metalwork cannot be studied properly without the Cesnola Collection. The Cesnola Collection of Cypriot antiquities is the most important collection outside Cyprus. In reinstalling and republishing the collection's major pieces, The Metropolitan Museum of Art is once again making accessible a significant part of its own history and a primary resource for the study of ancient Cyprus.

I.

THE PREHISTORIC PERIOD

[CA. 10,000 – CA. 1050 B.C.]

The prehistory of Cyprus covers nearly nine thousand years, from the beginning of the Neolithic age to the end of the Late Bronze Age. In recent years a pre-Neolithic site was discovered on the southern coast of the island, but no permanent settlement was found, only a shelter for hunters of pygmy varieties of elephants and hippopotamuses. The Cesnola Collection was formed at a time when evidence of the earliest phases of the prehistoric period (Neolithic and Chalcolithic) had not yet been discovered, so the earliest artifacts in the collection date from the Early Bronze Age (ca. 2500 B.C. or slightly later).

The objects described in Part I were all gifts to the dead, found in tombs. Settlement sites were not extensively excavated before the 1930s, some sixty years after Cesnola's activities on Cyprus had ceased. Although variants of the objects illustrated here were commonly in daily use, the examples in the Metropolitan Museum do not give a complete picture of everyday life on the island because they were specifically created to honor and please the dead and to indicate their status. They are fine artifacts, and some are exceptionally pleasing to modern viewers as works of art. Pottery, terracotta figurines, metallic and stone objects, and gold jewelry are included.

Most of the pieces are of Cypriot manufacture, but some, such as the luxury Mycenaean pottery and the vases of faience, are imports from the Aegean and the Levant. Of particular note are the two elegant Mycenaean kraters (cat. nos. 70, 71) that were apparently made on the Greek mainland and exported to Cyprus during the

fourteenth or thirteenth century B.C.—coincidentally, at the time when Cypriots were exporting copper to nearby areas. The geographical position of Cyprus, along with its wealth in copper, contributed to enhanced trade and cultural relations with its neighbors, especially during the Late Bronze Age.

At that time, Cypriots were using the script known as Cypro-Minoan, borrowed about 1500 B.C. from the Cretans and adapted to the native language. Unfortunately, this script remains undeciphered; long examples exist on baked-clay tablets and other documents found at urban centers such as Enkomi (on the eastern coast) and Kalavasos (on the southern coast), but the language is not known. These documents were first found in the 1950s at Enkomi. Engraved and painted characters of the Cypro-Minoan script appear on a number of vases in the Cesnola Collection.

The pottery of the prehistoric Cypriots, especially that produced in the Early and Middle Bronze Ages, is exuberant and imaginative in shape and in decoration, which accords with its intended use in tombs. Terracotta figurines were also produced in fairly large numbers and placed in tombs throughout the Bronze Age; they most commonly depict female figures that symbolize regeneration. Other funerary objects, especially those buried with men, include bronze tools and weapons. The Ces-

Opposite: Detail, cat. no. 71

nola Collection is rich in both locally made and imported wares of the Late Bronze Age.

Gold and silver jewelry appears on Cyprus as early as 2500 B.C. The gold examples here date from the Late Bronze Age. Also included is a group of cylinder seals from that period. Cyprus had a highly developed glyptic art, which shows influences from both the Near East and the Aegean region.

It should be mentioned here that Alasia, the Late Bronze Age name for Cyprus, is referred to as a copper-producing country on nineteenth-century B.C. clay tablets from Mesopotamia (Charpin 1990, pp. 125–27). It is from this era that we have real evidence for trade with the outside world: the appearance of a series of items of foreign manufacture or influence at sites in eastern Cyprus—for example, axes of tin bronze; the Cesnola Collection has one specimen (cat. no. 94).

The maritime trade of Cyprus is illustrated by the cargoes of three shipwrecks recently discovered in or near the region of the Aegean Sea, dating from the end of the fourteenth century B.C. to about 1200 B.C. In two cases copper ingots were found, but Cyprus also exported fine pottery, agricultural products, wood, and perfume. Valuable information about the trade relations between Cyprus and Egypt is furnished by correspondence between the pharaoh of Egypt and the king of Alasia, dating from the first half of the fourteenth century B.C. (The tablets bearing this correspondence were found in the palace of Tell el-Amarna in Egypt and today are scattered among various museums in Europe and the United States.) The Cesnola Collection has a number of objects of faience and alabaster that were imported into Cyprus from Egypt during this period.

COROPLASTIC (TERRACOTTA) ART

Throughout the Bronze Age, Cypriots produced handmade terracottas that translated their ideas about fertility and regeneration into clay. There is wide variation in the representation of the human figure in the terracottas from this time. Among the notable creations of the Early and Middle Cypriot periods are scenes from religious and secular life. They appear both as vase decorations and as independent coroplastic creations (for a survey of the coroplastic art of prehistoric Cyprus, see V. Karageorghis 1991).

EARLY AND MIDDLE CYPRIOT PERIODS (ca. 2500–ca. 1600 B.C.)

Red Polished Ware
Plank-shaped figurines are always female. Even when the breasts are not shown, it is certain that the figurines represent women because of their diadems, necklaces, earrings, and other ornaments. Early Cypriot plank-shaped figurines are stiff and strictly stylized, but by the Middle Cypriot period they have acquired arms and even short legs.

They are all handmade; molds were used much later, in the seventh century B.C. Incised decorations on both sides indicate facial characteristics, ornaments, and garments. Details of the developed, Middle Cypriot, examples can be seen in relief. Each figurine usually represents a single female figure, occasionally holding an infant. In some cases, a single body is represented with two necks, possibly an effort to represent a male and a female figure together.

Plank-shaped figurines were common during the Early Cypriot III– Middle Cypriot I periods. They do not represent divinities, but there is no doubt that they symbolize concepts of regeneration and fertility. They have long been known from tombs, and recently small numbers have been discovered at settlement sites (Frankel and Webb 1996, pp. 187–88; Mogelonsky 1996, p. 202). No sanctuary from this era has yet been located but, should one be found, it may well yield plank-shaped figurines. The flat shape and incised decoration of the early figurines may indicate the copying of wooden statues (xoana) that probably served as cult objects in sanctuaries.

The Cesnola Collection possesses only one early figurine of the plank-shaped type (cat. no. 2) (cf. V. Karageorghis 1991, pp. 49–52, pls. xx–xxxi). The other two are of the developed type (cat. nos. 1, 3). Their breasts and arms are clearly in relief, bent against their chests; catalogue number 3 is a classic example of the developed plank-shaped figurine, with its body and neck elliptical rather than rectangular in section and with its shoulders curving instead of exhibiting the stiff angularity of the earlier types. These figurines once wore earrings, probably of metal or thread; this feature can be observed occasionally on female figurines of the Middle Cypriot period, but it occurs more frequently in the Late Cypriot I and II periods.

Terracotta figurines of animals usually appear as part of the decoration on the rims of large cultic bowls or the shoulders of vases. Free-standing figurines (cat. nos. 5, 6) are rare (cf. V. Karageorghis 1991, pp. 103–4, pl. LVIII.4–6, nos. G13– G15; Frankel and Webb 1996, pp. 188–91; Mogelonsky 1996, pp. 203–4).

1. **Plank-shaped figurine**
Middle Cypriot (ca. 1900–
ca. 1600 B.C.)
Red Polished Ware
H. 17.6 cm (6⅞ in.)
74.51.1537 (Myres 2002)
Said to be from a rock-cut tomb
at Alambra

The solid-slab figurine has a flat
body but no legs. Its surface has a
dark brown slip. A turban was prob-
ably worn across the upper part of
the head; it is now detached, but it
left a different coloration on the
surface. The back is flat and plain.

BIBLIOGRAPHY: Doell 1873, p. 59,
pl. XIV.2, no. 837; Cesnola 1877,
p. 89, pl. VI; Cesnola 1894, pl. II.5;
V. Karageorghis 1976b, p. 130,
no. 100; J. Karageorghis 1977, p. 68;
Orphanides 1983, p. 8, pl. II, no. 4;
V. Karageorghis 1991, p. 88, pl. LI.5,
no. BJ.16.

2. **Plank-shaped figurine**
Early Cypriot III–Middle Cypriot I
(ca. 2000–ca. 1800 B.C.)
Red Polished Ware
H. 28.4 cm (11⅛ in.)
74.51.1534 (Myres 2001)
Said to be from Alambra

The solid, square-shouldered fig-
urine lacks arms and ears. The head
and neck were recently restored with
plaster. On the back, two groups of
vertical zigzag lines run along the
head and most of the neck.

BIBLIOGRAPHY: Cesnola 1894,
pl. I.4; Orphanides 1983, pp. 5–6,
pl. I, no. 1; V. Karageorghis 1991,
pp. 55–56, pl. XXI.1, no. BA.7.

3. **Plank-shaped figurine**
Middle Cypriot I (ca. 1900–
ca. 1800 B.C.)
Red Polished Ware
H. 20.7 cm (8⅛ in.)
74.51.1535 (Myres 2003)
Said to be from a rock-cut tomb
at Alambra

In contrast to that of the natu-
ralistic headdress, the incised deco-
ration of the solid figurine with
sloping shoulders is rather care-
lessly applied on both sides of the
neck and body. The decoration
on the back is similar to that on
the front.

BIBLIOGRAPHY: Doell 1873, p. 59,
pl. XIV.3, no. 838; Cesnola 1877,
p. 89, pl. VI; Cesnola 1894, pl. II.6;
Orphanides 1983, pp. 6–7, pl. III,
no. 2; V. Karageorghis 1991, pp. 82–
83, 93, pl. XLVIII.4, no. BI.5.

4. **Figurine in the form of an *askos***
Middle Cypriot I (ca. 1900–
ca. 1800 B.C.)
Red Polished Ware
H. 5.1 cm (2 in.); L. 7.9 cm (3⅛ in.)
74.51.1336 (Myres 59)

The solid, boat-shaped body has
a horned protome on each side.
The horns of one animal curve up-
ward; the other's horns are slightly
twisted. They may be a bull and a
ram, respectively. Their noses are
pointed, and punctures serve as
their ears and eyes. Zoomorphic
vases, or *askoi*, were commonly
made in this shape. Because of the
small size of this object, the sculp-
tor produced a solid terracotta fig-
urine. Had this been a functional
askos, the two protomes would
have served as spouts.

5. **Dog(?)**
Middle Cypriot I (ca. 1900–
ca. 1800 B.C.)
Red Polished Ware
H. 4.1 cm (1⅝ in.)
74.51.1293 (Myres 60)

The solid figurine has pointed
ears, one of which is detached. A
suspension handle projects from
the top of the body.

6. **Boar**
Early Cypriot III–Middle Cypriot I
(ca. 2000–ca. 1800 B.C.)
Red Polished Ware
H. 9.5 cm (3¾ in.)
74.51.834 (Myres 57)

The flattened body is heavy and
seems to be solid. Lime fills the
grooves.

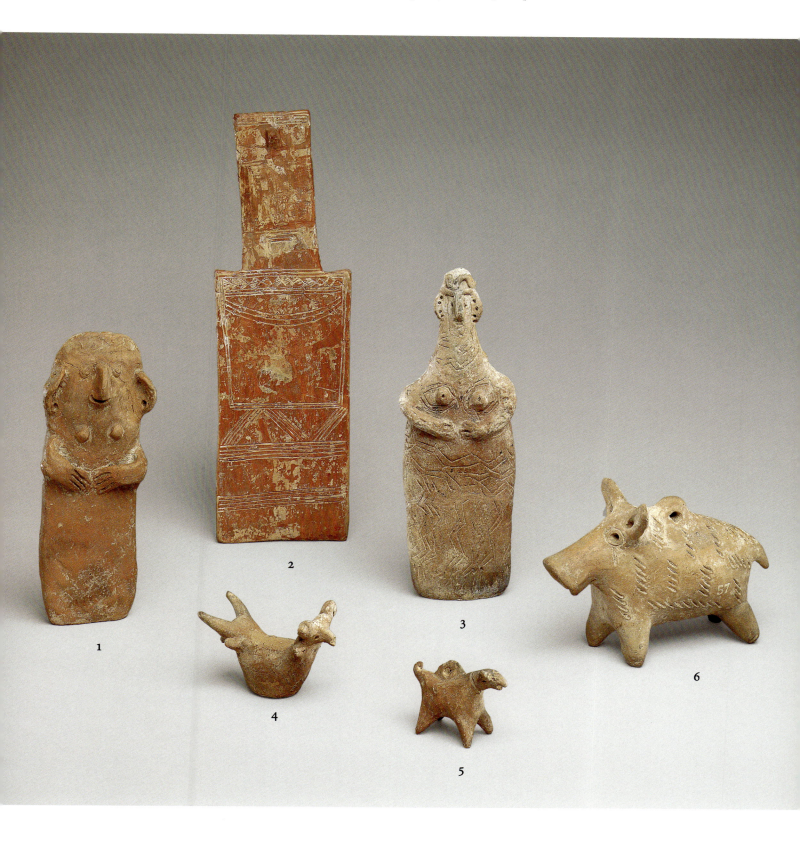

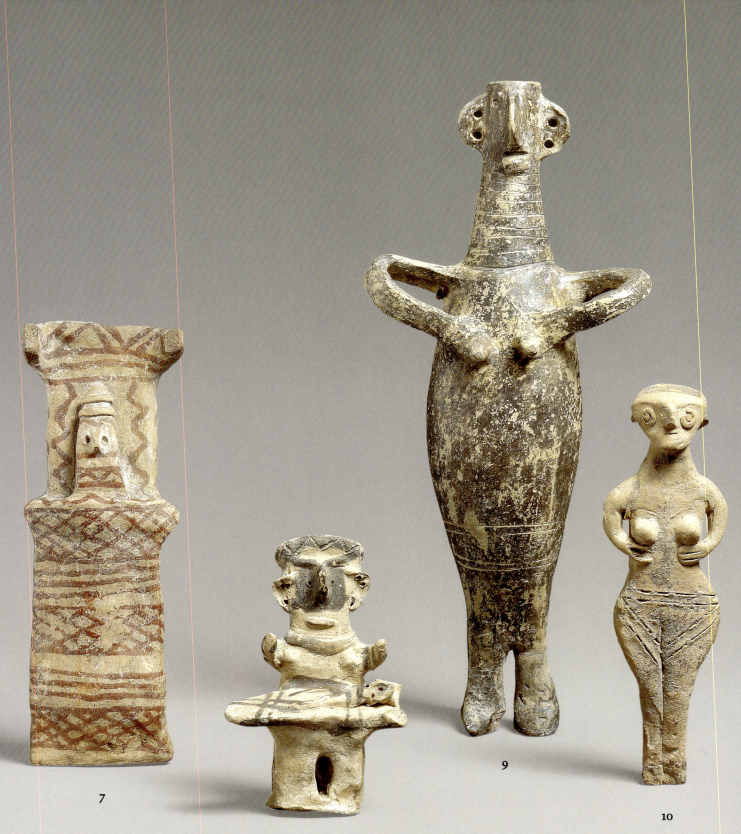

7

8

9

10

White Painted Ware

7. Cradle figurine

Middle Cypriot (ca. 1900–
ca. 1600 B.C.)
White Painted Ware
H. 17.6 cm (6⅞ in.)
74.51.1536 (Myres 2005)
Said to be from Nicosia-Ayia
Paraskevi

The figurine is solid. The lower
part of the cradle was cut off to
allow for attachment to a modern
base; the top part is missing. The
infant's head and neck were modeled
separately from the cradle, whose
back is entirely covered with paint.
Some clay figurines of infants in
cradles, without female or mother
figures, were buried in tombs and
are obvious fertility and regenera-
tion symbols. They were made
in both Red Polished and White
Painted wares.

BIBLIOGRAPHY: Cesnola 1894,
pl. II.7; V. Karageorghis 1976b,
p. 130, no. 101; J. Karageorghis 1977,
p. 66; Orphanides 1983, p. 7, pl. V,
no. 3; V. Karageorghis 1991, p. 173,
pl. CXXXVII.3, no. WHP.Ca.3.

8. Seated female with infant and cradle

Middle Cypriot (ca. 1900–
ca. 1600 B.C.)
White Painted Ware
H. 10.3 cm (4 in.)
74.51.1538 (Myres 2007)
Said to be from Alambra

This solid figurine holds a cradle
with an infant on her lap; the cradle,
its top now missing, was attached to
the middle of her body by a strap.
The seated female is a rare type of
White Painted Ware figurine. Such
works usually decorate large Early
and Middle Cypriot period bowls of
Red Polished Ware (e.g., V. Karageor-
ghis 1991, pp. 121–23, pls. LXXXIV.1,
LXXXV.6, nos. SC13, SC19). This fig-
urine may have become detached
from a large vase or, more probably,
from a flat platform. It should be
noted that, unlike the Red Polished
Ware figurines, the woman shown
here does not hold the cradle in
her arms.

BIBLIOGRAPHY: Cesnola 1894, pl. I.3;
V. Karageorghis 1976b, p. 131, no. 102;
J. Karageorghis 1977, p. 66, pl. 18a;
Orphanides 1983, pp. 8–9, pl. VII,
no. 5; V. Karageorghis 1991, pp. 170–
71, pl. CXXXVI.2, no. WHP.Bh.1.

Black Slip Ware

9. Female figurine

Middle Cypriot III–Late Cypriot I
(ca. 1725–ca. 1450 B.C.)
Black Slip Ware
H. 26.5 cm (10⅜ in.)
74.51.1544 (Myres 2004)
Said to be from a rock-cut tomb
at Alambra

The left foot and the lower part
of the leg are restored. The slip is
largely worn off on the back. This
figurine belongs to a small group
known in both Red Polished and
White Painted Ware, probably
from the later part of the Middle
Cypriot period (V. Karageorghis
1991, pp. 176–80). Unlike other
figurines of this group, it is hollow;
thus, it anticipates Late Cypriot II
nude female figures with large
pierced ears that have more or less
the same pose (see cat. nos. 11, 13,
and 14). The Black Slip fabric sug-
gests the date.

BIBLIOGRAPHY: Doell 1873, p. 59,
pl. XIV.8, no. 839; Cesnola 1877,
p. 89, pl. VI; Cesnola 1894, pl. II.12;
L. Åström 1972, fig. 16.4; V. Kara-
georghis 1976b, p. 131, no. 103;
J. Karageorghis 1977, p. 65; Orpha-
nides 1983, pp. 13–14, pl. IV, no. 11;
V. Karageorghis 1991, pp. 178–79,
pl. CXL.9, no. Ea.11.

LATE CYPRIOT II–III PERIODS
(CA. 1450–CA. 1050 B.C.)

Coroplastic art of the Late Cypriot II–III periods is characterized mainly by standing nude female figurines. Their arms are bent, their hands resting either against the sides of the body (e.g., cat. no. 14) or against the stomach below the breasts (e.g., cat. nos. 10, 11, and 15). They may also hold an infant (e.g., cat. nos. 12, 13) (cf. V. Karageorghis 1993a, pp. 3–13). The clay's fabric resembles that of Base-Ring Ware pottery from the same period (see cat. nos. 59–66). Some of the figurines are hollow, but others, usually smaller in size, are solid and flat (e.g., cat. nos. 10, 12). The surface is often shaved.

Several have a birdlike face and a large nose (e.g., cat. nos. 11–14). Some of these have large pierced ears that occasionally preserve earrings in clay (e.g., cat. nos. 11, 13) or metal. The pubic triangle is accentuated and the breasts are clearly shown. This type of figurine may be Syrian in origin; Cypriot sculptors adopted the type and created their own variations.

Another series of female figures is similar to those with the birdlike face, but the facial characteristics differ (e.g., cat. nos. 10, 15). The head is always flat. Black and brown paint are used around the neck; on the head and the pubic area the paint represents hair. The flat head and other characteristics, such as the curving locks of hair at the temples and, occasionally, on the back in relief, suggest that Mycenaean coroplastic art influenced

the type (cf. V. Karageorghis 1993a, pp. 22–23).

Seated female figurines, male figurines with quadrupeds, and animal figurines from the same period have also been found. They are less common than the standing female figurines illustrated here.

Base-Ring Ware

10. **Nude female**
Late Cypriot II (ca. 1450–
ca. 1200 B.C.)
Base-Ring Ware
H. 15.9 cm (6¼ in.)
74.51.1546 (Myres 2016)
Said to be from a tomb at Nicosia-Ayia Paraskevi
 The figurine is solid.

BIBLIOGRAPHY: Cesnola 1894, pl. II.17; Orphanides 1983, pp. 15–16, pl. XIV, no. 13; V. Karageorghis 1993a, p. 12, pl. IX.7, no. B(iii)3.

11. **Nude female with birdlike face**
Late Cypriot II (ca. 1450–
ca. 1200 B.C.)
Base-Ring Ware
H. 15.6 cm (6⅛ in.)
74.51.1541 (Myres 2011)
Said to be from Nicosia-Ayia Paraskevi
 The figurine is solid.

BIBLIOGRAPHY: Cesnola 1894, pl. II.8; Orphanides 1983, p. 11, pl. VIII, no. 8; V. Karageorghis 1993a, p. 8, pl. VI.2, no. A(iv)5.

12. **Nude female with birdlike face, holding an infant**
Late Cypriot II (ca. 1450–
ca. 1200 B.C.)
Base-Ring Ware
H. 13.2 cm (5¼ in.)
74.51.1545 (Myres 2013)
Said to be from Nicosia-Ayia Paraskevi
 The figurine is solid. Its large ears are not perforated, and each has two impressed pellets instead of large earrings.

BIBLIOGRAPHY: Cesnola 1894, pl. II.9; J. Karageorghis 1977, p. 74; Orphanides 1983, pp. 14–15, pl. XII, no. 12; V. Karageorghis 1993a, p. 9, pl. VI.10, no. A(v)7.

13. **Nude female with birdlike face, holding an infant**
Late Cypriot II (ca. 1450–
ca. 1200 B.C.)
Base-Ring Ware
H. 20.8 cm (8⅛ in.)
74.51.1542 (Myres 2012)
Said to be from Nicosia-Ayia Paraskevi
 The figurine is hollow.

BIBLIOGRAPHY: Cesnola 1894, pl. II.11; Orphanides 1983, pp. 11–12, pl. XI, no. 9; Merrillees 1988, p. 48; V. Karageorghis 1993a, p. 6, pl. III.8, no. A(ii)5.

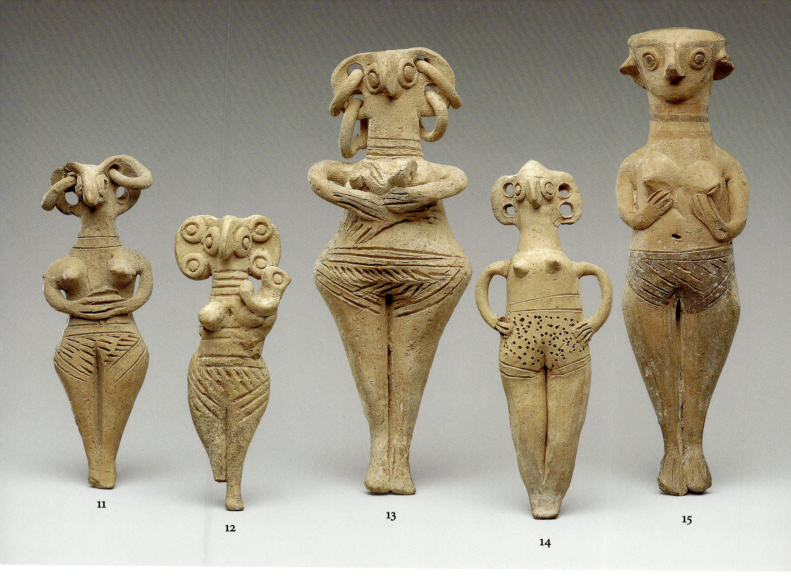

11 12 13 14 15

14. **Nude female with birdlike face**
Late Cypriot II (ca. 1450–
ca. 1200 B.C.)
Base-Ring Ware
H. 15.7 cm (6⅛ in.)
74.51.1547 (Myres 2009)
Said to be from Nicosia-Ayia
Paraskevi
 The figurine is hollow.

BIBLIOGRAPHY: Cesnola 1894,
pl. II.10; J. Karageorghis 1977, p. 74;
Orphanides 1983, p. 16, pl. IX,
no. 14; V. Karageorghis 1993a,
pp. 4–5, pl. II.5, no. A(i)12.

15. **Nude female**
Late Cypriot II (ca. 1450–
ca. 1200 B.C.)
Base-Ring Ware
H. 21.8 cm (8⅝ in.)
74.51.1549 (Myres 2014)
Said to be from a tomb at Nicosia-
Ayia Paraskevi
 The figurine is hollow. The groove
on the left breast is accidental.

BIBLIOGRAPHY: Doell 1873, p. 59,
pl. XIV.9, no. 841; Cesnola 1877,
p. 89, pl. VI; Cesnola 1894, pl. II.15;
J. Karageorghis 1977, p. 82; Orpha-
nides 1983, pp. 17–18, pl. XV, no. 16;
V. Karageorghis 1993a, p. 12, pl. IX.2,
no. B(ii)10.

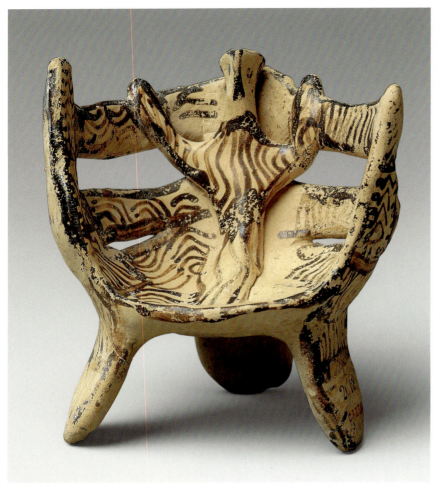

16

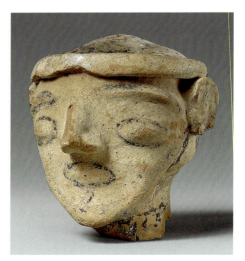

existence of four-legged thrones weakens his hypothesis. It is possible that three-legged thrones with a seated figure had cultic significance (cf. Iakovides 1970, p. 271, with references to previous discussions).

BIBLIOGRAPHY: Cesnola 1894, pl. I.2; Mylonas 1956, p. 114 n. 16; Richter 1966, p. 6 n. 14, fig. 13; French 1971, p. 170; Amandry 1986, p. 173, no. VII.55, pl. 7b.

17. Male head

Late Cypriot III (ca. 1200–
ca. 1050 B.C.)
Terracotta
H. 12.2 cm (4¾ in.)
74.51.1471 (Myres 1451)
Said to be from Idalion

This hollow head, together with another similar head (cf. V. Karageorghis 1993a, p. 32, no. L12), is here tentatively dated to the Late Cypriot III period, but an early Geometric date, as Myres suggested (1914, pp. 55–56), should not be excluded.

BIBLIOGRAPHY: Cesnola 1894, pl. XXX.55; V. Karageorghis 1993a, p. 32, pl. XIX.4, no. L12.

17

Mycenaean Ware

16. Human figure in three-legged chair

Mycenaean IIIB (13th century B.C.)
Terracotta
H. 8.9 cm (3½ in.)
74.51.1711 (Myres 2018)
Said to be from Alambra

The pinched face and flat head are characteristic of Mycenaean figurines. The lower part of the body is fused with the backrest of the throne as if the figure were shown in relief. Because of its small size, the figure appears to be standing rather than sitting. There are no indications of gender.

Numerous Mycenaean examples of chairs or thrones exist. Some, like this one, have a human figure seated in them. In two cases the figure is female (Amandry 1986).Others have no occupant. Except for a few rare cases, the thrones have three legs. Those with four legs, one of which is from Cyprus, are of late Mycenaean date (cf. Iakovides 1970, pp. 270–72). Amandry (1986) associated Mycenaean thrones with the tripod of the Pythia (the presiding priestess at the oracle at Delphi), but the

POTTERY

The ancient inhabitants of Cyprus started to produce pottery during the later part of the Neolithic period, in the middle of the fifth millennium B.C.

Imagination and exuberance characterize the Early and Middle Bronze Age ceramics produced on Cyprus. The vases are handmade, since the potter's wheel was not introduced until about 1600 B.C. They are richly decorated with painted, incised, and relief motifs, and their shapes are based on zoomorphic and anthropomorphic figures as well as on composite vessel forms. All illustrate the ability of the potter and show the desire to impress, a phenomenon that started in the Early Cypriot period.

By the middle of the second millennium B.C., the Cypriot artist was inspired by pottery imported from the Aegean and the Levant that is now found mainly in tombs.

EARLY AND MIDDLE CYPRIOT PERIODS
(CA. 2500–CA. 1600 B.C.)

Red Polished Ware
Red Polished Ware made its appearance in the repertoire of Cypriot ceramics at the very beginning of the Early Cypriot I period; it was introduced by emigrants from Anatolia who settled on the island soon after the middle of the third millennium B.C. Early Red Polished Ware from the "Philia Phase"—named after the region of northwestern Cyprus where this early fabric was first discovered—is not represented in the Cesnola Collection. The Red Polished Ware vessels that are published here all date from the Early Cypriot III period, or possibly slightly later, from Middle Cypriot I.

The surfaces were covered with red slip, and burnishing created their lustrous appearance. Sometimes linear motifs, incised before firing, decorate the vases. Lime, which was applied after firing, fills the incisions and contrasts with the red background.

Cypriot Red Polished Ware shapes, mainly jugs with a cutaway neck and a flat base, have affinities with those from Anatolia. By the end of the third millennium and into the beginning of the second millennium B.C., Cypriot potters were fashioning Red Polished Ware according to their own taste. Often the ornament consists of motifs—such as human figures, quadrupeds, birds, bucrania, and snakes—in relief or in the round. Some of the motifs used on Red Polished Ware are symbols connected with religious beliefs. For example, the bucranium and the stylized snake are, respectively, related to life and death. Not represented in the Cesnola Collection is a series of large Red Polished Ware bowls decorated with figures in the round that have to do with everyday life or religious practices.

These wares have long been known from finds in tombs throughout the island, but recently they have appeared at settlement sites as well (Frankel and Webb 1996; Coleman et al. 1996). Their shapes and decoration highlight the creative spirit of the Cypriot potter, showing the artist's sense of elegance as well as of geometric symmetry.

Red Polished Ware pottery and its derivatives were manufactured throughout the Early Cypriot period and, in southern Cyprus, much of the Middle Cypriot period—for more than five hundred years.

Potters of the Middle Cypriot period never attained the vivacity and originality seen in Early Cypriot works. They tried to liberate themselves from the long tradition of Red Polished Ware, but they did not achieve any truly new and successful style.

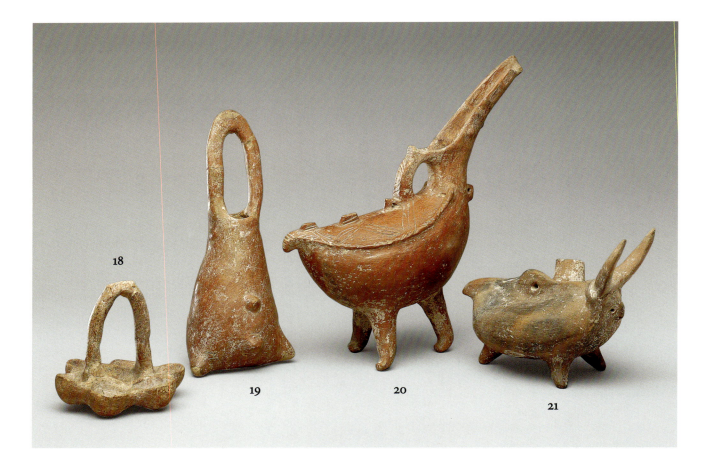

18. Miniature composite vase
Early–Middle Cypriot (ca. 2500–
ca. 1600 B.C.)
Red Polished Ware
H. 9.1 cm (3⅝ in.)
74.51.1304 (Myres 54)
Said to be from Idalion

 All seven bowls were made from
one piece of clay. They share a
common handle that had horned
lugs at the top, now missing.

BIBLIOGRAPHY: Cesnola 1877,
p. 103, pl. IX.

**19. Vase in the shape of a
 leather bag**
Early Cypriot (ca. 2500–
ca. 1900 B.C.)
Red Polished Ware
H. 20.3 cm (8 in.)
74.51.1302 (Myres 44)
Said to be from Alambra or Ayia
Paraskevi

 Two horned projections protrude
from the base and two more jut from
the middle of the body, imitating
the knobs of a leather bag.

BIBLIOGRAPHY: Cesnola 1894,
pl. XCVI.820.

20. Bird-shaped *askos*
Early–Middle Cypriot (ca. 2500–
ca. 1600 B.C.)
Red Polished Ware
H. 24.1 cm (9½ in.)
74.51.1290 (Myres 46)
Said to be from Alambra, Ayia
Paraskevi, or Idalion

 The body stands on three legs
with the feet turned backward.
"Toes" are indicated by grooves.

BIBLIOGRAPHY: Cesnola 1877, p. 103,
pl. IX; Cesnola 1894, pl. XCVI.825.

21. Zoomorphic *askos*
Early Cypriot (ca. 2500–
ca. 1900 B.C.)
Red Polished Ware
H. 12.1 cm (4¾ in.)
74.51.800 (Myres 47)

22. **Bowl**
Early–Middle Cypriot (ca. 2500–
ca. 1600 B.C.)
Red Polished Ware
H. 36.1 cm (14¼ in.); diam. 27.6 cm
(10⅞ in.)
74.51.1329 (Myres 1)
Said to be from Alambra

BIBLIOGRAPHY: Cesnola 1877, p. 95.

23. **Composite jug**
Early Cypriot III–Middle Cypriot I
(ca. 2000–ca. 1800 B.C.)
Red Polished Ware
H. 22.1 cm (8¾ in.)
74.51.1160 (Myres 86)
Said to be from Alambra

BIBLIOGRAPHY: Cesnola 1894,
pl. LXXXIII.742.

24. **Jug**
Early Cypriot III–Middle Cypriot I
(ca. 2000–ca. 1800 B.C.)
Red Polished Ware
H. 26.4 cm (10⅜ in.)
74.51.1195 (Myres 82)
Said to be from Alambra

BIBLIOGRAPHY: Cesnola 1894,
pl. LXXXIII.744.

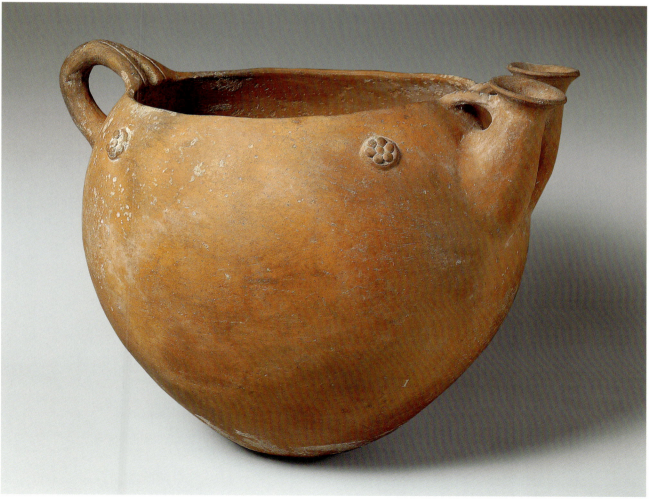

22

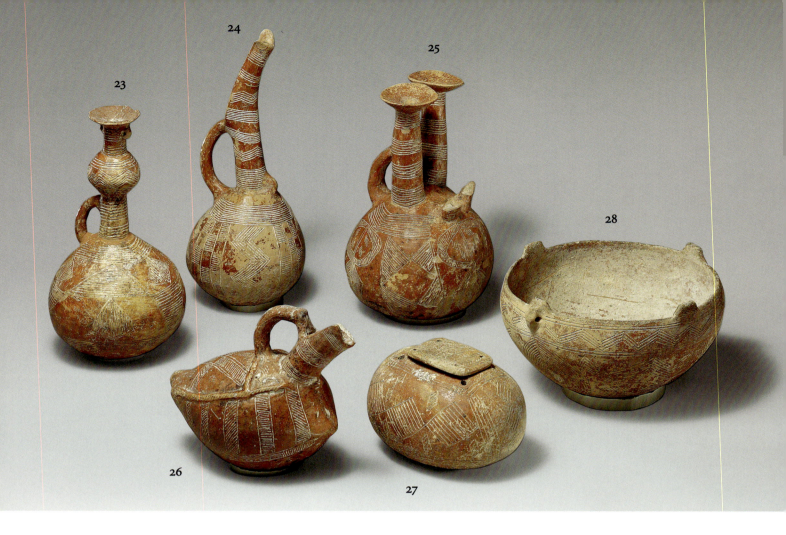

25. Jug with double neck
Early Cypriot III–Middle Cypriot I
(ca. 1900 B.C.)
Red Polished Ware
H. 21.8 cm (8⅝ in.)
74.51.1194 (Myres 87)

26. Bird-shaped *askos*
Early Cypriot III–Middle Cypriot I
(ca. 2000–ca. 1800 B.C.)
Red Polished Ware
H. 14.8 cm (5⅞ in.)
74.51.1202 (Myres 51)
Said to be from Alambra or Ayia
Paraskevi

BIBLIOGRAPHY: Cesnola 1894,
pl. XCVIII.842.

27. Pyxis with lid
Early Cypriot III–Middle Cypriot I
(ca. 2000–ca. 1800 B.C.)
Red Polished Ware
H. 9.1 cm (3⅝ in.)
74.51.1208 (Myres 53)
Said to be from Alambra or Ayia
Paraskevi

BIBLIOGRAPHY: Cesnola 1894,
pl. XCVI.823.

28. Bowl
Early Cypriot III–Middle Cypriot I
(ca. 2000–ca. 1800 B.C.)
Red Polished Ware
H. 10.6 cm (4⅛ in.); diam. 17.5 cm
(6⅞ in.)
74.51.1196 (Myres 89)
Said to be from Alambra or Ayia
Paraskevi

BIBLIOGRAPHY: Cesnola 1894,
pl. XCIX.846.

Black Polished Ware
A small group of vases in Black
Polished Ware appeared toward the
end of the Early Cypriot period.
The shapes in this ware are mainly
small bowls (e.g., cat. no. 29), bottles
(e.g., cat. no. 30), and jugs and jug-
lets (e.g., cat. no. 31) that resemble
Red Polished Ware vases. Their sur-
faces are black, a color achieved
through firing the vases in a reduc-
ing atmosphere (cf. Waern-Sperber
1988). Red Polished and Black Pol-
ished Ware pottery continued to be
produced on Cyprus into the begin-
ning of the Middle Bronze Age, or
the Middle Cypriot I–II period.

The Cesnola Collection possesses a large number of terracotta spindle whorls. They are usually conical in shape, and their decoration parallels Early and Middle Cypriot Red and Black Polished Ware pottery with engraved decoration. Spindle whorls were placed in tombs (of perhaps both men and women) so that the deceased could continue to spin wool in the next life. Spindle whorls also occur in settlement contexts (Frankel and Webb 1996, pp. 192–97; Mogelonsky and Bregstein 1996).

29. Bowl
Middle Cypriot I–II (ca. 1900– ca. 1725 B.C.)
Black Polished Ware
H. 5.3 cm (2⅛ in.); diam. 9.4 cm (3¾ in.)
74.51.1248 (Myres 131)
Said to be from Alambra or Ayia Paraskevi

Lime fills the grooved decoration.
BIBLIOGRAPHY: Cesnola 1894, pl. XCVII.828.

30. Bottle
Middle Cypriot I–II (ca. 1900– ca. 1725 B.C.)
Black Polished Ware
H. 13.2 cm (5¼ in.)
74.51.1234 (Myres 135)
Said to be from Alambra or Ayia Paraskevi

BIBLIOGRAPHY: Cesnola 1894, XCVII.830.

31. Juglet
Middle Cypriot I–II (ca. 1900– ca. 1725 B.C.)
Black Polished Ware
H. 8.8 cm (3½ in.)
74.51.1240 (Myres 134)
Said to be from Alambra or Ayia Paraskevi

Lime fills the grooved decoration.
BIBLIOGRAPHY: Cesnola 1894, pl. XCVII.832.

32. Conical spindle whorl
Early Cypriot III–Middle Cypriot I (ca. 2000–ca. 1800 B.C.)
Black Polished Ware
H. 3.8 cm (1½ in.)
74.51.913 (Myres 141)
Lime fills the engraved linear decoration.

33. Conical spindle whorl with rounded base
Early Cypriot III–Middle Cypriot I (ca. 2000–ca. 1800 B.C.)
Red Polished Ware
H. 4.6 cm (1¾ in.)
74.51.931 (Myres 110)
Lime fills the engraved linear decoration.

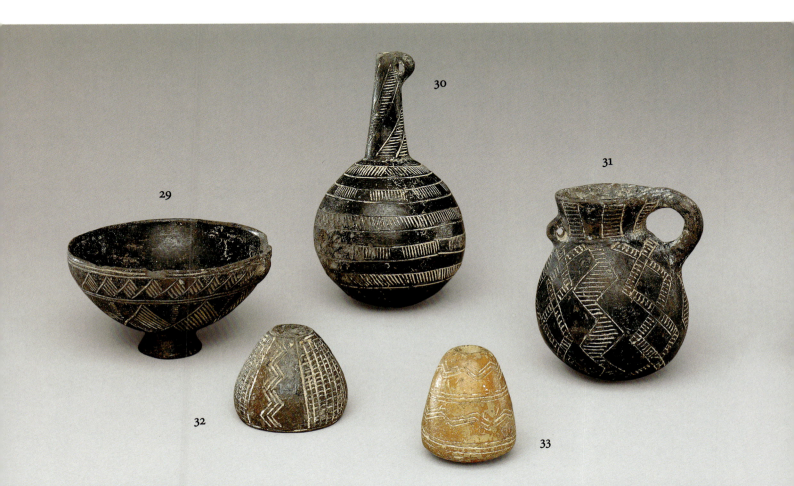

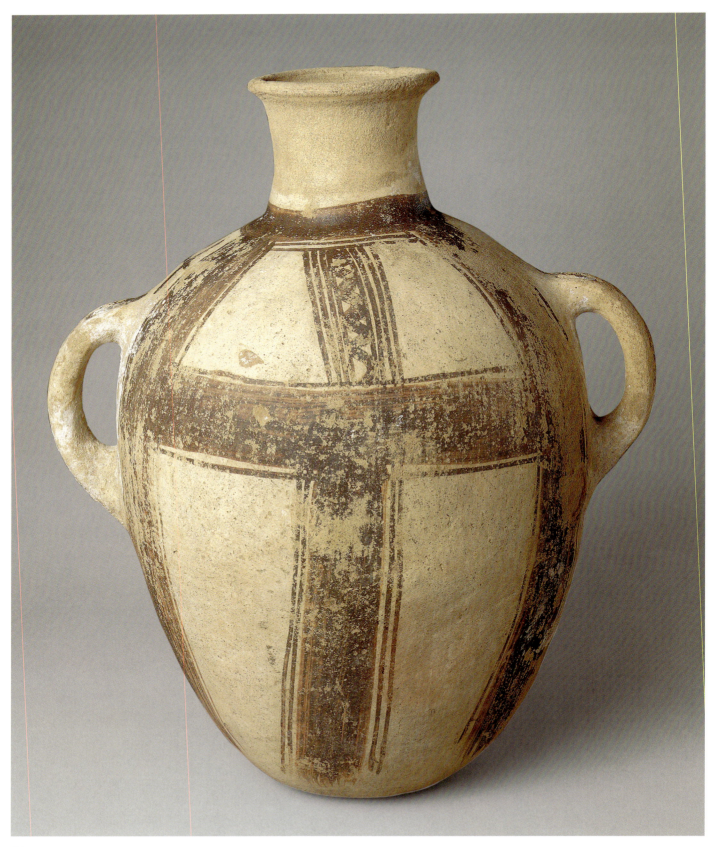

34

White Painted Ware

White Painted decoration was the prevailing style of Chalcolithic ware and reappeared at the end of the Early Cypriot III period. This later version of White Painted Ware became dominant in Cypriot ceramics by the Middle Cypriot II era and continued into the Middle Cypriot III period.

In White Painted Ware, linear geometric patterns decorate the entire surface of vases. In earlier works, this decoration is in a glossy red paint (e.g., cat. no. 35). Later, it is rendered with black matte paint. Broad bands cover the entire surface of large vases (e.g., cat. no. 34), recalling the decoration of Chalcolithic White Painted Ware vases.

New shapes were introduced with the White Painted Ware of the Middle Cypriot period, though the basic repertoire continues from that of Red Polished Ware. During this period, potters were fond of string-hole lugs, adding them to excess (e.g., cat. nos. 36, 37). Zoomorphic *askoi* were also favorites (e.g., cat. nos. 38, 39).

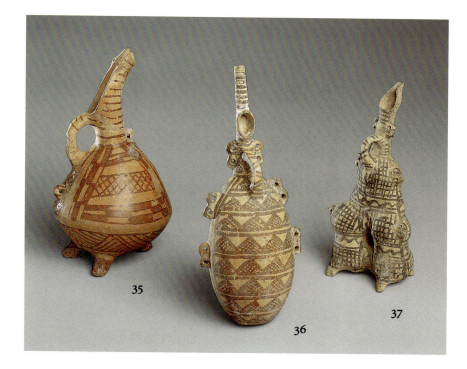

35

36

37

34. Amphora
Middle Cypriot III (ca. 1725–ca. 1600 B.C.)
White Painted V Ware
H. 44.1 cm (17⅜ in.)
74.51.845 (Myres 242)
Said to be from Alambra

BIBLIOGRAPHY: Cesnola 1894, pl. LXXXVIII.769; Gjerstad 1926, pp. 173–74, no. 4; P. Åström 1972, p. 76, fig. XVIII.10.

35. Jug
Middle Cypriot I (ca. 1900–ca. 1800 B.C.)
White Painted I Ware
H. 23.2 cm (9⅛ in.)
74.51.1316 (Myres 267)

36. Jug
Middle Cypriot II (ca. 1800–ca. 1725 B.C.)
White Painted III–V Ware
H. 25.3 cm (10 in.)
74.51.1047 (Myres 197)

37. Composite jug
Middle Cypriot II (ca. 1800–ca. 1725 B.C.)
White Painted III–IV Ware
H. 20.7 cm (8⅛ in.)
74.51.1050 (Myres 233)
Said to be from Alambra

BIBLIOGRAPHY: Cesnola 1894, pl. LXXXVIII.768; P. Åström 1972, p. 47.

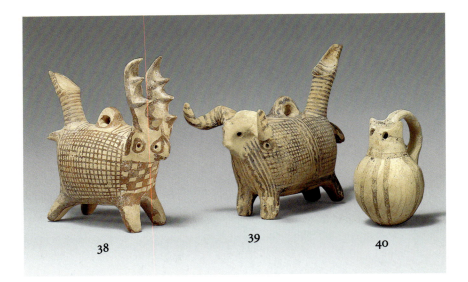

38　　　　　　　　　39　　　　　　40

38.　Zoomorphic *askos*
Middle Cypriot III (ca. 1725–
ca. 1600 B.C.)
White Painted V Ware
H. 14 cm (5½ in.)
74.51.795 (Myres 221)
Said to be from Idalion (Potamia)

BIBLIOGRAPHY: Cesnola 1894,
pl. XCV.811; P. Åström 1972, p. 77,
fig. XVIII.1; V. Karageorghis 1976b,
p. 127, no. 97.

39.　Zoomorphic *askos* with a ram's head
Middle Cypriot III (ca. 1725–
ca. 1600 B.C.)
White Painted I Ware
H. 14 cm (5½ in.)
74.51.801 (Myres 219)
Said to be from Idalion (Potamia)

BIBLIOGRAPHY: Cesnola 1894,
pl. XCV.817; P. Åström 1972, p. 77,
fig. XVIII.2.

40.　Rattle(?)
Late Cypriot IB (ca. 1600–
ca. 1450 B.C.)
White Painted V Ware
H. 9.2 cm (3⅝ in.)
74.51.804 (Myres 387)

The surface was smoothed with a
tool. Rattles of this common shape
are usually found in tombs of the
Late Cypriot IB period (P. Åström
1972a, pp. 63–64).

Black Slip II Ware
In the Middle Cypriot period, pot-
tery of the Black Slip II type was
entirely covered with a slip that
varied from red to dark brown
or black. The two vases shown
here (cat. nos. 41, 43) illustrate
this variation. Thin engraved lines
and thin bands in relief decorate
the vases.

41.　Jug
Middle Cypriot II (ca. 1800–
ca. 1725 B.C.)
Black Slip II Ware
H. 25.1 cm (9⅞ in.)
74.51.1256 (Myres 160)

Red-on-Black and Red-on-Red
wares developed in the eastern part
of Cyprus, on the Karpas Penin-
sula. They are characterized by
painted decoration that consists of
linear patterns, mainly straight or
wavy bands, that are applied in red
paint on a black surface or, some-
times, on a dark red surface. The
style was short-lived.

42.　Hemispherical shallow bowl
Middle Cypriot II (ca. 1800–
ca. 1725 B.C.)
Red-on-Black Ware
H. 9.9 cm (3⅞ in.); diam. 28.1 cm
(11⅛ in.)
74.51.974 (Myres 280)
Said to be from Amathus

BIBLIOGRAPHY: Cesnola 1894,
pls. CL.1108, .1109; P. Åström 1972,
p. 110.

43.　Tankard
Middle Cypriot II (ca. 1800–
ca. 1725 B.C.)
Black Slip II Ware
H. 24.5 cm (9⅝ in.)
74.51.1091 (Myres 156)

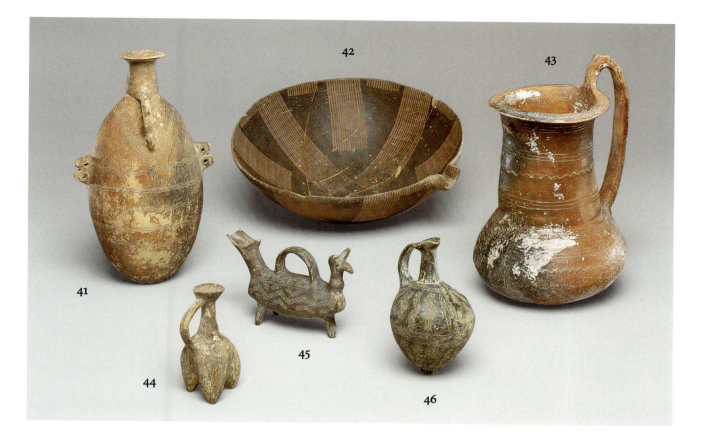

Black Slip III Ware

Incised decoration on a black or dark brown surface characterizes Black Slip III Ware pottery. In some ways this ware, with its thin walls and metallic quality, is the precursor of Base-Ring Ware pottery of the Late Cypriot period. The predominant shape is the small jug with a long, narrow neck and a funnel mouth, probably used for perfumed oils (cat. no. 46). Also shown here are a composite juglet of an unusual shape (cat. no. 44) and a zoomorphic *askos* (cat. no. 45).

44. Composite juglet
Middle Cypriot III (ca. 1725– ca. 1600 B.C.)
Black Slip III Ware
H. 9.5 cm (3¾ in.)
74.51.1249 (Myres 169)

45. Zoomorphic *askos*
Middle Cypriot III (ca. 1725– ca. 1600 B.C.)
Black Slip III Ware
H. 8.3 cm (3¼ in.)
74.51.842 (Myres 172)
BIBLIOGRAPHY: P. Åström 1972, p. 107.

46. Jug
Middle Cypriot III (ca. 1725– ca. 1600 B.C.)
Black Slip III Ware
H. 12.4 cm (4⅞ in.)
74.51.1237 (Myres 168)

This type of vase, with a long, narrow neck and funnel spout, may have contained perfumed oils. The shape and engraved decoration were probably inspired by Tell el-Yahudieh jugs (see p. 46).

LATE CYPRIOT PERIOD
(CA. 1600 – CA. 1050 B.C.)

White Slip Ware

White Slip and Base-Ring wares dominated the Cypriot ceramic repertoire for more than four hundred years. White Slip Ware vases are usually handmade of a hard, gritty clay that is covered with a thick slip (for a general discussion, see Popham 1972). Painted decoration in orange-red to black paint is applied over the slip. In some cases, the painted decoration is deliberately in two colors, black and red (e.g., cat. no. 49). Clay for this fabric can be found where the Troodos Mountains extend into central Cyprus (cf. Gomez et al. 1995). Recently, an open-air factory for producing White Slip Ware was found at the site of Sanida-Moutti tou Ayiou Serkou, in the southern foothills of the Troodos Mountains, thirty-two miles northeast of Limassol (Todd, Pilides, and Hadjicosti 1993, with further references). The most popular shape in this ware is the medium-size hemispherical bowl with a round base and a wishbone handle, usually referred to as a milk bowl. These bowls have been found in fairly large numbers in the Near East, Egypt, the Aegean, and as far west as the central Mediterranean and North Africa. At a time when fine wheel-made Mycenaean vases were readily available in the Mediterranean market, perhaps the handmade, primitive appearance of White Slip Ware vessels appealed to the taste even of the Aegeans. They may also have been popular because their hard shells and

impermeable surfaces made them suitable containers for hot liquids.

The earliest type, known as Proto-White Slip Ware, made its appearance at the very beginning of the Late Cypriot I period (ca. 1600 B.C.). It has been found almost throughout the island, therefore it may have been produced at more than one site. The Palaepaphos area, in western Cyprus, must have been a center of production, because fine White Slip Ware vases have been found in tombs there. Others were discovered in the area of Pendayia, in northwestern Cyprus. The surface of Proto-White Slip Ware is covered with a very thick slip, and the painted decoration is in orange-red matte paint. The red paint occasionally turned dark brown to black, and sometimes the white slip became gray, depending on the amount of oxygen in the kiln. The decoration is abstract and consists mainly of narrow latticed or hatched bands or wavy lines. In addition to the hemispherical bowls, there are also jugs of various sizes.

During the Late Cypriot I period, after the experimental stage of Proto-White Slip Ware, potters produced White Slip I Ware. It has a shiny surface and finely rendered painted decoration that resembles embroidered geometric motifs. Occasionally, the vase is left unpainted. White Slip I Ware pottery was sometimes made of fine white clay that differs from the usual dark gritty type. Examples have been found in the Palaepaphos area, and one fragment was found in the Aegean at the site of Phylakopi. The hemispherical bowl is the pre-

dominant shape (e.g., cat. no. 48), but there are also jugs (e.g., cat. no. 47), tankards (e.g., cat. no. 52), and large kraters.

In the Late Cypriot II period the production of White Slip Ware increased, but its quality declined. The surface of White Slip II Ware is matte, the painted decoration is in dark brown or black paint, and the decorative patterns are monotonous, usually consisting only of latticed bands. A notable exception is a krater fragment found recently at Kalavasos that is decorated in two colors with very naturalistically rendered birds (Cyprus Museum, Nicosia). Another bowl, in the Musée du Louvre, Paris, is painted with an octopus motif (Bossert 1951, p. 15, fig. 215, no. 215; Steel 1997). The Cesnola Collection includes fine examples of large kraters in White Slip II Ware (e.g., cat. nos. 51, 53). A small bowl (cat. no. 50) has a very unusual shape. The production of White Slip II Ware continued into the Late Cypriot IIIA period. It died out completely during the first half of the twelfth century B.C.

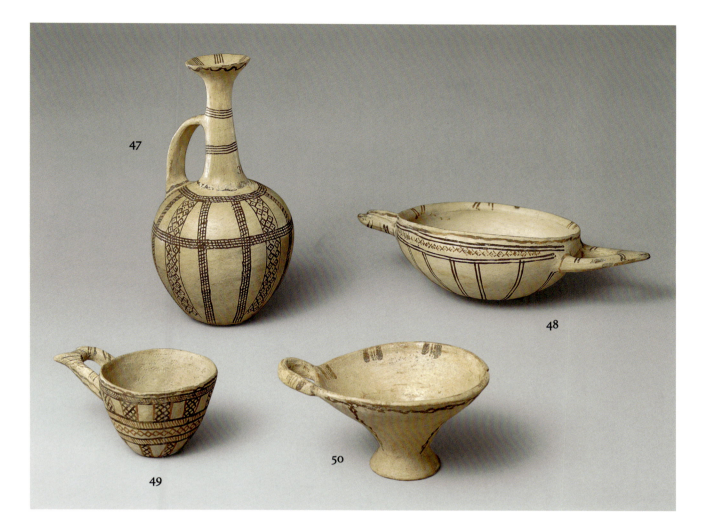

47. Jug
Late Cypriot I–II (ca. 1600–
ca. 1200 B.C.)
White Slip I–II Ware
H. 21.5 cm (8½ in.)
74.51.1365 (Myres 317)
Said to be from Alambra

BIBLIOGRAPHY: Cesnola 1894,
pl. LXXXVII.764.

48. Shallow bowl
Late Cypriot I (ca. 1600–
ca. 1450 B.C.)
White Slip I Ware
H. 6.2 cm (2½ in.); diam. 15.4 cm
(6⅛ in.)
74.51.1348 (Myres 292)

49. Handled bowl
Late Cypriot I (ca. 1600–
ca. 1450 B.C.)
White Slip I Ware
H. 5.7 cm (2¼ in.); diam. 8.1 cm
(3¼ in.)
74.51.1115 (Myres 295)

50. Conical bowl
Late Cypriot II (ca. 1450–
ca. 1200 B.C.)
White Slip II Ware
H. 7 cm (2¾ in.); diam. 11.9 cm
(4¾ in.)
74.51.1022 (Myres 298)
 Inside, below the rim, short ver-
tical strokes are flanked by thicker
vertical strokes.

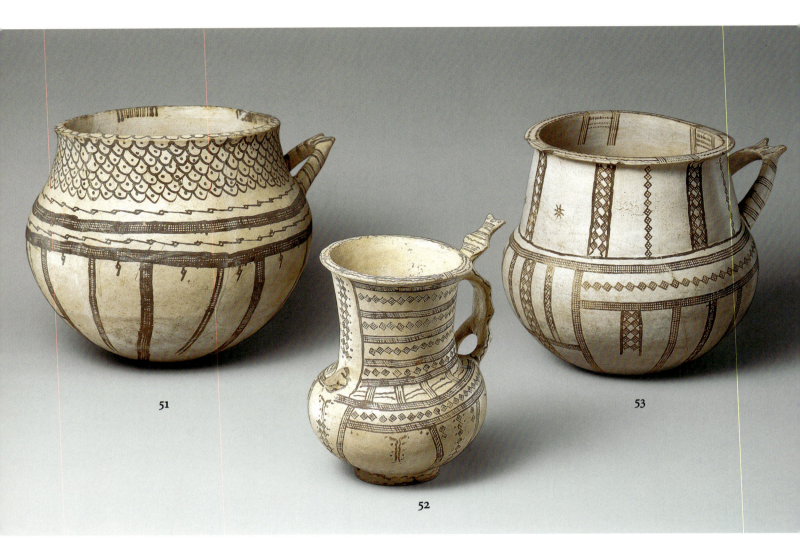

51

52

53

51. Large krater
Late Cypriot II (ca. 1450–
ca. 1200 B.C.)
White Slip II Ware
H. 26 cm (10¼ in.); diam. 24.8 cm
(9¾ in.)
74.51.1055 (Myres 310)
Said to be from Alambra
BIBLIOGRAPHY: Cesnola 1894,
pl. LXXXVI.761.

52. Tankard
Late Cypriot I (ca. 1600–
ca. 1450 B.C.)
White Slip I Ware
H. 22.4 cm (8⅞ in.)
74.51.1030 (Myres 313)
Said to be from Alambra
BIBLIOGRAPHY: Cesnola 1894,
pl. LXXXVII.765.

53. Large krater
Late Cypriot II (ca. 1450–
ca. 1200 B.C.)
White Slip II Ware
H. 25.1 cm (9⅞ in.); diam. 22.5 cm
(8⅞ in.)
74.51.1057 (Myres 308)

Base-Ring Ware

Base-Ring Ware is contemporaneous with White Slip Ware. Both were produced over a long period, beginning about 1600 B.C. and continuing into the first half of the twelfth century B.C. The term derives from the ring base that the jugs and bowls usually have, though there are cases where such a base is lacking. Base-Ring Ware is the natural successor to the monochrome fabrics from the end of the Middle Cypriot period, which are lighter than earlier pottery, such as the Red and Black Polished wares. Base-Ring Ware vessel walls are thin and hard. They exhibit a metallic quality that is also characteristic of the earlier Black Slip III Ware fabric (e.g., cat. nos. 44, 45). Base-Ring Ware vases are handmade and have a shiny dark gray to black surface, though occasionally they are brown. They are either plain or decorated in relief that consists of narrow bands or scrolls, often grooved to look like ropes (e.g., cat. nos. 54, 56). Sometimes, confronted coiling-snake motifs decorate the shoulders of jugs (e.g., cat. no. 57). The deep bowl with a wishbone handle is a popular shape (e.g., cat. no. 55). There are also jugs of all sizes, some of which are very elegant (e.g., cat. no. 54); tankards; lentoid flasks (e.g., cat. no. 60); "teapots" (e.g., cat. no. 66); and zoomorphic *askoi* (e.g., cat. nos. 63–65). One particular form, the jug with a tall, narrow neck and funnel rim, often referred to as a *bil-bil* (e.g., cat. nos. 56, 58), was much favored abroad. It is frequently found in Egypt as well as in the Levant and the Aegean. In Sicily (Thapsos), this shape was copied by local potters. It has been suggested that the *bil-bil* shape, which when viewed upside down resembles an opium poppy, was used for vessels containing opium or perfumed oils that were exported from Cyprus during the Late Bronze Age (Merrillees 1989).

During the Late Cypriot II period, the quality of Base-Ring Ware deteriorated. The vases have dull surfaces and are occasionally painted with irregularly applied bands of white paint (e.g., cat. nos. 60, 61). The shapes are less elegant than before (e.g., cat. no. 59), but the repertoire is enriched by the addition of zoomorphic *askoi* (e.g., cat. nos. 63–65), the most frequent being the bull-shaped *askos*. Another type that makes its appearance for the first time is the jug with vertical ridges around the body, often known as Bucchero Ware (e.g., cat. no. 62). In the Late Cypriot III period and later, this type of vessel was wheel-made, as was the conical bowl with a wishbone handle. The bowls lose the metallic quality of the earlier handmade examples.

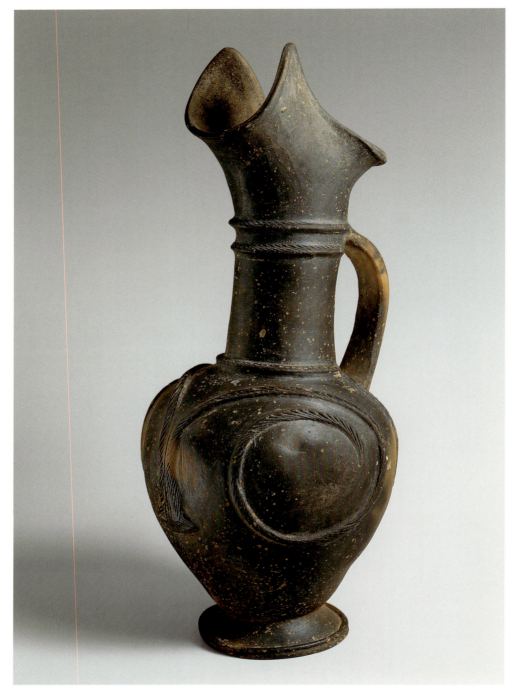

54

54. **Jug**
Late Cypriot I (ca. 1600–
ca. 1450 B.C.)
Base-Ring I Ware
H. 44.8 cm (17⅝ in.)
74.51.1084 (Myres 338)

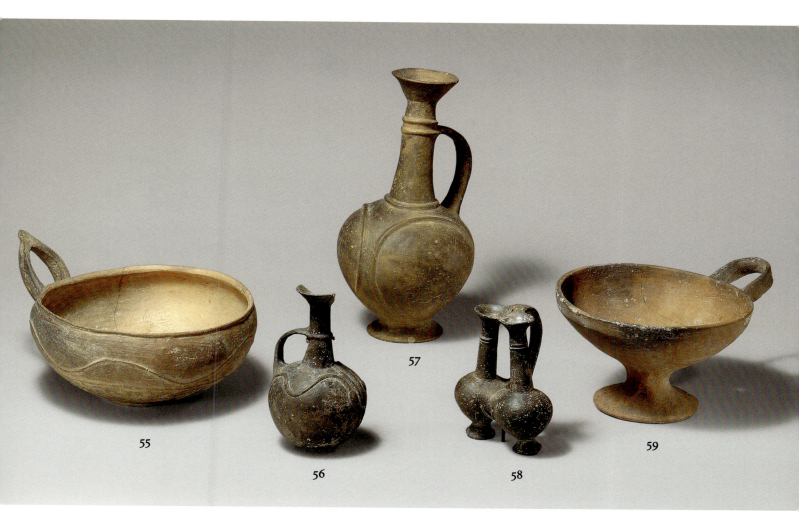

55

57

56

58

59

55. Bowl
Late Cypriot I (ca. 1600–
ca. 1450 B.C.)
Base-Ring I Ware
H. 10.6 cm (4⅛ in.); diam. 16.8 cm
(6⅝ in.)
74.51.1255 (Myres 363)

56. Jug
Late Cypriot I (ca. 1600–
ca. 1450 B.C.)
Base-Ring I Ware
H. 12.5 cm (4⅞ in.)
74.51.1171 (Myres 354)
 On the body, there is a motif of
two confronted coiling serpents.

Their heads are on the side opposite
the handle and appear on either
side of two vertical relief lines.

57. Jug
Late Cypriot I (ca. 1600–
ca. 1450 B.C.)
Base-Ring I Ware
H. 22.7 cm (9 in.)
74.51.1135 (Myres 342)

58. Double *bil-bil*
Late Cypriot I (ca. 1600–
ca. 1450 B.C.)
Base-Ring I Ware
H. 10.6 cm (4⅛ in.)
74.51.1185 (Myres 358)

59. Conical footed bowl
Late Cypriot II (ca. 1450–
ca. 1200 B.C.)
Base-Ring II Ware
H. 10.2 cm (4 in.); diam. 15.6 cm
(6⅛ in.)
74.51.1142 (Myres 364)

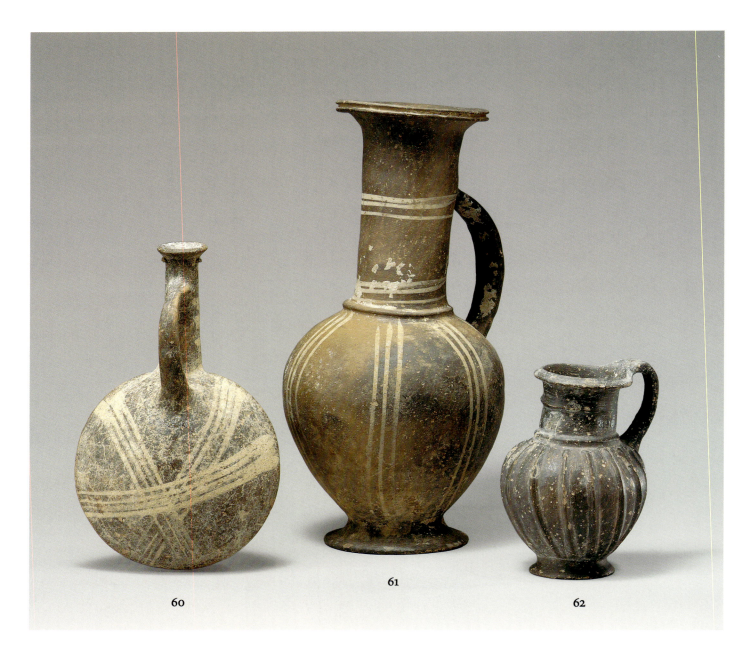

60

61

62

60. Lentoid flask
Late Cypriot II (ca. 1450–
ca. 1200 B.C.)
Base-Ring II Ware
H. 19.4 cm (7⅝ in.)
74.51.1163 (Myres 328)
Said to be from Alambra

BIBLIOGRAPHY: Cesnola 1894,
pl. LXXXVI.759.

61. Jug
Late Cypriot II (ca. 1450–
ca. 1200 B.C.)
Base-Ring II Ware
H. 28.1 cm (11⅛ in.)
74.51.1089 (Myres 322)

62. Jug
Late Cypriot II (ca. 1450–
ca. 1200 B.C.)
Base-Ring II Ware
H. 12.7 cm (5 in.)
74.51.598 (Myres 396)

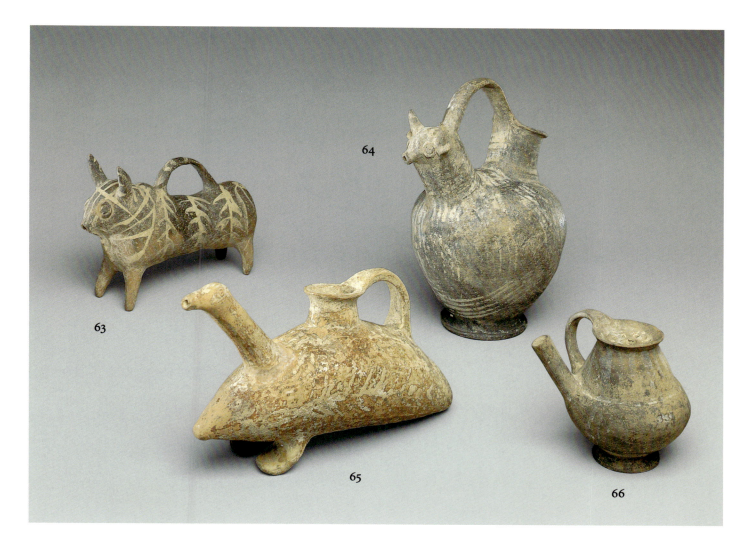

63. **Bull-shaped** *askos*
Late Cypriot II (ca. 1450–
ca. 1200 B.C.)
Base-Ring II Ware
H. 12.4 cm (4⅞ in.); L. 17 cm
(6¾ in.)
74.51.826 (Myres 334)
Said to be from Idalion
BIBLIOGRAPHY: Cesnola 1894,
pl. XCV.818.

64. *Askos* with bull protome
Late Cypriot II (ca. 1450–
ca. 1200 B.C.)
Base-Ring II Ware
H. 21 cm (8¼ in.)
74.51.786 (Myres 323)
BIBLIOGRAPHY: Doell 1873, p. 68,
pl. XVI.22, no. 4037; Cesnola 1877,
pl. VIII.

65. Bird-shaped *askos*
Late Cypriot II (ca. 1450–
ca. 1200 B.C.)
Base-Ring II Ware
H. 13.3 cm (5¼ in.); L. 22.4 cm
(8⅞ in.)
74.51.789 (Myres 332)
BIBLIOGRAPHY: Misch 1992, p. 171
n. 1.

66. **Teapot**(?)
Late Cypriot II (ca. 1450–
ca. 1200 B.C.)
Base-Ring II Ware
H. 9.7 cm (3⅞ in.)
74.51.1141 (Myres 331)

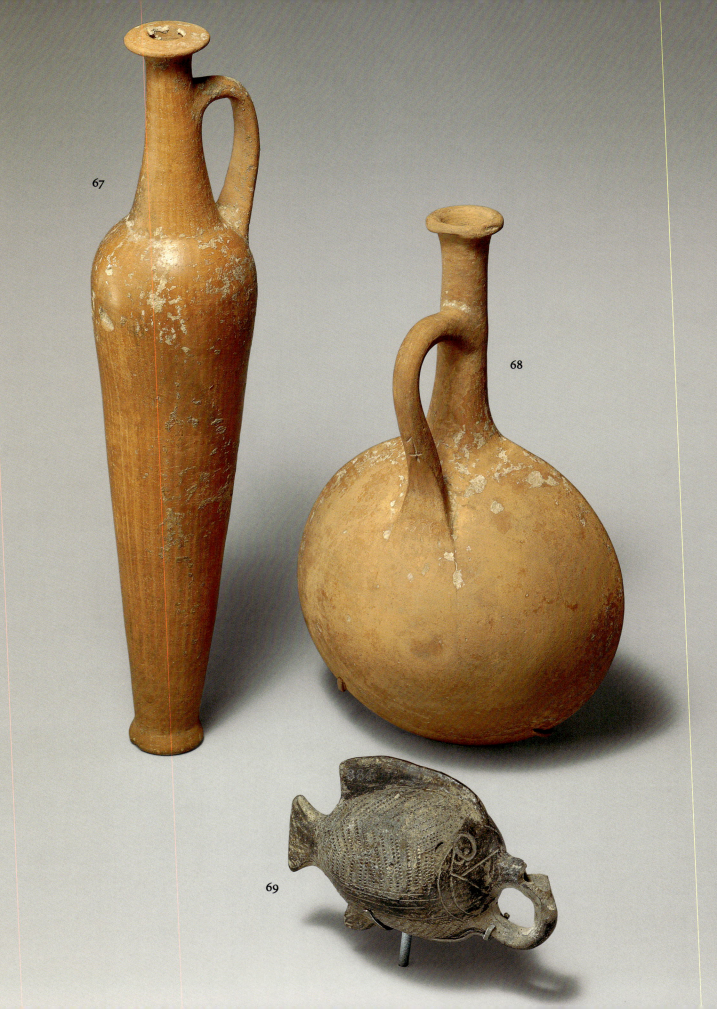

67

68

69

Red Lustrous Wheel-made Ware

Red Lustrous Wheel-made Ware vessels, previously regarded as foreign imports to Cyprus, are now considered to have been indigenous. Their production began sometime in the sixteenth century B.C., lasted for some 350 years and, finally, died out at the beginning of the twelfth century B.C. (for a general study, see Eriksson 1993).

Vases of this ware have a red burnished surface. The repertoire of shapes is limited; the main forms are the tall spindle-shaped bottle and the lentoid flask, both of which are illustrated here (cat. nos. 67, 68). Some of the vases, especially the spindle bottles, may have contained perfumed oils. Other forms include impressive arm-shaped vessels, possibly used as incense burners in religious rituals.

In support of the Cypriot origin of Red Lustrous Wheel-made Ware is the frequent presence on the vessels of simple signs in the undeciphered Cypro-Minoan script, the form of writing used on Cyprus during the Late Cypriot period. Signs were often engraved on the bases of spindle bottles before the firing process (e.g., cat. no. 67). Signs also appear on other vases (e.g., cat. no. 68). Although the identification of these simple signs as Cypro-Minoan has not been universally accepted, there are other arguments that support a Cypriot origin: the ware appears longer on Cyprus than elsewhere, and in greater quantity. Red Lustrous Wheel-made Ware vessels of the same fabric as those from Cyprus have also been found in the Levant, Egypt, and Anatolia.

67. Spindle bottle
Late Cypriot (ca. 1600– ca. 1050 B.C.)
Red Lustrous Wheel-made Ware
H. 35.6 cm (14 in.)
74.51.1321 (Myres 371)
Said to be from Maroni

A V sign was engraved on the base before firing.

BIBLIOGRAPHY: Cesnola 1903a, pl. CXL.8; Eriksson 1993, p. 207, no. 363.

68. Lentoid flask
Late Cypriot (ca. 1600– ca. 1050 B.C.)
Red Lustrous Wheel-made Ware
H. 26.2 cm (10⅜ in.)
74.51.1312 (Myres 376)
Said to be from Maroni

Before firing, a sign was engraved near the base of the handle (see detail below).

BIBLIOGRAPHY: Cesnola 1894, pl. CXLII.1060; Cesnola 1903a, pl. CXL.4; Daniel 1941, p. 281, Class V, no. 6; Eriksson 1993, p. 244, no. 844.

68. DETAIL

Tell el-Yahudieh Ware

Tell el-Yahudieh Ware pottery is not abundant on Cyprus. It appears in Middle Cypriot III–Late Cypriot IA tombs and is considered to be an import from Egypt. It was first manufactured there (in Nubia) and later in the Levant (at Ras Shamra). Tell el-Yahudieh Ware vases found on Cyprus are of the Egyptian type. Examples of the Levantine type are usually found only in that region. The ware received its name from the site of Tell el-Yahudieh in the Egyptian Delta, where it was first recorded. The most common form is a small jug with a biconical body (decorated with punctures), a narrow concave neck, an everted rim, and a button base. The narrow neck and funnel mouth suggest that these vessels were used for the export of precious perfumed oils. One specimen from Cyprus, however, has incised decoration of a Nilotic character, with birds and lotus flowers. It is from Morphou, in the northwestern part of the island (Vermeule and Wolsky 1990, pp. 296–97, 386–87, pls. 182, 183). The fish-shaped example illustrated here is a rare form found mainly in Egypt.

69. Fish-shaped vase

Late Bronze Age (ca. 1600– ca. 1050 B.C.)
Tell el-Yahudieh Ware
H. 7.3 cm (2⅞ in); L. 12.4 cm (4⅞ in.)
74.51.831 (Myres 384)

The head, fins, tail, lower body, and two horizontal bands on either side are burnished.

BIBLIOGRAPHY: Gjerstad 1926, pp. 202–3, no. 6; P. Åström 1972, p. 131; Kaplan 1980, pp. 32–33, 163, 323, fig. 124.c.

Mycenaean Pottery

Large numbers of Mycenaean vases started to inundate the Cypriot market at the beginning of the fourteenth century B.C., perhaps as a result of intensive trade relations between the Aegean and the eastern Mediterranean regions. Some of these luxury wares may have been exchanged for Cypriot copper. The krater was a popular form in the repertoire of Mycenaean vases, found almost exclusively in tombs on Cyprus and usually decorated in the pictorial style, with human and animal figures, notably in chariot scenes. In the early stages the compositions were realistically rendered, somewhat like the monumental fresco paintings that inspired them. During the later stages, pictorial stylization became stricter. The compositions lost their original liveliness, becoming merely ornamental.

Mycenaean vases in general and pictorially decorated kraters in particular had great appeal among wealthy Cypriots and other Near Easterners. Sometimes as many as half of the gifts in fourteenth- and thirteenth-century B.C. tombs consists of Mycenaean pottery; pictorial vases continued to be placed in tombs on Cyprus and the Levantine coast as late as about 1200 B.C., when trade relations between the Aegean and the Near East became restricted as the result of political turmoil.

Several scholars have suggested that Cypriots were involved in the creation of the Mycenaean pictorial style. This theory is based on the extraordinarily large numbers of such vases found on the island and

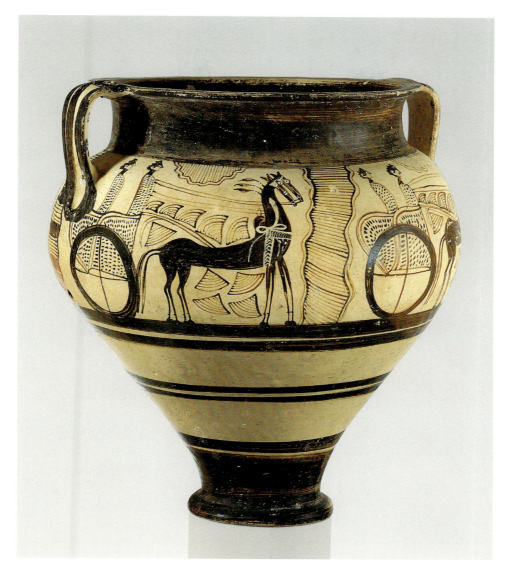

70. VIEW 1

the Levantine coast. Recent scientific research, however, has demonstrated that the clay used for the manufacture of the vases comes from the Argolid in the Greek Peloponnese. It cannot be ruled out, however, that some of the vases, especially those from the thirteenth century B.C., were made by Mycenaean potters working on Cyprus. That clay was traded in antiquity is

now well documented. Cypriots might have been responsible for regulating the trade in Mycenaean pictorial vases destined for the eastern Mediterranean market, for many of them bear Cypro-Minoan signs. These signs were engraved or painted after firing, usually on the bases or handles.

The Cesnola Collection is not rich in Mycenaean pottery, no

doubt because Cesnola was not very active in major Late Bronze Age cemeteries, such as those at Enkomi, Kition, and Kalavasos. The two chariot kraters illustrated here (cat. nos. 70, 71) and a fragmentary bird krater (74.51.5850) that is not described in this book are the only Mycenaean pictorial vases in the collection.

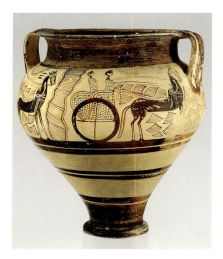

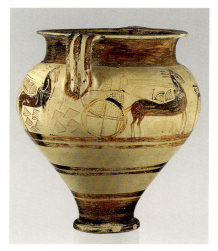

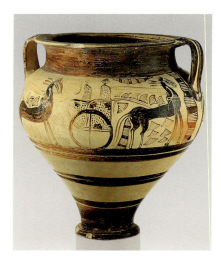

70. VIEW 2

70. VIEW 3

70. VIEW 4

70. **Mycenaean chariot krater**
Early Pictorial III or Late
Helladic IIIA:1 late style
(2nd quarter of the 14th century B.C.)
"Agora painter"
Terracotta
H. 36.7 cm (14½ in.); diam. (of mouth): 27.2 cm (10¾ in.)
74.51.964 (Myres 436)
Said to be from Amathus; probably from Maroni

Perforations at the base and the top of the handles facilitated the firing process. The two tall, armless occupants of the chariot wearing long spotted robes follow the tradition of Mycenaean chariot representations from the very beginning of the fourteenth century B.C. Static and symmetrical, the composition shows no attempt to render a specific narrative. The drawing is neat and elegant. Blots of paint on one of the chariot boxes may indicate that it was covered with the hide of an ox. The long-legged horses, with their harnesses rendered in white paint, follow the convention of Mycenaean vase painting: when two horses are meant to be represented, the painter, in an attempt to show perspective, depicts only one body, with two tails, two pairs of hind and forelegs, as well as two heads. This is one of the rare cases in which two chariot groups are depicted on each side of a krater. Usually there is only one.

BIBLIOGRAPHY: Cesnola 1877, p. 268; Cesnola 1894, pls. CII.853, CIII.854; Johnson 1980, p. 35, no. 251; Vermeule and Karageorghis 1982, pp. 20, 196, no. III.16; Rystedt 1990, pp. 168, 172 n. 4, fig. 3.

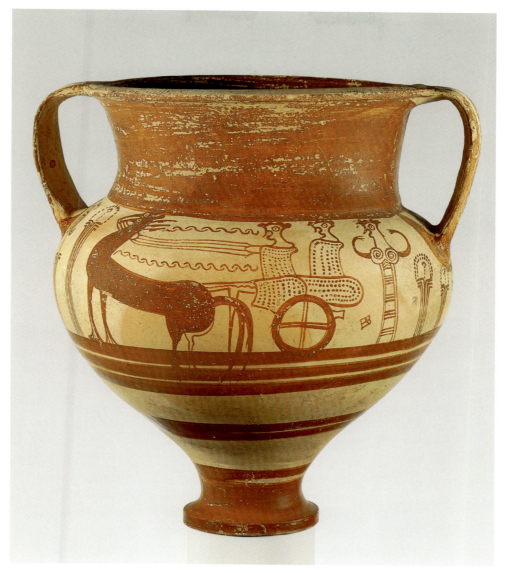

71. VIEW 1

71. **Mycenaean chariot krater**
Ripe Pictorial I or Late
Helladic IIIB:1 style
(1st half of the 13th century B.C.)
Terracotta
H. 41.6 cm (16⅜ in.); diam. (of
mouth): 30.8 cm (12⅛ in.)
74.51.966 (Myres 437)
Said to be from Nicosia-Ayia
Paraskevi

The krater is amphoroid in shape,
but of a developed form, with a
high neck and a bulging body.
Chariot compositions that face to
the left decorate the two shoulder
zones between the handles. Empty
spaces are filled with stylized high-
stemmed flowers or abstract motifs.
The principles of composition and
figure drawing are similar to those

of the earlier krater (cat. no. 70),
but even further removed from
reality. How the chariot box relates
to the wheel is unclear, and the
chariot pole springs directly from
the rear of the horses. The bodies
of the horses are less elegant than
those of their fourteenth-century B.C.
counterparts. No attempt was made
to confine the figural representation

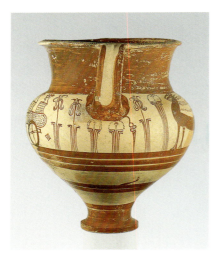

71. VIEW 2

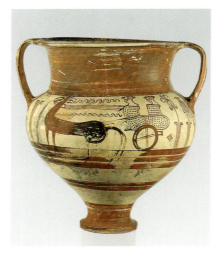

71. VIEW 3

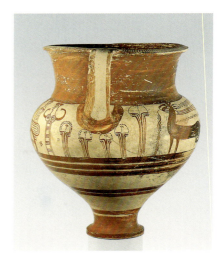

71. VIEW 4

71. DETAIL

within the shoulder zone—between the neckline and the horizontal bands around the middle of the body—since the hind legs and tails overlap these delimiting bands. This suggests that the potter (or an apprentice) prepared the rudimentary decoration, and the figural representation was the task of a different person.

What makes this krater interesting is the presence (on one side) of a female figure wearing a long robe, with both arms raised, body facing frontally, and head shown in profile, looking toward the adjacent chariot. She is depicted in a stylized manner, almost resembling the stylized high-stemmed flowers that fill the empty spaces of the composition. Her breasts are rendered with two antithetical spirals. The features of her face, and her short hair, resemble those of the male figures in the chariot box. Her arms are raised and her fingers splayed in what must be a meaningful gesture. She may be compared with mourning women who tear their cheeks in grief, but probably she is waving goodbye to departing warriors. It is unlikely that she represents a goddess of the type known in coroplastic art. Female figures in association with departure scenes are also known from earlier chariot kraters.

On the base is a sign in the Cypro-Minoan script, painted after firing (see detail at left). Such signs, which were often engraved after firing rather than painted, suggest Cypriot involvement in the distribution of Mycenaean pottery in the eastern Mediterranean.

BIBLIOGRAPHY: Cesnola 1877, p. 247; Cesnola 1894, pls. C.851, CI.852; Vermeule and Karageorghis 1982, pp. 36, 200, no. v.2.

Aegean-Type Pottery

Aegean-type pottery was made on Cyprus after about 1200 B.C., at a time when communications were restricted in the eastern Mediterranean and the trade in Mycenaean pottery had come to a halt. Many scholars associate the local manufacture of this type of pottery with the arrival of Achaeans from the Aegean who settled in various parts of Cyprus, such as Enkomi, Kition, and Hala Sultan Tekke. With local clay, they made pottery that imitated the shapes and decorative motifs of Aegean pottery of the same period. This phenomenon is observed at sites along the Levantine coast in Syria and Palestine that were rebuilt after the destruction of Late Bronze Age centers such as Ashkelon, Ekron, and Ras Ibn Hani.

This phase of Cypriot and Levantine pottery is usually referred to as Mycenaean IIIC:1b, but it should be recalled that the wares were made locally, with local clay, often under the influence of local styles.

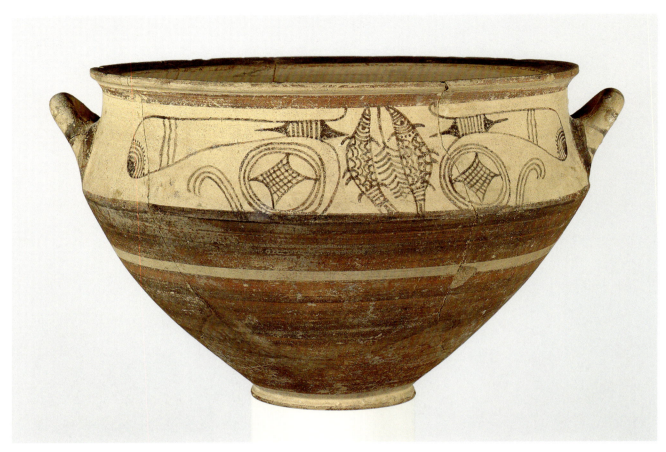

72

72. Krater
Mycenaean IIIC:1b style
(2nd half of the 12th century B.C.)
Terracotta
H. 21.5 cm (8½ in.); diam. 30.7 cm
(12⅛ in.)
74.51.429 (Myres 435)
Said to be from Idalion (Potamia)

 The open krater, with a carinated
profile, a monochrome lower part,
and a narrow decorated zone above,
has formal parallels not only in Late
Helladic IIIC pottery (cf. Mountjoy
1986, p. 174; Kling 1989, p. 127) but
also on Cyprus, where the shape
was already popular. The style of
the decoration, with two large,
elaborate, antithetical spirals and

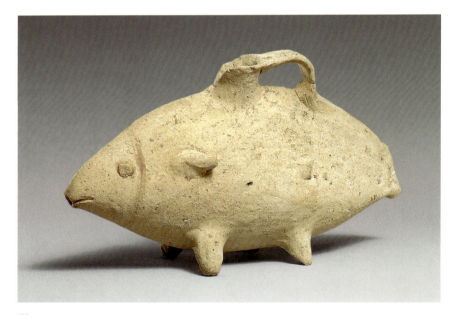

73

filling motifs in and around them, has been termed the Strict Sinda style (Kling 1989, p. 125). Here, the motifs consist of fish. This style represents a local Cypriot creation that uses decorative elements from various sources.

Kling has suggested that the Aegean carinated krater with ring base derives from "influence from the east rather than vice versa" (Kling 1989, p. 127). It was originally thought that the decoration of this krater was in two colors. The bichrome technique was used in Late Helladic IIIC, but it is mainly found on Philistine pottery from the Levant. Recent investigations undertaken in the Sherman Fairchild Center for Objects Conservation at the Metropolitan Museum have shown that the black color is a modern addition and that the vessel was originally painted only in red. The krater may be dated to the second half of the twelfth century B.C., which corresponds to the Late Helladic IIIC Middle period. It is surprising that this vase has rarely been mentioned in discussions of the Mycenaean IIIC:1b pottery of Cyprus.

BIBLIOGRAPHY: Cesnola 1894, pl. CXXIV.936; Vermeule and Karageorghis 1982, pp. 68, 208–9, no. VI.62

73. **Fish-shaped** *askos*
Late 13th century B.C.(?)
Terracotta
H. 15.9 cm (6¼ in.); L. 27.8 cm (11 in.)
74.51.788 (Myres 389)

The *askos* has four legs, modeled fins, and pellets for eyes. It probably imitates a Mycenaean IIIB (late-thirteenth-century B.C.) prototype. Traces of decoration in orange matte paint remain.

BIBLIOGRAPHY: Doell 1873, pl. XVI.18, no. 4034; Cesnola 1894, pl. XCV.812.

Proto-White Painted Ware
Cypriot Proto-White Painted Ware dates from the very end of the Late Bronze Age on Cyprus—the early eleventh century B.C. It forms a distinct class of pottery in which Aegean elements predominate in the forms of the vases and in their painted decorations. Levantine elements and local Cypriot ceramic traditions are also present. Proto-White Painted Ware has received considerable attention in recent years because its mixture of Aegean, Levantine, and Cypriot elements reflects the changing political and cultural climate on Cyprus during the early part of the eleventh century B.C. It is mainly known from the necropolis of Alaas, in eastern Cyprus, where vases comparable to those described here are found (cf. V. Karageorghis 1975a). The bottle with a cylindrical body (e.g., cat. no. 75) is well known on Cyprus

(cf. V. Karageorghis 1975a, p. 60, pl. XXIX, D6) and may be considered to be of Cypriot origin. The ring kernos (e.g., cat. no. 78) is also well known. It usually has miniature vases on top of the ring. Such kernoi had a long tradition in the Bronze Age ceramics of Cyprus (Pieridou 1973, p. 74, pl. 24.2–8; V. Karageorghis 1975a, p. 56). The form was also popular in the Levant.

The *askos* (cat. no. 77) with a spout in the form of a horse's head has parallels from Alaas and elsewhere on Cyprus (cf. V. Karageorghis 1975a, pp. 54–55, pl. XXXVII.K2, .K3). This example stands on three legs instead of the usual ring base and is decorated, on top of the body and on the handle, with miniature birds. It may be considered to belong to the ceramic tradition of Cyprus (cf. Pieridou 1973, pp. 74–75; Misch 1992, p. 197).

The horse-shaped rhyton (cat. no. 74) is matched by several other examples from Cyprus, but the origin of the type may be Aegean (cf. Pieridou 1973, p. 64; Catling 1974, pp. 107–8; V. Karageorghis 1975a, p. 55; Misch 1992, p. 204). Bird-shaped *askoi* (e.g., cat. no. 76) were extremely popular from a very early period both in the Aegean and on Cyprus. It has been suggested recently that the origin of this type is Aegean (Lemos 1994).

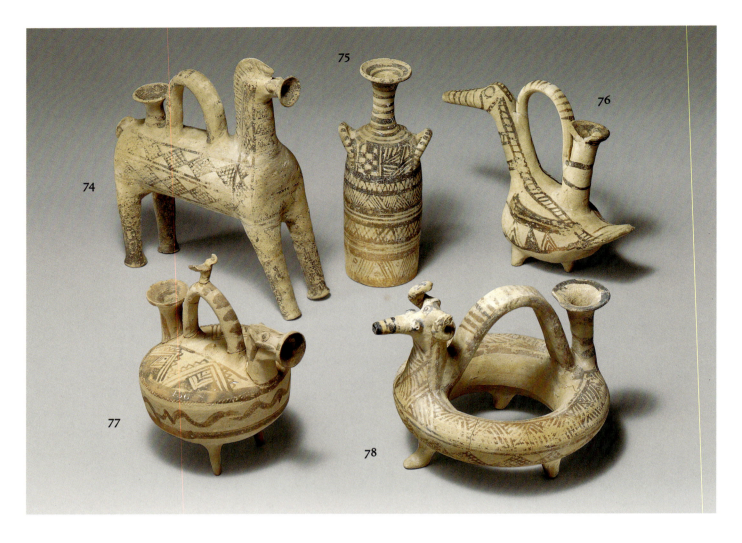

74. Horse-shaped rhyton
Late Cypriot IIIB
(early 11th century B.C.)
Proto-White Painted Ware
H. 22.7 cm (9 in.)
74.51.787 (Myres 525)

75. Bottle
Late Cypriot IIIB
(early 11th century B.C.)
Proto-White Painted Ware
H. 19.2 cm (7½ in.)
74.51.1051 (Myres 407)

76. Bird-shaped *askos*
Late Cypriot IIIB
(early 11th century B.C.)
Proto-White Painted Ware
H. 16.4 cm (6½ in.); L. 17.9 cm
(7 in.)
74.51.841 (Myres 529)

BIBLIOGRAPHY: Doell 1873, p. 68,
pl. XVI.19, no. 4035; V. Karageorghis
1975b, p. 68, pl. X.2.

77. *Askos* with horse protome
Late Cypriot IIIB
(early 11th century B.C.)
Proto-White Painted Ware
H. 15.9 cm (6¼ in.)
74.51.811 (Myres 456)

78. Ring kernos with ram protome
Late Cypriot IIIB
(early 11th century B.C.)
Proto-White Painted Ware
H. 13.8 cm (5⅜ in.)
74.51.810 (Myres 523)
Said to be from Idalion (Potamia)

BIBLIOGRAPHY: Cesnola 1894,
pl. XCV.816.

COPPER-BASED METALWORK

Weapons, Tools, and Regalia
Leaf-shaped spearheads with wooden shafts came in various sizes and appeared in tombs that date from the Early Bronze Age to the middle of the Late Bronze Age (cf. Catling 1964, p. 57, fig. 1.6). Terracotta models of sheathed daggers with flat tangs inserted into a wooden handle—often held in place with rivets—have also been found in tombs. Although there are no indications that the Early Bronze Age was a period of conflict on the island, spearheads are frequently encountered in tombs. The larger pieces, often incorrectly described as swords, may have been status symbols or simply standard weapons carried by males who had to be prepared for the dangers of everyday life (Swiny 1997, p. 206). In the Early Bronze Age and later, daggers and spearheads placed in tombs were bent, or "killed," intentionally. The bending ensured that they could not be used as weapons after burial (e.g., cat. no. 79).

79. Spearhead
Early Cypriot I (ca. 2300 B.C.)
Copper-based metal
L. (as bent): 29.2 cm (11½ in.)
74.51.5283 (Myres 4630)

BIBLIOGRAPHY: Richter 1915, p. 388, fig. 1392, no. 1392; Catling 1964, p. 57, fig. 1.4.

80. Spearhead
Early Cypriot III (ca. 2000 B.C.)
Copper-based metal
L. 44.6 cm (17½ in.)
74.51.5277 (Myres 4624)
Said to be from Alambra

BIBLIOGRAPHY: Cesnola 1903a, pl. LXXII.2; Richter 1915, p. 388, no. 1386.

81. Spearhead
Early Cypriot III (ca. 2000 B.C.)
Copper-based metal
L. 48.7 cm (19⅛ in.)
74.51.5275 (Myres 4622)

BIBLIOGRAPHY: Richter 1915, p. 387, no. 1384.

82. Spearhead
Early Cypriot III (ca. 2000 B.C.)
Copper-based metal
L. 21.8 cm (8⁹⁄₁₆ in.)
74.51.5269 (Myres 4616)

BIBLIOGRAPHY: Richter 1915, p. 387, no. 1378.

83. Spearhead
Probably Late Cypriot IIIA
(ca. 1200–ca. 1100 B.C.)
Copper-based metal
L. 35.4 cm (14 in.)
74.51.5309 (Myres 4695)
Said to be from Alambra

This spearhead has a tubular socket with a slit; two perforations on either side of the slit, near the edge, are for attaching a wooden shaft. One should note the impression of woven fabric near the end of the socket, and of binding near the shoulder. Spearheads such as this appeared in the Late Cypriot II period and were still in use during the twelfth century B.C. They are usually found in tombs (cf. Catling 1964, pp. 119–20, fig. 13.11, pl. 13.h). This type of weapon could have been introduced to Cyprus from the Aegean.

BIBLIOGRAPHY: Cesnola 1903a, pl. LXXII.1; Richter 1915, p. 393, fig. 1416, no. 1416.

84. Shepherd's crook
12th century B.C.
Copper-based metal
L. 12.4 cm (4⅞ in.)
74.51.5570 (Myres 4774)
Said to be from Kourion (the "Kourion Treasure")

The work belongs to a group of six known pieces that have been variously described as shepherd's crooks or scepters, but this example differs from the others because its tip is curved to form a scroll. The others merely point up or down. The straight shaft is tubular, with a slit near the lower part and rivet holes, one on either side. The construction suggests that the piece was once attached to a wooden shaft or rod. Its place of origin may be Cyprus, though its form could be Aegean-inspired. It is unlikely to have been a ceremonial scepter, which was more elaborate in design.

BIBLIOGRAPHY: Cesnola 1903a, pl. LV.2; Richter 1915, p. 459, fig. 1820, no. 1820; Gjerstad 1948, p. 142, fig. 24.15; Schaeffer 1952, p. 60; Catling 1964, p. 260; L. Åström 1972, pp. 485, 562; Kourou 1994, p. 209 n. 79.

85. Tweezers
Early Cypriot III (ca. 2000 B.C.)
Copper-based metal
L. 8.2 cm (3¼ in.)
74.51.5432 (Myres 4659)
These tweezers were used for the removal of superfluous hair.

BIBLIOGRAPHY: Richter 1915, p. 300, no. 877.

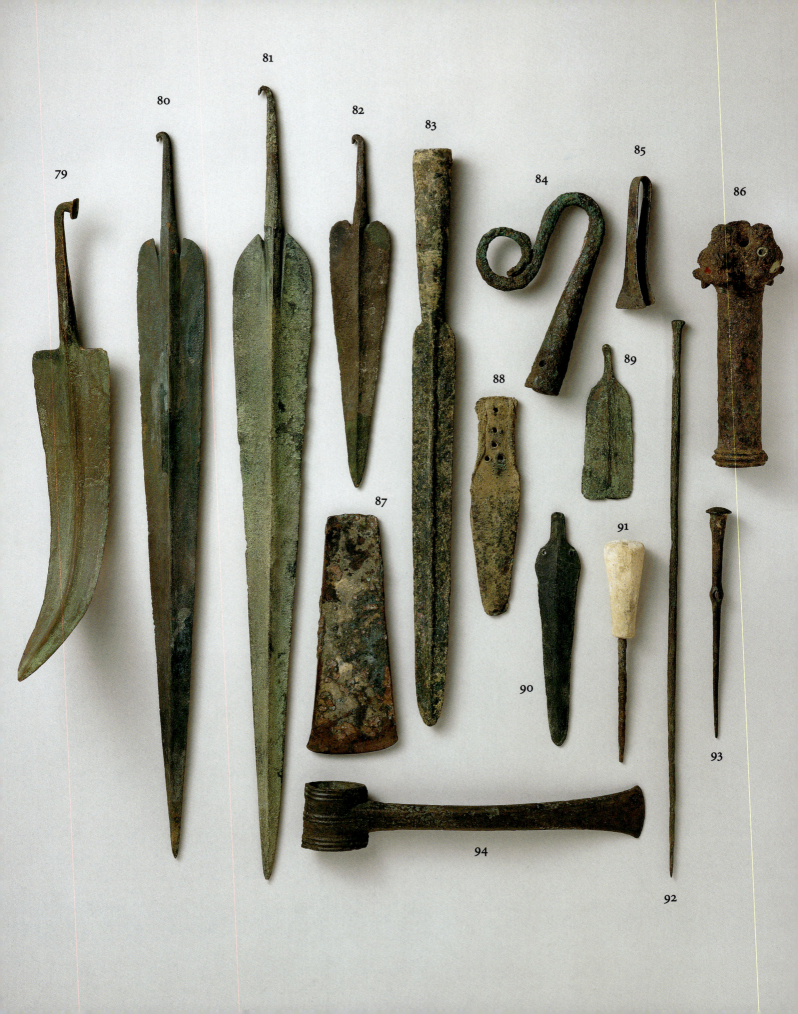

86. Scepter head

Late Cypriot II–III (ca. 1450–
ca. 1050 B.C.)
Tin bronze, glass, and carnelian
H. 14.7 cm (5¾ in.)
74.51.5696 (Myres 4771)
Said to be from Kourion (the
"Kourion Treasure")

The scepter head is in the form of
a tube topped by three mold-made
bull's heads arranged in an upright
position. The eyes of the bulls are
inlaid with glass that is not origi-
nal. On the forehead of each bull is
a crescent-shaped inlay. Two are
probably carnelian and the third is
of green glass paste. There are
ridges around the end of the tubu-
lar shaft.

This scepter head has been the
subject of much discussion (see
Buchholz 1986, pp. 149–50 n. 69,
fig. 25.a; 1991, p. 81, fig. 4.d), and
some scholars have doubted its
authenticity. There is no reason,
however, why it should not be con-
sidered genuine, though some of
the inlays may be modern replace-
ments. It is unclear whether the bu-
crania form the top or the bottom
of the piece. The present author
agrees with Kourou that the mold-
ing around the tubular shaft forms
the lower part (1994, p. 206, fig. 1.4).
Another piece, now missing, prob-
ably surmounted the three bucra-
nia on top of the shaft. Bucrania
are common in the arts and crafts
of Cyprus of the Late Cypriot II–III
period (cf. V. Karageorghis 1993a,
pp. 49–50), the date that is sug-
gested for this scepter.

BIBLIOGRAPHY: Cesnola 1877,
pp. 333, 335–36, pl. XXVIII; Cesnola
1903a, pl. LII.2; Richter 1915, p. 458,
fig. 1814, no. 1814; Buchholz 1986,
pp. 149–50 n. 69, fig. 25.a; Buchholz
1991, p. 81, fig. 4.d; Kourou 1994,
p. 206, fig. 1.4.

87. Flat axhead

Late Cypriot III (ca. 1150–
ca. 1100 B.C.)
Copper-based metal
L. 14.8 cm (5⅞ in.)
74.51.5399 (Myres 4643)

BIBLIOGRAPHY: Richter 1915, p. 432,
no. 1618.

88. Blade

Probably Late Cypriot (ca. 1600–
ca. 1050 B.C.) or later
Copper-based metal
L. 13.5 cm (5⅜ in.)
74.51.5290 (Myres 4692)

This unusual blade looks as
though it had been broken in
antiquity and reshaped.

BIBLIOGRAPHY: Cesnola 1903a,
pl. LXIV.3; Richter 1915, pp. 390–91,
no. 1403.

89. Razor

Middle Cypriot II (ca. 1800–
ca. 1725 B.C.)
Copper-based metal
L. 9.5 cm (3¾ in.)
74.51.5297 (Myres 4612)

Objects such as this one have
been correctly identified by Catling
as razors, an identification univer-
sally accepted today (Catling 1964,
pp. 67–68). They have short, un-
pointed blades, so they could not
have been used as weapons, and
they are too thin to have served as
tools. They appeared at the be-
ginning of the Early Bronze Age
and disappeared before the end of
the Late Bronze Age.

BIBLIOGRAPHY: Richter 1915, p. 385,
no. 1371.

90. Dagger blade

Early Cypriot III (ca. 2000 B.C.)
Copper-based metal
L. 14.4 cm (5⅝ in.)
74.51.5286 (Myres 4609)

BIBLIOGRAPHY: Richter 1915, p. 385,
no. 1368.

91. Chisel

Early Cypriot III (ca. 2000 B.C.)
Copper-based metal with bone
handle
L. 13.6 cm (5⅜ in.)
74.51.5699 (Myres 4655)

BIBLIOGRAPHY: Richter 1915, p. 438,
no. 1660.

92. Button-head pin

Early Cypriot III (ca. 2000 B.C.)
Copper-based metal
L. 34.3 cm (13½ in.)
74.51.5508 (Myres 4674)

This pin was used as a dress
fastener.

BIBLIOGRAPHY: Richter 1915, p. 302,
no. 888.

93. Toggle pin with button head

Middle Cypriot I (ca. 1900 B.C.)
Copper-based metal
L. 8.2 cm (3¼ in.)
74.51.5522 (Myres 4678)

Pins like this one were used as
dress fasteners.

BIBLIOGRAPHY: Richter 1915, p. 303,
no. 892.

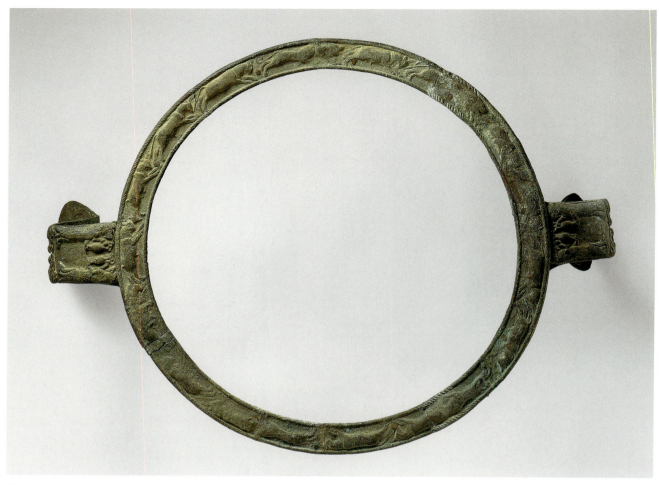

95

94. Shaft-hole ax

Middle Cypriot II (ca. 1800–
ca. 1725 B.C.)
Tin bronze
L. 20.3 cm (8 in.)
74.51.5389 (Myres 4698)
Said to be from Alambra

The shaft-hole ax is not common
on Cyprus, and this example has
been considered to be a foreign im-
port, possibly from Syria-Palestine.
It is interesting to note that this work
represents the earliest known use of
a double (closed) mold on Cyprus.

BIBLIOGRAPHY: Cesnola 1877, p. 88,
pl. V; Cesnola 1903a, pl. L.1; Richter
1915, p. 433, fig. 1632, no. 1632;
Deshayes 1960, p. 174, no. 1410;
Catling 1964, p. 66; Åström 1972,
pp. 139, 245; de Jesus 1976, p. 233,
pl. 1, 2.1; P. Swiny 1986, p. 157,
tab. 2, "shaft hole ax."

Vessels

95. Decorated rim and handles of
 an amphoroid krater

13th to early 12th century B.C.
Copper-based metal
Diam. 39.7 cm (15⅝ in.);
H. (of handles): 22.2 cm (8¾ in.)
and 20.9 cm (8¼ in.)

74.51.5685 (Myres 4703)
Said to be from Kition

The rim and handles belonged
to an amphoroid krater of Aegean
type. The body of the vessel, which
was made of a thin sheet of beaten
metal, has not survived. The rim
and handles, which are quite thick,
were cast separately and attached
by rivets to the body of the krater.
Damaged parts of the rim were
clumsily restored in modern times,
hence the discrepancies in the vari-
ous published descriptions. The
rim is flat, bordered by a cable pat-
tern, and decorated in relief with

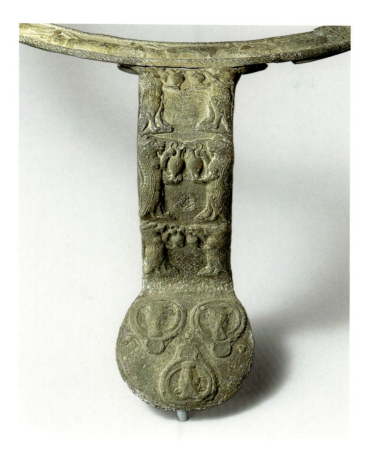

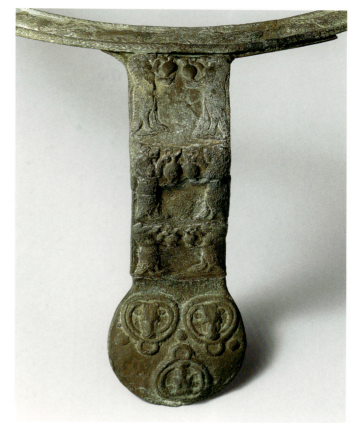

95. DETAIL

95. DETAIL

galloping lions chasing bulls and boars. There are fourteen bulls, three lions, and three boars.

Each S-shaped handle is decorated with three pairs of confronted genies. The winged and lion-headed genies wear crocodile hides and tails, just as they are commonly portrayed in Aegean art. Each genie holds an oinochoe, or wine jug, of Aegean shape. The lower attachments of the handles are decorated with three identical bucrania with long horns that curve toward the mouths. The bucrania are enclosed within a circle with a loop attached below.

Metal amphorae with decorated rims and handles are extremely rare. Those that have survived display strong Aegean stylistic influence and were probably made on Cyprus during the twelfth century B.C. Another Cypriot example, similar to this one, comes from a mid-eleventh-century B.C. tomb at Kourion (Catling 1964, p. 157). A third example, containing the remains of a man, was excavated at Lefkandi in Euboea. It may have been part of the fortune of a Greek hero who had returned from Cyprus, as described by Homer. Archaeological evidence, particularly from Crete, corroborates this theory (Catling 1995; for a recent discussion, see Kanta 1998, pp. 57–60).

BIBLIOGRAPHY: Cesnola 1903a, pl. LIV.1, 2; Richter 1915, pp. 222–24, figs. 620, 620 detail, no. 620; Richter 1953, p. 17 n. 42, pl. 10.b; G. McFadden 1954, p. 138; Catling 1964, pp. 157–61, pl. 23.b, c; Matthäus 1985, pp. 229–32, pl. 69, no. 528.

Tripods

Metal rod tripods (e.g., cat. no. 96) and four-sided stands, especially those decorated with figural representations, constitute some of the finest technical and artistic expressions of Late Bronze Age Cyprus. They were also admired in the Aegean, where Cypriot prototypes were imitated during the early first millennium B.C. They were treasured by their owners and passed from one generation to the next (Catling 1984, p. 91). Some were acquired as gifts long after they were made on Cyprus and taken to the Aegean by returning heroes (Catling 1995, p. 128). As noted above, during the early part of the twelfth century B.C., metalwork developed on Cyprus under strong Aegean influence. Several of the rod tripods from Cyprus and the rim and handles of a krater (cat. no. 95) may have been made in the same workshop (Catling 1964, pp. 197–98).

Cast tripods and rod tripods may be contemporaneous, both dating from the thirteenth through the eleventh century B.C. Until one was found at Ugarit in Syria (Schaeffer 1956, pp. 262–65), all the known examples of cast tripods came from tombs and sanctuaries on Cyprus; the Syrian example was dated by the excavator to the fourteenth century B.C. (Schaeffer 1956, pp. 245–55). Today, the accepted date for that piece is the twelfth century B.C. (Catling 1964, pp. 202–3). Cast tripods (cat. no. 97) are usually small and lack the elaborate structure and decoration of rod tripods (cat. no. 96).

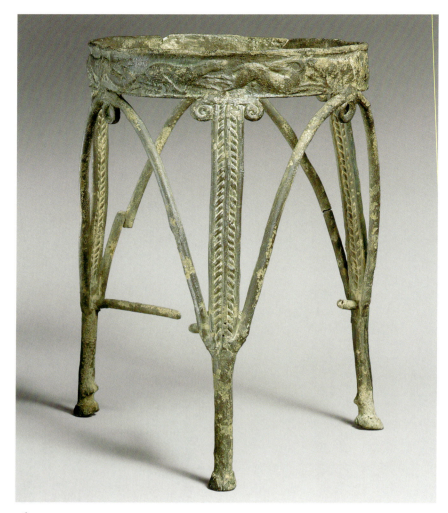

96

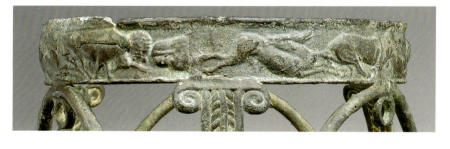

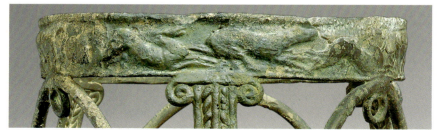

96. DETAILS

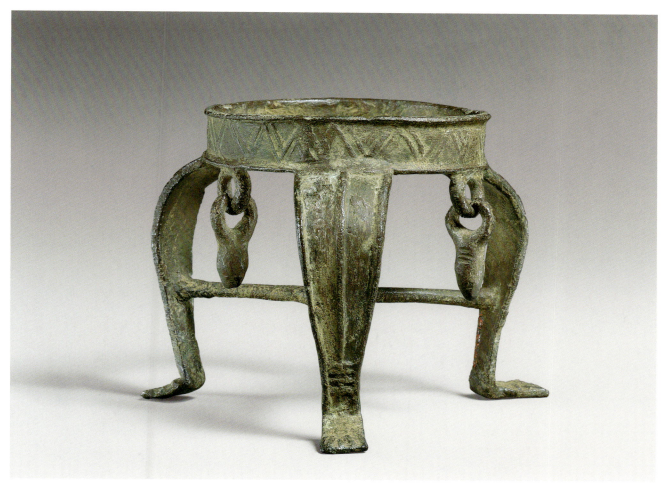

97

96. Rod tripod decorated with a frieze of animals

13th or early 12th century B.C.
Copper-based metal
H. 37.5 cm (14¾ in.); diam. 24.8 cm (9¾ in.)
74.51.5684 (Myres 4704)
Said to be from Kourion
(the "Kourion Treasure")

The band at the top of the tripod was cast flat in one piece and the ends were brazed together; it is decorated in low relief with a frieze of hounds pursuing wild goats. The band was damaged and repaired, apparently in antiquity, thus obscuring the composition. Bent rods connecting the legs each have a ring where they meet the decorated band; these rings originally held pendants.

BIBLIOGRAPHY: Cesnola 1877, p. 335; Cesnola 1903a, pl. XLIV.4; Richter 1915, pp. 345–48, figs. 1180, 1180 detail, no. 1180; Richter 1953, p. 17 n. 41, pl. 10.a; Catling 1964, pp. 197–98, pl. 30.a–c, no. 15; Matthäus 1985, p. 303, pls. 95, 96, no. 691.

97. Cast tripod

13th or 12th century B.C.
Copper-based metal
H. 9.8 cm (3⅞ in.); diam. 8.6 cm (3⅜ in.)
74.51.5587 (Myres 4705)
Said to be from Idalion

BIBLIOGRAPHY: Cesnola 1903a, pl. LXII.2; Richter 1915, p. 348, fig. 1181, no. 1181; Gjerstad 1948, p. 150, fig. 27.2; Catling 1964, pp. 201–2, pl. 32.c, no. 29; Catling 1984, p. 85, pl. VIII.4; Matthäus 1985, p. 311, pl. 100, no. 701.

FAIENCE

The importation of faience vases into Cyprus began in the Late Bronze Age, particularly from Egypt during the 19th Dynasty. Another source was the Levantine coast, but it is also likely that faience vases were made locally, in a style that absorbed influences from Egypt, the Levant, and the Aegean.

The shapes of faience vessels found on Cyprus often reflect Aegean types, as seen in the works illustrated here (cat. nos. 98, 100), a two-handled flask and a pseudo stirrup flask. The bulls represented on the two-handled flask and the bowl (cat. no. 101) may have been inspired by Egyptian representations. The bull on the flask, however, also resembles bulls in the Pastoral Style of Cypriot vase painting; the blots of paint on the animal's body are particularly characteristic (see Peltenburg and McKerrell 1974, pp. 124–25).

In the fourteenth and thirteenth centuries B.C. many other luxury goods were imported into Cyprus from Egypt and the Levant, and Egyptian materials arrived via the Levant. The objects included alabaster and glass vases as well as scarabs (Caubet, Karageorghis, and Yon 1981, p. 55; for a general study of faience objects from Cyprus, see Peltenburg and McKerrell 1974, pp. 105–44).

98. **Flask**
End of the 13th century B.C.
Faience
H. 11.9 cm (4¾ in.)
74.51.5073 (Myres 1570)
Said to be from near Idalion

The green-glazed surface and black-painted decoration have now mostly worn off. On either side of the shoulder a quadruped leaps to the right. One is a bull and the other a goat or a gazelle, with its head turned backward and its tail curved upward.

BIBLIOGRAPHY: Cesnola 1877, p. 102; Cesnola 1903a, pl. CIX.1; Foster 1979, p. 52 n. 339.

STONE VASES

The form of stone vases, especially amphoriskoi, was often dictated by the hardness of the material. Ceramic amphorae with vertical handles, well known on Cyprus from Mycenaean imports during the fourteenth and thirteenth centuries B.C., were produced on the island during the Late Cypriot III period. Stone examples (cat. nos. 117, 119) often imitate these local ceramic forms.

Vases in gypsum with the same form and decoration as the steatite amphoriskos (cat. no. 120) have been found at Kition and Enkomi in tombs of the Late Cypriot IIIA period (early twelfth century B.C.), a date which may be assigned to this vase. Hatched tangent triangles, however, were also a popular motif during the eleventh century B.C.

Alabaster vases have been found in tombs from the Late Cypriot II–III period and may have been imported from Egypt or Syria (cf. L. Åström 1972, p. 603). Some of them resemble Cypriot or Mycenaean forms (e.g., cat. nos. 114, 115). One ceramic shape that recurs in alabaster is the Cypriot Base-Ring Ware jug, widely known in Egypt. Others are the Mycenaean-type amphora with vertical handles and the Egyptian type with horizontal loop handles.

In the archaeological literature, the hard yellowish calcareous material from which many vases were made is frequently referred to as "Egyptian alabaster." This convention is followed in the descriptions here. There are many variations of this material, and the color ranges from off-white to yellowish. Some examples have vertical banding, others have horizontal, and some have none. Lilyquist has argued correctly that what we call "Egyptian alabaster" may not be Egyptian at all and that stone resembling Egyptian material could have been quarried elsewhere (Lilyquist 1996 and 1997). This point raises a number of problems. Since stone of this type cannot be found on Cyprus, what is the origin of these vases? Is it possible that they were made by Cypriot craftsmen using imported materials? The development of an "international style" in the eastern Mediterranean, especially during the Late Bronze Age, may have encouraged the production of Egyptian-type vases in a variety of locales. Questions about the production of stone vases will continue until a database of quarries, objects, and isotope studies is established to enable more thorough and detailed analysis.

Lilyquist considers the bulk of the vases of calcareous stone in the Cesnola Collection to be Cypriot

(e.g., cat. no. 114), one to be Palestinian (cat. no. 115), and only one (74.51.5107, not illustrated here) to be Egyptian in all respects, except for its solid flat-bottomed foot (Lilyquist 1996, p. 158 n. 212).

Vases of local Cypriot stone are usually found in Late Cypriot IIIA–IIIB tombs. Those of steatite are miniature vessels, such as amphoriskoi, jars, bowls, and bathtubs, which are usually decorated with engraved linear patterns. There are also amphorae of local gypsum and limestone similarly embellished (cf. L. Åström 1972, p. 604). Tripod bowls or mortars made of andesite or steatite are also found. Mortars (e.g., cat. no. 121) have grooved patterns. The Cesnola Collection also includes a mortar made of alabaster or gypsum (cat. no. 123), an unusual material for such vessels (for a general discussion of stone vases found on Cyprus, see L. Åström 1972, pp. 602–5).

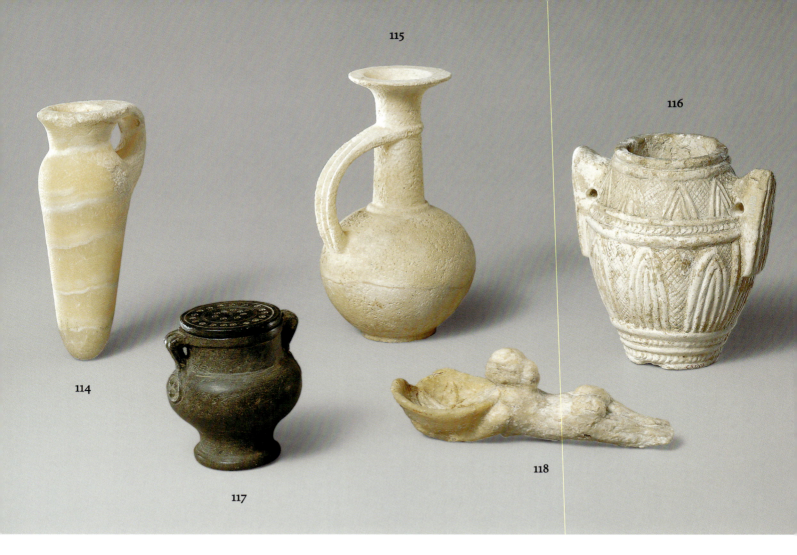

114. **Jug**
Late Cypriot II(?) (ca. 1450–
ca. 1200 B.C.)
Yellowish alabaster
H. 13.9 cm (5½ in.)
74.51.5085 (Myres 1622)
Said to be from Amathus

Similar vases of Egyptian ala-
baster are known from the Middle
and Late Bronze Ages in Egypt and
the Levant, such as a vessel from
Abydos now in the Ashmolean
Museum, Oxford (Lilyquist 1996,
p. 145, pl. 6.2, right).

BIBLIOGRAPHY: Cesnola 1903a,
pl. CXIII.9; Lilyquist 1996, p. 158
n. 212.

115. **Jug**
Late Cypriot II (ca. 1450–
ca. 1200 B.C.)
Yellowish alabaster
H. 14.7 cm (5¾ in.)
74.51.5111 (Myres 1628)
Said to be from Amathus

This Egyptian-alabaster vessel is
similar in shape to a *bil-bil*. The
form imitates Base-Ring I Ware
pottery jugs that were exported
to Egypt in large numbers from
about 1600 B.C. on. They are usu-
ally found in tombs and probably
contained perfumed oils or opium.
The same shape was reproduced
in Egyptian glass.

BIBLIOGRAPHY: Cesnola 1877,
pl. XVIII; Cesnola 1903a, pl. CXIII.8;
L. Åström 1972, pp. 542, 603; Lily-
quist 1996, p. 158 n. 212.

116. **Amphoriskos**
Late Cypriot IIIA (ca. 1200–
ca. 1100 B.C.)
Gypsum
H. 11.8 cm (4⅝ in.)
74.51.5109 (Myres 1643)
Said to be from Amathus

Amphorae of local gypsum have
been found in Late Cypriot IIIA
tombs at Kition and elsewhere
(L. Åström 1972, p. 604).

BIBLIOGRAPHY: Cesnola 1877,
pl. XVIII; Cesnola 1903a, pl. CXI.2.

117. **Amphoriskos**
Late Cypriot IIIA
(early 12th century B.C.)
Dark gray steatite
H. (of vessel): 6.8 cm (2⅝ in.);
diam. (of lid): 4.7 cm (1⅞ in.);
thickness (of lid): .6 cm (¼ in.)
74.51.5023A (vessel, Myres 1543),
.5023B (lid, Myres 1541)
Said to be from Amathus

At the base of each handle is a
circle in relief that contains three
knobs. This motif is clearly an imi-
tation of a metallic handle that
might have been attached to the
body with rivets (cf. cat. no. 95).
The lid is flat, with a tenon on its
underside for insertion into the
mouth of the vessel.

BIBLIOGRAPHY: Cesnola 1903a,
pl. CXV.5 (shows 74.51.5023A,B);
L. Åström 1972, pp. 543, 604.

118. **Ladle**
Late Cypriot III (ca. 1200–
ca. 1050 B.C.)
Grayish white gypsum
Preserved L. 13.4 cm (5¼ in.)
74.51.5119 (Myres 1644)
Said to be from Amathus

The ladle is held by a nude girl
whose figure forms the shaft of the
handle; the lower parts of her legs
are missing. At the bottom of the
bowl is a rosette in relief; the sur-
face is very worn. The material,
Cypriot gypsum, suggests that the
ladle was made locally. The form,
however, is known from the art of
18th Dynasty Egypt, when these
vessels were crafted from mate-
rials such as alabaster and wood.
A Cypriot artist might well have
copied such an object. An ivory
counterpart was found in a Late
Cypriot III tomb (L. Åström 1972,
p. 553, fig. 76, pp. 554, 613). The
form of that vase reappears on
Cyprus during the Hellenistic
period (Vessberg and Westholm
1956, pp. 175, 219, fig. 64.3).

BIBLIOGRAPHY: Cesnola 1877,
pl. XVIII; Cesnola 1903a, pl. CXII.1.

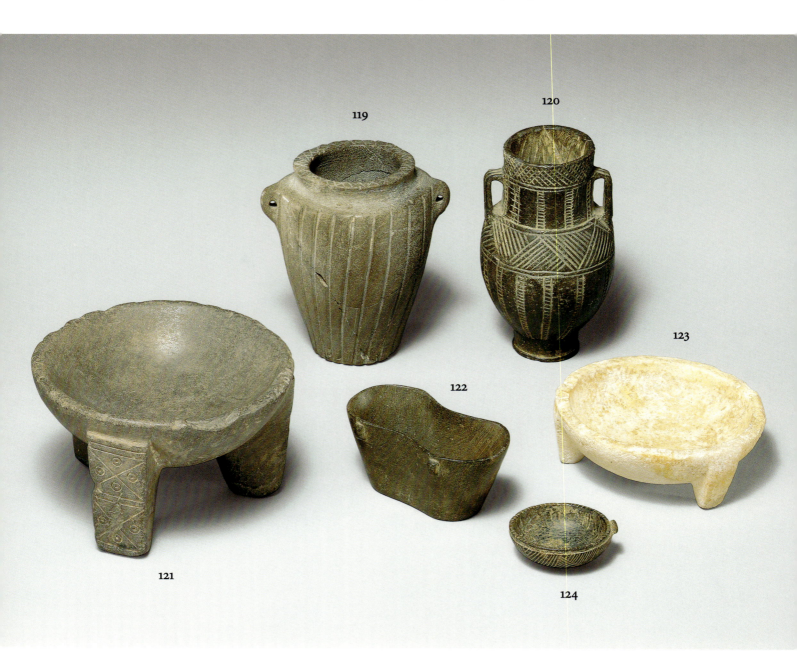

119. Amphoriskos
Late Cypriot II–III (ca. 1450–
ca. 1050 B.C.)
Gray steatite
H. 11.9 cm (4¾ in.)
74.51.5050 (Myres 1542)
Said to be from Amathus

BIBLIOGRAPHY: Cesnola 1903a,
pl. CXV.3; L. Åström 1972, pp. 543,
604.

120. Amphoriskos
Early 12th century B.C.
Dark gray to black steatite
H. 13.1 cm (5⅛ in.); diam.
(of mouth): 5.1 cm (2 in.)
74.51.5057A (Myres 1540)
Said to have been purchased at a
bazaar in Nicosia

Around the base is a circle with
radiating strokes. In the middle of
the circle are two parallel horizon-
tal lines; between them are three
engraved signs thought to be in
either Archaic Phoenician or
Cypro-Minoan script.

The amphoriskos, with no find
spot known, does not provide any
independent chronological evi-
dence. It is possible that the inscrip-
tion on the base was engraved after
the original carving of the vase (see
detail at right).

BIBLIOGRAPHY: Cesnola 1877,
pp. 247, 442, pl. 12.27, no. 27;
Schaeffer 1952, p. 217 n. 3; Masson
1961, p. 40, no. 2; L. Åström 1972,
pp. 543, 604; Masson and Sznycer
1972, pp. 128–30, pls. XIX.1, XXII.2;
Teixidor 1977, p. 67, fig. 26, no. 26.

121. Mortar
Late Cypriot II–III (ca. 1450–
ca. 1050 B.C.)
Dark gray steatite
H. 8.3 cm (3¼ in.); diam. 13 cm
(5⅛ in.)
74.51.5055 (Myres 1533)
Said to be from Amathus

BIBLIOGRAPHY: Cesnola 1903a,
pl. CXV.8.

122. Miniature bathtub
12th or 11th century B.C.
Dark gray steatite
H. 4.3 cm (1¾ in.); L. 9.3 cm
(3⅝ in.)
74.51.5025 (Myres 1544)
Said to be from Amathus

The bathtub was introduced to
Cyprus at the very beginning of the
twelfth century B.C. and is associ-
ated with the arrival of the first
Aegean settlers. Several real bath-
tubs of clay or limestone have been
found on Cyprus, in settlements
and in tombs. They were most likely
used for purification purposes.
Miniature bathtubs, some of which
have been found in tombs, may
have served as substitutes (V. Kara-
georghis 1983, p. 437 n. 14).

BIBLIOGRAPHY: Cesnola 1903a,
pl. CXV.2; L. Åström 1972, pp. 544,
605.

120. DETAIL

123. Mortar
Probably 12th century B.C.
Yellowish alabaster or gypsum
H. 3.7 cm (1½ in.); diam. 10.9 cm
(4¼ in.)
74.51.5139 (Myres 1631)
Said to be from Amathus

Mortars of this type were usually
made of stone such as andesite or
steatite. They are normally found
with pestles (L. Åström 1972,
p. 600) and may have been used
to grind ocher for pigment.

BIBLIOGRAPHY: Cesnola 1903a,
pl. CXII.4.

124. Miniature bowl
Late Cypriot III (12th century B.C.)
Black steatite
H. 1.9 cm (¾ in.); diam. 5.1 cm (2 in.)
74.51.5026 (Myres 1539)

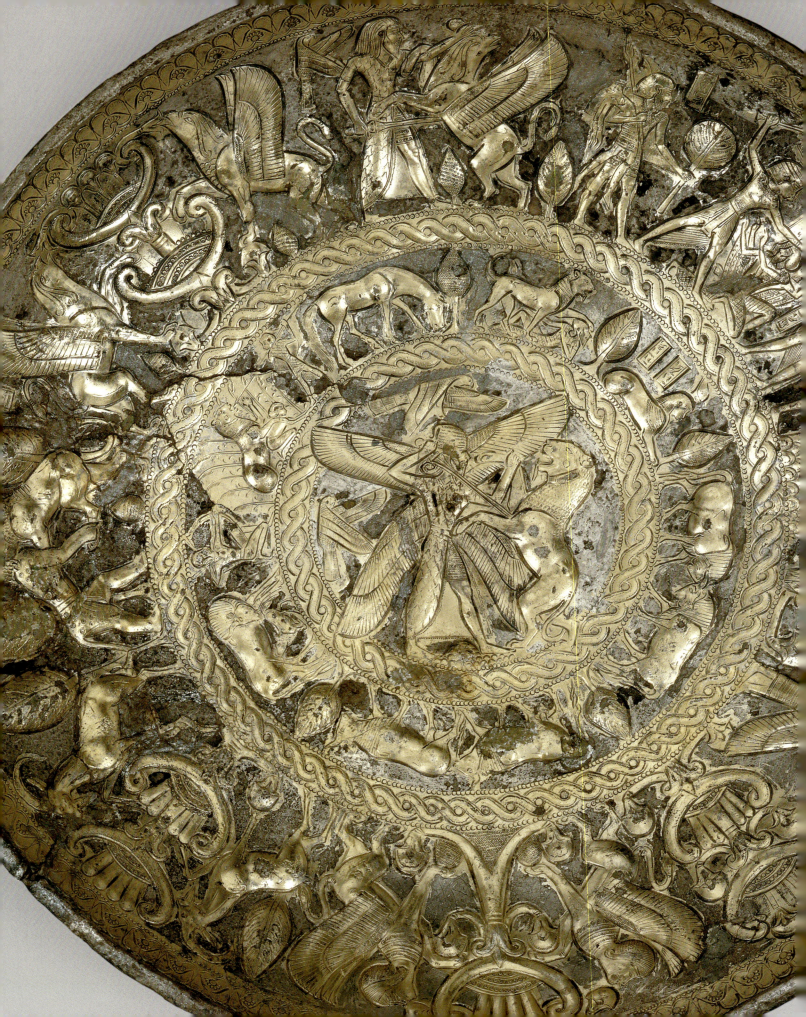

II.

THE CYPRO-GEOMETRIC AND CYPRO-ARCHAIC PERIODS

[CA. 1050–CA. 480 B.C.]

On Cyprus, as in the Aegean, the early part of the first millennium B.C. has traditionally been referred to as the Dark Ages. In the Aegean, illiteracy and poverty prevailed after the dissolution of the Mycenaean empire and the abandonment of palaces, but Cypriots retained some of the wealth they had acquired during the Late Bronze Age, and they never lost their script, which had only to be adapted to the needs of the Greek language. Greek was introduced to the island by the Achaean immigrants who fled to Cyprus in successive waves during the twelfth and eleventh centuries B.C. The elite Achaean society, politically dominant by the eleventh century B.C., must have created the independent kingdoms ruled by *wanaktes*, or kings, on the island. Cypriots continued to trade with the Levant, as their Greek ancestors had, thus ensuring relative prosperity and uninterrupted commercial and cultural contacts during the Dark Ages.

Although the art of Cyprus during the Cypro-Geometric period (ca. 1050–ca. 750 B.C.) was influenced by the Aegean as well as the Levant, Cypriots developed their own idiom, as they had done earlier, during the Bronze Age. In pottery they were fond of imaginative forms, richly decorated with painted motifs, often in black and red. Most pottery of the Cypro-Geometric period was made on Cyprus, but there are some notable imports from the Aegean and the Levant.

From the end of the ninth century B.C. there is evidence of a Phoenician presence on Cyprus. The Phoenicians established the cult of their goddess, Astarte, in a monumental temple at Kition, on the southern coast, where inscriptions, pottery, and other objects have been found. Their interest in Cyprus derived mainly from the island's copper mines and its forests, which provided timber for shipbuilding.

The occupation of Cyprus by the Assyrians about 709 B.C. brought the island closer to the cultures of the Near East, though contacts with the Aegean, evident from the number of Greek imports seen in the following pages, were never broken. (Scholars have recently expressed doubts about whether the Assyrian "occupation" was anything more than political influence, with the Phoenicians acting as the Assyrians' local agents.) The independent kingdoms of Cyprus flourished under Assyrian domination since the Cypriot kings enjoyed considerable independence as long as they paid tribute regularly to the Assyrian king.

Variety can be seen in the artifacts—mostly found in tombs—that date from the Cypro-Archaic I (ca. 750–ca. 600 B.C.) and Cypro-Archaic II (ca. 600–ca. 480 B.C.) periods. In addition to pottery, there are terracotta figurines and a notable series of decorated metal bowls, probably from royal tombs. Similar bowls are in European and Cypriot museums, but the richest collection of all is in the Metropolitan Museum.

Opposite: Detail, cat. no. 299

POTTERY

The Cypriot potter became more independent by the beginning of the first millennium B.C., and by the beginning of the Cypro-Archaic period, about 750 B.C., pottery manufacture reached its apogee. This achievement is manifest less in the variety of shapes—for the wheel did not allow the freedom of hand-made pottery—than in the figural decoration painted on the curved surfaces of the vases. The Cesnola Collection has some very fine examples of this pottery.

The final, brief high point of Cypriot ceramics spans the sixth to the fifth century B.C., when, in the northwestern part of Cyprus, the local potters created a series of jugs whose shoulders were decorated with hand- or mold-made human figures that functioned as spouts. The painted decoration of these vases, however, was derived completely from motifs found on Greek ceramics.

CYPRO-GEOMETRIC PERIOD (CA. 1050–CA. 750 B.C.)

Pottery of the Cypro-Geometric period derives largely from Proto-White Painted Ware, in shape and decoration. Gradually, during this time Cypriot potters asserted their own tastes, which then prevailed over the Aegean and Levantine elements of Proto-White Painted wares.

125. Lentoid flask

Cypro-Geometric I (ca. 1050– ca. 950 B.C.), 11th century B.C.
Bichrome Ware
H. 27 cm (10⅝ in.); max. D. 12.5 cm (4⅞ in.)
74.51.431 (Myres 545)

The fabric of this flask is made of a buff-brownish clay mixed with grit, which gives it a coarse texture. The thick walls of the vessel are covered with a burnished buff to pinkish-buff slip. One side is almost flat; the other is more convex.

The flask has long been regarded as Cypriot. Benson dated it to the Late Cypriot III period, "doubtless towards the latter part of it" (Benson 1984, p. 10). Although he recognized Levantine affinities, he stressed the Mycenaean features of the shape and decoration (1984, pp. 15–16). Iacovou correctly refuted Benson's arguments and characterized this piece as "strongly Near Eastern" (1988, p. 68), referring, as Benson also did, to a flask of similar shape from the ancient Palestinian city of Megiddo (Benson 1984, pp. 9–10, fig. 10).

A close examination of the fabric leaves no doubt that this piece is a Levantine import. The clay, the slip, the burnished surface, and the paint in two distinct colors—black and red—all have parallels among Levantine lentoid flasks, imported into Cyprus during the eleventh century B.C. (cf. V. Karageorghis 1975a, p. 57, with bibliography). The specific and unmistakable characteristic of lentoid flasks from the Levantine region is a hand-burnished surface (cf. Bikai 1983, p. 400; 1987, p. 5, no. 3). Lentoid flasks of Cypriot Proto-White or

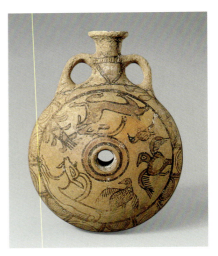

125. VIEW 1

Proto-Bichrome Ware are never hand-burnished.

The form of catalogue number 125, with a hole through the middle, parallels that of the Megiddo flask, which dates from the twelfth or eleventh century B.C. The Cesnola Collection has a late variant of the same type (cat. no. 141). Also from Megiddo, dating from the second half of the eleventh century B.C., is a pictorially decorated piece in the Bichrome style, the well-known Orpheus jug (Israel Department of Antiquities and Museums, Jerusalem), whose ornamentation is comparable in broad stylistic terms with the pictorial decoration of catalogue number 125 (Loud 1948, pls. 76.1, 142.20, jug 438), a strong indication that the latter was an early Levantine import to Cyprus.

BIBLIOGRAPHY: Cesnola 1877, p. 333; Benson 1975, pp. 134–35 n. 18, pl. 2.5a; Benson 1984, figs. 1–4.

130. Amphora
Cypro-Geometric I
(ca. 1050–ca. 950 B.C.)
Black Slip I Ware
H. 25.3 cm (10 in.)
74.51.637 (Myres 464)

The shape of this grooved amphora was particularly favored in Cypro-Geometric Proto-White Painted Ware. Bases with a splaying stand are also found in twelfth- and eleventh-century B.C. ceramics. Grooved Black Slip pottery, probably inspired by Late Bronze Age metallic prototypes, was produced throughout the Cypro-Geometric period.

BIBLIOGRAPHY: Gjerstad 1948, fig. X.13.

131. Jar
Cypro-Geometric III
(ca. 850–ca. 750 B.C.)
Bichrome III Ware
H. 39.2 cm (15⅜ in.)
74.51.476 (Myres 629)

This is a fine example of a type that can either be barrel-shaped or have convex sides like pilgrim, or lentoid, flasks. The simple painted decoration is strictly geometric and symmetrical. There are centered nipples on either side of the body.

BIBLIOGRAPHY: Cesnola 1877, p. 181; Gjerstad 1948, fig. XXIII.13.

132. Pilgrim flask
Cypro-Archaic I–II
(ca. 750–ca. 480 B.C.)
Black Slip Grooved Ware
H. 14.8 cm (5⅞ in.)
74.51.1259 (Myres 500)

Black Slip Grooved Ware is a Cypriot type that has been recognized only recently (V. Karageorghis 1982). Very few shapes appear in this ware; the pilgrim flask is the most characteristic. The ware had metallic prototypes, some of which are known from Etruria. It should be noted, however, that both the Etruscan and the Cypriot flasks had Near Eastern clay prototypes that were imported into both regions sometime during the eighth century B.C. Most of the known Cypriot examples were found in the region of Amathus.

BIBLIOGRAPHY: Colonna-Ceccaldi 1882, pl. XXIX.29.

133. Barrel-shaped flask
Cypro-Geometric III
(ca. 850–ca. 750 B.C.)
Black-on-Red I (III) Ware
H. 21 cm (8¼ in.)
18.82.2 (Ex coll: Cesnola Collection; Gift of Mrs. Robert W. de Forest, 1918)

The flask is an excellent specimen of its type. Black-on-Red I (III) Ware, introduced from the Levant, developed into one of the finest ceramics of the Cypro-Geometric III and Cypro-Archaic periods. Recent research has shown that all the examples found on Cyprus were made locally. Black-on-Red Ware was particularly popular in the western part of Cyprus (cf. Karageorghis and Olenik 1997, pp. 28–29); it was exported to various parts of the Mediterranean, especially to the Aegean, where small flasks were used as perfume bottles. Their shapes were imitated in the Dodecanese Islands and Crete (cf. Coldstream 1979b, pp. 261–62). This flask has a small nipple on one side of the body; the other side is flat.

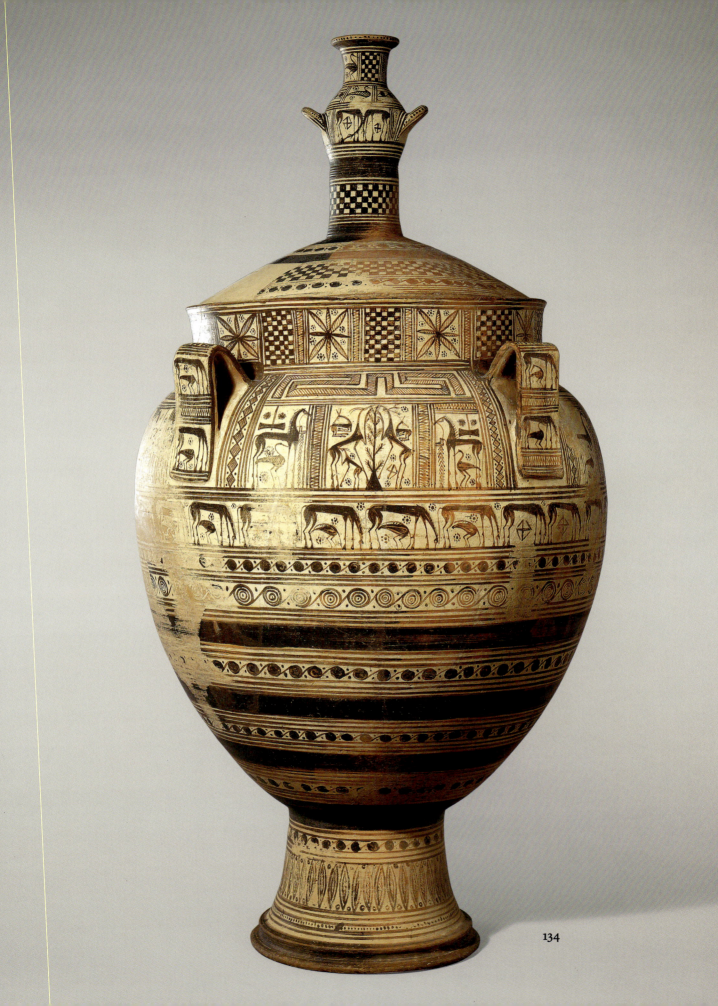

134

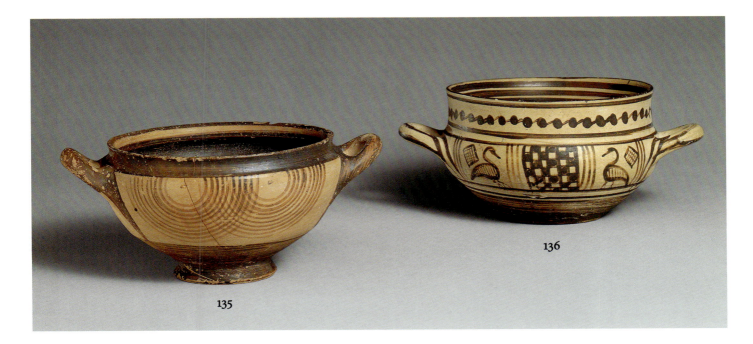

135

136

134. Krater with lid
Greek, Euboean,
ca. mid-8th century B.C.
Attributed to the Cesnola Painter
(Coldstream)
Terracotta
H. 114.9 cm (45¼ in.)
74.51.965 (Myres 1701)

The decoration on the shoulder features three figural motifs, all enclosed in metopes: pairs of goats flanking a tree, a tethered horse with a pendant double ax and a bird, and a grazing horse with a bird. The zone below shows a procession of grazing horses, each paired with a bird. The knob of the lid is in the form of a hydria.

Large size did not preclude the shipment of vases during the Geometric period. The source of this work, which ultimately served a funerary purpose, has long been a subject of scholarly controversy. In 1949 Kondoleon attributed it to Naxos (1949, pp. 11–19), whereas in 1971 Coldstream considered it Euboean (1971, pp. 1–15). Considerable evidence from a variety of places supports Coldstream's attribution. JRM

BIBLIOGRAPHY: Gisler 1993–94, pp. 11–94; Moore n.d.

135. Skyphos
Greek, Euboean, 1st half of the 8th century B.C.
Terracotta
H. 8.6 cm (3⅜ in.)
74.51.589 (Myres 1710)

Rudimentary though it appears, this type of skyphos is noteworthy in two respects. The concentric circles were drawn with a combination multiple brush and compass, and the result attests to considerable technical mastery. The widespread diffusion of such cups, moreover, provides a tangible record of the trading activity of the Euboeans. JRM

BIBLIOGRAPHY: Kearsley 1989, type 5a.

136. Skyphos
Greek, Attic, ca. mid-8th century B.C.
Terracotta
H. 9.4 cm (3¾ in.)
74.51.588 (Myres 1703)

Like the Euboean skyphos (cat. no. 135), this example is commonplace but therefore informative in documenting the distribution of mainland Greek objects over great distances. JRM

BIBLIOGRAPHY: Gjerstad et al. 1977, p. 27, no. 63.

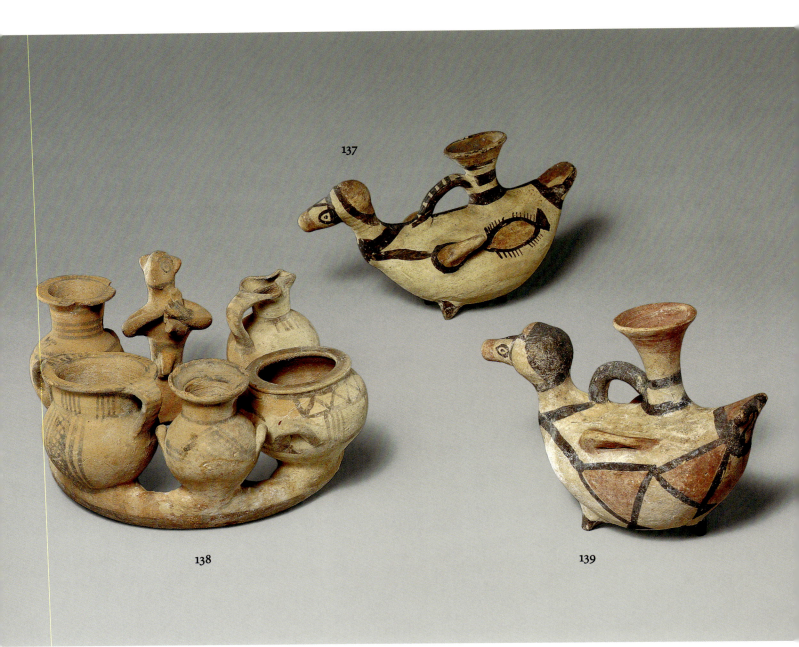

137

138

139

137. Bird-shaped *askos*
Cypro-Geometric III
(ca. 850–ca. 750 B.C.)
Bichrome III–IV Ware
H. 13 cm (5⅛ in.)
74.51.785 (Myres 530)

A bird-shaped *askos* from the
eleventh century B.C. is also illus-
trated (see cat. no. 76). Bird *askoi*

are usually decorated with abstract
or floral painted motifs. The fish
motifs on this example are excep-
tional. Fish and birds often appear
together in the decoration of vases
from this period and later.

138. Ring kernos
Cypro-Geometric III
(ca. 850–ca. 750 B.C.)
White Painted III Ware
Max. H. 11.4 cm (4½ in.); diam.
(of ring): 17.1 cm (6¾ in.)
74.51.660 (Myres 899)

The kernos is made up of five
different vases and a human figure.

The geometric decoration appears only on the outside. The human figure has a cylindrical body, prominent male genitals, a pointed nose, large ears, a round head, circular eyes—each with a dot in the center and a curved "eyebrow" above—a beard, and small depressions for the mouth. The figure holds a lyre in his left arm, and he plays it with his right hand. Black paint appears on his hair, genitals, ears, eyes, beard, the band around his waist, his left hand, and his fingers. The kernos is one in a series of examples illustrated here (see cat. nos. 78, 127). The decoration of the ring, with five miniature vases and a lyre player, is unusual. The presence of objects and a figure that represent music and drinking suggests that the piece symbolizes a banquet. (For a similar kernos found on Crete, see Kanta 1998, p. 53, no. 207; the human figure on the Cretan example is of the "goddess with uplifted arms" type [see cat. nos. 211–13].)

139. Bird-shaped *askos*
Cypro-Geometric III
(ca. 850–ca. 750 B.C.)
Bichrome III–IV Ware
H. 13.7 cm (5⅜ in.)
74.51.813 (Myres 531)

Phoenician Pottery
The Phoenicians influenced political and cultural life on Cyprus for more than four hundred years, especially at Kition and Amathus. Their pottery affected the development of Cypriot ceramics, as local potters often imitated Phoenician vessels. The importation of Levantine pottery started in the eleventh century B.C. (see cat. no. 125) and became more common at the end of the ninth century B.C.—when the Phoenicians settled on Cyprus—and later.

Large quantities of Phoenician pottery have been found in tombs and sanctuaries on the island. Particularly common are Red Slip, Black Slip, and Bichrome wares. Of note are jugs and juglets with broad mushroom-shaped lips (Bikai 1987, p. 48). These containers held perfumed oils, a trade commodity. There are also larger vessels, known as Canaanite jars, for storing oil, wine, and other liquids. In the Classical period (ca. 480– ca. 310 B.C.), the Phoenicians developed a strong taste for imported wares from Attica, in Greece. At this time, the quality of indigenous Phoenician pottery degenerated.

140. Jug

7th century B.C.

Phoenician Red Slip and
Bichrome Ware

H. 15.7 cm (6⅛ in.)

74.51.1401 (Myres 479)

Said to be from a tomb at Kition

A Phoenician inscription, en-
graved after firing, is on one side
of the shoulder: l'ntš (see detail
below). The reading "to Anthos"
has been called into question.

BIBLIOGRAPHY: Cesnola 1877,
p. 442, pl. 12, no. 26; Cesnola 1894,
pl. CXLI.1052; Cesnola 1903a,
pl. CXXIII.23; Karageorghis and
Karageorghis 1956, p. 351; Masson
and Sznycer 1972, pp. 114–15, pl. XV.1;
Amadasi and Karageorghis 1977,
p. 134, pl. XXV.1, no. D6; Teixidor
1977, p. 67, no. 25; Bikai 1987, p. 27,
no. 322.

141. Ring vase

7th century B.C.

Phoenician Red Slip Ware

H. 19 cm (7½ in.)

74.51.650 (Myres 473)

Said to be from Kourion

This ring vase has been men-
tioned in connection with the
imported eleventh-century B.C.
lentoid flask (cat. no. 125). Its shape
is also related to vases that had a
long tradition on Cyprus (Gjerstad
1948, figs. V.8, XIV.2).

BIBLIOGRAPHY: Cesnola 1894,
pl. CXXXIII.982; Myres 1946a, p. 93;
Gjerstad 1948, fig. XLIII.14.

142. Jug

7th century B.C.

Phoenician Red Slip Ware

H. 24.1 cm (9½ in.)

74.51.643 (Myres 472)

The tall, elegant neck is a charac-
teristic that appears in both Cyp-
riot Red Slip II (IV) and Cypriot
Black Slip IV Ware (cf. Gjerstad
1948, figs. XLIII.10, .11, .16; Bikai
1987, pls. XIV.353, 355, 356).

BIBLIOGRAPHY: Myres 1946a, p. 93;
Gjerstad 1948, fig. XLIII.10.

140. DETAIL

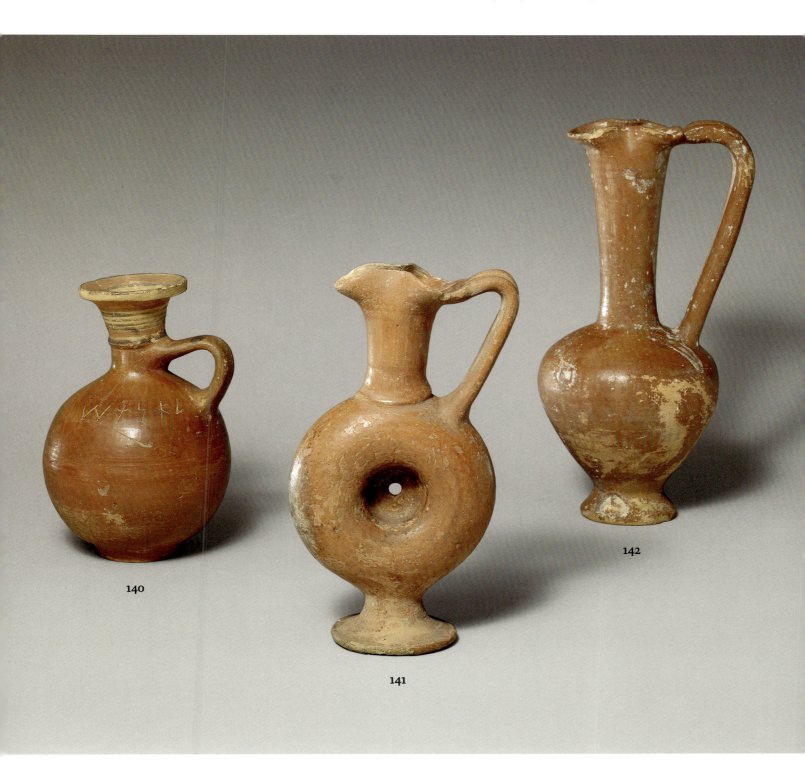

140

141

142

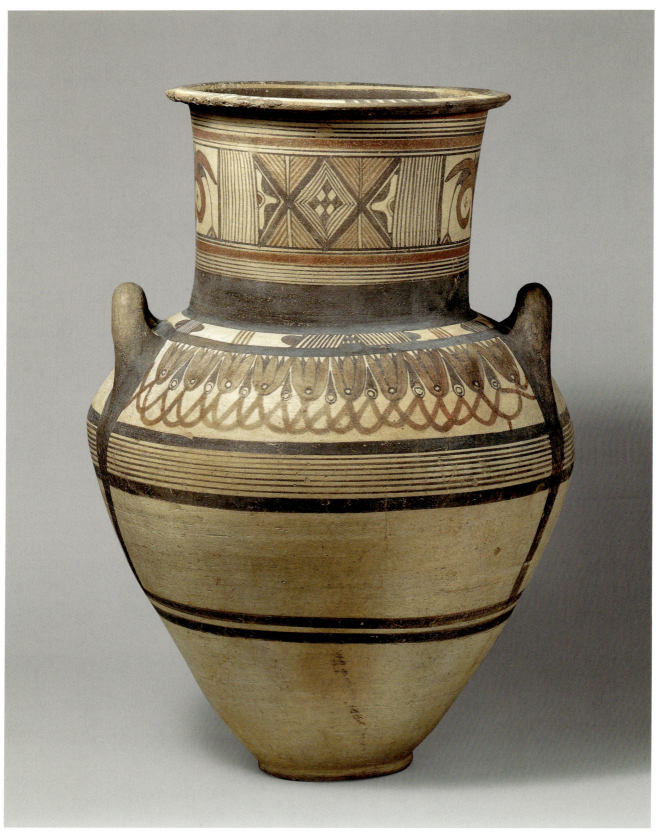

143

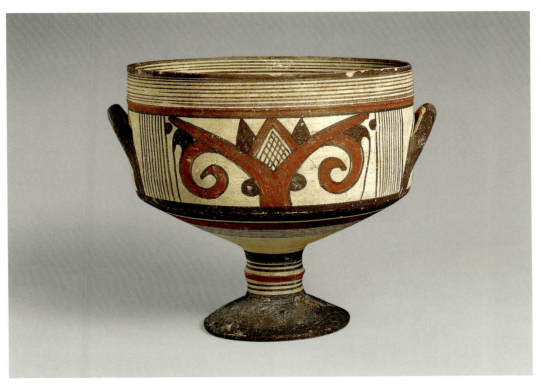

144

CYPRO-ARCHAIC PERIOD
(CA. 750 – CA. 480 B.C.)

143. Amphora
Cypro-Archaic I
(ca. 750 – ca. 600 B.C.)
Bichrome IV Ware
H. 80.3 cm (31⅝ in.)
74.51.972 (Myres 696)
Said to be from Ormidhia

Large amphorae decorated in the Bichrome IV technique were common to the eastern part of Cyprus. The shoulder zone of each side is usually ornamented with a frieze of lotus flowers alternating with buds. On the neck, lotus flowers in panels alternate with geometric motifs. The lotus motif is oriental in origin, and it appears frequently in the arts and crafts of the Cypro-Archaic period.

BIBLIOGRAPHY: Cesnola 1877, p. 181; Cesnola 1894, pl. CXII.885.

144. Kylix
Cypro-Archaic I
(ca. 750 – ca. 600 B.C.)
Bichrome IV Ware
H. 18.4 cm (7¼ in.); diam. 19.4 cm (7⅝ in.)
74.51.467 (Myres 676)

A central rectangular panel containing a large stylized lotus flower appears on each side between the handles. The inside of the kylix is decorated with groups of horizontal bands; lines and concentric bands and circles are at the bottom. The footed bowl with accurately rendered ornament is common in Bichrome IV Ware and exemplifies ceramic works of the Cypro-Archaic I period.

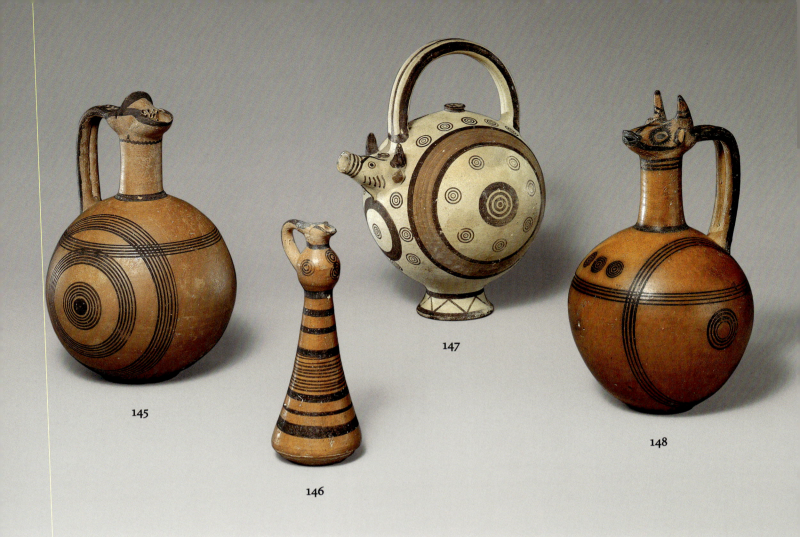

145

146

147

148

145. Jug
Cypro-Archaic I
(ca. 750–ca. 600 B.C.)
Black-on-Red II (IV) Ware
H. 19.7 cm (7¾ in.)
74.51.607 (Myres 818)

The jug has a strainer spout
(cf. Gjerstad 1948, fig. XLIX.2). Such
pieces probably had Phoenician
prototypes in metal or ceramic
(cf. Bikai 1987, pl. XV.378). They
may have been used to strain herb-
flavored liquids.

BIBLIOGRAPHY: Gjerstad 1948,
fig. XXXIX.8.

146. Composite jug
Cypro-Archaic I
(ca. 750–ca. 600 B.C.)
Black-on-Red II (IV) Ware
H. 14.5 cm (5¾ in.)
74.51.887 (Myres 843)

There are several parallels for this
work among other Black-on-Red II
(IV) Ware vessels (e.g., Karageor-
ghis and Olenik 1997, nos. 72, 73).

147. Trick vase
Cypro-Archaic I
(ca. 750–ca. 600 B.C.)
Bichrome IV Ware
H. 21 cm (8¼ in.)
74.51.584 (Myres 519)

The foot serves as a means for
filling the vessel through an inside
tube. Trick-vase *askoi* first appeared
in the Cypro-Geometric period
(cf. Gjerstad 1948, figs. XXXIX.19,
XLII.9). An example from that
period is illustrated (cat. no. 126).

BIBLIOGRAPHY: Gjerstad 1948,
fig. XXXVI.9.

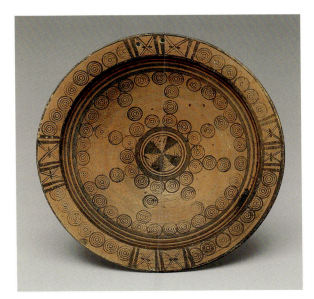

149. FRONT

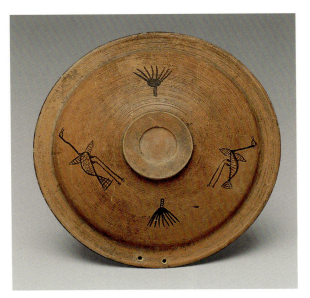

149. BACK

148. Jug
Cypro-Archaic I
(ca. 750–ca. 650 B.C.)
Black-on-Red II (IV) Ware
H. 20.6 cm (8⅛ in.)
74.51.606 (Myres 819)
Said to be from Idalion

The zoomorphic spout often appears in Cypriot pottery. The prototype may be a metallic jug of oriental provenance known in the Punic world (cf. Karageorghis and Olenik 1997, no. 71).

BIBLIOGRAPHY: Cesnola 1894, pl. CXX.919; Gjerstad 1948, fig. XXXIX.13; Hermary 1997.

149. Dish
Cypro-Archaic I
(ca. 750–ca. 600 B.C.)
Black-on-Red II (IV) Ware
H. 7 cm (2¾ in.); diam. 29.2 cm (11½ in.)
74.51.988 (Myres 869)
Said to be from Kourion

A pictorial decoration that betrays the hand of an inexperienced painter is on the outside of the dish, perhaps added as an afterthought. This is odd, because the outside surfaces of Black-on-Red dishes normally feature concentric bands, not pictorial images.

BIBLIOGRAPHY: Cesnola 1894, pl. CXXXII.976.

The Free-Field and Pictorial Styles of Pottery Decoration
The pictorial style in Iron Age vase painting began in the Cypro-Geometric period (see cat. no. 129). The style continued sporadically until the Cypro-Geometric III period, when it became a major part of the repertoire of Cypriot vase painting. During the Cypro-Archaic I–II periods a special pictorial style, usually called the "free-field" style, developed in the eastern part of the island.

Vessels in the free-field style were produced in either the White Painted or the Bichrome technique; linear and geometric decorations are absent. The vase painter, freed from the spatial restrictions of encircling bands, lines, and panel divisions, applied a single figural motif or a figural composition to the curved surface. The most common shape is the jug with trefoil rim. The painter's careful choice of motifs suited to the curved surfaces of the vases led to successful aesthetic effects. Subjects favored in the free-field style are human figures, quadrupeds, birds—often paired with fish—and combinations of motifs in ambitious compositions. Decorative ornaments such as stylized flowers are also favored.

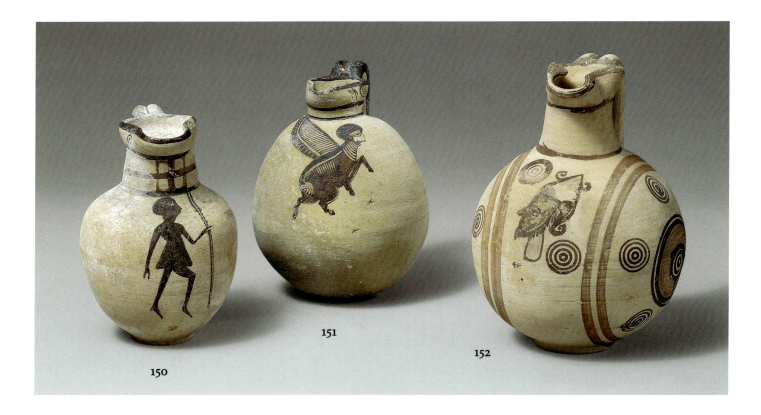

150

151

152

150. Small jug
Cypro-Archaic I
(ca. 750 – ca. 600 B.C.)
White Painted IV Ware
H. 19.1 cm (7½ in.)
74.51.532 (Myres 762)
Said to be from Ormidhia

This piece is decorated with a human figure holding spears and marching to the right. He is drawn entirely in silhouette, which is unusual, and has the facial characteristics of a black. Blacks often appear in Cypriot iconography (cf. V. Karageorghis 1988a).

BIBLIOGRAPHY: Cesnola 1894, pl. CXXIX.962; Karageorghis and Des Gagniers 1974a, pp. 27–28, 119, 146, no. VII.5; Karageorghis and Des Gagniers 1974b, p. 66, no. VII.5; V. Karageorghis 1988a, pp. 22–23, fig. 13, no. 13.

151. Jug
Cypro-Archaic I
(ca. 750 – ca. 600 B.C.)
Bichrome IV Ware
H. 20.2 cm (8 in.)
74.51.512 (Myres 753)

The winged anthropomorphic quadruped on the jug cannot be identified.

BIBLIOGRAPHY: Perrot and Chipiez 1885, p. 304, fig. 243; Karageorghis and Des Gagniers 1974a, pp. 61, 126, 147, no. XXIII.5; Karageorghis and Des Gagniers 1974b, p. 225, no. XXIII.5; Sophocleous 1985, pp. 21, 51, 229 (mislabeled as no. 75.51.512), fig. 2.

152. Jug
Cypro-Archaic I
(ca. 750 – ca. 600 B.C.)
Bichrome IV Ware
H. 23.9 cm (9⅜ in.)
74.51.508 (Myres 714)
Said to be from Kourion

The small protome, with his face painted red and wearing a horned helmet, may represent a human figure wearing a mask. Masks appear on other jugs of the same period (e.g., Karageorghis and Des Gagniers 1979, vases SX.1,.2). Anthropomorphic masks also appear in contemporaneous coroplastic art (see cat. nos. 222, 223, 226).

BIBLIOGRAPHY: Cesnola 1894, pl. CXVIII.911; Karageorghis and Des Gagniers 1979, pp. 34, 184, 196, vase SX.4.

153. Jug
Cypro-Archaic I
(ca. 750–ca. 600 B.C.)
Bichrome IV Ware
H. 31.5 cm (12⅜ in.)
74.51.539 (Myres 768)
Said to be from Ormidhia

The painting depicts a horse and rider: a small figure, perhaps an acrobat, runs on the animal's back. Acrobats sometimes appear on horseback in coroplastic art of the same period (cf. p. 152; V. Karageorghis 1995, pp. 68–70). The composition was possibly determined by the painter's inability to position the rider's body correctly. Or it may simply reflect the painter's sense of humor. The lotus flower in front of the horse is also unusual; it may be just decorative.

BIBLIOGRAPHY: Cesnola 1877, p. 333; Cesnola 1894, pl. CXXIX.963; Groenewegen-Frankfort and Ashmole 1972, pp. 372, 374, no. 567; Karageorghis and Des Gagniers 1974a, pp. 12–14, 117, 146, no. I.4; Karageorghis and Des Gagniers 1974b, p. 17, no. I.4.

154. Jug
Cypro-Archaic I
(ca. 750–ca. 600 B.C.)
White Painted IV Ware
H. 23.2 cm (9⅛ in.)
74.51.511 (Myres 761)
Said to be from Ormidhia

The ship that decorates this jug is a rare motif; it appears on only a few vases of the period (Karageorghis and Des Gagniers 1974b, pp. 122–23; Barnett 1958, p. 227, pl. XXIII). Ships are far more common in coroplastic art (Karageorghis and Des Gagniers 1974a, p. 38;

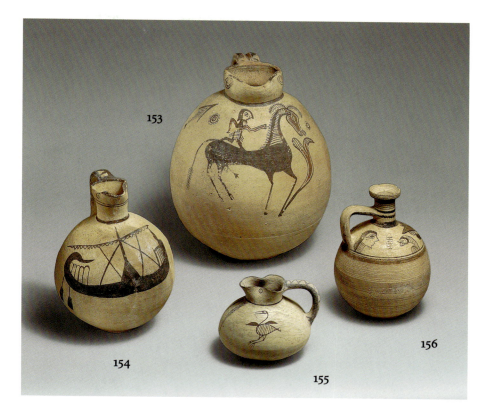

cf. cat. nos. 253, 254). The appearance of ships in Cypriot art and iconography demonstrates the importance of maritime trade.

BIBLIOGRAPHY: Murray 1877, pl. XLV, fig. 37; Cesnola 1894, pl. CXXIX.964; Karageorghis and Des Gagniers 1974a, pp. 38, 121, 146, no. XI.3; Karageorghis and Des Gagniers 1974b, p. 123, no. XI.3; Westerberg 1983, pp. 45, 55–57, 59, 66, fig. 55, no. 55; Basch 1987, pp. 259, 261, fig. 567, no. 567.

155. Jug
Cypro-Archaic I
(ca. 750–ca. 600 B.C.)
Bichrome IV Ware
H. 11.8 cm (4⅝ in.)
74.51.537 (Myres 736)

Most jugs of this type were made in the region of Amathus toward the end of the Cypro-Archaic I period. They are always decorated with one or more birds, with long legs and spread wings (cf. Karageorghis and Des Gagniers 1974b, vases XXV.J.1–20).

156. Jug
Cypro-Archaic I
(ca. 750–ca. 600 B.C.)
Bichrome IV Ware
H. 19.7 cm (7¾ in.)
74.51.531 (Myres 763)

This vase does not belong to the free-field group. The figural decoration is limited by the bands around the body. The motifs, one human and two animal protomes, are not easily explained (cf. Karageorghis and Des Gagniers 1979, vase SX.3).

BIBLIOGRAPHY: Karageorghis and Des Gagniers 1974a, pp. 37, 121, 146, no. X.7; Karageorghis and Des Gagniers 1974b, p. 121, no. X.7.

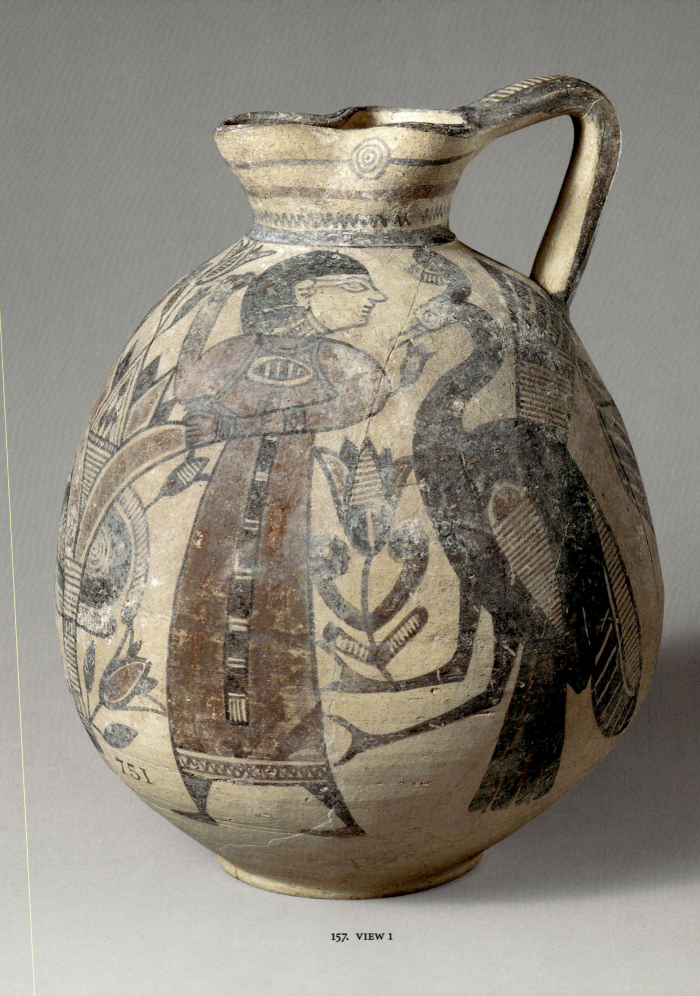

157. VIEW 1

157. **Jug**
Cypro-Archaic I
(ca. 750–ca. 600 B.C.)
Bichrome IV Ware
H. 24.1 cm (9½ in.); diam. (of rim):
6.5 cm (2½ in.)
74.51.509 (Myres 751)
Said to be from Golgoi(?) or Kition

The painter of this jug was able and ambitious. The composition consists of two human figures, two birds, a central lotus flower, and smaller lotus flowers, all strictly symmetrical, demonstrating perfection in figural drawing but producing a rather static decorative composition. Another jug is similar in composition (cat. no. 158), which suggests that both are the work of the same artist and were manufactured in the same workshop.

BIBLIOGRAPHY: Cesnola 1894, pls. CVI.859,.860; Myres 1946a, p. 103; Karageorghis and Des Gagniers 1974a, pp. 29–32, 70, 79, 119, 138, 146, nos. VIII.8, XXV.1.5(k); Karageorghis and Des Gagniers 1974b, pp. 75–76, no. VIII.8; J. Karageorghis 1977, pp. 190–91, pl. 32b.

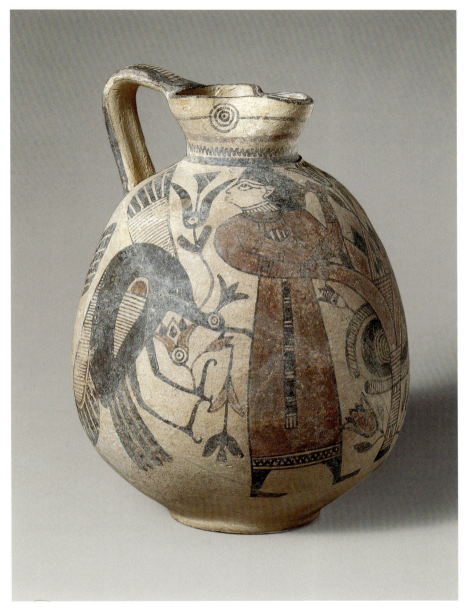

157. VIEW 2

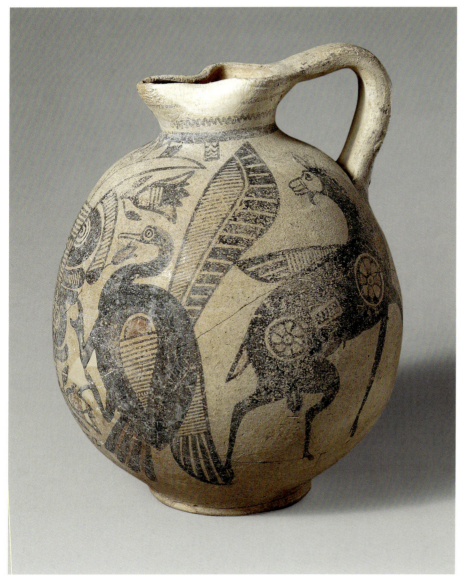

158. VIEW 1

158. **Jug**
Cypro-Archaic I
(ca. 750–ca. 600 B.C.)
Bichrome IV Ware
H. 23.8 cm (9⅜ in.)
74.51.510 (Myres 752)
Said to be from Kition

BIBLIOGRAPHY: Cesnola 1894,
pl. CVI.857,.858; Karageorghis and
Des Gagniers 1974a, pp. 54–55, 68,
75, 125, 133, 147, nos. XVIII.10,
XXV.e.21; Karageorghis and Des
Gagniers 1974b, p. 208, no. XVIII.10;
Markoe and Serwint 1985, p. 41,
no. 40.

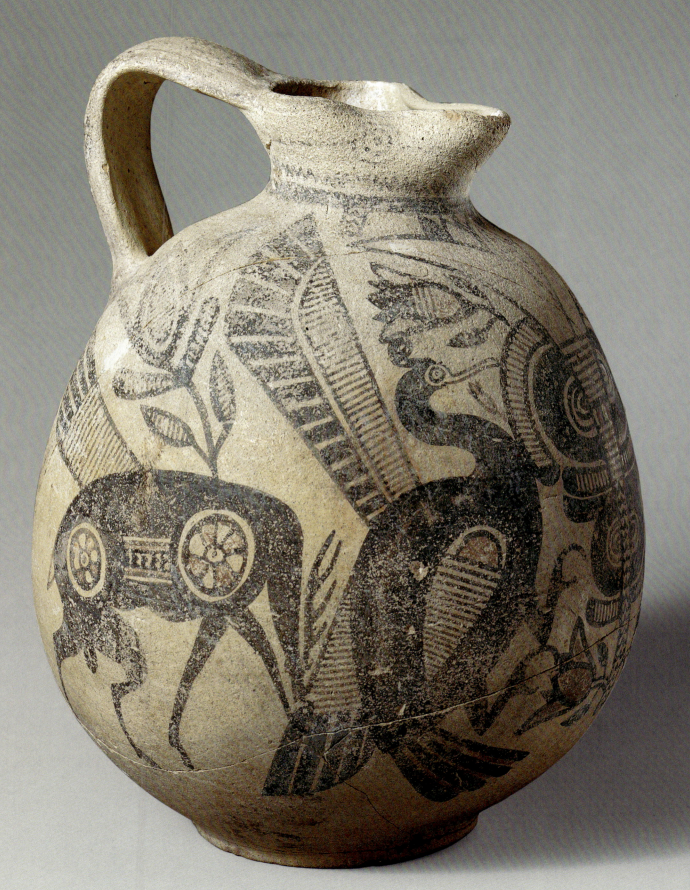

158. VIEW 2

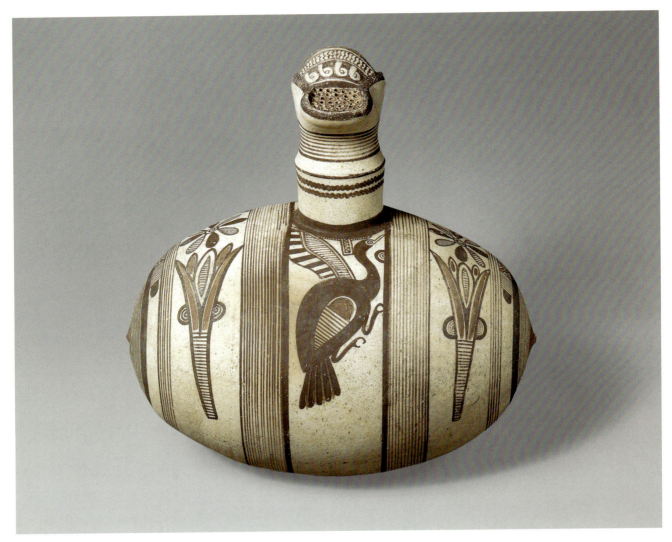

159

159. Barrel-shaped jug
Cypro-Archaic I
(ca. 750–ca. 600 B.C.)
Bichrome IV Ware
H. 35 cm (13¾ in.); L. 32 cm
(12⅝ in.); diam. (of rim):
10 cm (4 in.)
74.51.517 (Myres 765)

The bird on this jug is similar to that on catalogue number 160, so the pieces can be attributed to the same group. Catalogue number 160, however, is in the free-field style; no encircling bands place spatial restrictions on the figural decoration.

BIBLIOGRAPHY: Murray 1877, p. 405, fig. 17; Perrot and Chipiez 1885, pp. 284, 287, fig. 220; Gjerstad 1948, fig. XLIX.2; Karageorghis and Des Gagniers 1974a, pp. 67, 72, 130, 147, no. XXV.b.24; Karageorghis and Des Gagniers 1974b, p. 312, no. XXV.b.24.

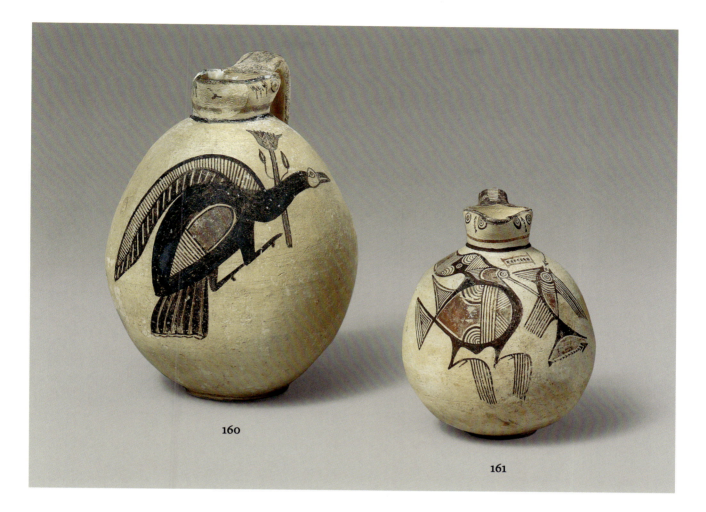

160

161

160. **Jug**
Cypro-Archaic I
(ca. 750–ca. 600 B.C.)
Bichrome IV Ware
H. 25.3 cm (10 in.)
74.51.503 (Myres 754)
Said to be from Ormidhia
 This jug belongs to a group of
vases, probably painted in a single
workshop, that combine a highly
stylized bird with a lotus flower
(cf. Karageorghis and Des Gagniers
1974b, vases xxv.f.4–6, 13, 14).

BIBLIOGRAPHY: Cesnola 1894,
pl. CXXVIII.958; Gjerstad 1948,
fig. XXXIV.3; Groenewegen-
Frankfort and Ashmole 1972, p. 372,
no. 565; Karageorghis and Des
Gagniers 1974a, pp. 68, 76, 133, 147,
no. XXV.f.12; Karageorghis and Des
Gagniers 1974b, p. 396, no. XXV.f.12.

161. **Jug**
Cypro-Archaic I
(ca. 750–ca. 600 B.C.)
Bichrome IV Ware
H. 16.8 cm (6⅝ in.)
74.51.527 (Myres 757)
Said to be from Ormidhia
 The composition of a bird catch-
ing a fish was popular in Cypriot
vase painting (cf. Karageorghis
and Des Gagniers 1974b, vases
XXIV.b.45–47). Such vessels may
have originated in one or two
workshops in the eastern part of
the island. The source of the scene
may be Nilotic, but Cypriot artists
adapted it to their own taste.

BIBLIOGRAPHY: Murray 1877,
pl. XLVI, fig. 38; Cesnola 1894,
pl. CXXVIII.960; Karageorghis and
Des Gagniers 1974a, pp. 63–65,
70, 79, 128, 147, nos. XXIV.b.46,
XXV.i.10(c); Karageorghis and
Des Gagniers 1974b, p. 269,
no. XXIV.b.46; Markoe and Ser-
wint 1985, p. 40, no. 39.

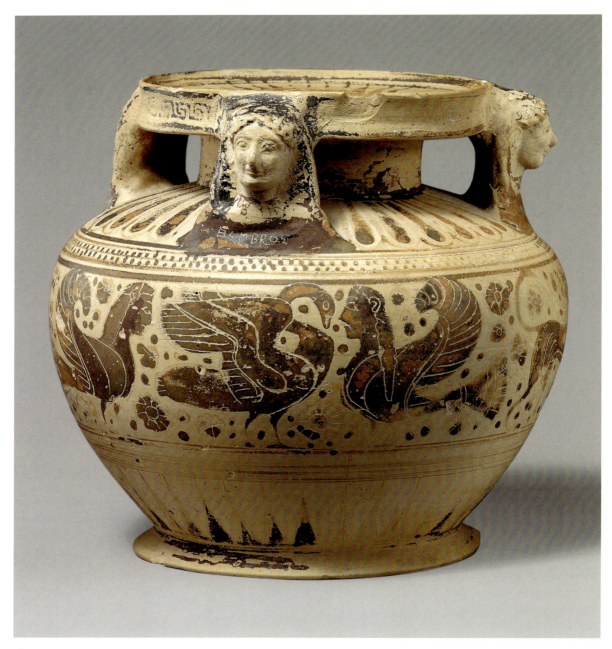

162

162. Pyxis
Corinthian, Late Corinthian,
ca. 550 B.C.
Terracotta
H. 14.6 cm (5¾ in.)
74.51.364 (Myres 1724)

The shape and decoration of
the vase are current for the Late
Corinthian period. Of note are the
names inscribed underneath each
of the female heads: Himero,
Charita, and Iopa. The figures have
been interpreted either as nereids
(daughters of the sea god Nereus)
or as hetairai (courtesans).

JRM

BIBLIOGRAPHY: Lorber 1979,
pp. 92–93.

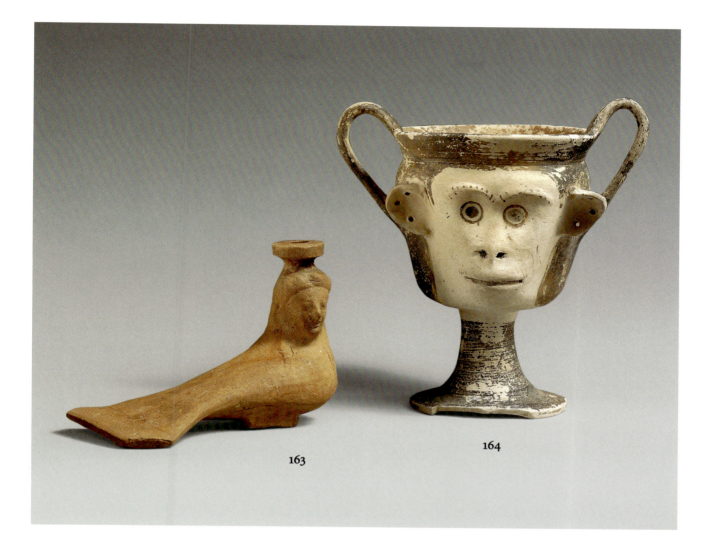

163

164

163. Plastic vase
Eastern Greek, late 6th century B.C.
Terracotta
L. 11.9 cm (4¾ in.)
74.51.836 (Myres 1723)

Plastic vases in the shape of
sirens were produced from about
570 to the end of the sixth cen-
tury B.C. and have been found
throughout the eastern Mediterra-
nean area, principally on Rhodes
and in southern Italy. The physi-
ognomy of the sphinx and the sum-
mary articulation place this work
among the latest examples (see
Ducat 1966, pp. 61–89). J R M

164. Kantharos
Eastern Greek or Cypriot,
mid-6th century B.C.
Terracotta
H. 14.6 cm (5¾ in.)
74.51.369 (Myres 773)

The origin of this unique vase
has proved difficult to pinpoint.
The kantharos is characterized by
two high, vertical handles; a deep
bowl; and a foot. The shape and the
monkey's face clearly indicate an
Archaic date. The eastern Aegean
area demonstrates a predilection
for vases that assume a figural
form. Pertinent to this piece are

examples in the shape of monkeys,
associated with Rhodes (Ducat
1966, pp. 120–24), as well as kan-
tharoi in which the bowl is mod-
eled as a face (Walter-Karydi 1973,
pp. 30–31). The grainy quality of
the clay and the matte glaze raise
the possibility that this is a local,
Cypriot work inspired by one or
more eastern Greek models.

J R M

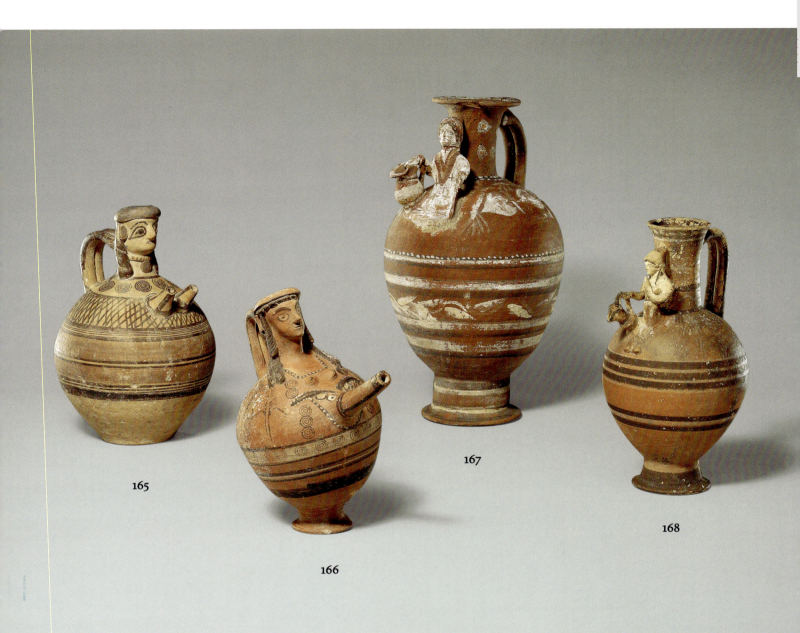

165

166

167

168

Anthropomorphic Jugs

From the beginning of the second millennium B.C., in the Middle Cypriot period, potters tended to put human features on their ceramics. During the Cypro-Archaic I–II periods (ca. 750–ca. 480 B.C.), parts of female figures continued to ap-

pear on vases. Vessels have not only heads and necks but also (as on cat. nos. 165, 166), necklaces, breasts in the form of spouts, and, in some cases, arms and hands. All known examples have been found in tombs, but some of these jugs may have been used as ritual vessels in sanc-

tuaries of the Great Goddess. A piece comparable to catalogue number 165 is now in the Musée du Louvre, Paris (Caubet, Hermary, and Karageorghis 1992, p. 115, no. 143 [N3343]).

165. Anthropomorphic jug

Cypro-Archaic II
(ca. 600–ca. 480 B.C.)
Bichrome V Ware
H. 26.8 cm (10½ in.)
74.51.566 (Myres 793)
Said to be from Idalion

The top of the head is open; the face is handmade.

BIBLIOGRAPHY: Doell 1873, p. 69, pl. XVI.23, no. 4061; Murray 1877, pp. 402–3, fig. 10; Cesnola 1894, pl. CXVII.908; Gjerstad 1948, fig. L.6; Groenewegen-Frankfort and Ashmole 1972, pp. 373–74, no. 568.

166. Anthropomorphic trick vase

Cypro-Archaic I
(ca. 750–ca. 600 B.C.)
Bichrome Red I (IV) Ware
H. 23.5 cm (9¼ in.)
74.51.564 (Myres 931)
Said to be from Episkopi

The central axis of the vase leans backward. The foot serves as the means for filling the vessel through an inside tube (cf. cat. no. 147).

BIBLIOGRAPHY: Cesnola 1894, pl. CXLII.907; Gjerstad 1948, fig. XLII.5.

Jugs with Hand- or Mold-made Figures on the Shoulder

In the Cypro-Archaic I–II periods, anthropomorphic features occurred on the spouts and shoulders of jugs. In the Cypro-Archaic II period, a variant of this trend developed: A handmade or, later, a mold-made female figure holding a miniature jug that served as a spout occupies the shoulder opposite the handle (cat. nos. 167, 168).

Vases of this type are usually decorated in White Painted, Bichrome, Black-on-Red, Bichrome Red, or, more rarely, Polychrome technique. The motifs, especially those found on vases from the Cypro-Classical period, often derive from Greek art. Sometimes they are engraved. This type of vase developed in the region of Marion (modern-day Polis Chrysochous), where the majority of imported Greek vases of the Classical period have been found. It has been suggested that this new type of pottery was created in order to compete with imported wares. Ornament often overfills the surfaces, with disappointing aesthetic results. (For a recent study of these wares, see Vandenabeele 1998.) In some cases, instead of a mold-made female figure, an animal protome serves as a spout (Vandenabeele 1998, p. 23).

167. Jug with female figure on the shoulder

Cypro-Classical II
(ca. 400–ca. 310 B.C.)
Polychrome Ware
H. 37.5 cm (14¾ in.)
74.51.573 (Myres 940)
Said to be from Kourion

On the shoulder a seated female holds a jug in her right hand. Her face is mold-made.

BIBLIOGRAPHY: Cesnola 1894, pl. CXXXIV.985.

168. Jug with female figure on the shoulder

Late 6th–early 5th century B.C.
Bichrome Red II (V) Ware
H. 27.8 cm (11 in.)
74.51.563 (Myres 937)

On the shoulder opposite the handle, a seated female figure holds a miniature jug in her right hand; the face is mold-made, but the rest of the body is handmade. The bottom of the jug has a hole that leads into the body of the vase.

BIBLIOGRAPHY: Vandenabeele 1994, p. 29; Vandenabeele 1998, p. 170, no. 1646.

STONE SCULPTURE

Cypriot coroplasts began to produce large-scale terracotta sculpture during the second half of the seventh century B.C. Stone sculpture from this period is rare, and at present only works from the region of Golgoi are known. It has been suggested that sculpture in stone followed the production of works in terracotta (see Hermary 1991, p. 146).

There is no marble on Cyprus—or any other hard stone suitable for carving large-scale sculpture. The Cypriot artist was confined to soft limestone, abundant in the central and southeastern parts of the island. So it is not surprising that the earliest sculpture appeared in the Golgoi area and gradually spread to other centers, such as Idalion, Arsos, and Kition, in the same limestone-rich region.

By the beginning of the sixth century B.C., the developing art of stone sculpture reached its zenith. During this period, the Phoenicians were actively present on the island, and they introduced elements of Egyptian art. This influ-ence can be seen in a series of large and small male votaries, though local taste forms the iconographic basis of many Cypriot votaries and priests. A general characteristic of the Cypriot sculpture of this era was polychrome decoration, a fea-ture also present in Greek sculp-ture. Black, red, and other colors are preserved on many examples in the Cesnola Collection, which pos-sesses some of the finest examples of Cypriot sculpture from the sixth and fifth centuries B.C.

The Human Form in Archaic Sculpture

A series of statues representing young beardless male figures, char-acterized as princes, wear typical Cypriot short trousers, often deco-rated with a rosette in relief (e.g., cat. no. 169), and a diadem, also adorned with rosettes (e.g., cat. no. 170). Their stance is rigid, and they are never larger than lifesize (Hermary 1989, p. 44).

One of the earliest (cat. no. 169) resembles a Greek kouros. It is pos-sible that the heads of catalogue numbers 169 and 170 did not origi-nally belong to the bodies.

169. **Beardless male votary**
Beginning of the 6th century B.C.
Limestone
Preserved H. 73 cm (28¾ in.)
74.51.2479 (Myres 1045)
Said to be from the temple at Golgoi
 The votary wears a Cypriot belt.

BIBLIOGRAPHY: Doell 1873, p. 22, pl. III.6, no. 68; Cesnola 1885, pl. XLVIII.285; Myres 1946b, p. 103; Myres 1946c, p. 63.

170. **Beardless male votary**
Mid-6th century B.C.
Limestone
H. 92.7 cm (36½ in.)
74.51.2473 (Myres 1256)
Said to be from the temple at Golgoi
 A short-sleeved tunic reaches to the waist, where it appears to be neatly tucked into a red-painted Cypriot loincloth.

BIBLIOGRAPHY: Doell 1873, p. 22, pl. III.9, no. 67; Cesnola 1885, pl. XI.13; Perrot and Chipiez 1885, p. 142, fig. 95; Myres 1946b, p. 103, pl. 32.

Bearded human figures wearing conical headdresses, made in both limestone and terracotta, have a long history in Cypriot sculpture, dating from the end of the seventh to the fifth century B.C. (see Markoe 1987 and Hermary 1989, pp. 22–33). These sculptures repre-sent priests or dignitaries, though ordinary people wore the same headdress (Hermary 1989, p. 22), the top of which is often bent toward the back; bands support the two cheekpieces.

The earliest sculptures, from about 600 B.C., have accentuated facial characteristics: a large nose,

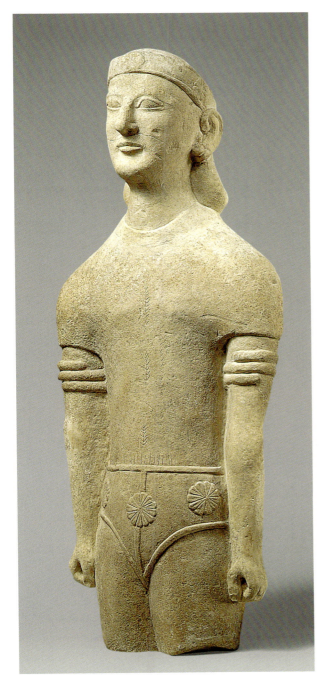

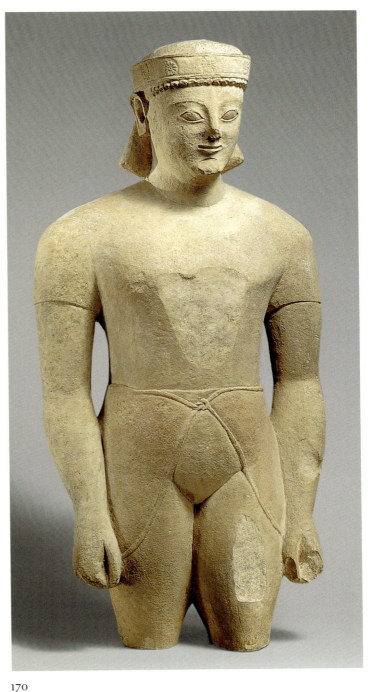

169

170

pointed lips, and large eyes. Catalogue number 171 is one of the most impressive examples of this early type. Gradually, under the influence of Greek art, the features and expressions evolved and became

more refined. The attitude of the figure as well as the treatment of the drapery also followed the tendencies of eastern Greek art. The sculptor gave close attention to such details as beard curls, fringes

of hair above the forehead, and mustaches. The Cesnola Collection has some good sixth-century B.C. examples of this style (cat. nos. 172, 173), though the heads may not have originally belonged to the bodies.

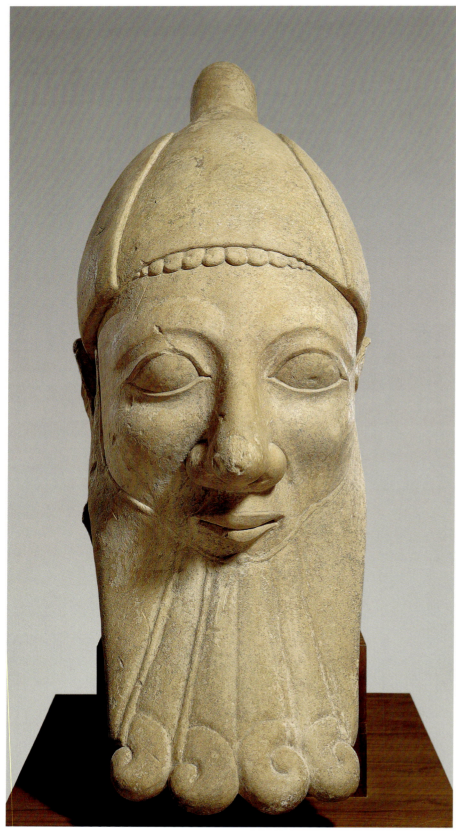

171. VIEW 1

171. Colossal head of a bearded figure wearing a conical helmet

Beginning of the 6th century B.C.

Limestone

H. 88.3 cm (34¾ in.)

74.51.2857 (Myres 1257)

Said to be from near the temple at Golgoi

BIBLIOGRAPHY: Doell 1873, p. 45, pl. VIII.6, no. 237; Cesnola 1877, pp. 122–23; Cesnola 1885, pl. XXXIX.253; Myres 1946b, pp. 101, 103, pl. 31; Myres 1946c, pp. 62, 64; Gjerstad 1948, p. 96, pl. II.a,b; Masson 1971b, pp. 312, 317, fig. 4; Connelly 1991, p. 95.

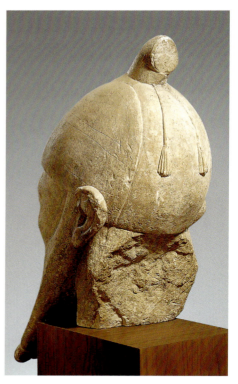

171. VIEW 2

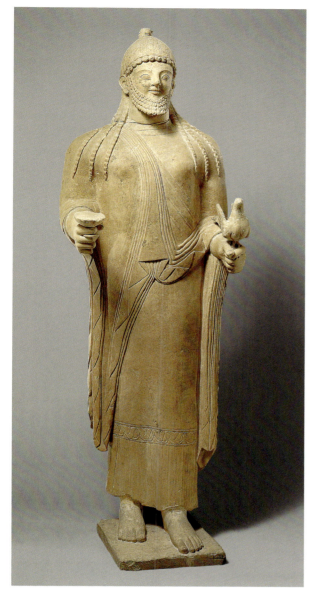

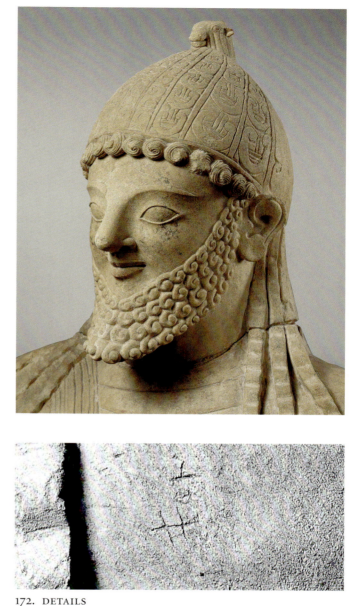

172

172. DETAILS

172. **Priest**
Last quarter of the 6th century B.C.
Limestone
H. (with base): 217.2 cm (85½ in.)
74.51.2466 (Myres 1351)
Said to be from west of the temple
at Golgoi

The priest's feet and the plinth
that he stands on are modern. The
helmet is divided into vertical pan-
els whose decoration, in low relief,

consists of rows of red-painted
lotus flowers, which may represent
the "tree of life" that often appears
in the art of the Near East. At the
top is a bull protome. Black, red,
and yellow paint once colored the
details of the helmet and protome,
and red paint survives on the folds
of the mantle. Two of the original
six engraved signs in the Cypriot
syllabic script remain on the left

shoulder (see detail above). The
inscription has been read as "of the
Paphian Goddess" (τάς παφίας),
but this is by no means certain.

The richly decorated garments
and the dove (though the one here
may not be original) leave no doubt,
however, about the figure's identity
as a priest of the Paphian Goddess.
Hermary's reexamination of this
statue (Masson and Hermary 1993,

pp. 30–34) stresses the extraordinary character of the helmet; its bull protome may be a further sacerdotal indication (see also cat. no. 174, where the helmet is surmounted by a bird). This statue has been discussed extensively (Masson and Hermary 1993, with further references), and several scholars have expressed doubts as to the authenticity of the arms and the attributes. It is now believed that only the dove is questionable; it may come from another statue.

BIBLIOGRAPHY: Doell 1873, p. 11, pl. I.12, no. 1; Cesnola 1877, pp. 130–32; Cesnola 1885, pl. LXV.431; Cesnola 1903a, pl. CXLI.2; Myres 1946b, p. 101; Gjerstad 1948, p. 115; Masson 1961, pp. 44, 283, no. 262; Masson 1971b, p. 317; Vermeule 1974, p. 288; Masson and Hermary 1993.

173. Bearded figure wearing a conical helmet

Last quarter of the 6th century B.C.
Limestone
H. (with base): 191.8 cm (75½ in.)
74.51.2460 (Myres 1352)
Said to be from the temple at Golgoi
 Traces of red paint once were present on both the drapery and the lips.

BIBLIOGRAPHY: Doell 1873, p. 15, pl. I.13, no. 29; Cesnola 1877, pp. 142–44; Cesnola 1885, pl. LX.407; Myres 1946b, p. 101; Myres 1946c, pp. 62, 64; Gjerstad 1948, p. 114; Vermeule 1974, p. 288; Markoe 1987, p. 122, pl. XLII.1.

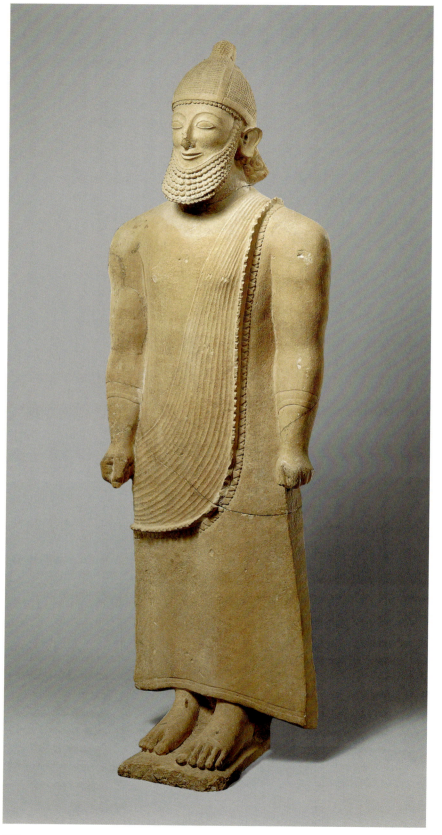

173

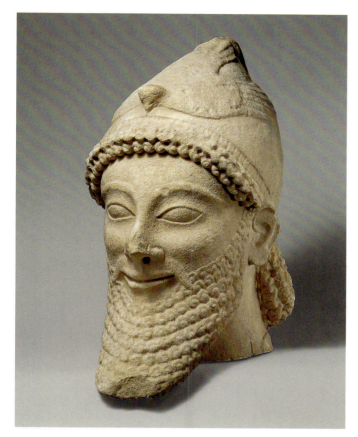

174

175

174. Bearded male head wearing a pointed helmet

Last quarter of the 6th century B.C.
Limestone
H. 44.5 cm (17½ in.)
74.51.2848 (Myres 1284)
Said to be from the temple at Golgoi

The front of the helmet is covered by a bird with large open wings, shown in relief.

BIBLIOGRAPHY: Doell 1873, p. 45, pl. VIII.11, no. 235; Cesnola 1885, pl. LIX.404; Myres 1946c, p. 62; Masson and Hermary 1993, p. 33, pl. IV.

175. Bearded male head wearing a Greek helmet

End of the 6th century B.C.
Limestone
H. 32.4 cm (12¾ in.)
74.51.2810 (Myres 1285)
Said to be from the temple at Golgoi

The smooth-surfaced helmet has hinged cheekpieces and a solid nose guard. There are traces of pink paint on the beard.

Warriors wearing such helmets appeared early in the coroplastic art of Cyprus (cf. V. Karageorghis 1993b, p. 87). This piece imitates contemporaneous Corinthian helmets.

BIBLIOGRAPHY: Cesnola 1885, pl. CV.688; Groenewegen-Frankfort and Ashmole 1972, p. 375, fig. 572.

The influence of Egyptian sculpture was apparent from the very beginning of the sixth century B.C., even before the so-called Egyptian domination of Cyprus, usually thought to have occurred about 570 B.C. The first Egyptianizing elements in Cypriot sculpture were no doubt due to the activities of the Phoenicians. The Cesnola Collection possesses fine examples of young votaries in Egyptianizing style. Their royal dress (often decorated in relief), broad shoulders, and stiff attitude are distinguishing characteristics.

The influence of Greek as well as Egyptian sculpture can be seen in catalogue number 180, from the first half of the sixth century B.C.

The stance and dress of the figure recall Egyptian sculpture, whereas the facial characteristics and treatment of the hair betray the influence of Greek styles. In their usual pose, the Egyptianizing votaries have one arm bent to the chest (see cat. nos. 181, 182). Some wear a pectoral and the double crown of Egypt (cat. nos. 176, 182). These specifically Egyptian regalia do not appear until the second quarter of the sixth century B.C., and their occurrence may be due to the Egyptian presence on the island (Hermary 1989, p. 49). A *shenti*, or Egyptian kilt (see cat. no. 176), is decorated not only with the uraeus (the sacred cobra, protector of the pharaoh) but also with the head of Bes (or Medusa?). The figure's left arm is bent forward to allow him to hold the hilt of what was possibly a sword. Another figure (cat. no. 177) is also ready to draw his sword from his scabbard, but his attitude is less stiff than that seen earlier (cat. no. 176). Catalogue number 177 probably dates from the end of the sixth century B.C., and the influence of Greek sculpture is present once again in the details of the head.

176. **Male votary in Egyptian dress wearing the double crown of Egypt**
2nd or 3rd quarter of the
6th century B.C.
Limestone
H. 59 cm (23¼ in.)
74.51.2603 (Myres 1266)
Said to be from the temple at Golgoi
The central panel of the kilt is decorated in relief with an eye above and the head of Bes (or

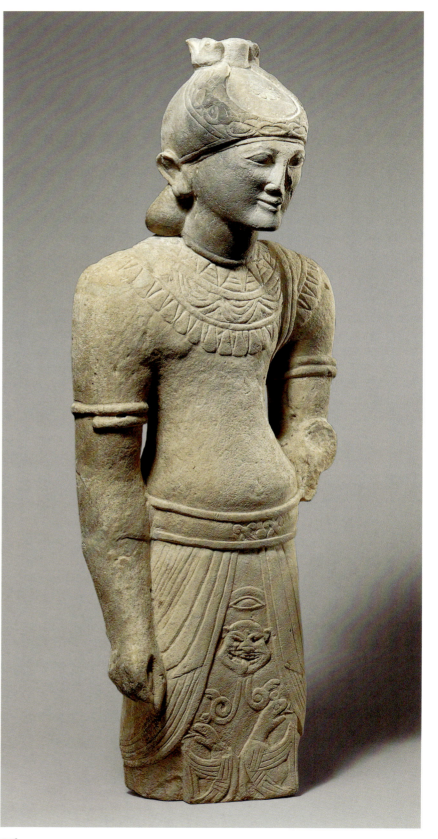

176

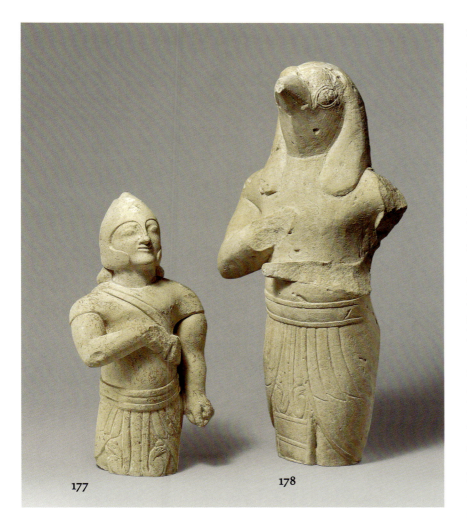

177 178

178. Male figure with a falcon's head

1st half of the 6th century B.C.
Limestone
Preserved H. 40 cm (15¾ in.)
74.51.2516 (Myres 1268)
Said to be from the Karpas
Peninsula

The slightly upward-tilted head has large round eyes and a prominent beak, the tip of which has been restored. There are traces of red paint on the belt and the kilt.

The falcon-headed figure is a rare type that probably represents the Egyptian god Horus; it is also possible that the statue represents a human figure wearing a mask (compare cat. no. 194; see Hermary 1989, p. 290, nos. 586, 587). There are only a few representations of Horus in Cypriot sculpture. Despite the Egyptian character of the god, there is no doubt that the figure was made on Cyprus of native limestone. Its attitude and drapery, as well as the Egyptian kilt with relief decoration and the details of the figure's face, are in harmony with other Egyptianizing statues of the same period.

BIBLIOGRAPHY: Cesnola 1877, p. 344; Cesnola 1885, pl. XXIV.58; Perrot and Chipiez 1885, pp. 204–5, fig. 137; Gjerstad 1948, p. 103; Hermary 1981, pp. 17–18, pl. 2, no. 3.

Medusa?) below. There are traces of burning on the head.

BIBLIOGRAPHY: Doell 1873, p. 17, pl. II.7, no. 39; Cesnola 1877, p. 154; Cesnola 1885, pl. XLII.279; Myres 1933, p. 34 n. 19; Gjerstad 1948, pp. 112, 114; Wilson 1975, pp. 99–100, pl. 18a; Brönner 1994, p. 51, pl. XVIc, no. m.

177. Warrior in Egyptian dress

End of the 6th century B.C.
Limestone
H. 26.8 cm (10½ in.)
74.51.2600 (Myres 1049)
Said to be from the temple at Golgoi

The right hand is bent to draw a sword from its scabbard, which hangs under the left arm. The scabbard is supported by a double strap that crosses over the right shoulder.

BIBLIOGRAPHY: Cesnola 1885, pl. XLII.265.

179. **Statuette of a youth wearing a**
shenti

Beginning of the 6th century B.C.

Limestone

H. 12.4 cm (4⅞ in.)

74.51.2571 (Myres 1033)

Said to be from a tomb at Amathus

This work was long considered to
be an Egyptian import. Hermary,
however, has rightly classified it as
an Egyptianizing statue made on
Cyprus; although it closely follows
Egyptian prototypes, it was made
of Cypriot limestone and dates
from the beginning of the sixth
century B.C. (Hermary 1981, p. 16).
The statue may have been buried
with an Egyptian (Hermary 1981,
p. 17).

BIBLIOGRAPHY: Cesnola 1885,
pl. XXXIV.215; Gjerstad 1948, pl. VI;
J. Karageorghis 1977, p. 207; Soph-
ocleous 1985, pl. XLV.1, appendix II;
Hermary 1981, pp. 16–17, pl. 2,
no. 2.

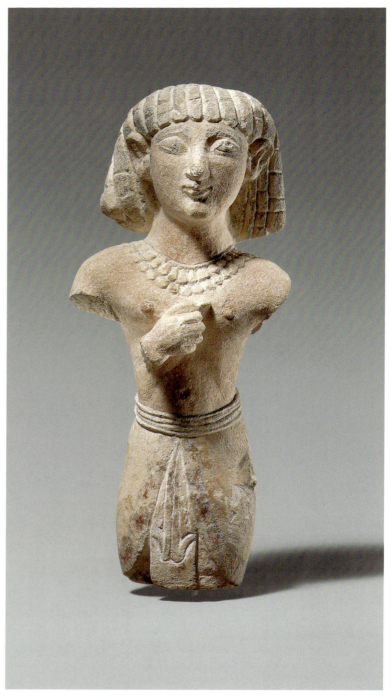

179

180. **Male votary in Egyptian dress**
1st half of the 6th century B.C.
Limestone
H. 104.8 cm (41¼ in.)
74.51.2471 (Myres 1356)
Said to be from the temple at Golgoi

BIBLIOGRAPHY: Doell 1873, p. 21,
pl. III.10, no. 62; Cesnola 1877,
p. 145; Cesnola 1885, pl. IX.11; Perrot
and Chipiez 1885, figs. 79, 123, 125;
Gjerstad 1948, pl. X; Richter 1960,
p. 93; Hermary 1981, pp. 17 n. 29,
18 n. 30; Senff 1993, p. 29 n. 246.

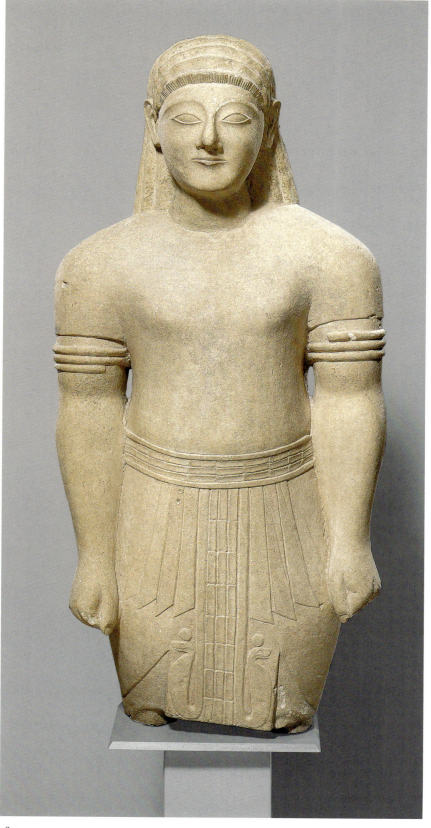

180

181. **Male votary in Egyptian dress**
2nd quarter of the 6th century B.C.
Limestone
H. 136.5 cm (53¾ in.)
74.51.2467 (Myres 1361)
Said to be from west of the temple at Golgoi

On the left forearm there is an inscription in the Cypriot syllabary that reads, "I am [the statue] of Tamigoras [Timagoras?]" (see detail below).

BIBLIOGRAPHY: Doell 1873, p. 19, pl. II.6, no. 49, pl. IX.7, no. 311; Cesnola 1885, pl. III.5; Perrot and Chipiez 1885, p. 127, fig. 80; Myres 1946b, p. 101, pl. 31; Masson 1961, pp. 44, 283, fig. 81, no. 263; Masson 1971b, p. 317, fig. 9.

181. DETAIL

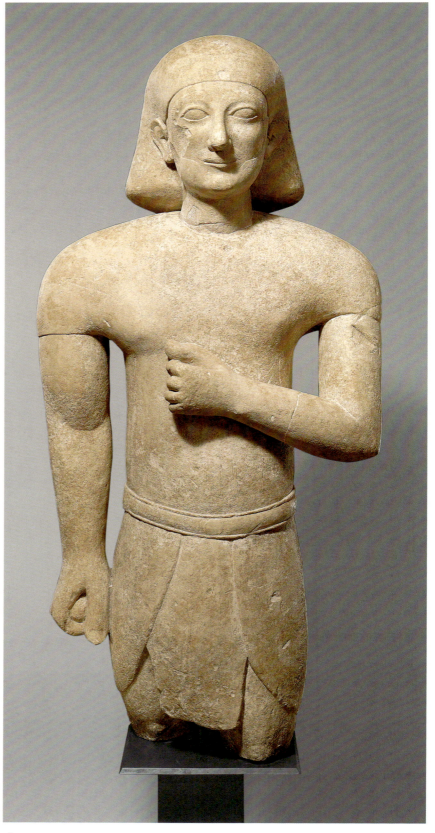

181

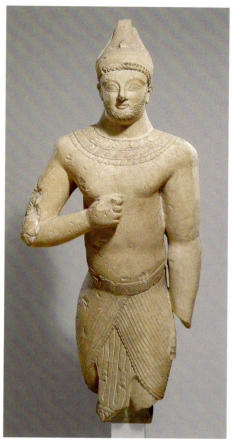

182. VIEW 2

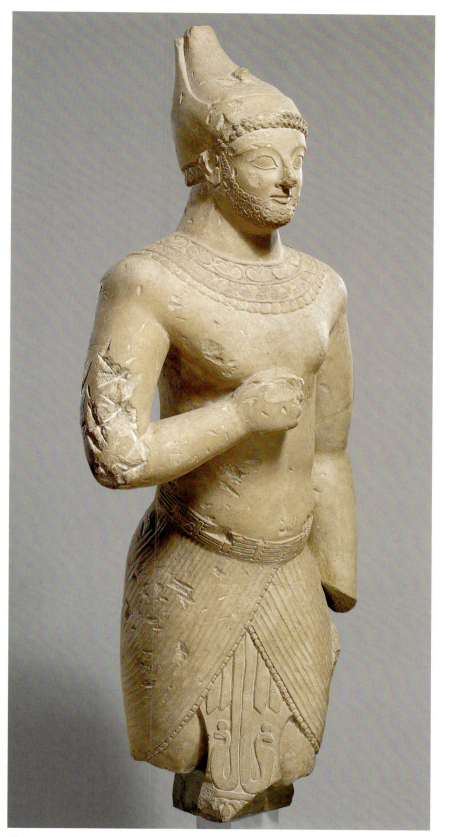

182. VIEW 1

182. **Male votary in Egyptian dress wearing the double crown of Egypt**

3rd quarter of the 6th century B.C.
Limestone
H. 130.2 cm (51¼ in.)
74.51.2472 (Myres 1363)
Said to be from the temple at Golgoi

The left shoulder and arm are restored. Myres observed traces of red color on the kilt.

BIBLIOGRAPHY: Doell 1873, p. 18, pl. II.9, no. 43; Cesnola 1877, p. 131; Cesnola 1885, pl. XLIII.280; Myres 1946b, pl. 31; Gjerstad 1948, pp. 99–100; Markoe 1990, pp. 111, 113–14, fig. 2; Senff 1993, p. 50, pl. 61.a; Brönner 1994, p. 50, pl. XV.b,.c, no. 1.

183. Hathoric stele

2nd quarter of the 6th century B.C.

Limestone

H. 87.6 cm (34½ in.);

max. W. 51.4 cm (20¼ in.)

74.51.2475 (Myres 1414)

Said to be from the necropolis at Golgoi

Capitals (or stelai) with images of the Egyptian goddess Hathor were popular at Amathus, particularly in the early fifth century B.C. Works such as this one functioned as religious symbols both in the cult of the Great Goddess of Cyprus and in funerary contexts. Hathor's assimilation with the Cypriot goddess and her presence on funerary stelai derive from her role as the goddess of life, the protector against evil and death. On Cyprus the iconography of the Egyptian goddess was adapted to the styles of Cypriot sculpture. She often appears in the form of a capital surmounted by a *naiskos* (small shrine). She also appears in the Amathus-style vase painting and in the minor arts (for a general study, see Hermary 1985).

BIBLIOGRAPHY: Cesnola 1885, pl. XVIII.27; Masson 1971b, p. 316; Hermary 1985, pp. 676, 678, 681, fig. 23; Sophocleous 1985, p. 126, pl. XXXI.1.

183

184. Female votary

Beginning of the 6th century B.C.

Limestone

H. 76.2 cm (30 in.)

74.51.2541 (Myres 1263)

Said to be from the temple at Golgoi

Female figures of this type, richly decorated with necklaces, ear caps, and earrings, are common in Cypriot sculpture from the beginning of the sixth century B.C. Their posture is rigid, with a flat body and plain headdress. They either play a musical instrument or hold an offering, a flower, or a fruit. They do not represent the Great Goddess, but, with their rich jewelry, they may represent priestesses or even worshippers of the goddess.

BIBLIOGRAPHY: Doell 1873, p. 14, pl. I.8, no. 21; Cesnola 1885, pl. X.12; J. Karageorghis 1977, p. 214.

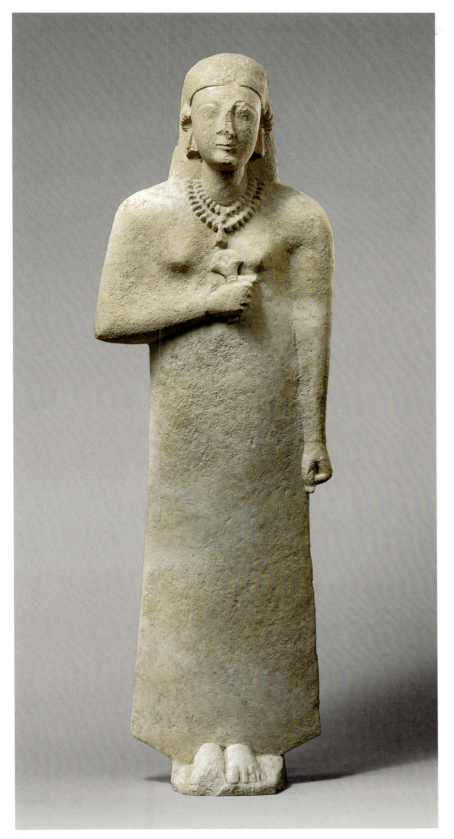

One of the most common attributes of sixth- and fifth-century B.C. male and female Cypriot statuary is a wreath of leaves worn around the head. It is not always easy to identify the leaves, though myrtle, laurel, and ivy are often represented. The people who wore such wreaths were probably associated with a divinity, such as Aphrodite or Apollo, in whose sanctuaries these votive statues were dedicated (Hermary 1989, p. 112).

The smiling expression and the neat rendering of the hair, beard, and mustache of catalogue number 185 indicate that it dates from the very end of the sixth century B.C. The vigor of very early fifth-century B.C. Cypriot sculpture, or Gjerstad's Archaic Cypro-Greek style, can be seen in catalogue number 186 (Gjerstad 1948, p. 120). Somewhat earlier, from the third quarter of the sixth century B.C., is catalogue number 187, a head with long locks of hair and a torso draped in the Greek style. He holds a lustral branch in his right hand (Hermary 1989, p. 263, cf. no. 535).

184

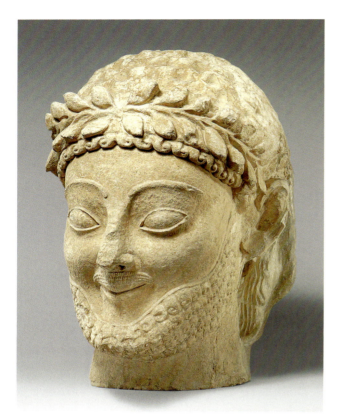

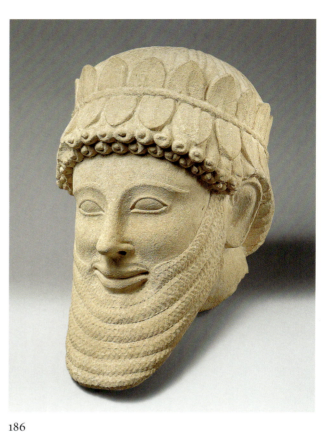

185

186

185. Bearded male head wearing a wreath
End of the 6th century B.C.
Limestone
H. 38.1 cm (15 in.)
74.51.2836 (Myres 1281)
Said to be from the Karpas Peninsula

BIBLIOGRAPHY: Doell 1873, p. 46, pl. IX.9, no. 344; Cesnola 1877, p. 141; Cesnola 1885, pl. LXXXII.540; Gjerstad 1948, p. 114.

186. Bearded male head wearing a wreath
Early 5th century B.C.
Limestone
H. 34.3 cm (13½ in.)
74.51.2841 (Myres 1286)
Said to be from the temple at Golgoi

BIBLIOGRAPHY: Doell 1873, p. 46, pl. IX.14, no. 352; Cesnola 1877, p. 141; Colonna-Ceccaldi 1882, pl. V; Cesnola 1885, pl. LXXII.470; Perrot and Chipiez 1885, pp. 190–91, fig. 128; Gjerstad 1948, p. 115.

187. Male votary wearing a wreath
3rd quarter of the 6th century B.C.
Limestone
H. 57.2 cm (22½ in.)
74.51.2646 (Myres 1062)
Said to be from the temple at Golgoi

BIBLIOGRAPHY: Doell 1873, p. 24, pl. III.7, no. 78; Cesnola 1885, pl. LXVII.446.

190. VIEW 4

his right hand at waist level, but Cesnola's "restorations" have drastically altered this unusual sculpture.

It is unfortunate that the statue of Herakles kneeling (cat. no. 191) is fragmentary. It may have formed part of a pediment group, and the style may have been influenced by Greek sculpture from the end of the sixth century B.C. It is unique among Cypriot sculptural works.

190. **Herakles**
ca. 530–520 B.C.
Limestone
H. 217.2 cm (85½ in.)
74.51.2455 (Myres 1360)
Said to be from west of the temple at Golgoi

The carving on the back of the figure is rough. Herakles once held arrows in his right hand; the bow on his left arm was broken and incorrectly restored with a club, which has now been removed. A border of red paint runs along the neck and the edges of the chiton.

BIBLIOGRAPHY: Doell 1873, pp. 37–38, pl. VII.9, no. 178; Cesnola 1877, pl. XII; Cesnola 1885, pl. LXXXVIII.585; Myres 1946c, p. 65; Sophocleous 1985, pp. 31–32, 52, pl. V.4; Hermary 1990, p. 193, no. 3; V. Karageorghis 1998a, p. 69, fig. 27.

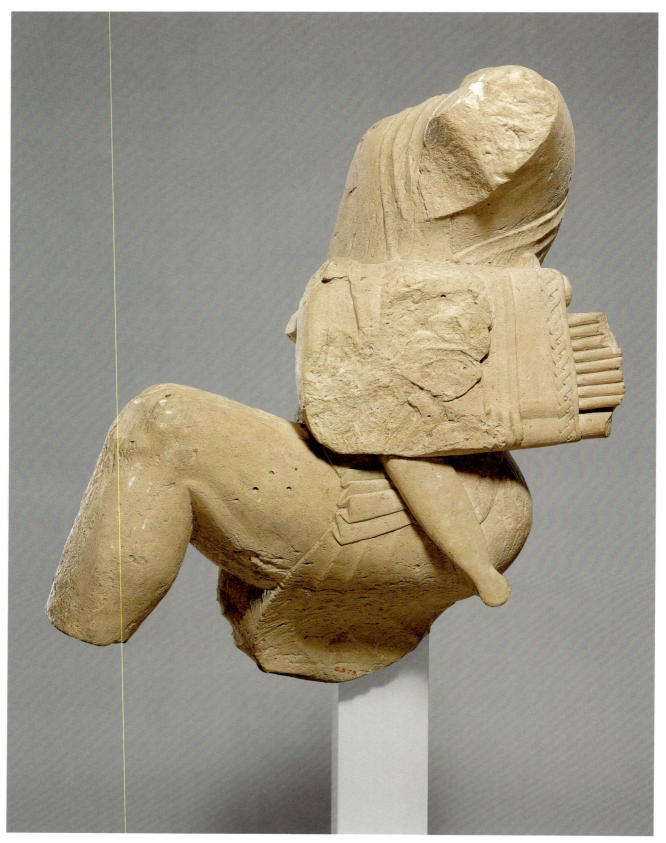

191

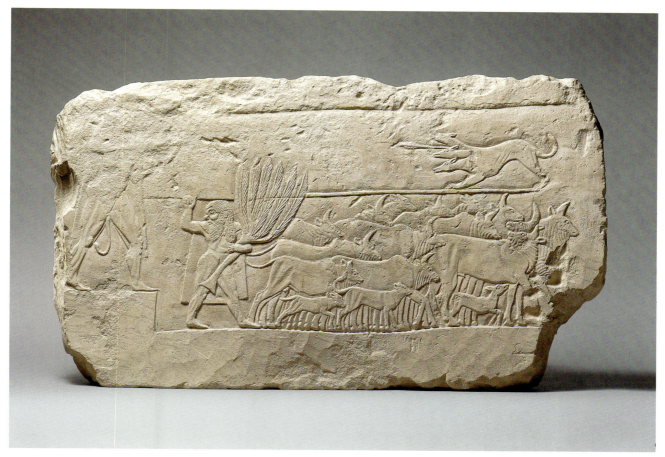

192

191. Herakles kneeling

End of the 6th century B.C.

Limestone

H. 71.1 cm (28 in.)

74.51.2500 (Myres 1409)

Said to be from the temple at Golgoi

Herakles is represented here as an archer, probably drawing his bow.

BIBLIOGRAPHY: Doell 1873, pp. 40–41, pl. VII.10, no. 190; Cesnola 1877, pp. 154–55; Cesnola 1885, pl. CXXVIII.923; Hermary 1990, p. 195, no. 31.

192. Slab with scene of Herakles stealing the cattle of Geryon

End of the 6th century B.C.

Limestone

H. 52 cm (20½ in.); L. 87.3 cm (34⅜ in.); D. 7.5–10.5 cm (3–4⅛ in.)

74.51.2853 (Myres 1368)

Said to be from a site near the temple at Golgoi

The lower right-hand corner of the slab is slightly damaged, and at the top it was cut back. The front is decorated in low relief with a mythological scene: Herakles stealing the cattle of the monster Geryon, which were guarded by the herdsman Eurytion and his three-headed dog, Orthros. Geryon himself is absent. On the far left, a large figure of Herakles stands on a rectangular podium. The upper part of his body is damaged.

The relief is divided into two registers. In the upper register, at the far right, is Orthros, who has been shot by an arrow that protrudes from one of his three necks. In the lower register is Eurytion, who has the face of a satyr and walks to the right, turning his head back toward Herakles. He holds a stone in his raised right hand and in his left arm carries an uprooted tree, with which he drives away the cattle, rendered in depth in a style that recalls both Egyptian and Greek vase-painting prototypes.

The background was painted red, which would have made the relief stand out more vividly. Some pigment survives.

Reliefs with mythological representations or scenes of everyday life were common in Cypriot art, especially during the Classical period. The myth of Herakles and the monster Geryon was popular in Cypriot sculpture of the sixth century B.C. Its favor derived from the influence of late Archaic Greek art, which is apparent in this work. Herakles, as a god, played an important part in Cypriot religion and iconography during the sixth and fifth centuries B.C. His enemies are rendered as monsters.

The relief is low and flat, resembling a drawing rather than a three-dimensional sculpture. This technique of carving was followed by sculptors at Golgoi into the fourth century B.C. (see cat. no. 352). Two-dimensional representations, such as drawings or paintings, may have inspired the use of this sculptural technique to render narratives involving numerous figures, often arranged in two registers, as here.

BIBLIOGRAPHY: Doell 1873, pp. 47–48, pl. XI.6, no. 763; Cesnola 1877, pp. 135–37, pl. XII; Cesnola 1885, pl. CXXII.912; Masson 1971b, p. 317, fig. 10; Tatton-Brown 1979, p. 287; Tatton-Brown 1984, pp. 170–71, pl. XXXIII.1; Hermary 1990, p. 195, no. 27; Senff 1993, p. 63 n. 518; V. Karageorghis 1998a, pp. 58–60, figs. 23a,b.

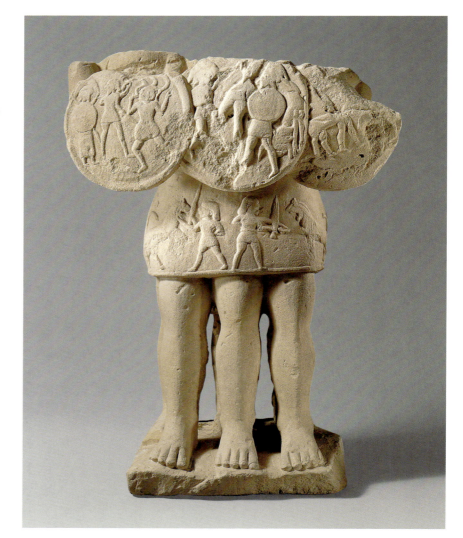

193

193. Geryon

2nd half of the 6th century B.C.
Limestone
H. 52.7 cm (20¾ in.)
74.51.2591 (Myres 1292)
Said to be from the temple at Golgoi

Geryon, whose three heads are missing, has three legs in front and three in back. Three pairs of arms, crudely rendered, can be seen behind the upper border of the three shields, which are decorated in relief with scenes from Greek mythology. Hair falls on the shoulders of the middle body.

The three bodies wear a single short tunic; its relief decoration shows two youths, who may represent Herakles, in combat with lions. In the central shield Herakles carries away one of the Kerkopes. The Kerkopes were monkeylike creatures whom Herakles carried away by hanging them upside down from a pole. Here, Herakles holds one, while another attacks him. In the right shield, which is very damaged, Herakles is shown in a kneeling position aiming at a centaur. The scene on the left shield

depicts Perseus beheading Medusa in the presence of Athena.

Representations of the three-bodied Geryon appear on Cyprus early, first in terracotta and later in limestone. This work may be identified without hesitation with Geryon, a monster associated with a Greek myth that was well known throughout the Mediterranean (see Tatton-Brown 1979 and V. Karageorghis 1989 for more on Geryon on Cyprus). Geryon lived in the westernmost limits of the world. As one of the labors for King Eurystheus, Herakles was sent to bring back Geryon's fine herd of cattle. Here, Geryon is represented in isolation, not in relation to other Greek mythological figures. The sculptor drew on Greek representations of the deeds of Herakles and

Perseus for the rich decoration of the shields and the tunic. The low reliefs lack the precision of the reliefs on the Golgoi sarcophagus (cat. no. 331), but they are important iconographically.

BIBLIOGRAPHY: Doell 1873, pp. 39–40, pl. VII.8, no. 187; Cesnola 1877, pp. 155–56; Cesnola 1885, pl. LXXXIII.544; Tatton-Brown 1979, pp. 287–88; Tatton-Brown 1984, pp. 172–73, pl. XXXIII.5; V. Karageorghis 1989, p. 93; V. Karageorghis 1998e, pp. 60–61, fig. 24.

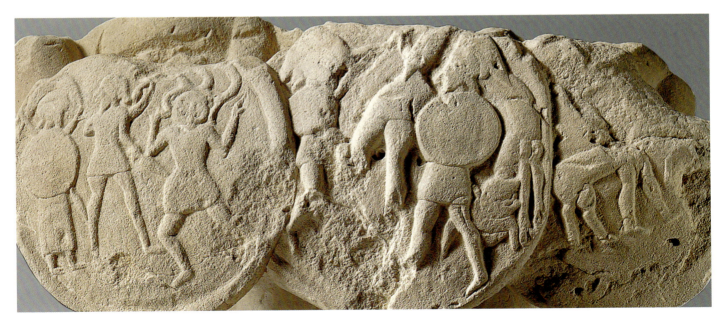

193. DETAIL

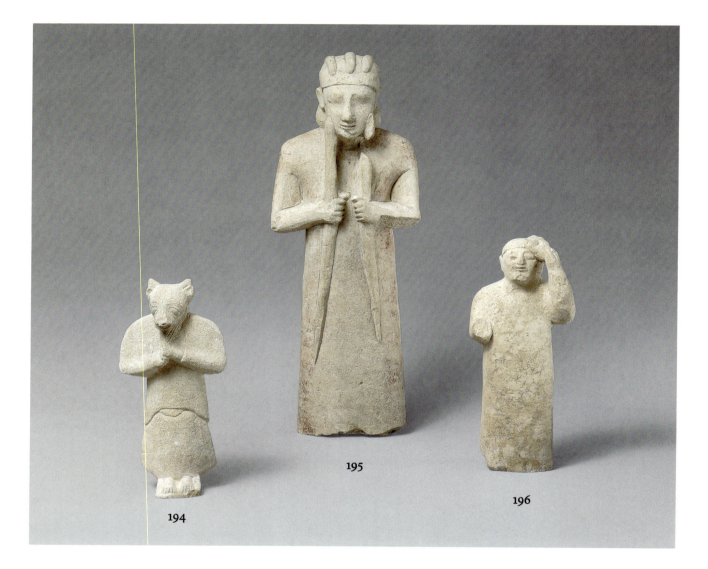

194

195

196

194. Priest(?) wearing a bull's-head mask

2nd quarter of the 6th century B.C.
Limestone
H. 21.4 cm (8⅜ in.)
74.51.2515 (Myres 1029)
Said to be from the temple at Golgoi

The body is flat, carved only in front. The figurine may represent a priest wearing a bull's-head mask for a ritual performance (cf. Hermary 1979). Male figures wearing such masks are known from terracottas found at Amathus (e.g., V. Karageorghis 1987a, p. 16; cf. cat. no. 225, and V. Karageorghis 1995, pp. 55–57). Votive bull's-head masks of terracotta are also represented in the Cesnola Collection (cat. nos. 221, 224).

BIBLIOGRAPHY: Doell 1873, p. 44, pl. VII.4, no. 221; Cesnola 1885, pl. XXIV.57; Perrot and Chipiez 1885, pp. 205–6, fig. 138; Myres 1946c, p. 63; Hermary 1979, p. 734, no. 1; Sophocleous 1985, p. 18, pl. III.8.

195. Snake charmer

1st half of the 6th century B.C.
Limestone
Preserved H. 40.6 cm (16 in.)
74.51.2529 (Myres 1022)
Said to be from Amathus

The figure holds a serpent in each hand. On top of his head are the heads of three other serpents; their bodies hang behind.

Snakes and bulls have a long tradition of religious significance on Cyprus as symbols of fertility. An over-lifesize terracotta figure of Bes holding snakes was found in a sanctuary at Patriki, in eastern Cyprus (V. Karageorghis 1971b, pp. 32–34, pl. xv, no. 7; V. Karageorghis 1993b, pp. 35–36, pl. XXIV.1, no. 92). It holds a pose strikingly similar to that of the figure here, though it is unlikely that the Museum's figure represents a god. In antiquity, there must have been those on Cyprus, as there are today in some parts of the island, who had a special relationship with nonvenomous snakes. These snakes are usually more than three feet long and are thought to bring luck to the household. Hermary cites a passage from Pliny the Elder (*Natural History* 28.30–31), previously referred to by both de Ridder and Myres (Hermary 1981, p. 18), that mentions a family of Cypriots, the Ophiogenes, who had a hereditary responsibility for curing people bitten by snakes.

BIBLIOGRAPHY: Cesnola 1877, p. 344; Cesnola 1885, pl. XXXII.209; Hermary 1981, p. 18, pl. 3.1, no. 4; Sophocleous 1985, pp. 73–74, 210, pl. XVI.5.

196. Human figure holding a lion mask

Late 6th century B.C.
Limestone
H. 23.8 cm (9⅜ in.)
74.51.2505 (Myres 1031)
Said to be from the temple at Golgoi

The workmanship of this figure is crude, and the lower part has been sawed off. The left arm is bent upward and the hand holds what appears to be a lion mask. It seems that the mask has just been removed from the face. There are traces of red paint along the sides of the body.

Votive clay masks representing lions appeared on Cyprus and in the Levant as early as the eleventh century B.C. During the Late Bronze Age, human figures wearing lion's-head masks appear in Cypriot glyptics and may represent the Egyptian goddess Sekhmet (Porada 1992, p. 369). The lion was feared as a dangerous animal (cf. V. Karageorghis 1993b, p. 118).

BIBLIOGRAPHY: Cesnola 1885, pl. LVII.381; Hermary 1979, p. 735.

Musicians

In the art of Archaic Cyprus, flute players, male and female, appear in both limestone and terracotta and are found in sanctuaries and tombs (cf. Pryce 1931, pp. 25–26; Hermary 1989, pp. 285–86, 387). They were placed in the sanctuary to produce music to please the divinity. Players of the double flute were equipped with a *phorbeia*, the mouth band strapped around the head of the player to hold the flute in place. Sometimes it is indicated in relief, as in catalogue numbers 197 and 199, but it can also be depicted with paint. Other musicians are also common, for example, lyre players (cat. no. 198) or tambourine players. The flute player (cat. no. 199) and the lyre player (cat. no. 198) may have belonged to a group of musicians.

197. Male flute player
1st half of the 6th century B.C.
Limestone
H. 26.7 cm (10½ in.)
74.51.2508 (Myres 1024)
Said to be from the temple at Golgoi

The flute is attached to the face with a *phorbeia* (mouth band), which has traces of red paint. A vertical band of pink paint runs above the head and forms part of the mouth band. Traces of a black band cross the border of the sleeves and run along the sides of the chiton.

BIBLIOGRAPHY: Doell 1873, p. 20, pl. II.3, no. 54; Cesnola 1885, pl. XXI.42; Myres 1946c, p. 62.

198. Lyre player
2nd quarter of the 6th century B.C.
Limestone
H. 45.2 cm (17¾ in.)
74.51.2509 (Myres 1265)
Said to be from west of the temple at Golgoi

The Egyptianizing influence is evident in the smooth hair (a wig) and the stiff pose. The harp is triangular and has a pillar emerging from a scrolled base into a floral capital. At the top is a head of a griffin. This piece may have formed part of a sculptural group (with cat. no. 199).

BIBLIOGRAPHY: Cesnola 1885, pl. XII.14; Myres 1946c, p. 68; Gjerstad 1948, p. 103; Masson 1971b, p. 317.

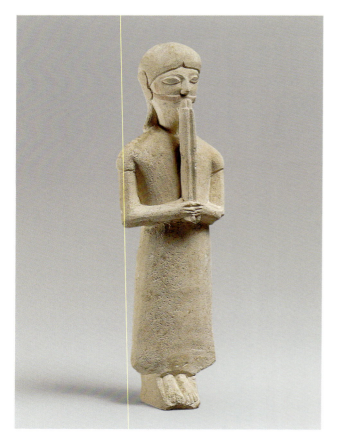

197

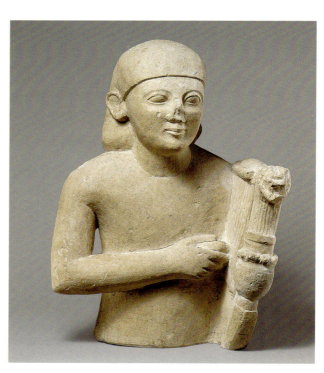

198

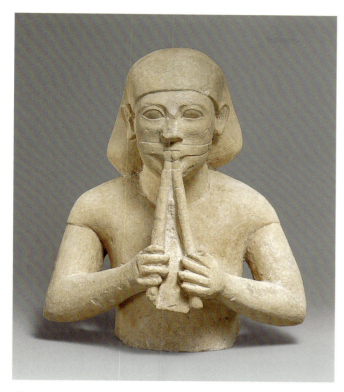

199

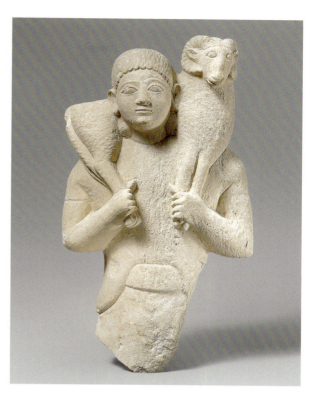

200

199. Player with a double flute
2nd quarter of the 6th century B.C.
Limestone
Preserved H. 40 cm (15¾ in.)
74.51.2517 (Myres 1264)
Said to be from west of the temple
at Golgoi

Only the upper part of this male
figure is preserved. The Egyptianiz-
ing influence is evident in the
smooth hair (a wig) and the stiff
pose. The player uses a *phorbeia*
(mouth band) that prevents the
swelling of the cheeks, thus helping
to control the breath. This piece
may have formed part of a sculp-
tural group (see cat. no. 198).

BIBLIOGRAPHY: Doell 1873, p. 19,
pl. II.5, no. 52; Cesnola 1885,
pl. XIII.15; Gjerstad 1948, p. 103;
Masson 1971b, p. 317.

200. *Kriophoros*
Early 6th century B.C.
Limestone
H. 32.7 cm (12⅞ in.)
74.51.2533 (Myres 1120)
Said to be from the temple of
Apollo Hylates at Kourion

The back of the piece is flat. The
surface of the ram has been chis-
eled to resemble fleece.

Small-size sculptures of *kriophoroi*
(ram bearers) made of Cypriot lime-
stone have been found in the sanctu-
ary of Hera on Samos and elsewhere
(Blinkenberg 1931, pp. 430–33, pl. 71;
Gjerstad 1948, pp. 319–20, figs. 44, 45;
Schmidt 1968, pp. 56–57, pls. 96–97).
They were also made in terracotta
(V. Karageorghis 1995, p. 51, pl. xxv.6,
no. 43). This figure is the only
medium-size sculpture of the type,
however. Gjerstad dates it to the

Neo-Cypriot style, in the early sixth
century B.C. (Gjerstad 1948, p. 107).
The figure, presumably a herds-
man, is bringing one of his flock to
be sacrificed.

BIBLIOGRAPHY: Cesnola 1885,
pl. XVI.21; Perrot and Chipiez 1885,
pp. 187, 189, fig. 126; Myres 1946c,
p. 63.

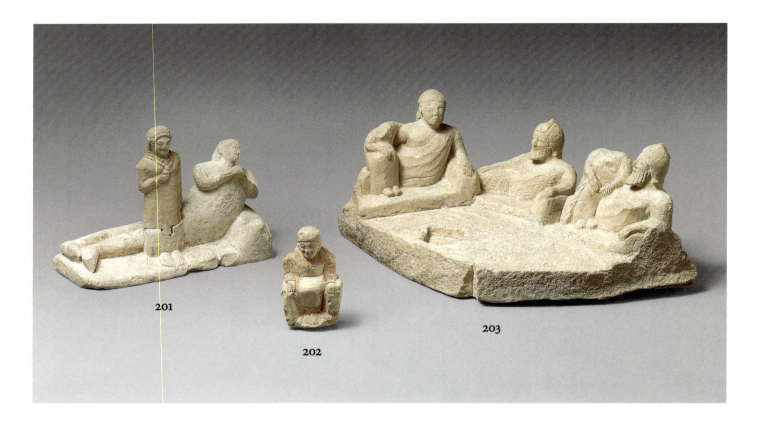

201 202 203

**201. Figural group with recumbent
 votary**
6th century B.C.
Limestone
H. 18 cm (7⅛ in.); L. (of plinth):
24 cm (9½ in.); W. (of plinth):
10.4 cm (4⅛ in.)
74.51.2504 (Myres 1142)
Said to be from the temple at Golgoi

The reclining figure is completely
draped with a tunic. His upper
torso is slightly raised and rests on
pillows, placed on the right side of
the couch, which is rendered as a
rectangular plinth. There is a cavity
in front of the upper part of the
pillows. His face is battered. He
raises both arms to hold what may
be a cup or a double flute. In front
of him, near the middle of his body,
a female figure who does not be-
long to the group stands in a

strictly frontal position. Originally,
there must have been a seated
female figure, as in the banquet
scene in catalogue number 203. She
wears a long-sleeved chiton and
two beaded necklaces. Her left arm
stretches along the side of her body.
Her right arm is bent up against
her chest to hold what may be a
flower. She seems to hold some-
thing small and flat in her left
hand. Around her hair is a broad
fillet. Below the fillet is a curly
fringe of hair. Grooved hair falls on
either side of her face. Red colors
her dress and lips. She appears to
be smiling.

This work is similar in style to
the banquet scene (cat. no. 203).
It represents only a reclining male
figure and a female figure, who was
originally seated across his knees,

but now, as restored by Cesnola,
is not related to her companion
in any way.

BIBLIOGRAPHY: Cesnola 1885,
pl. LXXVII.492.

202. Seated female figure
3rd quarter of the 6th century B.C.
Limestone
H. 11.4 cm (4½ in.)
74.51.2564 (Myres 1134)
Said to be from a tomb at Amathus

Transverse strokes of black and
red paint appear on the front of the
throne. There is a large hole below
the figure's knees and two more on
the sides, perhaps intended to hold
a wooden stick, which would act as
the axle of a chariot. If so, the fig-
ure may compare with representa-
tions of Astarte on a chariot (cf.
V. Karageorghis 1997).

Seated female figures usually hold an infant or a musical instrument. This work may portray a worshipper.

BIBLIOGRAPHY: Cesnola 1885, pl. LVII.372; Hermary 1981, p. 34, pl. 7, no. 25.

203. Banquet scene

End of the 6th century B.C.
Limestone
Max. H. 17.5 cm (6⅞ in.);
max. L. (of plinth): 44.5 cm
(17½ in.); max. W. (of plinth):
27 cm (10⅝ in.); thickness (of
plinth): 4.6 cm (1¾ in.)
74.51.2577 (Myres 1020)
Said to be from the temple at Golgoi

A group of human figures rests on a base. Originally, the base may have been elliptical or rectangular with rounded corners, only one of which now survives. The figures are arranged around the base, seated on couches. On the floor, off center, there is a rectangular cavity, probably once an inset for an altar or offering table.

On the right a bearded male figure with bent knees reclines on a couch. His bent left arm rests on a pillow, and with his right arm he embraces a young girl who sits across his knees. She is draped with a short-sleeved chiton and a cloak, the ends of which fall along her right leg. She wears bracelets around her wrists. A head that did not belong to the body has now been removed. The male figure wears a conical cap and a long tunic. It is not certain whether the head belongs to the body.

The reclining figure in the center, who has no companion, wears a chiton and a "fleecy" mantle that leaves his right shoulder uncovered. His left arm rests on a pillow; his right arm rests on his leg. He wears a pointed headdress with upturned cheekpieces. He is bearded, but again it is not certain that the head belongs to the body.

The group on the left includes another bearded reclining male and seated female. The female figure wears a long dress that reaches to her feet; her head is missing. The facial characteristics of the bearded male, whose head probably belongs to the body, are quite different from those of the other figures. His eyelids are ridged, and he has a short beard and a mass of hair that falls to his shoulders.

Judging by the treatment of the drapery of the korai, this group dates from the end of the sixth century B.C. It is a characteristic example of the small stone sculpture of Cyprus. Here the artist has taken advantage of the ease with which limestone is carved. Little attention was paid to stylistic rules, perspective, or scale. The main purpose was to tell a story. The fully dressed banqueters recline on cushions, not on beds as in Greek banquet scenes. The sculptor found it difficult to relate the female figures to their male companions. As a group, however, it is charming, more because of its naive spirit than its artistic merits (for a general discussion of Cypriot banquet scenes of this period, see Dentzer 1982, pp. 157–59). Banquet scenes also appear on Cypro-Phoenician metallic bowls (Markoe 1985, p. 57; here see cat. no. 298).

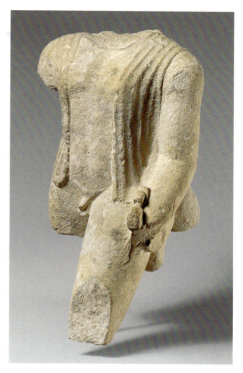

204

BIBLIOGRAPHY: Cesnola 1885, pl. LXVI.432; Perrot and Chipiez 1885, p. 184, fig. 121.

204. Traveler (?)

6th century B.C.
Limestone
H. 38.1 cm (15 in.)
74.51.2593 (Myres 1071)
Said to be from the temple at Golgoi

A heavy-set male figure dressed in a short chiton appears to be moving forward. Based on the various objects that this figure carries, sword and quiver in his left hand and bow and flask slung over his left shoulder, Myres considered him to have been "dedicated in connection with some journey" (Myres 1914, p. 164, no. 1071).

BIBLIOGRAPHY: Cesnola 1885, pl. XLII.272.

Funerary Sculpture

205. **Coffin model**

Cypro-Geometric I
(ca. 1050–ca. 950 B.C.)
Limestone
H. 16.2 cm (6⅜ in.); L. 22.5 cm
(8⅞ in.); W. 13.5 cm (5⅜ in.)
74.51.5166 (Myres 1662)
Said to be from a tomb at Golgoi

The long sides and the legs of
the coffin are decorated with facing
horizontal rows of engraved lat-
ticed triangles. The narrow sides
are also identically decorated with
a central rectangular panel that en-
closes a linearly rendered human
figure marching to the right; the
raised arms hold stylized branches;
on either side is a swastika. Outside
the rectangle two quadrupeds walk
toward the panel; their long curv-
ing horns are schematized.

In Cypriot art miniature models
of coffins appear early, in the late
Bronze Age, in both limestone and
terracotta (cf. V. Karageorghis 1987b,
pp. 44–46). This model, with its
geometric decoration and stylized,
linear, almost abstract human and
animal motifs, probably dates from
the Cypro-Geometric I period. It is
likely that such works were directly
inspired by wooden originals, deco-
rated either in relief or with inci-
sions, the same techniques used in
modern chests. During the Cypro-
Archaic period terracotta chests
became popular (V. Karageorghis
1996, pp. 82–83).

BIBLIOGRAPHY: Cesnola 1885,
pl. LXXIX.505; V. Karageorghis
1987b, p. 44.

206. **Cippus with lion and sphinx**

2nd quarter or middle of the
6th century B.C.
Limestone
H. 40.7 cm (16 in.)
74.51.2551 (Myres 1021)
Said to be from the temple at Golgoi

The fragmentary object consists
of part of a lion and part of a male
sphinx. They are joined at their
backs, but it is not clear whether
they were two sides of an elaborate
armrest, for example, or the front
and back of a finial or similar sculp-
tural embellishment. Cesnola noted
that there was once a necklace
painted green and red around the
sphinx's neck. He has a curly beard
and wears a pointed helmet with
upturned flaps. A sphinx wearing a
similar headdress was recently found
at Tamassos (Christou 1997).

Funerary monuments topped by
lions or sphinxes come mainly from
Golgoi or Idalion and date from the
sixth century B.C. The creatures
appear alone or in pairs and are
shown either seated or recumbent.
Images of the lion and the sphinx
were introduced to Cyprus from
Egypt as guardians of tombs. They
are also features of Archaic and
Classical Greek sculpture. When
two lions or two sphinxes are repre-
sented they are shown back to back
and looking to the side. This work,
however, shows two apotropaic mon-
sters, a lion and a bearded sphinx,
back to back and looking straight
ahead, recalling a stele from Cyprus
with two recumbent sphinxes
(V. Karageorghis 1976a, pp. 868,
870–71, fig. 61).

BIBLIOGRAPHY: Cesnola 1885,
pl. XLII.273.

205

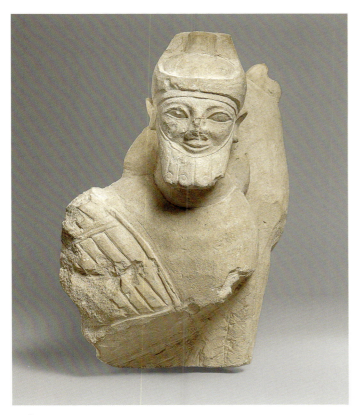

206. VIEW 1

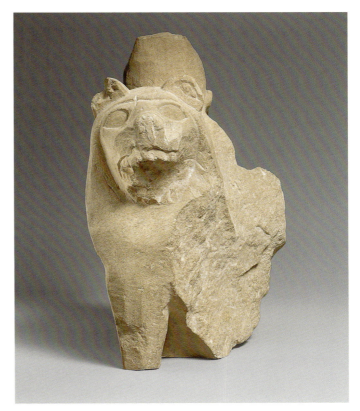

206. VIEW 2

COROPLASTIC (TERRACOTTA) ART

Cypriot sculptors did not have a local source of marble, so they used limestone, which offered only limited possibilities. To produce life-size and over-lifesize sculptures, they also turned to clay. By the seventh century B.C. they were using molds, which allowed them to produce features accurately. They also continued to produce small clay figurines, which have been found in both sanctuaries and tombs.

Cypriot terracottas are often painted, and they follow the currently prevailing styles of pottery decoration. In most cases the potter was probably also a coroplast. At least it seems that pottery and clay figurines were made in the same workshops.

Overseas, in the Aegean, Cypriot terracottas were popular. In the seventh and sixth centuries B.C., a great number of them, even large statues, come from the temple of Hera on Samos. Others have been found on Rhodes and at sites along the western coast of Asia Minor.

Mass production of figurines became possible with the introduction of the mold. Its use accelerated the degeneration of coroplastic art. By the beginning of the Classical period the Cypriots imported molds from the Greek world, and Cypriot coroplastic art lost its originality.

207. **Wall bracket**
Cypro-Geometric I
(ca. 1050–ca. 950 B.C.)
Bichrome I Ware
H. 39.1 cm (15⅜ in.)
74.51.550 (Myres 543)
Said to be from Idalion

A bull protome in high relief appears at the top of the handmade, solid piece. The elliptical flat shaft is perforated at the top to allow for suspension. A stylized tree motif in black flanks the bucranium. At the lowest part of the shaft, inside the bowl, the black outline of a fish is filled with red.

Wall brackets or lampstands serving as incense burners appear in ceramics of the Late Cypriot II period, and there are also some bronze examples from the Late Cypriot II–III periods. Terracotta wall brackets were exported from Cyprus and were popular in the Aegean, where they have been found at places such as Tiryns. Several were included in the cargo of a Late Bronze Age shipwreck discovered in 1982 off the southern coast of Turkey near Ulu Burun. They are usually found in sanctuaries.

Terracotta wall brackets continued to be produced during the Cypro-Geometric and even the Cypro-Archaic periods, but not as frequently as during the Late Cypriot period. Some of the Cypro-Geometric examples are decorated in relief. Motifs such as the bucranium seen here or figures of a nude Astarte with coiling snakes attest to the religious significance of these objects (see V. Karageorghis 1993a, pp. 71–73, 95–96).

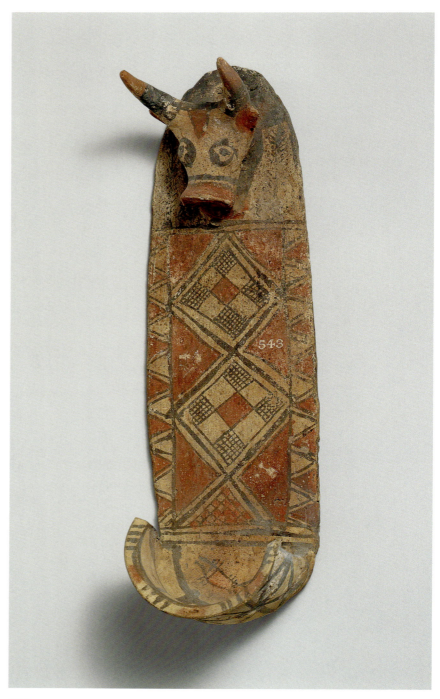

207

BIBLIOGRAPHY: Cesnola 1894, pl. CXIII.888; Gjerstad 1948, pp. 170–71, fig. 37.28; Caubet and Yon 1974, p. 124 n. 1; Karageorghis and Des Gagniers 1974a, pp. 63, 65, 128, no. XXIV.d.51; V. Kara-georghis 1993a, pp. 71–72, fig. 59, no. GJ4.

Large-scale Sculpture

The manufacture of large-scale hollow terracotta sculpture began on Cyprus in the mid-seventh century B.C. Works from this early period are best known from the sanctuary of Ayia Irini (cf. Gjerstad 1948, p. 93). Sculpture in what is called the Neo-Cypriot style dates from the end of the seventh and the beginning of the sixth century B.C. and has been found at various sanctuaries on Cyprus, such as those at Idalion, Tamassos, and Salamis (cf. V. Karageorghis 1993b, pp. 26– 52). The same style is encountered among large-scale terracotta sculptures from the sanctuary of Hera on Samos that date from a slightly earlier period. The export of Cypriot molds for sculpture is probably how Cypriot-style sculpture came to be on the island of Samos. Molds are known to have been exported during later periods. Problems associated with the appearance of Cypriot sculpture on Samos and its dating are still a matter of debate, however (cf. Hermary 1991).

There are some fine examples of Neo-Cypriot–style sculpture in the Cesnola Collection. The common characteristics of these heads are precise features, large ridged eyes, and "feathered" eyebrows. The expressions on the faces reveal the influence of Greek sculpture. Abundant color accentuates the facial characteristics, the hair, and the helmet or crown worn by the figures. Two heads (cat. no. 209, one of the finest pieces, and cat. no. 208) are said to have been found at Amathus, though this site has not produced other large-scale sculpture of this type. Many

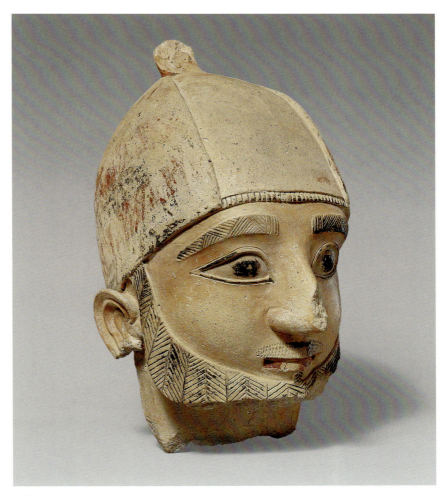

208

works such as catalogue number 210 were found at Idalion, in the temple of Apollo, which was excavated in 1868 (Lang 1878). It is possible that there was a regional school of large-size terracotta sculpture at Idalion (Caubet 1992; V. Karageorghis 1993b, pp. 45–50, 53–59; on limestone sculpture from Idalion, see Gaber-Saletan 1986).

208. **Bearded male head wearing a helmet**

ca. 600 B.C.
Terracotta
H. 29.2 cm (11½ in.)
74.51.1458 (Myres 1457)
Said to be from Amathus
 The head is mold-made.

BIBLIOGRAPHY: Cesnola 1894, pl. XV.116; Hermary 1991, p. 143 n. 50, pl. XXXIX.c; V. Karageorghis 1993b, p. 40, pl. XXV.2, no. 95.

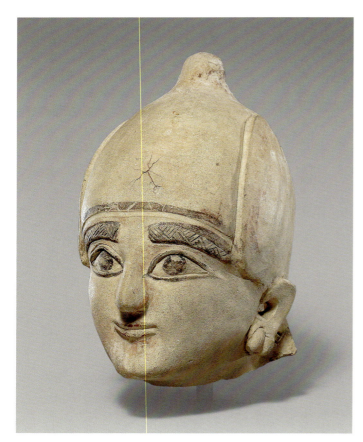

209

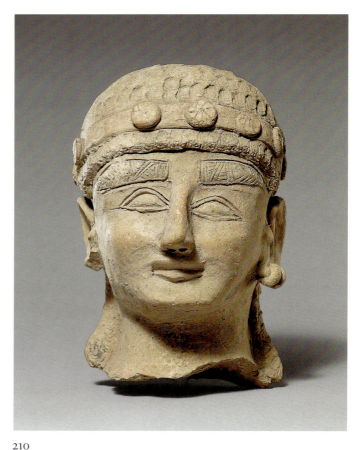

210

209. Large male head wearing a helmet

ca. 600 B.C.
Terracotta
H. 22.2 cm (8¾ in.)
74.51.1443 (Myres 1456)
Said to be from Amathus(?)

The head is mold-made, and the face is colored with diluted red paint.

BIBLIOGRAPHY: Cesnola 1894, pl. XV.115; Myres 1946b, pl. 32; Brown 1983, pp. 75–76 n. 18; Hermary 1991, p. 142 n. 38, pl. XXXVIII.a; V. Karageorghis 1993b, p. 45, pl. XXVIII.3, no. 109.

210. Beardless male head

ca. 600 B.C.
Terracotta
H. 17.5 cm (6⅞ in.)
74.51.1450 (Myres 1454)
Said to be from Idalion

He wears two earrings in his earlobes and his ears have holes through their centers, probably for additional embellishments. Impressed curls form the hair.

BIBLIOGRAPHY: Cesnola 1894, pl. XXXVII.299; Myres 1946b, pl. 32.

Deities and Sanctuaries
Figurines of the "goddess with uplifted arms" type appear for the first time on Cyprus during the eleventh century B.C. They are usually found in sanctuaries, such as the one at Kition, but also come from tombs (V. Karageorghis 1993a, p. 82; V. Karageorghis 1998). These figurines are associated with a local goddess of fertility, later known as Astarte-Aphrodite (see p. 142). Whether the figurines represent the goddess herself or her priestess is not easy to determine (cf. J. Karageorghis 1977, pp. 141–46; V. Karageorghis 1993a, pp. 82–86).

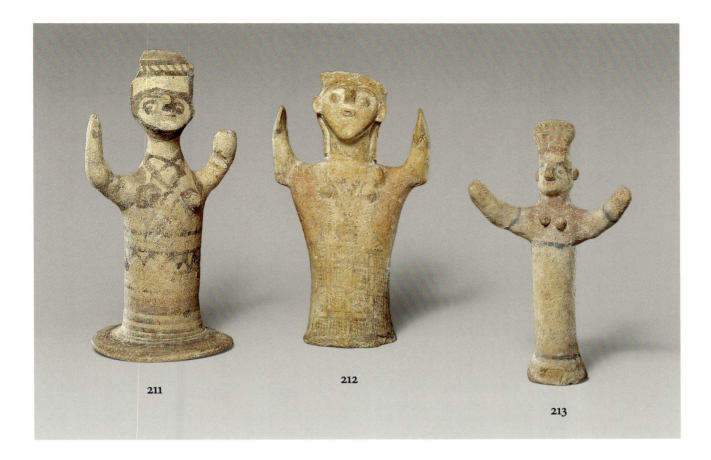

211 212 213

This type of figurine was introduced to Cyprus via Minoan Crete, but the actual origin may be the Mycenaean Greek mainland. Other Minoan elements appeared in the religion and art of Cyprus during the eleventh century B.C., probably introduced by immigrants from Crete, who were among those who settled on the island at that time.

Figurines of the "goddess with uplifted arms" type continued to be produced on Cyprus into the late Cypro-Archaic period (e.g., cat. no. 213) and were often shown nude (cf. V. Karageorghis 1998). Their main characteristic is a high tiara. Early examples (e.g., cat. nos. 211, 212) are richly decorated with painted motifs. Like the Cretan examples, they wear bracelets and necklaces with pendants and have painted spots on their cheeks.

211. Standing female figurine of the "goddess with uplifted arms" type

Cypro-Geometric II–III
(ca. 950–ca. 750 B.C.)
Terracotta
H. 23.2 cm (9⅛ in.)
74.51.1610 (Myres 2025)
Said to be from a tomb at Ormidhia

The figurine is wheel-made and hollow. On the back of the head are horizontal parallel bands for the tiara and vertical parallel bands for the hair. On the back of the torso are two diagonal bands. The lower triangle formed by these lines contains a latticed lozenge and a latticed triangle.

BIBLIOGRAPHY: Cesnola 1894, pl. XII.90; J. Karageorghis 1977, p. 143, pl. 24d; V. Karageorghis 1977b, pp. 18–19 n. 52, pl. IV.3; V. Karageorghis 1993a, p. 83, pl. XXXVII.1, no. LGA(iv)7.

212. Standing female figurine of the "goddess with uplifted arms" type

Cypro-Geometric II–III
(ca. 950–ca. 750 B.C.)
Terracotta
H. 21.5 cm (8½ in.)
74.51.1609 (Myres 2027)
Said to be from a tomb at Ormidhia

The figure is wheel-made and hollow; the upper part of the cylin-

drical body is flattened. The figu-rine has red coloring on her palms, a band around her wrist, and hatched Maltese crosses (tattoos?) on the outer part of her forearms.

BIBLIOGRAPHY: Cesnola 1894, pl. XII.91; J. Karageorghis 1977, p. 142, pl. 23b; V. Karageorghis 1977b, pp. 17–18 n. 50, pls. IV.1,.2; V. Karageorghis 1993a, pp. 83–84, pl. XXXVII.2, no. LGA(iv)10.

213. Standing female figurine of the "goddess with uplifted arms" type

Cypro-Archaic II
(ca. 600–ca. 480 B.C.)
Terracotta
H. 18.4 cm (7¼ in.)
74.51.1615 (Myres 2026)
Said to be from a tomb at Ormidhia

The figure is handmade.

BIBLIOGRAPHY: Cesnola 1894, pl. XII.87.

In the main cities of Cyprus, espe-cially during the Cypro-Archaic period, the goddess Astarte was venerated in large temples, such as those at Kition and Palaepaphos, as well as in numerous rural sanctuar-ies (see general discussion in Ben-nett 1980, pp. 270–321). A cult of a female divinity existed on Cyprus from a much earlier period and was fostered further under the influence of the Phoenicians dur-ing the Iron Age. Numerous figu-rines appear in both sanctuaries and tombs. They show the goddess or her priestess nude or wearing a fine garment that allows the form of her body to be seen in detail. She wears elaborate jewelry, such as ear caps, earrings, and necklaces with pendants, which recalls de-scriptions of the goddess in the Homeric Hymns.

Her iconography was no doubt influenced by that of the East. She is usually mold-made and shown either with both arms extended along her sides (e.g., cat. no. 214) or with her hands supporting her breasts, a gesture directly con-nected with fertility. The type with hands holding the breasts was par-ticularly favored at Amathus (e.g., cat. no. 215; V. Karageorghis 1987a, pp. 21–22).

The frequent appearance of Astarte figurines in tombs, mainly of the early sixth century B.C., may be related to the idea of regenera-tion, a common theme in all peri-ods of Cypriot art and life.

214. Female figurine

Cypro-Archaic
(ca. 750–ca. 480 B.C.)
Terracotta
H. 34.6 cm (13⅝ in.)
74.51.1580 (Myres 2140)
Said to be from a tomb at Amathus

The tall figurine is mold-made, solid, and hollowed out at the back, where there are traces of finger marks. A flat plaque forms the background for her head and shoulders.

BIBLIOGRAPHY: Cesnola 1894, pl. XXIII.187.

215. Nude female figurine

Cypro-Archaic II
(ca. 600–ca. 480 B.C.)
Terracotta
H. 17.8 cm (7 in.)
74.51.1552 (Myres 2146)
Said to be from a tomb at Nicosia-Ayia Paraskevi

This Amathus-type figurine is mold-made and flat at the back. Her arms are bent in loops, each with a deep hollow inside.

BIBLIOGRAPHY: Doell 1873, p. 59, pl. XIV.11, no. 844; Cesnola 1877, pl. VI; Cesnola 1894, pl. III.19; J. Karageorghis 1977, p. 208.

216. Female figurine

Cypro-Archaic II
(ca. 600–ca. 480 B.C.)
Terracotta
H. 23.2 cm (9⅛ in.)
74.51.1579 (Myres 2144)
Said to be from a tomb at Amathus

The figurine is mold-made and hollowed out at the back. She stands against a flat plaque. The figure was broken at the lower part of the belly and is now repaired. She is standing naked under an umbrella(?) or wearing a long veil, indicated by a very wide crown(?) of rosettes shown with pellets above her head, demonstrating that the figure is the goddess herself.

BIBLIOGRAPHY: Cesnola 1894, pl. XXIV.193; J. Karageorghis 1977, p. 208.

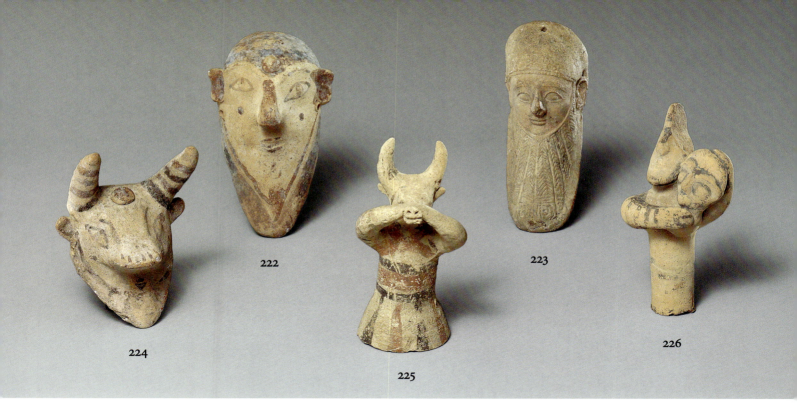

222

223

224

225

226

The two figurines below illustrate how some anthropomorphic and zoomorphic masks were used on Cyprus during the Cypro-Archaic period. Several, wearing or carrying masks or protomes, come from sanctuary and tomb contexts, especially in the regions of Amathus and Kourion. Similar figures were also crafted of limestone (cf. cat. nos. 194, 196, and 403; V. Karageorghis 1995, pp. 54–57). The wearers of the masks were probably priests or worshippers who participated in a ritual, possibly a dance. By wearing a mask that represented another person or a bull, the user acquired the qualities of that person or animal. Bull masks are usually associated with a male divinity.

In the Mediterranean world, wearing masks was an old custom that first appeared in the Near East, where images of people in masks are found on seals. In the Aegean, the wearing of masks appeared at

an early stage and is associated with the birth of Greek dramatic performances, which started as a form of religious ritual in honor of the god Dionysos.

225. Standing male figurine wearing a bull mask

Cypro-Archaic I
(ca. 750–ca. 600 B.C.)
Terracotta
H. 13 cm (5⅛ in.)
74.51.1619 (Myres 2046)
Said to be from a tomb at Ormidhia

The cylindrical body is wheel-made.

BIBLIOGRAPHY: Cesnola 1877, p. 51; Cesnola 1894, pl. XXVII.217; V. Karageorghis 1995, p. 56, pl. XXVIII.3, no. 1(x)b.5.

226. Standing bearded male figurine holding an anthropomorphic protome

Cypro-Archaic
(ca. 750–ca. 480 B.C.)
Terracotta
H. 13 cm (5⅛ in.)
74.51.1608 (Myres 2040)
Said to be from a tomb at Ormidhia

The protome may have been intended to represent a mask.

BIBLIOGRAPHY: Doell 1873, p. 61, pl. XV.6, no. 876; Cesnola 1894, pl. VIII.60; V. Karageorghis 1995, p. 54, fig. 29, no. 1(x)a.1.

Music was pleasing to divinities as well as to mortals. Terracotta figurines of musicians were often placed in sanctuaries and tombs; limestone figures are also frequently found in sanctuaries (cf. cat. nos. 197, 199). A small terracotta musician was less expensive to dedicate than one in limestone, however.

Male and female tambourine players are commonly represented, as rhythmic music often accompanied both sacred and festive dances. Other instruments depicted are the triangle, flute, and lyre.

Catalogue number 228 is among the earliest figurines of the Cypro-Archaic period. He wears a helmet and was probably playing a tambourine while dancing. The perforations on either side of the base indicate that the figurine had movable legs and belongs to a group of similar works that may have been used as toys (cf. V. Karageorghis 1995, p. 41, pls. XIX.9–11, nos. I[vii]1–3).

If the crown decorated with pellets can be taken as an indicator of gender, a second tambourine player (cat. no. 229) may be a female musician. It is more difficult to decide whether catalogue number 230 is male or female. The figure holds a tambourine against the chest, but it has been suggested that the round object held by this and other similar figurines (see also cat. no. 237) represents the disk of Astarte. The interpretation is unlikely, however, for some bearded figurines carry the same type of object. The spot on each cheek of catalogue number 230 may suggest that it represents a female; there is no other indication of gender. Although the piece is said to have been found at Idalion, its style and fabric point to the workshops of Amathus (cf. V. Karageorghis 1987a, pls. III–VII).

Two figurines (cat. nos. 231, 232) represent a style known mainly from the sanctuary at Kamelarga in Larnaca. Figurines in this style have mold-made faces and cylindrical wheel-made bodies (V. Karageorghis 1995, p. 33, with further references). The majority of the Kamelarga figurines are female, but often it can be difficult to identify the gender. Bearded and beardless pieces were made from the same mold; beards were added at a later stage of the production process. The style of these figurines warrants a sixth-century B.C. date.

One female figurine (cat. no. 237) sits on a proper throne with a backrest, holding a tambourine against her chest. She may represent a priestess of the Great Goddess.

In addition to the tambourine players, there is a musician with his head tilted backward, shown in the act of playing his flute (cat. no. 233). The style of this figure is the same as that of the early tambourine player (cat. no. 228) and of a male carrying a quadruped (cat. no. 264).

The instrument played by another female figurine (cat. no. 234) is not easy to identify. It is a metallic triangle, probably played with a metallic rod. Terracotta figurines from the Kamelarga sanctuary are often shown playing triangles. This figurine belongs stylistically to the Kamelarga group, despite its supposed provenance, Idalion.

Yet another female figurine (cat. no. 227) is heavily draped with a ceremonial dress and richly decorated with jewelry. She is mold-made, of a type that may date from about 500 B.C. She plays a lyre and may represent a priestess of the Great Goddess of the island.

227. Female musician with a lyre
Cypro-Archaic II
(ca. 600–ca. 480 B.C.)
Terracotta
H. 27.6 cm (10⅞ in.)
74.51.1670 (Myres 2166)
Said to be from Lapithos
 The figure is mold-made and hollow, with a vent in the coarsely made back.

BIBLIOGRAPHY: Cesnola 1894, pl. XXXIV.287; J. Karageorghis 1977, p. 216; Monloup 1994, p. 109 n. 4.

228. Standing male figurine
Cypro-Archaic I
(ca. 750–ca. 600 B.C.)
Terracotta
H. 14.5 cm (5¾ in.)
74.51.1692 (Myres 2042)
Said to be from a tomb at Ormidhia
 The figure is hollow and wheel-made. A bowl or a tambourine, which did not belong to the figure, was previously added, but it has been removed.

BIBLIOGRAPHY: Doell 1873, pp. 60–61, pl. XV.4, no. 875; Cesnola 1894, pl. VIII.58; V. Karageorghis 1995, p. 59, no. I(xi)9.

229. Tambourine player
Cypro-Archaic II
(ca. 600–ca. 480 B.C.)
Terracotta
H. 9.5 cm (3¾ in.)
74.51.1675 (Myres 2055)
Said to be from a tomb at Idalion
 The figure is handmade and solid.

BIBLIOGRAPHY: Cesnola 1894, pl. VI.40; J. Karageorghis 1977, p. 216; Meyers 1991, p. 17.

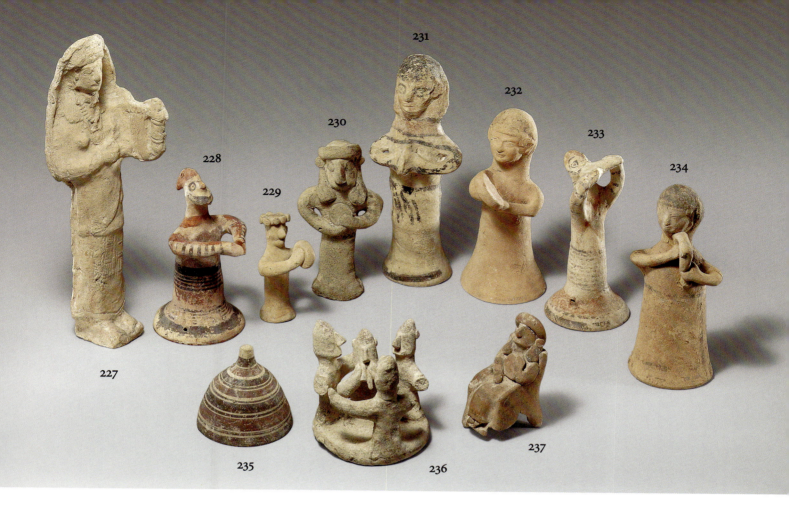

230. Standing figurine holding a disk, possibly a tambourine
Cypro-Archaic II
(ca. 600–ca. 480 B.C.)
Terracotta
H. 14.4 cm (5⅝ in.)
74.51.1682 (Myres 2054)
Said to be from a tomb at Idalion
 The figure is handmade and solid.

BIBLIOGRAPHY: Cesnola 1894,
pl. VII.46; J. Karageorghis 1977, p. 216.

231. Tambourine player in the Kamelarga style
Cypro-Archaic II
(ca. 600–ca. 480 B.C.)
Terracotta
H. 21 cm (8¼ in.)
74.51.1680 (Myres 2031)
Said to be from Salines, near Larnaca

The Kamelarga style is known from numerous other clay figurines. The figure is wheel-made and hollow, with a vent in the back of the head. The mold-made face is painted red.

BIBLIOGRAPHY: Cesnola 1894,
pl. VI.39; J. Karageorghis 1977,
p. 205.

232. Female tambourine player in the Kamelarga style
Cypro-Archaic II
(ca. 600–ca. 480 B.C.)
Terracotta
H. 17.2 cm (6¾ in.)
74.51.1679 (Myres 2030)
Said to be from Salines, near Larnaca

The figure is wheel-made and hollow, with a vent in the back of the head.

BIBLIOGRAPHY: Cesnola 1894,
pl. VI.43; Singer et al. 1956,
pp. 276–77, fig. 262; J. Karageorghis 1977, p. 205.

233. Standing male figurine playing a double flute
Cypro-Archaic I
(ca. 750–ca. 600 B.C.)
Terracotta
H. 14.9 cm (5⅞ in.)
74.51.1691 (Myres 2043)
Said to be from a tomb at Idalion
 The figure is wheel-made and hollow.

BIBLIOGRAPHY: Cesnola 1894,
pl. V.30; V. Karageorghis 1995, p. 38,
pl. XIX.2, no. I(vi)3.

234. Female musician
Cypro-Archaic II
(ca. 600 – ca. 480 B.C.)
Terracotta
H. 17.3 cm (6⅞ in.)
74.51.1668 (Myres 2035)
Said to be from a tomb at Idalion

The figure is wheel-made and hollow; the head is mold-made and hollow with a vent at the back.

BIBLIOGRAPHY: Cesnola 1877, p. 51; Cesnola 1894, pl. V.32.

235. Bell
Cypro-Archaic (ca. 750 – ca. 480 B.C.)
Terracotta
H. 6.8 cm (2⅝ in.); diam. 7.6 cm (3 in.)
74.51.960 (Myres 741)

The bell is wheel-made and has a knob on the top, set to one side. There is a perforation below the knob.

Bells of this type, rendered in bronze, formed part of the gear of horses at the beginning of the Cypro-Archaic period. This clay model may have been used as a toy. Bells have come from tombs at Palaepaphos, Amathus, and elsewhere. They date from the Cypro-Archaic I–II periods (V. Karageorghis 1996, p. 88).

236. Round dance
Cypro-Archaic (ca. 750 – ca. 480 B.C.)
Terracotta
H. 9.5 cm (3¾ in.)
74.51.1650 (Myres 2118)
Said to be from Lapithos

Three male dancers encircle a central male figure playing a double flute. The composition is handmade, with all the figures attached to a single circular disk.

There are black diagonal bands on the front of the bodies and black horizontal bands across the shoulders.

Compositions of figures dancing in a circle around a sacred tree or around a flute player are common in the coroplastic art of the Cypro-Archaic period, and the earliest compositions date from the eleventh century B.C. The figures are both male and female; sometimes the dancers are female and the musician is male (cf. V. Karageorghis 1995, pp. 132–37). These scenes may be associated with religious performances. A paved ring or floor for such dances has been discovered in the sanctuary of Apollo Hylates at Kourion and may date from the Late Classical period (Buitron and Soren 1979, pp. 24–25).

BIBLIOGRAPHY: Cesnola 1894, pl. XXXIII.279; V. Karageorghis 1995, p. 133, pl. LXXVIII.4, no. III(i)5.

237. Female figurine wearing a long robe
Late Cypro-Archaic II
(ca. 600 – ca. 480 B.C.)
Terracotta
H. 9.7 cm (3⅞ in.)
74.51.1685 (Myres 2180)
Said to be from Idalion

The figure is handmade and solid. Both arms are bent forward to hold a disk-shaped object, possibly a tambourine, against her chest.

BIBLIOGRAPHY: Cesnola 1894, pl. VII.53.

A sizable number of terracotta figurines found in tombs represent a simple cart (without horses

or mules), with one or more reclining male figures. They are shown in a leisurely mood. In one case (cat. no. 239), a passenger plays a flute. The figurines may represent people going to a feast (cf. V. Karageorghis 1995, pp. 121–23).

238. Model for a chariot
Cypro-Geometric III
(ca. 850 – ca. 750 B.C.)
White Painted III Ware
H. 10.2 cm (4 in.)
74.51.1108 (Myres 410)

The model is wheel-made, with perforations through the sides for the axle and at the front for a tubular pole. A band of broad crosshatching runs along the inside, below the rim.

Chariots were popular on Cyprus from the Late Bronze Age on, for warfare and, probably, for transport. They continued to be used during the first millennium B.C.; Herodotus (5.113) mentions that chariots were employed in warfare on Cyprus as late as the Classical period, in the fifth century B.C. (see cat. no. 353), when they were used only for ceremonial purposes in Greece (Crouwel 1992, p. 105). Many clay models of chariots with horses have been found as offerings in sanctuaries, particularly that of Ayia Irini.

The wheel-made type of terracotta chariot without horses, such as this one, usually has a male figure inside the chariot box, but there are no traces of a charioteer in the piece shown here. Although several examples of the wheel-made type without horses have been found, they all, unfortunately,

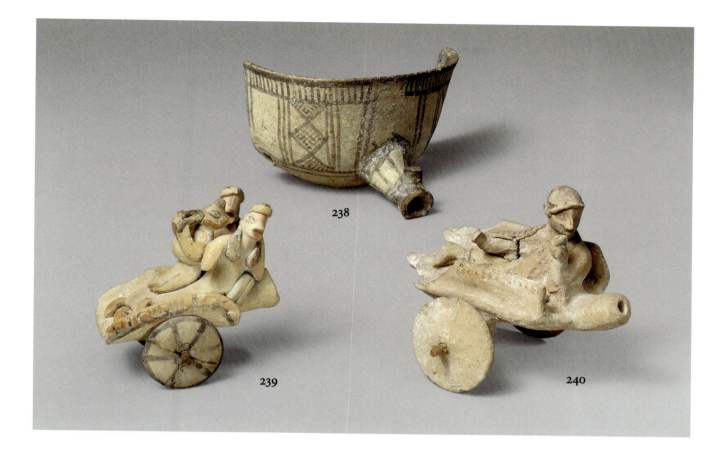

lack an exact provenance. Stylistically, they belong to the Cypro-Geometric III–Cypro-Archaic I periods, because their painted decoration resembles that of contemporaneous pottery (V. Karageorghis 1995, pp. 101–3).

239. Model of a cart with three human figures

Cypro-Archaic II
(ca. 600–ca. 480 B.C.)
Terracotta
H. 10.8 cm (4¼ in.)
74.51.1792 (Myres 2110)
Said to be from a tomb at Alambra

The model is handmade. Two human figures recline side by side on the floor of the cart, supported by cushions under their left and right elbows, respectively. A third, smaller human figure sits on their laps and plays the double flute. The flute player wears a conical headdress; a double flute is held to his mouth with a horizontal band (*phorbeia*). The other figures wear turbans around their heads; one, with long locks of hair falling on the chest, may be a woman. The outer figure is a bearded man. They both wear long tunics that reveal only their feet. They seem to have open mouths, indicating that they are singing.

BIBLIOGRAPHY: Doell 1873, p. 62, pl. XIV.15, no. 940; Cesnola 1894, pl. XIV.108; Crouwel 1985, pp. 204, 206, 209, 212, 217, pl. XXXI.4, no. TM1; J. Karageorghis 1991,
p. 167; V. Karageorghis 1995, p. 122, pl. LXXIII.5, no. II(iv)5.

240. Model of a cart with a human figure

Cypro-Archaic II
(ca. 600–ca. 480 B.C.)
Terracotta
H. 12.1 cm (4¾ in.)
74.51.1802 (Myres 2111)
The model is handmade.

BIBLIOGRAPHY: Crouwel 1985, pp. 204, 212, 218, pl. XXXIII.7, no. TM34; V. Karageorghis 1995, p. 122, pl. LXXIII.4, no. II(iv)4.

Riding a horse, in warfare or for transport, was the privilege of an elite society. On some occasions, to honor the dead, horses were sacrificed and placed in the dromoi of royal tombs, such as those at Salamis and elsewhere on Cyprus (V. Karageorghis 1973, pp. 12, 120). Terracotta representations of horses have been found in sanctuaries and tombs (V. Karageorghis 1996, pp. 23–28).

Figurines of horses carrying a rider were common during the Cypro-Archaic I–II periods. Some date from as early as the Cypro-Geometric III period. Horses with high arched necks normally date from the Cypro-Archaic I period (e.g., cat. no. 242).

The coroplast of the pair of horses (cat. no. 241) created a peculiar figurine. Showing a single body with two heads was a conventional way of representing two animals side by side. The piece recalls a group of horse-and-rider figurines of the Cypro-Archaic I period that have been associated with acrobatic circus performances on ancient Cyprus; a performer would have stood with a foot on each of two horses (V. Karageorghis 1995, p. 69; cf. cat. no. 153).

One rider (cat. no. 243) sits sideways. This position, which appears earlier among some Late Bronze Age and Cypro-Geometric period figurines, occurs again in the Cypro-Archaic period. Perhaps it was reserved for women or dignitaries. It is not easy to determine why the rider on this figurine sits sidesaddle (cf. V. Karageorghis 1995, p. 94).

Horse-and-rider figurines were particularly suited as offerings to a male divinity, and numerous examples have been found in the sanctuary of Apollo Hylates at Kourion (Young and Young 1955, pp. 54–169). Horses with the characteristic regional style of Kourion are portrayed with a conical topknot and a thick tail. The horses may wear a breastplate and tassels around the neck. The rider is helmeted, and his legs are fully rendered; sometimes he wears trousers, as in catalogue number 244. Black, red, and, occasionally, yellow richly decorate both the horses and the riders (cf. Young and Young 1955, pp. 57–59). The painted decoration is often applied on a white undercoat that covers the entire surface of the figurine. Catalogue numbers 244 and 246 are representative of the high quality that the Kourion coroplasts attained.

The vigor and elegance of horse-and-rider figurines of the Cypro-Archaic I period was lost during the Cypro-Archaic II period, as is evident in an example that shows the rider seated sidesaddle (cat. no. 247). The animal is probably a donkey, judging by its long ears. A work from the same period (cat. no. 245) is unusual and no doubt depicts a scene from everyday life. The jars on the donkey's back show that, by the Cypro-Archaic II period, animals other than horses were used for riding and transport. The contents of the jars may have been wine or olive oil. Myres asserted that the jars were in panniers and that their form is characteristic of work from the seventh and sixth centuries B.C. (1914, p. 343).

241. **Pair of horses with a common body**
Cypro-Archaic I
(ca. 750–ca. 600 B.C.)
Terracotta
H. 15.1 cm (6 in.)
74.51.1766 (Myres 2081)
Said to be from Ormidhia

BIBLIOGRAPHY: Cesnola 1894, pl. LXX.643; V. Karageorghis 1996, p. 28, pl. XIII.7, no. G.25.

242. **Figurine of a horse and rider**
Cypro-Archaic I
(ca. 750–ca. 600 B.C.)
Terracotta
H. 23.5 cm (9¼ in.)
74.51.1771 (Myres 2088)
Said to be from Ormidhia

BIBLIOGRAPHY: Cesnola 1894, pl. LXXII.651; V. Karageorghis 1995, p. 65, pl. XXXII.1, no. II(i)a.22.

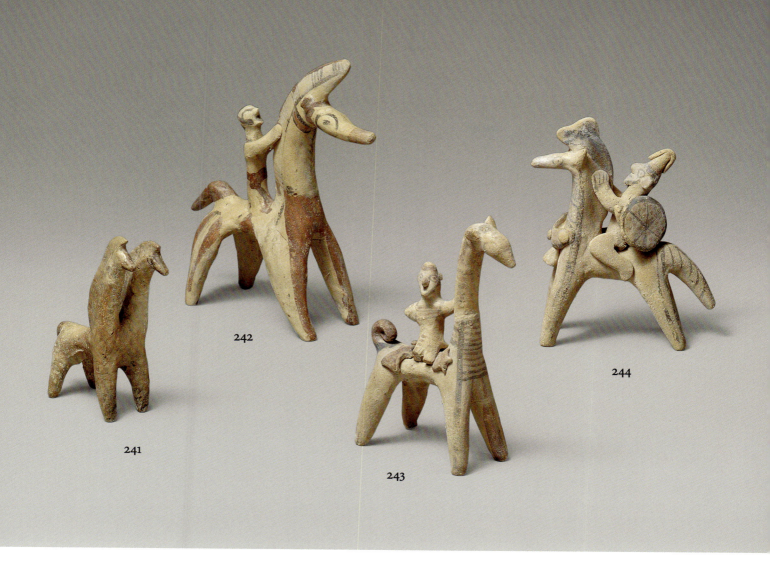

242

241

244

243

243. Figurine of a horse and rider
Cypro-Archaic I–II
(ca. 750–ca. 480 B.C.)
Terracotta
H. 19.9 cm (7⅞ in.)
74.51.1772 (Myres 2086)
Said to be from a tomb at Idalion

 The animal was described by
Cesnola, a professional cavalry offi-
cer, as a "camel with somewhat the
aspect of a giraffe."

BIBLIOGRAPHY: Cesnola 1894,
pl. LXIX.636; V. Karageorghis 1995,
p. 94, pl. XLIX.1, no. II(i)d.2.

244. Figurine of a horse and rider
Cypro-Archaic I–II
(ca. 750–ca. 480 B.C.)
Terracotta
H. 19.1 cm (7½ in.)
74.51.1778 (Myres 2093)
Said to be from the temple of
Apollo Hylates at Kourion

BIBLIOGRAPHY: Cesnola 1894,
pl. LXXII.655; Myres 1933, pp. 35
n. 26, 36 n. 32; Crouwel and Tatton-
Brown 1988, p. 82, pl. XXVI.3;
V. Karageorghis 1995, pp. 73–74,
pl. XXXVII.2, no. II(i)b.16.

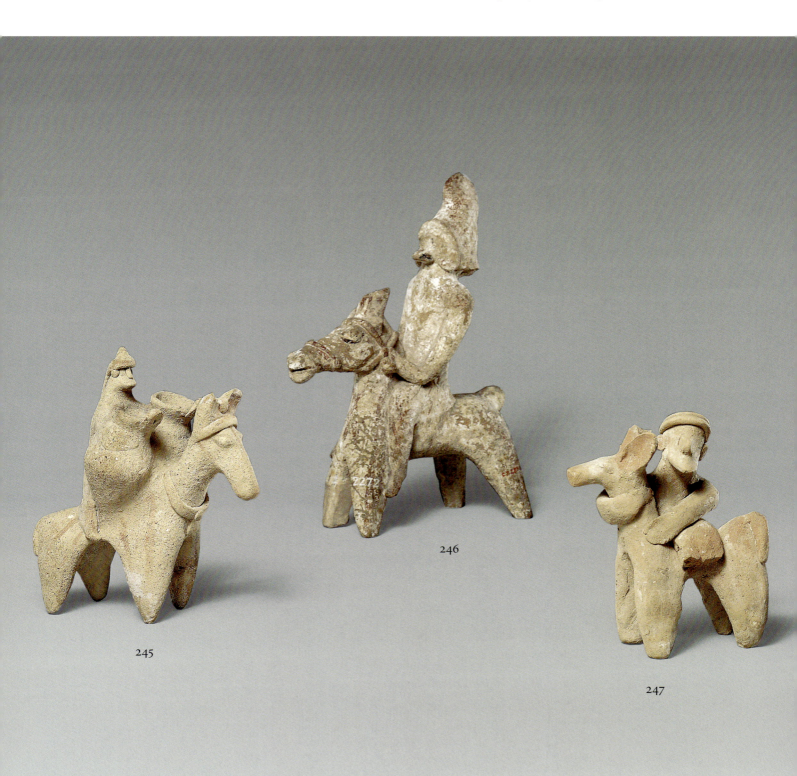

245

246

247

248. Standing figurine of an Assyrian-type male
Cypro-Archaic (ca. 750–ca. 480 B.C.)
Terracotta
H. 41.5 cm (16⅜ in.)
74.51.1713 (Myres 2170)
Said to be from a tomb at Kouklia (Palaepaphos)

The figure is mold-made and hollow. A large portion of the front of the body below the waist was missing and is now restored. The back is complete, but roughly rendered, and has a vent.

Mold-made male figures such as this one are usually categorized as Assyrian or Phoenician. Their facial characteristics and drapery are unlike those of standard Cypriot figures. The Phoenicians may have introduced molds for this type of figurine, made not only as free-standing works but also as warriors and charioteers in chariot models. The example here is by far the largest ever found. The type is known not only on Cyprus but also on Samos, where it is dated to the mid-seventh century B.C. The type continues into the later sixth century B.C. (cf. V. Karageorghis 1995, pp. 19–23, 113–15).

BIBLIOGRAPHY: Cesnola 1894, pl. IX.70.

249. Figurine of a shield bearer
Cypro-Archaic II
(ca. 600–ca. 480 B.C.)
Terracotta
H. 15.1 cm (6 in.)
74.51.1657 (Myres 2100)
Said to be from Idalion

BIBLIOGRAPHY: Doell 1873, p. 60, pl. XV.5, no. 874; Cesnola 1877,

p. 203; Cesnola 1894, pl. IX.67; Myres 1933, pp. 35 n. 26, 36 n. 37.

250. Warrior group
Cypro-Archaic II(?)
(ca. 600–ca. 480 B.C.)
Terracotta
H. 15.1 cm (6 in.)
74.51.1644 (Myres 2102)
Said to be from a tomb at Episkopi, near Kourion

Two warriors stand on a flat, oblong plaque, with which the lower parts of their bodies are integrated.

BIBLIOGRAPHY: Cesnola 1894, pl. X.74; Myres 1933, pp. 35 n. 26, 36 n. 37; V. Karageorghis 1995, p. 137, pl. LXXIX.2, no. III(ii)3.

During the Cypro-Archaic period, clay models of shields, usually round and with a central spike, were placed in sanctuaries and tombs. Occasionally, a mold-made omphalos in the shape of an animal's head juts out from the center. The outside surfaces of the shields are painted black and red in the style of Bichrome Ware vases of the Cypro-Archaic I–II periods (e.g., cat. no. 252; cf. V. Karageorghis 1996, pp. 83–87). Catalogue number 251 is unique because it is decorated in the pictorial style.

251. Votive shield
Cypro-Archaic
(ca. 750–ca. 480 B.C.)
Terracotta
Diam. 16.5 cm (6½ in.)
74.51.5882 (not in Myres)

The shield is wheel-made, and part of it is missing. It has a conical pointed spike.

252. Votive shield
Cypro-Archaic
(ca. 750–ca. 480 B.C.)
Terracotta
Diam. 16.5 cm (6½ in.)
74.51.1260 (Myres 554)
Said to be from Alambra

The shield is wheel-made, rather shallow, and slightly deformed. It has a central pointed spike and a handle on the inside.

BIBLIOGRAPHY: Cesnola 1894, pl. LXXXIX.774; Myres 1933, p. 36 n. 37; V. Karageorghis 1996, p. 86, pl. XLIX.5, no. Y.a.8.

Clay models of boats, with or without crew, appear on Cyprus during the Middle Bronze Age and later. There are several models from Cypro-Archaic tombs at Amathus (e.g., cat. no. 254) and elsewhere. The reappearance of boat models in the Archaic period may be the result of the enhancement of Cypriot maritime trade through Phoenician involvement in the affairs of the island (V. Karageorghis 1995, p. 128). One of the most detailed boat models known is seen here (cat. no. 253). Others are much simpler (V. Karageorghis 1995, pp. 128–31; see also V. Karageorghis 1996, pp. 72–77, for models of ships without a crew).

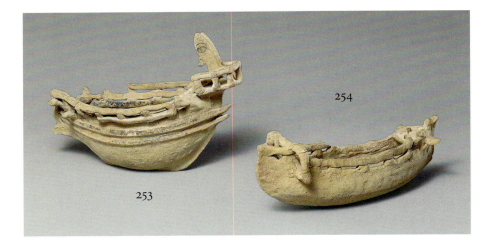

254

253

253. **Model of a warship**
Cypro-Archaic
(ca. 750–ca. 480 B.C.)
Terracotta
H. 10.7 cm (4¼ in.); L. 25.7 cm
(10⅛ in.); H. (with helmsman):
17.8 cm (7 in.)
74.51.1752 (Myres 2127)
Said to be from a tomb at Amathus

A single figure sits with his back against the poop deck and his arms extended to touch the gunwale. The hull of the ship is broad, with a rounded bottom and a pronounced keel. There is a ram(?) at the bow. Below the gunwale there are two parallel strakes in relief. Two horizontal parallel planks are above the gunwale. The upper one is inside and the lower one is outside, forming a bulwark. They are fastened to the frames that project separately above the hull. There are catheads for the anchor in the bow. At the stern there is a semicircular gallery with a rail on short thick stanchions. Between the bulwark and the stern there is a crossbeam projecting on both sides of the hull. A small thwart is inside the hull, below the crossbeam. A mast

socket is inside the hull. Traces of black and red paint are on the outside and the mast socket. This is one of the most accurately rendered models of a warship known. The preceding description relies on Westerberg (1983) and Basch (1987). The latter discusses in detail the various parts of the ship and their function.

BIBLIOGRAPHY: Cesnola 1877, p. 259, top drawing; Cesnola 1894, pl. LXXVII.702; Westerberg 1983, pp. 41–42, 48, 50–51, 53, 57, 61, 63, 66, fig. 50, no. 50; Basch 1987, pp. 250, 252–54, figs. 536–42; V. Karageorghis 1995, p. 130, pl. LXXVI.4, no. II(vi)10.

254. **Boat model**
Cypro-Archaic
(ca. 750–ca. 480 B.C.)
Terracotta
L. 25.6 cm (10⅛ in.)
74.51.1750 (Myres 2128)
Said to be from a tomb at Amathus

The model is handmade and roughly rendered. It has horizontal strakes, an open bulwark, a gallery at the stern with two large portholes for the anchors, and promi-

nent catheads at the bow. A human figure said to be in the boat is not visible. Traces of diluted red paint are on the stern and prow.

BIBLIOGRAPHY: Cesnola 1894, pl. LXXVII.701; Westerberg 1983, pp. 42–43, 48, 55, 57, 61, 63, 66, fig. 51, no. 51; Basch 1987, pp. 254, 258, fig. 558; V. Karageorghis 1995, p. 131, pl. LXXVI.3, no. II(VI)11.

Animals and Monsters

255. **Centaur**
Cypro-Archaic II
(ca. 600–ca. 480 B.C.)
Terracotta
H. 12.1 cm (4¾ in.)
74.51.1662 (Myres 2065)
Said to be from a tomb at Idalion

The centaur is handmade and solid, with a cylindrical animal body. He has human forelegs with prominent knees and small feet. The tail is broken. He holds a fragmentary red-painted shield in his left arm.

Monsters, especially centaurs, are popular in Cypriot art (cf. V. Karageorghis 1996, pp. 1–9). They may have associations with religious beliefs that concern the forces of nature. Several figurines of centaurs or minotaurs were found among the offerings in the sanctuary at Ayia Irini. Centaurs are usually represented as human figures from the waist upward, with the section representing a horse added to the back of the torso.

BIBLIOGRAPHY: Perrot and Chipiez 1885, p. 200, fig. 135; Cesnola 1894, pl. XXVII.218; Myres 1933, p. 35 n. 25; V. Karageorghis 1996, p. 8, pl. VI.3, no. A.22.

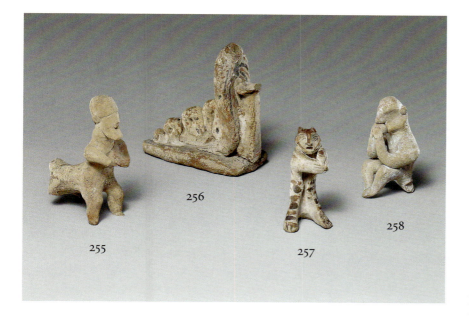

255 256 257 258

256. Snake

Cypro-Archaic (ca. 750–ca. 480 B.C.)
or Cypro-Classical (ca. 480–
ca. 310 B.C.)
Terracotta
H. 13.8 cm (5⅜ in.); L. 14.5 cm
(5¾ in.)
74.51.1760 (Myres 2132)

The body of the snake, meant to
be a cobra, rests on a triangular
plaque; the vertical coils become
higher toward the head. The fore-
part is upright, attached to a col-
umn, which has what appears to be
a shallow bowl at the top. The head
of the snake is broken. Between the
bowl and the cobra is what looks
like a baby cobra, its head missing,
the upper half of its body just
above the rim of the bowl. The
group was made in several pieces
that were joined together: the coil-
ing body, the front of the body, the
baby cobra, the column and bowl,
and the plaque.

The piece probably reflects Egyp-
tian prototypes that are found in
various media. Often the cobra,

protector of the pharaoh, is associ-
ated with other figures such as Bes
(cf. cat. no. 195).

BIBLIOGRAPHY: V. Karageorghis
1996, p. 47, pl. XXVIII.1, no. Q.a.1.

Monkeys and bears were popular
in the coroplastic art of the Cypro-
Archaic period. These animals ex-
isted in the Mediterranean area at
that time, perhaps even on Cyprus.
As they are today, they were seen
then as objects of fun. Terracotta
figurines of monkeys and, more
rarely, of bears found on Cyprus
usually show the animals in natu-
ralistic positions, suggesting that
the coroplasts had personal knowl-
edge that allowed them to capture
exact postures (V. Karageorghis
1996, pp. 16–21). Catalogue num-
ber 258 was identified by Myres
(1914, p. 342) as a monkey because
of its posture, but it is more likely
to be a seated male (V. Karageor-
ghis 1995, p. 137, no. III[iii]2).

257. Monkey holding an unidentifiable object

Cypro-Archaic
(ca. 750–ca. 480 B.C.)
Terracotta
H. 9.4 cm (3¾ in.)
74.51.1645 (Myres 2068)
Said to be from a tomb at
Ormidhia

The object the monkey holds
was made by folding a flat plaque
of clay; it could be an infant mon-
key. The animal's rounded face
resembles that of a human.

BIBLIOGRAPHY: Cesnola 1894,
pl. XXVII.221; V. Karageorghis 1994,
p. 64, fig. 8, no. g; V. Karageorghis
1996, p. 19, pl. IX.9, no. E.C.16.

258. Seated male figurine

Cypro-Archaic (ca. 750–ca. 480 B.C.)
or Cypro-Classical (ca. 480–
ca. 310 B.C.)
Terracotta
H. 10.3 cm (4 in.)
74.51.1640 (Myres 2067)
Said to be from a tomb at Alambra

The figure holds a round red
object to his mouth, possibly a
fruit. Although the attitude is that
of a seated monkey, known from
early Greek zoomorphic vases,
nothing else in the anatomy of the
figure supports Myres's suggestion
that it is actually a monkey. Ces-
nola, in his description, misunder-
stood the stool and suggested that
the figure was originally seated
sidesaddle on a horse.

BIBLIOGRAPHY: Cesnola 1894,
pl. XI.82; V. Karageorghis 1995,
p. 137, pl. LXXIX.5, no. III(iii)2.

Scenes and Models of Everyday Life

As early as the prehistoric period, the Cypriot coroplast showed a particular talent for representing scenes from everyday life. In the Cypro-Archaic II period, such scenes are frequent and have been found in tombs, obviously to "remind" the dead of their activities in life. Representations of bread preparation—from the grinding of corn to the kneading of dough to baking—were favored. Similar scenes were common in the Levant and the Aegean during the same period.

Two figurines described below are characteristic (cat. nos. 260, 261). Catalogue number 260 shows a primitive way of baking bread, by placing the dough flat against the inside of the oven. A comparable object comes from a tomb at the palace of Vouni (Gjerstad et al. 1937, p. 315, pl. CV.1.32, Tomb 7, no. 32).

Whether catalogue number 265 represents a woman kneading dough is not certain, but her posture suggests this activity. Nor is it certain whether the piece formed part of a larger composition. Catalogue number 262, possibly a toy, may represent a figure engaged in the same activity. Similar toys were used in the Aegean. Whether this figure is male or female is unclear (cf. V. Karageorghis 1995, p. 143).

259. Six figures attached to a plaque

Cypro-Archaic (ca. 750 – ca. 480 B.C.)
Terracotta
H. 9.6 cm (3¾ in.); L. 15.3 cm (6 in.)
74.51.1440 (Myres 2116)
Said to be from Episkopi, near Kourion

In the middle of the group a seated figure leans on a staff that he holds in his right hand, while his left hand rests on his left knee. He wears a conical headdress, and his nose and ears are formed of pellets. To his right is another bearded figure, similarly rendered, who holds a small horned quadruped (a kid?). His torso is integrated with the plaque, but his legs are not indicated. The other figures are seated and rendered in the same way. In front and by the right foot of the central figure are two round, hollowed lumps of clay that may represent bowls. Behind him, on the left, stands a third figure, also with a nose and ears of pellets, but with a round head. He holds an unidentifiable object, now broken, in both hands; it has been interpreted as a cup or an umbrella. To his left, a fourth standing figure holds a circular shield on his left arm and, below it, a short dagger in a scabbard. He extends his right arm to touch the man next to him. He also wears a conical headdress, and his facial characteristics are like those of the others. In front of the shield bearer is a fifth person, whose torso is fixed to the plaque. Across his lap are the legs of a prostrate figure, whom he is beating with a flat stick held in his right hand. The prostrate figure has a conical headdress and pellet ears. Both his arms are flat on the ground and are slightly raised. His face touches the ground. All the figures are richly decorated with black and red paint.

This work has been described as "one of the most ambitious and lively representations attempted by the coroplasts of the Cypro-Archaic period" (V. Karageorghis 1995, p. 141). The scene consists of various figures who perform a specific act at a single moment in time. Exactly what the figures are doing is not easy to determine, however. One suggestion made by Cesnola is that the scene shows "a punishment before a judge" who is surrounded by his attendants (1894, pl. x.76). Myres agreed, comparing the judge to a Homeric king leaning on his staff of office (1914, pp. 346–47; for references to other interpretations of this scene, see V. Karageorghis 1995, pp. 140–41).

BIBLIOGRAPHY: Cesnola 1894, pl. x.76; V. Karageorghis 1995, pp. 140–41, pl. LXXXI.2, no. III(iv)1.

260. A woman baking bread in a circular oven

Cypro-Archaic (ca. 750 – ca. 480 B.C.)
Terracotta
H. 7.6 cm (3 in.)
74.51.1755 (Myres 2122)
Said to be from a tomb at Episkopi, near Kourion

The woman, whose original head is missing, leans over an open oven. With her right hand she is apparently placing dough on the hot inner surface. A circular hole near the base of the oven would function as a draft. Five flat circular disks, representing dough, line the interior wall of the oven.

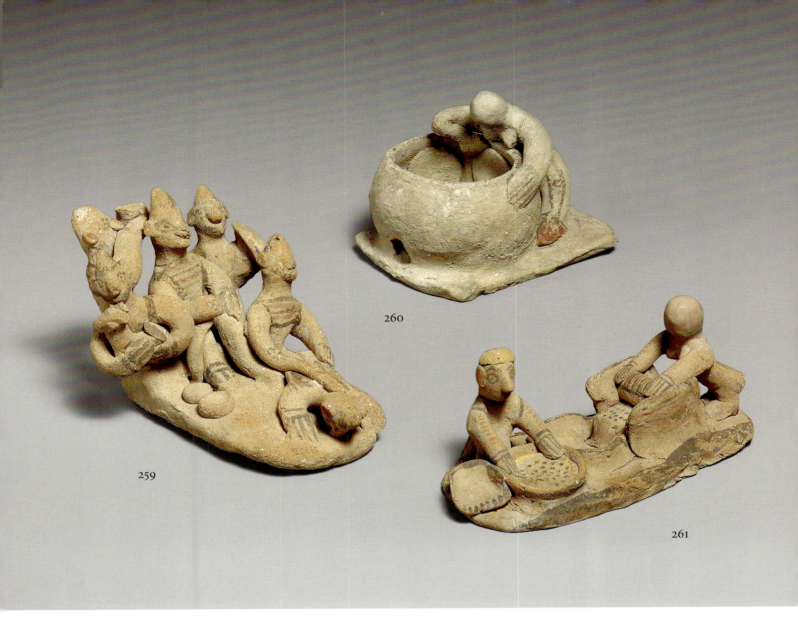

259

260

261

BIBLIOGRAPHY: Cesnola 1894,
pl. x.73; Sparkes 1962, p. 137, no. 79;
Sparkes 1981, p. 176, pl. 4a n. 27;
J. Karageorghis 1991, p. 153.

261. Two figures grinding and sieving corn

Cypro-Archaic (ca. 750–ca. 480 B.C.)
Terracotta
H. 6.2 cm (2½ in.); L. 15.4 cm
(6⅛ in.)
74.51.1643 (Myres 2120)
Said to be from a tomb at Episkopi,
near Kourion

The figures rest on an oblong, flat base. On the right a female figure, her original head missing, faces to the left. Her hands hold an elliptical stone implement, under which is a quern that rests inside a trough with upright sides. The grinding apparatus is bordered on three sides by a U-shaped enclosure. Dots of black paint on the stone implement indicate corn. On the left is a second figure who has no breasts, but the red spots on the cheeks suggest that this figure, too,

is female. She holds a sieve, which fits into a shallow receptacle, probably a wicker tray. At the far left of the composition is a shovel(?). Both figures sit, but there is no clear indication of their legs. There is only a support at their backs.

BIBLIOGRAPHY: Cesnola 1894,
pl. x.75; Sparkes 1962, p. 137, no. 80;
Vandenabeele 1986, p. 40, fig. 3,
no. 5; J. Karageorghis 1991, p. 150.

262. Toy in the form of a male(?) figure

Cypro-Archaic (ca. 750–ca. 480 B.C.)
Terracotta
H. 12.4 cm (4⅞ in.); L. 15.7 cm
(6⅛ in.)
74.51.1646 (Myres 2123)
Said to be from a tomb at
Ormidhia

The piece is modeled in the
round and formed of separate
pieces.

BIBLIOGRAPHY: Cesnola 1894,
pl. XXVII.220; Vandenabeele 1986,
p. 41, fig. 6, no. 3; J. Karageorghis
1991, p. 152; V. Karageorghis 1995,
p. 143, pl. LXXXII.4, no. III(v)5.

263. Figurine holding an amphora on her head

Cypro-Archaic I
(ca. 750–ca. 600 B.C.)
Terracotta
H. 18.3 cm (7¼ in.)
74.51.1617 (Myres 2038)
Said to be from a tomb at Episkopi,
near Kourion

The figure is wheel-made and
hollow. No hole connects the in-
terior of the amphora with the
interior of the head.

There are more than fifteen
known female figurines that have
wheel-made bodies and heads, fa-
cial characteristics and arms added
by hand, and a jar carried on the
head. It is not certain whether
figurines of this group have any
significance beyond the represen-
tation of a woman carrying a jar,
probably with water or some other
liquid in it.

BIBLIOGRAPHY: Cesnola 1894,
pl. XX.154.

264. Standing male figurine holding a quadruped

Cypro-Archaic I
(ca. 750–ca. 600 B.C.)
Terracotta
H. 16 cm (6¼ in.)
74.51.1613 (Myres 2041)
Said to be from a tomb at
Ormidhia

The figurine has a wheel-made
body with perforations on either
side of the lower edge for the
attachment of movable legs (see
also cat. nos. 225, 228). Offering an
animal to a god was a pious way of
seeking a favor or thanking a divin-
ity for fulfilled prayers (V. Kara-
georghis 1995, pp. 43–53). Whether
in the form of a small terracotta
figurine or a large limestone statue
(cf. cat. no. 200), a representation
of a gift to the god in a sanctuary
would serve to remind the divinity
eternally of that offering.

BIBLIOGRAPHY: Cesnola 1877,
p. 203; Perrot and Chipiez 1885,
pp. 188, 190, fig. 127; Cesnola 1894,
pl. VIII.55.

265. Female figurine kneading dough

Cypro-Archaic (ca. 750–ca. 480 B.C.)
Terracotta
H. 17.3 cm (6⅞ in.)
74.51.1624 (Myres 2121)
Said to be from a tomb at Idalion

BIBLIOGRAPHY: Doell 1873,
p. 877, pl. XV.1; Cesnola 1894,
pl. XXVII.222.

266. Model of a table

Cypro-Archaic (ca. 750–ca. 480 B.C.)
Terracotta
H. 7.3 cm (2⅞ in.); L. 12.2 cm
(4¾ in.); W. 5.9 cm (2⅜ in.)
74.51.1790 (Myres 2124)
Said to be from a tomb at Alambra

This work is one of only three
known table models from Cyprus.
The two with certain provenance
come from tombs (V. Karageorghis
1996, pp. 80–81). Three-legged
tables also appear in the Aegean
and the Near East. Their probable
date is the sixth century B.C. The
Cypriot examples are decorated
with paint, also the fashion for
contemporaneous vases.

BIBLIOGRAPHY: Cesnola 1894,
pl. XIV.111; Richter 1926, pp. 83–84,
fig. 200; Baker 1966, p. 258, fig. 405;
Richter 1966, pp. 67–68 n. 11,
fig. 345; V. Karageorghis 1996, p. 81,
pl. XLVI.2, no. X.a.2.

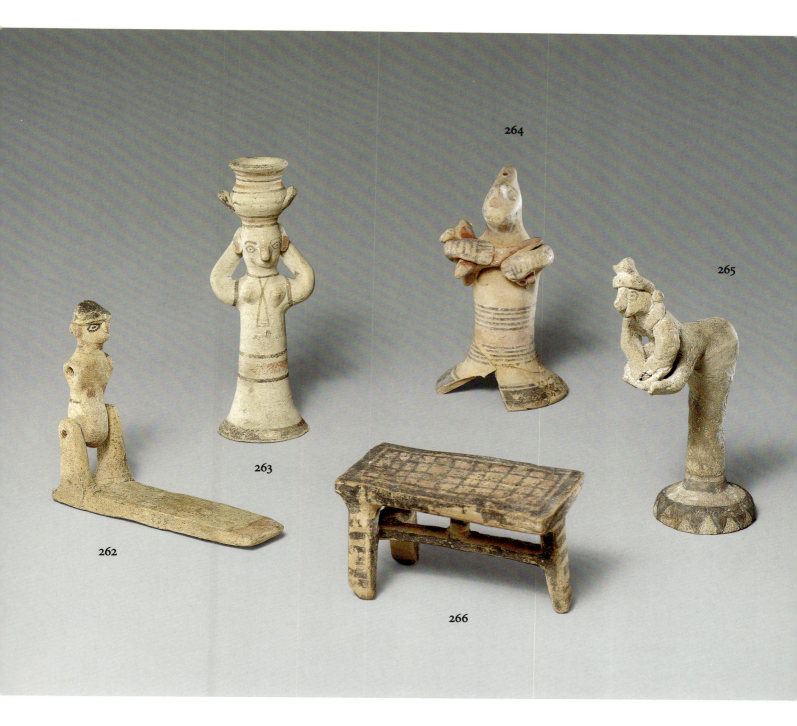

METALWORK

Weapons

Swords represented in the Metropolitan Museum by one complete and one fragmentary example (cat. nos. 268, 270) come from Cyprus and conform to the Homeric description of the silver-studded sword. The best-preserved weapon of this type comes from Royal Tomb 3 at Salamis (V. Karageorghis 1967, p. 45, no. 25). Besides the two fragmentary examples in the Cesnola Collection, there is one in the Fitzwilliam Museum, Cambridge. The piece in Cambridge comes from Tamassos, also from a royal tomb. Recently, another complete sword of this type was found in a Cypro-Archaic II tomb at Mari (Hadjicosti 1997). These swords, made for the Cypriot elite, may come from one or more specialized workshops; Salamis may have been a center of production.

267. Sword
11th–10th century B.C.
Iron and wood
L. 69.6 cm (27⅜ in.)
74.51.5671 (Myres 4725)
Said to be from Kourion

Traces of wood from the scabbard survive; the handle plates may have also been made of wood. The rivets are missing, but rivets on other swords from the same period are often made of bronze.

Swords of this type have been found in tombs of the Cypro-Geometric I period, such as that at Palaepaphos-Skales (V. Karageorghis 1983, pp. 24, 155, 230, 373). The form is Aegean and first appears

on Cyprus in bronze in the early twelfth century B.C. The first iron versions were produced on Cyprus.

BIBLIOGRAPHY: Cesnola 1903a, pl. LXXIV.2; Richter 1915, pp. 400–401, fig. 1462, no. 1462; Catling 1964, p. 116 n. 5.

268. Sword
Cypro-Archaic II
(ca. 600–ca. 480 B.C.)
Iron, silver, and bronze
L. 59.4 cm (23⅜ in.)
74.51.5670 (Myres 4726)
Said to be from Kourion (the "Kourion Treasure")

The broad, leaf-shaped blade bears traces of the wooden scabbard. The terminal of the semicircular tang is missing; the sides of the tang are lined with a silver band. The one surviving rivet is made of bronze; its head is covered with silver. Of the other rivets, only bronze corrosion survives. Silver binding protected the edges. Possibly there are traces of an iron sheath.

BIBLIOGRAPHY: Cesnola 1877, p. 335; Cesnola 1903a, pl. LXXIV.1; Richter 1915, pp. 401–2, fig. 1463, no. 1463.

269. Mace head
8th century B.C.
Bronze
H. 17.1 cm (6¾ in.); max. W. 7.6 cm (3 in.)
74.51.5594 (Myres 4768)
Said to be from a vault at Kourion (the "Kourion Treasure")

The weapon is cast and bifurcated, with each side ribbed in the form of a convex eight-petaled rosette. In the middle is a large transverse sockethole for the shaft.

Two bronze mace heads are

known; one was found in a Cypro-Geometric III–Cypro-Archaic I tomb from the eighth century B.C. The type originated, no doubt, in the Near East (Kourou 1994, p. 212). It has been suggested that the maces may have been used as symbols of authority by people who played an important role in the metal industry (Kourou 1994, p. 214). The most common form is the tubular type, or scepter. Several almost identical examples of this version have been found, mainly in tombs of the Archaic period (Kourou 1994, p. 212).

BIBLIOGRAPHY: Cesnola 1903a, pl. LI.2; Richter 1915, p. 458, fig. 1813, no. 1813; Gjerstad 1948, p. 142, fig. 24.12; Catling 1964, p. 261; Kourou 1994, pp. 212, 220, fig. 3.2, no. 8 (cites incorrect registry number).

270. Fragment from the tang of an iron sword
Cypro-Archaic II
(ca. 600–ca. 480 B.C.)
Iron, silver, bronze, and ivory
H. 12.1 cm (4¾ in.)
74.51.5672 (Myres 4727)

What appears to be a silver binding on either side of the border as well as three bronze rivets with silver heads are preserved. The cylindrical hilt retains plaques of ivory. The straps of silver were held to the hilt and to each other by means of a metallic, possibly silver, ring, now missing. Traces of the ring survive in the metal; grooves survive on the ivory. It is unclear whether there was originally a pommel.

BIBLIOGRAPHY: Richter 1915, p. 402, no. 1464.

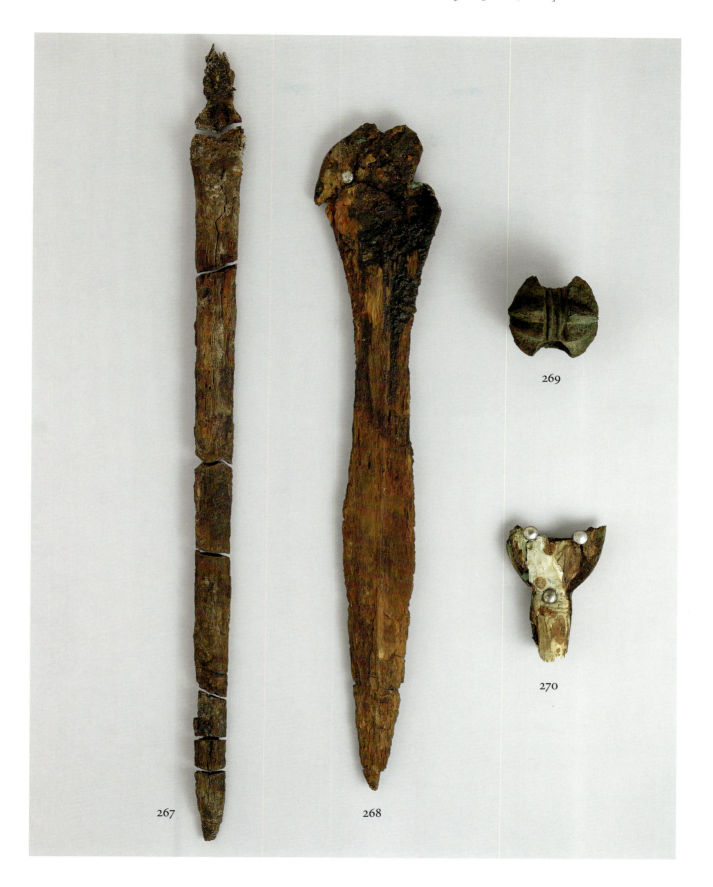

267

268

269

270

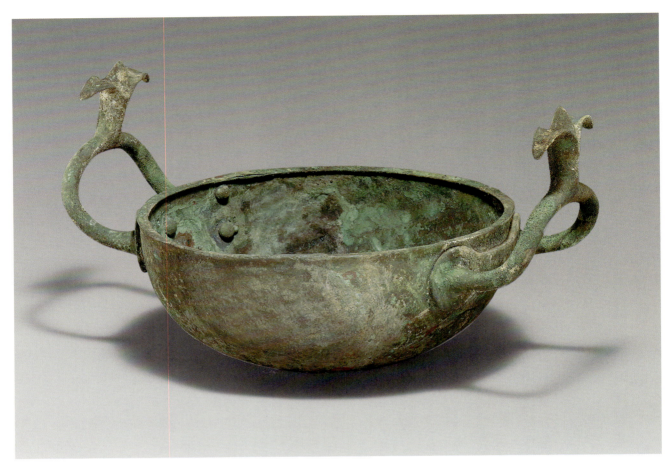

271

Vessels

Tombs of the Cypro-Geometric period at Palaepaphos contained bronze bowls whose handles were decorated with lotus flowers (V. Karageorghis 1983, pp. 124–25). Although the same type of bowl was also produced in the Cypro-Archaic period (see general discussion in Matthäus 1985, pp. 195–96), the examples shown here (cat. nos. 271, 272) are probably from the Cypro-Geometric period. A similar pair of large handles from Cyprus is now in the British Museum, London (Matthäus 1985, p. 195, no. 472). This type of bowl may have originated on Cyprus. Matthäus notes that the lotus-

flower motif may derive from Near Eastern sources (1985, p. 126). Bowls with lotus-flower handles have been found in the Levant, the Aegean, and Italy (cf. also Tatton-Brown 1997, p. 34, and, earlier, Chavane 1982, pp. 31–33). Most recently, several examples were found on Crete (Stampolides 1994, p. 30; Catling 1996, pp. 561–62). From the late Cypro-Geometric III period, there are numerous small clay examples of this type in Black Burnished Ware. They were made in Phoenicia and exported to Cyprus (Bikai 1981, p. 27).

271. Bowl with handles in the shape of lotus flowers

Cypro-Geometric III
(ca. 850–ca. 750 B.C.)
Bronze
H. 15 cm (5⅞ in.); H. (with handles): 27 cm (10⅝ in.); diam. 34.6 cm (13⅝ in.)
74.51.5673 (Myres 4914)
Said to be from Kourion (the "Kourion Treasure")

The two loop handles are riveted to the body through thick figure-eight–shaped attachments. Five rivets with hemispherical heads can be seen inside the bowl.

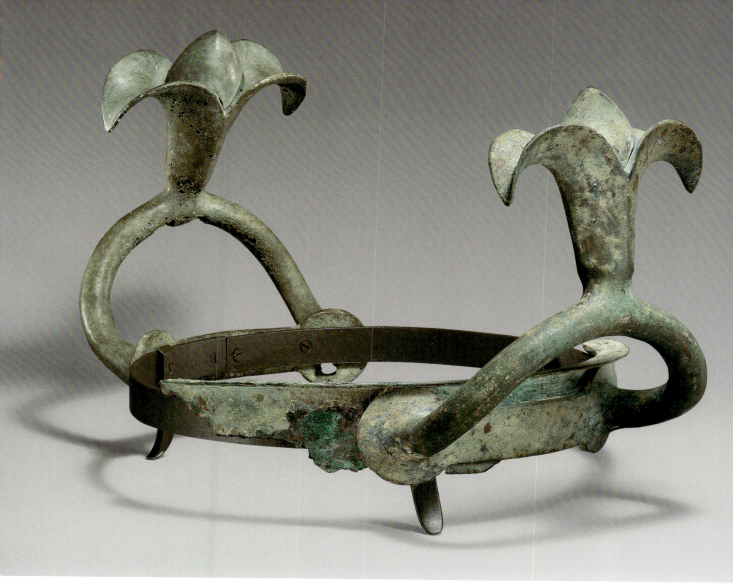

272

BIBLIOGRAPHY: Cesnola 1903a, pl. XLIV.1; Richter 1915, pp. 200–201, fig. 533, no. 533; Matthäus 1985, pp. 195–96, pl. 52, no. 470.

272. **Rim of bowl with handles in the shape of lotus flowers**

Cypro-Geometric III
(ca. 850–ca. 750 B.C.)
Bronze
Max. H. (of handles): 31.9 cm
(12½ in.); reconstructed diam.
(of bowl): 40.7 cm (16 in.)
74.51.5674 (Myres 4915)
Said to be from Kourion (the
"Kourion Treasure")

Only the rim of the bowl and its
two horizontal loop handles sur-
vive. The handles were riveted to
the bowl below the rim by means
of an oblong flat attachment.

BIBLIOGRAPHY: Cesnola 1877, p. 339, pl. XXX; Cesnola 1903a, pls. LIII.1, 2; Richter 1915, p. 201, fig. 534, no. 534; Matthäus 1985, pp. 195–96, pl. 50, no. 471.

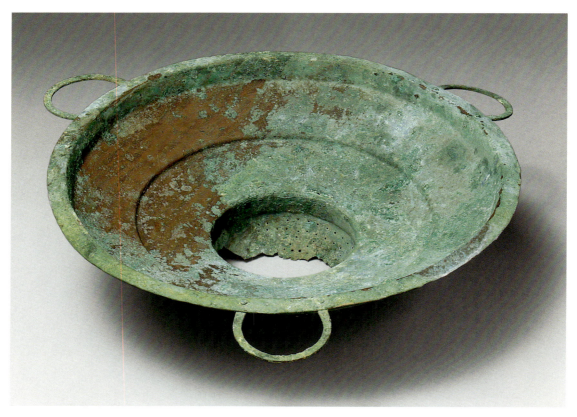

273

273. Strainer

10th century B.C.
Bronze
H. 12.2 cm (4¾ in.); diam. 37.5 cm
(14¾ in.)
74.51.5611 (Myres 4935)
Said to be from a vault at Kourion
(the "Kourion Treasure")

The strainer has a shallow con-
ical body with a stepped profile,
a flat, out-turned rim, and three
horizontal loop handles that are
riveted below the rim. The sieve
is broken.

Two- or three-handled bronze
strainers were copied in clay dur-
ing the Cypro-Geometric I period
and later. Recent discoveries at
the necropolises of Palaepaphos-
Skales and Amathus yielded both

the bronze and the clay variants
(V. Karageorghis 1983, pp. 363,
372; Karageorghis and Iacovou
1990, p. 95). The prototype for the
shape may be Near Eastern, but
the Cypriots quickly assimilated
the strainer bowl into their own
repertoire of shapes. In particular,
the strainer was adopted by the
elite of society in the tenth cen-
tury B.C. (cf. V. Karageorghis
1983, p. 76).

BIBLIOGRAPHY: Cesnola 1903a,
pl. XLVIII.1; Richter 1915, p. 231,
fig. 640, no. 640; Gjerstad 1948,
p. 152, fig. 29.2; Matthäus 1985,
pp. 262, 266, pl. 77, no. 577.

274. Phrygian bowl

Probably 7th or 6th century B.C.
Bronze
H. 4.7 cm (1⅞ in.); diam. 28 cm
(11 in.)
74.51.5617 (Myres 4917)
Said to be from Kourion (the
"Kourion Treasure")

Bowls of this type are called
"Phrygian," after the region in
Anatolia where many examples
have been discovered (see Matt-
häus 1985, pp. 134–36, for a general
discussion of the type). The con-
centration of bowls in that area—
particularly in tombs at the site of
Gordion—and their high quality
suggest that they were manufac-
tured there. Phrygian bowls were
made from the eighth through the

sixth century B.C. They may have served for drinking or pouring libations. Their movable handles would have been awkward when the vessels were full, so they probably allowed the bowls to hang on walls when not in use. The flattened shape of this example suggests that it dates from the seventh or sixth century B.C. The shape of the band around the rim of the vessel differs from that of bowls found in Phrygia. Currently, however, it is not possible to determine whether this example was imported or made on Cyprus.

BIBLIOGRAPHY: Cesnola 1877, p. 339, pl. XXX; Cesnola 1903a, pl. XLVII.4; Richter 1915, pp. 203–4, fig. 538, no. 538; Gjerstad 1948, p. 152, fig. 28.19; Richter 1953, p. 33 n. 27, pl. 21.f; Matthäus 1985, pp. 134–36, pls. 26, 27, no. 373.

275. Phiale
Cypro-Archaic I–II
(ca. 750–ca. 480 B.C.)
Bronze
H. 4.9 cm (1⅞ in.); diam. 11.3 cm
(4½ in.)
74.51.5597 (Myres 4930)

Shallow bowls, or phialai, with a central omphalos were common on Cyprus during the late Cypro-Archaic period (Matthäus 1985, pp. 139–46). However, the type represented here, with a hemispherical body, is rare (Matthäus 1985, p. 146).

BIBLIOGRAPHY: Richter 1915, p. 215, fig. 585, no. 585; Matthäus 1985, p. 146, pl. 30, no. 402.

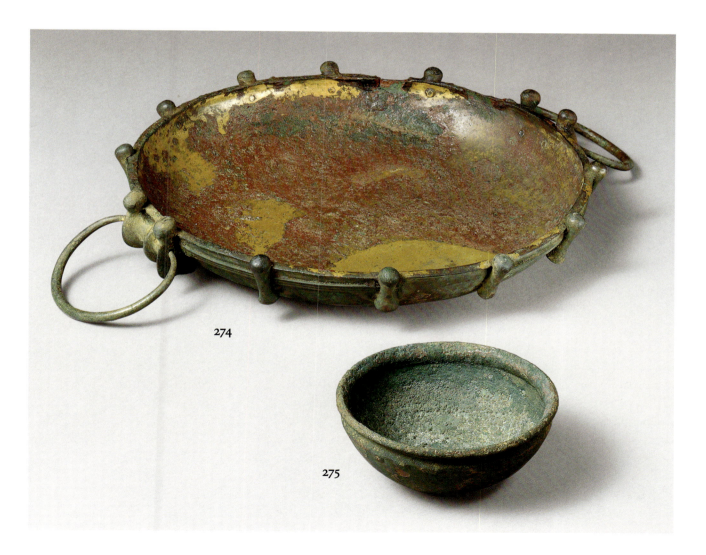

274

275

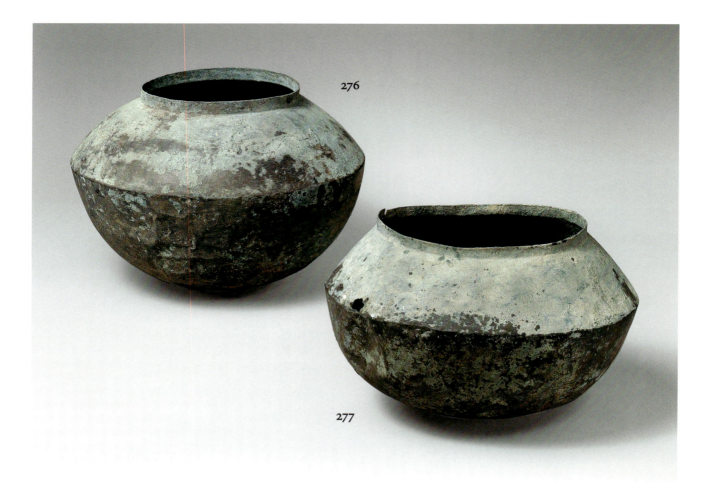

276

277

Although several examples of cal-
drons from Cyprus are known,
there is little information to eluci-
date the date and function of the
type seen here (cat. nos. 276, 277).
In his study of the form, Matthäus
noted that these vessels were placed
in tombs during the Cypro-Archaic
period (for a detailed discussion of
the type, see 1985, pp. 201–5). The
form may have antecedents in the
late Cypro-Geometric period and
it may have survived into the Clas-
sical period. The best chronological
evidence for the vessels comes from
a series of caldrons found in the
royal tombs at Tamassos, in cen-
tral Cyprus, that date from the
sixth century B.C., or the Cypro-

Archaic II period (Matthäus 1985,
p. 203). Unlike caldrons of slightly
different form, the round-bodied
handleless type with a carinated
shoulder does not seem to have
been used for the burial of human
remains. Instead, such caldrons
were placed in tombs as part of
the funerary offerings. The origin
of the form probably lies in Greece,
where vessels of the same shape
occur in contexts that date from
the Middle Geometric period
into the eighth century B.C. Several
examples come from the Athenian
Kerameikos, where they functioned
as urns. The exact chronological
and functional connections be-
tween the caldrons used in Greece

and those used later on Cyprus are
unknown.

276. **Caldron**
Probably Cypro-Archaic
(ca. 750–ca. 480 B.C.)
Bronze
H. 26 cm (10¼ in.); max. diam.
38.4 cm (15⅛ in.); diam. (of
mouth): 24.4 cm (9⅝ in.)
74.51.5636 (Myres 4949)
Probably from Kourion (the
"Kourion Treasure")

This slightly deformed caldron
may have been constructed from
two separate sheets of metal. There
is a small repair on the rim that
dates from antiquity.

BIBLIOGRAPHY: Richter 1915, p. 227, fig. 626, no. 626; Matthäus 1985, pp. 201–2, pl. 54, no. 490.

277. Caldron
Probably Cypro-Archaic
(ca. 750–ca. 480 b.c.)
Bronze
H. 31.6 cm (12½ in.); max. diam. 42.7 cm (16⅞ in.); diam. (of mouth): 22.5 cm (8⅞ in.)
74.51.5633 (Myres 4948)
Said to be from Kourion (the "Kourion Treasure")

The floor of the vessel has patches indicating that it was repaired in antiquity. It was made from one sheet of metal.

BIBLIOGRAPHY: Cesnola 1903a, pl. XLV.1; Richter 1915, p. 227, fig. 625, no. 625; Gjerstad 1948, p. 152, fig. 29.1; Matthäus 1985, p. 202, pl. 55, no. 489.

Attachments
The exact identification of the ten bronze attachments that follow has been the subject of much discussion. In 1958 Amandry identified them as parts of decorated iron tripod stands. He combined them with similar objects in Berlin and suggested that two pairs of bull protomes (cat. no. 278: 74.51.5619, 74.51.5620 and 74.51.5621, 74.51.5622), two bull protomes in Berlin, and the legs ending in bull hooves (cat. no. 279) belonged to a single tripod. According to his reconstruction, the other pair of bull protomes (cat. no. 278: 74.51.5618 and 74.51.5623), one bull protome in Berlin, and the lion paws (cat. no. 280) belonged to another tripod. Liepmann's and Matthäus's research shows that a different reconstruction is preferable (for a general discussion and bibliography, see Matthäus 1985, pp. 337–40). In their reconstruction, all the bull protomes (New York and Berlin) and the three bull's legs (New York and Berlin) belong to one tripod.

The lion paws, however, were once attached to rectangular iron rods and are more likely to be from a piece of furniture (Liepmann 1968, p. 47). Matthäus dates the reconstructed tripod to the early seventh century b.c., though he does not exclude a date in the second half of the eighth century b.c.

Tripods decorated with bull protomes and hooves were prestige objects in the Mediterranean world of the eighth through the seventh century b.c. Their origin is oriental, but Cyprus, rich in copper, may have been a center of their production (cf. Matthäus 1985, p. 339). Many caldrons with bull protome attachments come from Cyprus; a bronze caldron with an iron tripod was found in Salamis Royal Tomb 79, which dates from about 700 b.c. (V. Karageorghis 1973, pp. 97–108). These objects reached a wide clientele throughout the Mediterranean (Chavane 1982, pp. 13–14) and were owned by the elite of society during the period of orientalizing awareness.

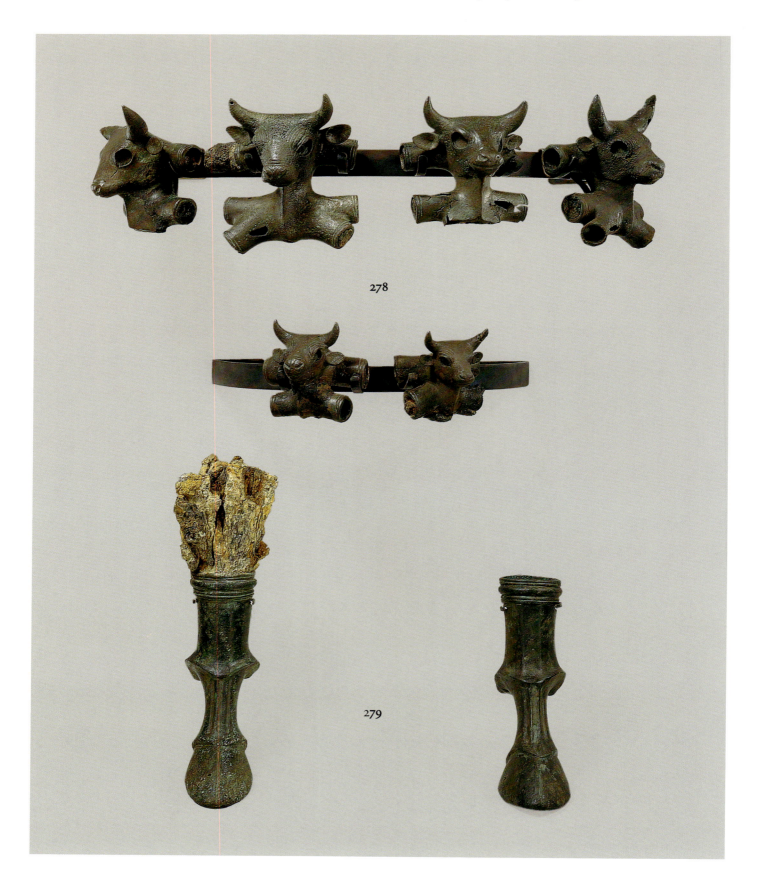

278

279

278. **Six tripod attachments in the form of a bull's head**

7th century B.C.

Bronze

H. 8.4 cm (3¼ in.) (74.51.5619; Myres 4759); 8.4 cm (3¼ in.) (74.51.5620; Myres 4760); 10.7 cm (4¼ in.) (74.51.5621; Myres 4761); 10.7 cm (4¼ in.) (74.51.5622; Myres 4762); 7 cm (2¾ in.) (74.51.5618; Myres 4758); 7 cm (2¾ in.) (74.51.5623; Myres 4763); L. of upper socket: 8.5 cm (3⅜ in.) (74.51.5619); 8.5 cm (3⅜ in.) (74.51.5620); 8.5 cm (3⅜ in.) (74.51.5621); 8.5 cm (3⅜ in.) (74.51.5622); 7.5 cm (3 in.) (74.51.5618); 7.5 cm (3 in.) (74.51.5623); L. of lower socket: 9.3 cm (3⅝ in.) (74.51.5621); 9.3 cm (3⅝ in.) (74.51.5622)

Only number 74.51.5622 is said to be from a vault at Kourion (the "Kourion Treasure")

Originally each cast-metal piece formed part of an iron tripod. Traces of iron rods are preserved in the sockets.

BIBLIOGRAPHY: Cesnola 1877, p. 339, pl. XXX; Cesnola 1903a, pl. LVI.1; Richter 1915, pp. 348–50, figs. 1182–87, nos. 1182–87; Amandry 1956, pp. 252–54, pls. XXX.1.a,.b, 2.a,.b, XXXI.1.a,.b,2.a,.b,XXXII.1.a,.b, 2.a,.b; Amandry 1958, pp. 73–76, pl. V; Liepmann 1968, pp. 40–45, figs. 1–4, 8–11, 14–17; Matthäus 1985, pp. 336–39, pl. 110, nos. 719.e–f, h–i, l–m.

279. **Two tripod attachments in the form of a bull's hoof**

7th century B.C.

Bronze

H. 14 cm (5½ in.) (74.51.5574); H. (including iron fragment): 21.6 cm (8½ in.) (74.51.5575) 74.51.5574 (Myres 4756), 74.51.5575 (Myres 4757)

Number 74.51.5575 is said to be from Kourion (the "Kourion Treasure")

The hooves are made of cast metal. Although number 74.51.5574 (at right in photograph opposite) has a socket at the top, unlike number 74.51.5575 (at left), it does not preserve an iron rod. The iron rod of number 74.51.5575 is now very corroded and swollen.

BIBLIOGRAPHY: Cesnola 1903a, pl. LII.3; Richter 1915, pp. 349–50, figs. 1188–89, nos. 1188–89; Richter 1953, p. 32 n. 24, pl. 21.b; Amandry 1956, pp. 252–54; Amandry 1958, pp. 73–76, pl. V; Liepmann 1968, pp. 46–47, figs. 20–21; Matthäus 1985, pp. 336–39, pl. 111, nos. 719.b,c.

280. **Two furniture attachments in the form of a lion's paw**

7th century B.C.

Bronze

H. 4.7 cm (1⅞ in.) (74.51.5568, .5567); L. 7.6 cm (3 in.) (74.51.5568), 7.9 cm (3⅛ in.) (74.51.5567) 74.51.5568 (Myres 4952), 74.51.5567 (Myres 4951)

Number 74.51.5567 is said to be from a vault at Kourion (the "Kourion Treasure")

Each furniture attachment has four toes, is hollow, and is made of cast metal. Both attachments have a rectangular socket in the back for an iron bar that was rectangular in section. The pieces are concave underneath.

BIBLIOGRAPHY: Perrot and Chipiez 1885, p. 413; Cesnola 1903a, pl. LVI.2; Richter 1915, pp. 350–52, figs. 1190–91, nos. 1190–91; Amandry 1958, pp. 73–76, pl. V; Liepmann 1968, p. 47, fig. 25.

280

The following two works were used as lamp holders. The ring or other horizontal feature at the top supported the lamp, and the stand itself would have been set over a tall shaft, probably of wood. The struts below each volute of catalogue number 281, obviously intended to strengthen the piece, are an unusual feature. Many similar lampstands have been found on Cyprus, but they also appear in the Near East, the Aegean, and the central Mediterranean. A version in ivory, probably ornamental, was found in Royal Tomb 79 at Salamis, which dates from the end of the eighth century B.C. (V. Karageorghis 1973, p. 119). Lampstands of this variety were made on Cyprus, probably under Phoenician influence, from the eighth through the sixth century B.C. Bronze incense burners, or thymiateria, decorated with drooping petals similar to those on the lampstands shown here were popular in the Punic world (Caubet, Hermary, and Karageorghis 1992, pp. 79—80, nos. 86—88).

281. Lamp holder
Cypro-Archaic (ca. 750—ca. 480 B.C.)
Bronze
H. 32.2 cm (12⅝ in.)
74.51.5641 (Myres 4966)
Probably from Kourion (the "Kourion Treasure")

BIBLIOGRAPHY: Richter 1915, pp. 366—67, no. 1271; Raubitschek 1978, pp. 699, 701, pl. 215.1.

282. Lamp holder
Cypro-Archaic (ca. 750—ca. 480 B.C.)
Bronze
H. 32.9 cm (13 in.)

74.51.5639 (Myres 4964)
Probably from Kourion (the "Kourion Treasure")

The lamp holder has two registers of drooping petals attached to a rod.

BIBLIOGRAPHY: Cesnola 1877, p. 336; Richter 1915, p. 367, fig. 1272, no. 1272; Raubitschek 1978, p. 699, pl. 215.1.

283. Jug with tubular spout
Cypro-Archaic II
(ca. 600—ca. 480 B.C.)
Bronze
H. (with handle): 22.5 cm (8⅞ in.)
74.51.5697 (Myres 4921)
Said to be from Idalion or Kourion

The lower part of the handle ends in a flat attachment in the shape of a feline (lion?) head.

The slightly biconical shape of the piece recalls similar spouted jugs made of clay from the Cypro-Archaic II period (cf. Gjerstad 1948, figs. L.2,.4,.5). Matthäus considers the vessel to be a mixture of Cypriot and Greek elements, perhaps the product of a Greek craftsman working on Cyprus (for a detailed discussion of the piece, see 1985, pp. 249—50). Both the foot and the mouth of the vessel suggest a Greek connection, as does the handle with the motif of a lion.

BIBLIOGRAPHY: Cesnola 1903a, pls. XLVI.3, LVIII.1; Richter 1915, p. 185, fig. 481, no. 481; Gjerstad 1948, pp. 153—54, fig. 29.12; Matthäus 1985, pp. 249—50, pl. 73, no. 552.

284. Thymiaterion
Cypro-Archaic II
(ca. 600—ca. 480 B.C.)
Bronze

H. 14.8 cm (5⅞ in.); diam. (of bowl): 12.1 cm (4¾ in.); diam. (of plate): 22 cm (8¾ in.)
74.51.5566 (Myres 4922)
Said to be from Kourion

The conical bowl is attached to the fragmentary shallow bowl with three rivets.

Objects such as this have been found in tombs and sanctuaries of the sixth century B.C. They are usually identified as lamp holders or thymiateria (incense burners) and appear to derive from a Phoenician prototype. The shape is more common in clay than in metal. The most common variant of this shape consists of two bowls, one inside the other, with a lid that is perforated at the top to allow smoke to escape. Clay thymiateria of that type were found in the sixth-century B.C. sanctuary of Baal-Hamman at Meniko (V. Karageorghis 1977c, pp. 39—41; on the type, see Chavane 1982, pp. 71—75). They are also known from other areas associated with Phoenicians, such as southern Spain, Malta, Sardinia, and Italy at Pithekoussai.

BIBLIOGRAPHY: Cesnola 1903a, pl. LV.3; Richter 1915, pp. 205—6, fig. 564, no. 564; Gjerstad 1948, p. 150, fig. 27.22; Chavane 1982, p. 72 n. 14; Matthäus 1985, p. 282, pl. 85, no. 610.

285. Horse bit
Cypro-Archaic I(?)
(ca. 750—ca. 600 B.C.)
Bronze
L. 32.4 cm (12¾ in.)
74.51.5387 (Myres 4772)
Said to have been found at Kourion (the "Kourion Treasure")

The bit is made of two twisted

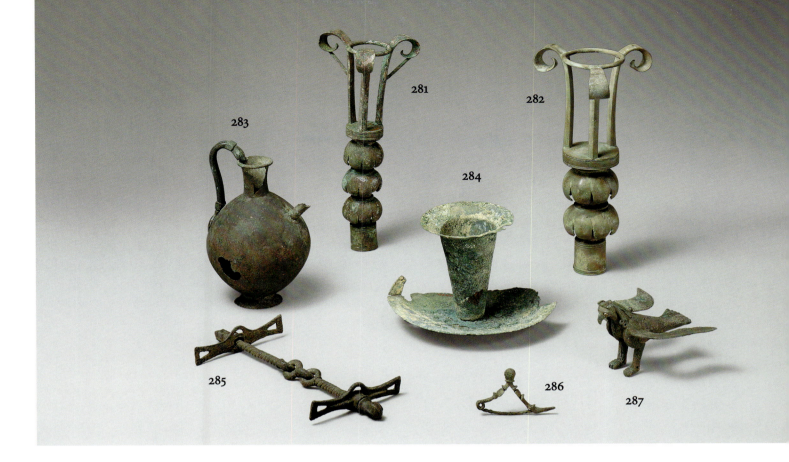

pieces joined at their loop-shaped inside ends to a single figure-eight–shaped piece. They have outer rounded terminals with a hole in the center that would have been attached to reins. Two oblong plaques on each side served as cheekpieces. They each have three perforations so that they could be attached to the leather straps of the gear.

Horse bits similar to this one have been found in association with skeletons of horses buried before the entrances of the royal tombs at Salamis and elsewhere. They are usually made of iron and date from the Cypro-Archaic I–II periods. Although this piece does not have an exact provenance, it was probably found in association with a horse burial. Typologically, the bits from Cypro-Archaic tombs at Amathus and Palaepaphos resemble those found on the Greek mainland

that date from the Mycenaean period (Richter 1915, pp. 426, 428, fig. 1600, no. 1600; V. Karageorghis 1967, p. 21 n. 9). Catling rightly mentions that horse bits could have been placed alone as gifts in tombs, not necessarily in conjunction with horse burials (1996, pp. 570–71).

BIBLIOGRAPHY: Cesnola 1903a, pl. XLV.2; Richter 1915, pp. 426, 428, fig. 1600, no. 1600; Donder 1980, p. 27, pl. 5.30, no. 30.

286. Fibula

Cypro-Archaic (ca. 750–ca. 480 B.C.)
Bronze
L. 9.2 cm (3⅝ in.)
74.51.5543 (Myres 4747)

The fibula was cast and is triangular in shape. It has an angular bow, an ovoid knob and a disk at the top, and moldings consisting of a double-ax motif on the sides.

Fibulae of this type are a purely Cypriot development (cf. Gjerstad 1948, p. 144, type 4b, pp. 382–84). They were exported to the Aegean and Palestine and have even been found in the western Mediterranean, where they were imitated.

BIBLIOGRAPHY: Cesnola 1903a, pl. LXIII.5; Richter 1915, p. 313, fig. 937, no. 937; Gjerstad 1948, p. 144, fig. 25.43.

287. Bird

Cypro-Archaic (?)
(ca. 750–ca. 480 B.C.)
Bronze
H. 10.5 cm (4⅛ in.); L. 13.6 cm (5⅜ in.)
74.51.5571 (Myres 4765)
Said to be from Kourion (the "Kourion Treasure")

The bird may be an eagle. It is mold-made and hollow, with inlaid eyes of glass; the right eye is

missing. The lower parts of the legs are perforated horizontally, and there is an attachment hole in the lower part of the body.

The bird may have been made as an attachment for another object. Richter (1915, p. 7) dated it tentatively to the eighth century B.C., but such a date seems too early.

BIBLIOGRAPHY: Cesnola 1877, p. 339, pl. XXX; Cesnola 1903a, pl. LXV.4; Richter 1915, p. 7, fig. 4, no. 4; Richter 1953, p. 32 n. 26, pl. 21.d.

Lamps

288. Saucer-shaped lamp
Cypro-Archaic (ca. 750–ca. 480 B.C.)
Bronze
L. 14.3 cm (5⅝ in.); W. 12.5 cm
(5 in.); diam. 12.7 cm (5 in.)
74.51.5650 (Myres 4980)

BIBLIOGRAPHY: Richter 1915, p. 379, fig. 1326, no. 1326; Matthäus 1985, p. 271, pl. 82, no. 601.

289. Open lamp
End of the 6th century B.C.
Terracotta
H. 23.3 cm (9⅛ in.)
74.51.2364 (Myres 1855)
Said to be from Rizokarpaso, on the Karpas Peninsula

The lamp was set within an "envelope" that is open next to the nozzle, as if it were a second nozzle and possibly meant to house a second wick. This was done in order to attach the entire piece to a vertical handle. The front of the handle is mold-made with a knobbed loop at the top. The mold-made section, decorated with a figure of Bes, was flattened and attached to a rough, undecorated rear slab in order to make the handle hollow. Signs in the Cypriot syllabary were engraved on the flat rim of the lamp before firing. The inscription reads: "[I am the lamp] of Philotimos" (see detail opposite).

This form of lamp is most unusual. It is interesting not only for the iconography of Bes but also because the name of the maker, Philotimos, is known. This lamp dates from the third or last quarter of the sixth century B.C. (Wilson 1975, p. 95; however, see Masson 1971a, p. 448 n. 5, fig. 13, where he notes that D. M. Bailey dates it to the late seventh to the early sixth century B.C.). The figure of Bes is popular on Cyprus from the Late Bronze Age on.

BIBLIOGRAPHY: Cesnola 1877, pl. VIII.56; Cesnola 1894, pl. CXLII.1059; Cesnola 1903a, pl. CXL.14; Masson 1961, p. 329, no. 329; Masson 1971a, p. 448 n. 5, fig. 13; Wilson 1975, p. 102, no. 8.

290. Saucer-shaped lamp
Cypro-Archaic (ca. 750–ca. 480 B.C.)
or Cypro-Classical (ca. 480–
ca. 310 B.C.)
Plain White Ware
H. 6.8 cm (2⅝ in.); L. 14.5 cm
(5¾ in.)
74.51.1818 (Myres 2520)

The body of the lamp was made first and then the base was added. This method of manufacture was necessary because the tubular projection in the center stabilized the oil when the lamp was carried. Traces of burning can be seen on the rim of the tubular projection and on the pinched rim.

The saucer-shaped lamp with one pinched nozzle made its appearance in the Late Cypriot period. There are specimens of the same type in bronze (Matthäus 1985, pp. 267–69). Gradually, however, the body of the lamp became shallow, with a broad out-turned rim and a longer nozzle (Matthäus 1985, pp. 269–70). A large number of lamps, in clay, have been found in tombs of the Cypro-Archaic and Cypro-Classical periods. The variant with two nozzles, though not common (Matthäus 1985, pp. 271–72), is also found in the Phoenician and Punic worlds (Cintas 1976, pp. 306–17); it may have been introduced to Cyprus from the Levant (Oziol 1977, p. 25, pl. 3, nos. 36–37).

BIBLIOGRAPHY: Cesnola 1894, pl. CXXXVIII.1007.

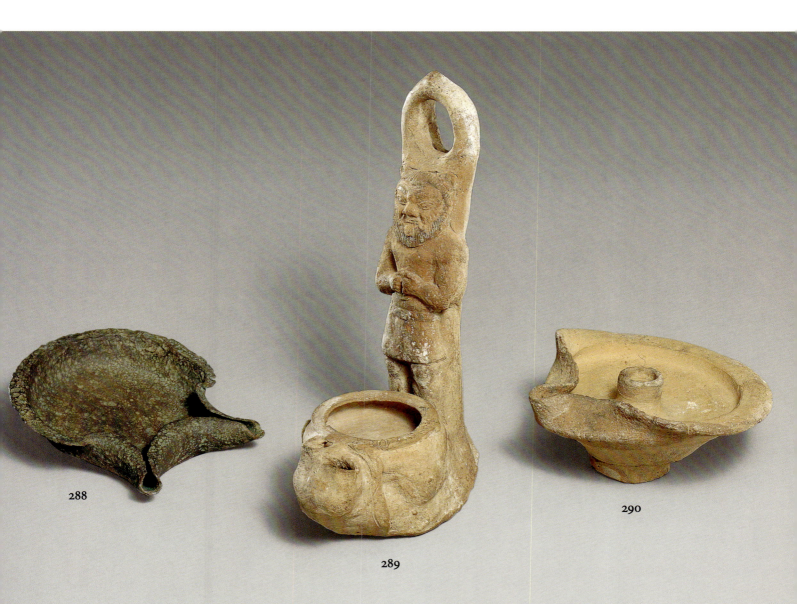

288

289

290

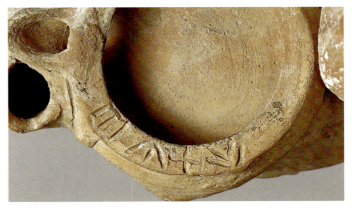

289. DETAIL

Silver

291. Juglet
Cypro-Geometric III (ca. 850–
ca. 750 B.C.) to Cypro-Archaic I
(ca. 750–ca. 600 B.C.)
Silver
H. (including handle): 15.9 cm
(6¼ in.)
74.51.4592 (Myres 4592)
Said to be from Kourion

At the lower end of the handle a
flat, round attachment is riveted to
the body.

Jugs of this globular shape origi-
nated in the Phoenician world of
the ninth century B.C., when they
first appeared in Red Slip Ware
(cf. Gjerstad 1948, fig. XLIII.13).
Their use was widespread in the
eighth and seventh centuries B.C.
Red Slip II Ware versions are fre-
quently found in Cypriot tombs,
and the form was imitated in other
ceramic fabrics. Several examples
come from Royal Tomb 79 at
Salamis, where the vessels were
covered with a thin sheet of tin
to make them look like silver
(V. Karageorghis 1973, p. 115). Simi-
lar vessels of bronze, which usu-
ally have a palmette attachment at
the lower end of the handle, were
used throughout the Mediterranean,
as far west as Spain (Matthäus 1985,
pp. 242–43). Silver versions must
have been appreciated not only on
Cyprus but also in the Aegean,
where silver vases made by the
Phoenicians of Sidon were very
much admired.

BIBLIOGRAPHY: Cesnola 1903a,
pl. XXXIV.4; Gjerstad 1948, pp. 160–
61, fig. 33.14; von Bothmer 1984,
p. 18, no. 5; Matthäus 1985, pp. 238,
241–43, pl. 71, no. 538.

292. Juglet
Cypro-Archaic I
(ca. 750–ca. 600 B.C.)
Silver
H. 17.7 cm (7 in.)
74.51.4586 (Myres 4586)
Said to be from Kourion

The handle, attached to the neck
by means of a narrow, flat strap with
two rivets positioned just below the
neck ridge, has a rope ornament
along either side. One rivet secures
the handle to the shoulder.

The mushroom-lipped, ridged,
narrow-necked juglet was a popu-
lar shape in Cypriot ceramics from
the Cypro-Geometric III period
through the end of the Cypro-
Archaic period. This example, in
silver, is unique, and its shape com-
pares with that of ceramic exam-
ples of the Cypro-Archaic I period
(cf. Gjerstad 1948, fig. XXXIII.13). The
same shape was also popular in the
Aegean, where the juglets probably
held perfumed oil. These vessels
circulated widely in the Aegean and
were imitated in the Dodecanese
and on Crete (cf. Coldstream 1979b,
pp. 261–62).

BIBLIOGRAPHY: Cesnola 1903a,
pl. XXXIV.3; Gjerstad 1948, pp. 160–
61, fig. 33.13; von Bothmer 1984,
pp. 18–19, no. 7; Matthäus 1985,
pp. 236–37, pl. 70, no. 533.

293. Juglet
End of the Cypro-Archaic I period
(ca. 750–ca. 600 B.C.)
Silver
Preserved H. (including handle):
10.7 cm (4¼ in.)
74.51.4588 (Myres 4588)
Said to be from Kourion

Toward the end of the Cypro-
Archaic I period, this shape was

popular in the ceramic repertoire
of Amathus, where juglets, in both
White Painted IV and Bichrome IV
wares, were often decorated with
long-legged birds and stylized trees
(cf. Gjerstad 1948, figs. XXVIII.28,29,
and cat. no. 155). This silver version
is unique.

BIBLIOGRAPHY: Cesnola 1903a,
pl. XXXIV.5; Gjerstad 1948, pp. 160–
61, fig. 33.15, no. 15; Matthäus 1985,
pp. 237–38, pl. 71, no. 535.

294. Mouth plate
Cypro-Archaic (ca. 750–ca. 480 B.C.)
or Cypro-Classical (ca. 480–
ca. 310 B.C.)
Gilded silver
L. 7.6 cm (3 in.)
74.51.3004 (Myres 3004)

Similar mouth plates were used
during the Late Bronze Age to
"seal" the mouths of the dead.
They are common on Cyprus in
both gold and silver (L. Åström
1972, pp. 507–8). Other mouth
plates are known from the Cypro-
Archaic and Cypro-Classical peri-
ods (Gjerstad 1948, pp. 220, 222).
There is no independent evidence
for the dating of this piece, but the
thick and realistically rendered
lips suggest the later date.

There is a perforation at either
end of the mouth plate.

295. Cup
Probably 5th century B.C.
Silver
H. 7.9–8.2 cm (3⅛–3¼ in.); diam.
12.5–13.4 cm (4⅞ in.–5¼ in.)
74.51.4581 (Myres 4581)
Said to be from Kourion

The sixth-to-fifth-century B.C. and
earlier dates previously assigned to
this cup (cf. von Bothmer 1984,

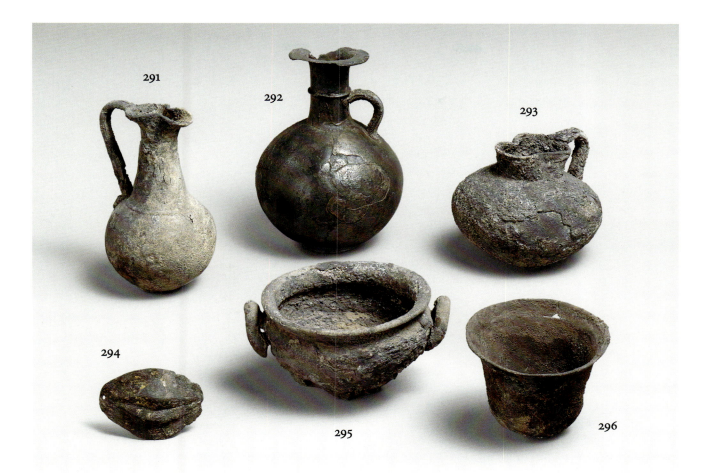

pp. 18–19, no. 8, and Matthäus 1985, p. 189, no. 460) are too early. As with catalogue number 296, this cup most likely dates from the fifth century B.C. There are ceramic versions of the shape in Stroke Polished I (VI) Ware from the Cypro-Classical I period (cf. Gjerstad 1948, fig. LXI.22).

BIBLIOGRAPHY: Cesnola 1903a, pl. XXXIV.1; Gjerstad 1948, pp. 160–61, fig. 33.12, no. 12; von Bothmer 1984, pp. 18–19, no. 8; Matthäus 1985, p. 189, pl. 49, no. 460.

296. Bowl
5th or possibly 4th century B.C.
Silver
H. 9.1 cm (3⅝ in.); diam. 10.4 cm (4⅛ in.)
74.51.4566 (Myres 4566)
Said to be from Kourion

This bowl has no parallel in Cypro-Archaic pottery. In the ceramic repertoire of the island the nearest shape is seen in Plain White VI Ware of the fifth century B.C., where it has a high foot (cf. Gjerstad 1948, fig. LXI.33). This silver vase may originally have been a goblet that has now lost its foot. There are no signs of such a foot on the corroded surface of the vessel, however. Parlasca compares this piece with a bronze vessel from Ras Shamra, in Syria, that dates from the third quarter of the fourth century B.C. (1955, pp. 137–38) as well as with Alexandrian vessels from Egypt.

BIBLIOGRAPHY: Cesnola 1903a, pl. XXXV.4; Parlasca 1955, p. 138 n. 58; von Bothmer 1984, p. 18, no. 6.

Decorated Metal Bowls

Since Gjerstad's pioneer classification of these bowls in 1946, several new studies have appeared. Three of the most important were published almost simultaneously in 1985 and 1986 (Markoe 1985; Matthäus 1985; and Hermary 1986). There are now more such bowls known, some of them found in datable contexts. They are usually referred to as Cypro-Phoenician or Near Eastern bowls. Apart from those found on Cyprus, a large number have been found at sites in Italy, the Aegean, and the Near East (for a general stylistic survey and detailed descriptions, see Markoe 1985). Today, more than one hundred metal bowls decorated in a Near Eastern style are known.

The bowls are made of bronze, silver, gilded silver, or gold. Usually they are decorated in repoussé, with the contours of the figures and their details engraved. Some simply have engraved decoration. Most of the bowls are shallow, with or without a central omphalos. The earliest examples date from about 900 B.C. (Popham 1995), and production continued into the seventh century B.C. The decoration appears on the interior in one or more zones around a central motif.

Stylistically, the decoration varies. Some bowls betray a strong Egyptian influence (Markoe 1985, pp. 30–33), but the Egyptian representations are standard, without any precise symbolism. Several bowls are decorated with repeated motifs such as antithetical sphinxes, a hero fighting a lion, and the birth of Horus, scenes that are also known in Phoenician ivory carving and

other works of art from the eighth through the seventh century B.C. Some of the vessels have scenes of religious dancing, processions in honor of a seated female divinity, or banquets. In some cases there are continuous narratives in miniature (Markoe 1985, p. 67) that depict a specific legend, usually a military engagement.

Where the bowls were manufactured is still a matter of debate. The Phoenicians were involved in the production of at least some of the bowls. On those found in Italy, signatures, possibly of artists, appear in Phoenician characters (Hermary 1986, p. 194). There is no reason to believe, however, that those found on Cyprus were imported into the island. On two bowls, the names of the owners, Epiorwos (see cat. no. 302) and King Akestor of Paphos (see cat. no. 299), appear engraved in characters of the Cypriot syllabary, in specially reserved spaces (Markoe 1985, p. 73; Hermary 1986, p. 194). This important evidence supports the Cypriot origin of these and other bowls of the same style found on Cyprus. The bowls from Italy are usually larger. It is possible that Phoenician artists working in Italy made the bowls there.

The bowls must have been luxury or prestige objects that were considered essential possessions by the elite of the Mediterranean—Cyprus, the Aegean, and Etruria. Homer's reference to a silver mixing bowl made by the Phoenicians of Sidon and transported overseas indicates that the high-quality silver circulating within the boundaries of the Phoenician world was well regarded (*Iliad* 23.740–45;

Hermary 1986, p. 194). A silver bowl found recently at Lefkandi and dated to about 900 B.C. reinforces the idea of Euboean contact with Cyprus and the Levant at an early stage (Popham 1995). It also illustrates the influence that Phoenician art exercised first in Euboea and, later, in other parts of Greece during the orientalizing period.

Cesnola claimed that he found eight decorated metal bowls in the vaults of a temple at Kourion that formed part of the so-called Kourion Treasure (1877, pp. 335–36). Whether his discovery of the treasure is authentic has never been substantiated (Markoe 1985, p. 176). Instead, there is every reason to believe that these bowls were found in large royal tombs, like one recently excavated at Kourion (Christou 1996a, pp. 170–82).

297. Bowl

ca. 710–675 B.C.
Gold-plated silver
H. 3.2 cm (1¼ in.); diam. 15.4 cm (6⅛ in.)
74.51.4553 (Myres 4553)
Said to be from Kourion (the "Kourion Treasure")

The entire inner surface of this shallow bowl is gold plated. The decoration is in shallow repoussé; outlines and details are rendered with incisions. The inside surface is divided into two registers and a medallion by circles framed by beaded chains. Inside the medallion a bull stands on a ground line, facing right. In the inner register is a frieze of seven horses grazing with lowered heads; punctured stippling indicates their tails. The outer register is filled with a cow and a calf, a

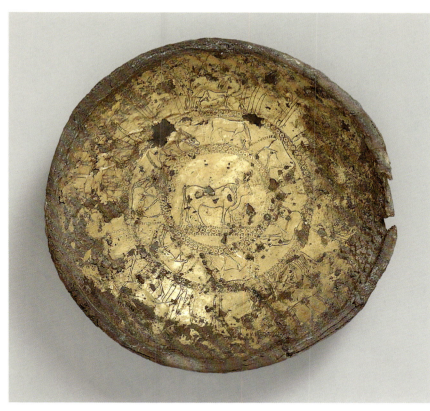

297

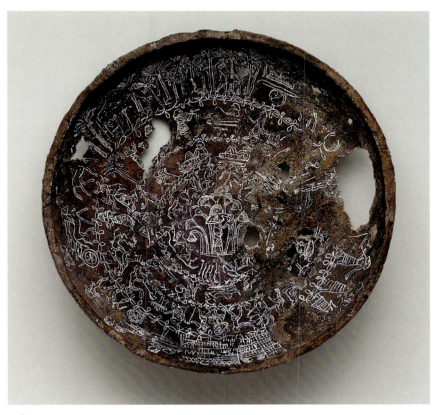

298

horse with a foal, and a standing horse. Five groups of papyrus thickets are in the background.

The animal motifs filling the medallion and the two registers of this bowl are common in the iconography of the Near East: the bull has a long tradition in Cypriot and Levantine art, from the Late Bronze Age on; the suckling cow is a favorite motif in ivory carving; and the horse and foal are popular in northern Syrian iconography. The papyrus thickets as a background for animal motifs, however, are Egyptian in origin.

BIBLIOGRAPHY: Cesnola 1903a, pl. XXXIII.4; Gjerstad 1946, pp. 3, 11–12, pl. XI; Markoe 1985, pp. 180–81, 263, no. CY12; Matthäus 1985, pp. 166, 174–75, pl. 40, no. 433.

298. **Bowl**
ca. 675–625 B.C.
Bronze
H. 3.5 cm (1⅜ in.); diam. 15.3 cm (6 in.)
74.51.4555 (Myres 4555)

The bowl is fragmentary; it has a thick, flat rim and a round base. The decoration is engraved, without repoussé. The decoration consists of a central medallion and four concentric zones on the inside. The central medallion is filled with a figure of Isis suckling Horus, with papyrus plants in the background. In zone one (starting from the center part) there is a frieze of animals (horses and bulls), a herdsman, and a papyrus grove. In zone two is a banqueting scene with male figures, who recline on couches, and other standing figures, possibly musicians. In zone three is a male figure reclining on a couch; other male

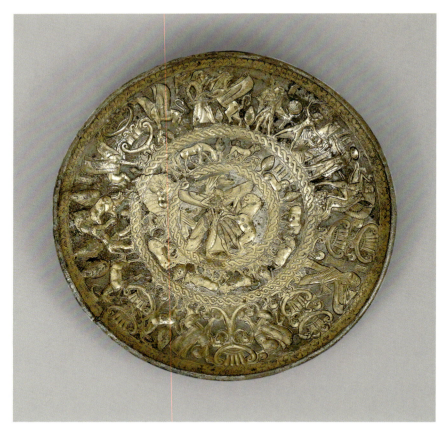

299

and female figures are seated or standing to bring gifts, which include sacrificial animals. Zone four, the broadest, depicts a journey with human figures in carts (one carries a lyre) from a citadel to a palm grove and back. The citadel has three levels and battlements with defenders in them.

Fortifications and battlements with defenders inside are common in Assyrian palace reliefs (Markoe 1985, pp. 51–52). The medallion decoration is, of course, a standardized Egyptian scene. The continuous narrative style is described in the entry for catalogue number 305.

BIBLIOGRAPHY: Gjerstad 1946, pp. 3, 8–9, 16, pl. IV; Crouwel 1985, p. 204; Markoe 1985, pp. 181–82, 264, no. CY13; Matthäus 1985, pp. 162–63, 172–73, pls. 32, 35, no. 425; Hermary 1986, pp. 186–87.

299. Bowl with a round base

725–675 B.C.; recarving of inscription, beginning of the 5th century B.C.
Silver
H. 3.1 cm (1¼ in.); diam. 16.8 cm (6⅝ in.); thickness .32 cm (⅛ in.)
74.51.4554 (Myres 4554)
Said to be from Kourion (the "Kourion Treasure")

The decoration of this shallow bowl is in repoussé; the outlines and details of the figures are indicated with incisions. The outer zone is enclosed within a narrow circular zone filled with a lotus-and-bud chain.

The medallion is filled with a four-winged deity, in Assyrian dress, who wields a sword to kill a rampant lion. Egyptian falcons appear above the deity's head and behind him. The narrow inner zone is decorated with a series of animals separated by a cypress tree. These are (clockwise): a lion striding over a fallen human figure who symbolizes, in Egyptian iconography, the pharaoh conquering his enemies; a crouching sphinx, wearing the double crown of Egypt, with two cartouches in the field above; two confronted bulls; two bulls marching to the right; a group of animals with a cow suckling her calf; a kneeling archer attacking a lion from behind; another human figure attacking the lion with a spear; a lion perching on the back of a kneeling male human figure; a grazing horse. The outer, broader zone is decorated with a variety of scenes: a human figure in Assyrian dress killing a rampant griffin; a falcon behind the human figure; an Egyptian king striking enemy

captives, while behind him a human figure holds a spear and a fan, with a corpse over his right shoulder; in front of the king, a falcon-headed god (Re-Harakhte) brandishing a sword; a human figure wearing a short loincloth, killing a griffin; a winged Egyptian goddess (Isis); pairs of confronted sphinxes, goats, and griffins on either side of stylized palmettes; between the pair of griffins and the pair of goats, a human figure dressed in a lion's skin (Melqart?), fighting a lion; to the right of a cypress tree, a cartouche between a lion and a griffin.

Inside the bowl, in a specially reserved space above the main scene of the outer zone—a human figure in Assyrian dress killing a griffin—is an engraved inscription consisting of thirteen signs in the Cypriot syllabary, reading: "I am [the bowl] of Akestor, king of Paphos." This inscription is partly erased. A second syllabic inscription appears above the scene of "Melqart" fighting the lion. It reads: "I am [the bowl] of Timokretes."

This is probably the most important of all the decorated metal bowls from Cyprus, not only because of its excellent state of preservation but also because of its royal owner, King Akestor of Paphos, who is mentioned in the engraved inscription inside the bowl. This is the second royal bowl of this type. Another one, also found at Kourion, mentions a king or prince named Diweithemis (Markoe 1985, p. 78). Akestor's inscription was partly erased and the inscription of Timokretes was added, presumably when the bowl changed hands. It is not certain when the inscription

was altered—perhaps at the beginning of the fifth century B.C., when Paphos fell to the Persians.

The inscriptions document that these two royal bowls were highly valued and formed part of the tomb gifts offered to the warrior aristocracy of the Cypro-Archaic I period (cf. Markoe 1985, pp. 78–79). The iconography of the bowl combines a number of Egyptian, Assyrian, and Phoenician stylistic elements. The hieroglyphs are nonsensical. A similar series appears on a silver bowl from Salamis (Markoe 1985, pp. 185–86, no. CY20). The various motifs of heroes or kings killing a monster or a king striding over his enemies are well known in Egyptian iconography and were taken over by the Phoenicians, who then introduced these iconographic elements to Cyprus. They appear, for example, on horse blinkers of about 700 B.C. from Royal Tomb 79 at Salamis (V. Karageorghis 1973, p. 81). Many such scenes also appear in Phoenician ivory carvings. The

subjects are standardized, without any narrative chain, unlike those on bowls such as catalogue numbers 298 (Markoe 1985, pp. 181–82, no. CY13) and 305 (Markoe 1985, p. 177, no. CY7) that narrate one episode at one specific time.

BIBLIOGRAPHY: Cesnola 1877, p. 329; Gjerstad 1946, pp. 10–11, pl. VII; Mitford 1963, pls. IV–VII; Masson 1983, p. 412, no. 180a; von Bothmer 1984, pp. 7, 20, no. 10; Markoe 1985, pp. 177–79, 256, no. CY8; Matthäus 1985, pp. 164–65, pl. 37, no. 429; Hermary 1986, p. 185.

300. **Bowl**
5th century B.C.
Silver
H. 5.4 cm (2⅛ in.); diam. 10.3–10.5 cm (4–4⅛ in.)
74.51.4562 (Myres 4562)

The deep bowl has convex sides with fluting radiating from the bottom; above the fluting a frieze depicts thirteen birds marching in tandem. A depression on the base forms an omphalos.

300

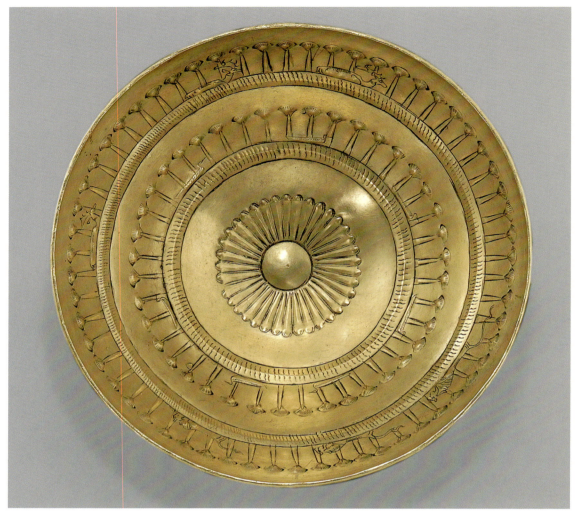

301

The bowl has been dated by scholars to the fifth or the seventh century B.C., but a date in the fifth century B.C. is appropriate. Both the shape and the decoration have parallels in eastern Greek ceramics. Parlasca compares the shape of this piece with that of a bronze bowl from Ras Shamra, in Syria, dated to the third quarter of the fourth century B.C. (1955, p. 138 n. 58; see also cat. no. 296).

BIBLIOGRAPHY: Cesnola 1903a, pl. xxxv.1; Parlasca 1955, p. 138 n. 58; Oliver 1977, p. 24 n. 1; von Bothmer 1984, p. 22 n. 13; Markoe 1985, pp. 184, 267, no. Cy18; Matthäus 1985, pp. 187–88, pls. 48, 49, no. 457.

301. **Bowl**
ca. 700 B.C.
Gold
H. 4.9 cm (1⅞ in.); diam. 14.2 cm (5⅝ in.); weight: 122.27 g (4⅓ oz.)
74.51.4551 (Myres 4551)
Said to be from Kourion

The bowl, intact and unique, has a conical body with convex sides. It is decorated in repoussé with incisions on the inside. Around the omphalos are thirty-six petals of a rosette. The rest of the body is divided by two thick grooved ridges into two concentric zones decorated with papyrus motifs. Seven ducks, symmetrically arranged, swim. Their plumage is rendered with thin grooves. There are three bulls and three fallow deer; only the upper half of their bodies are shown. The remainder of their bodies are supposed to be hidden by the marshes where they are swimming. Their anatomical details are rendered with grooves. The tails are

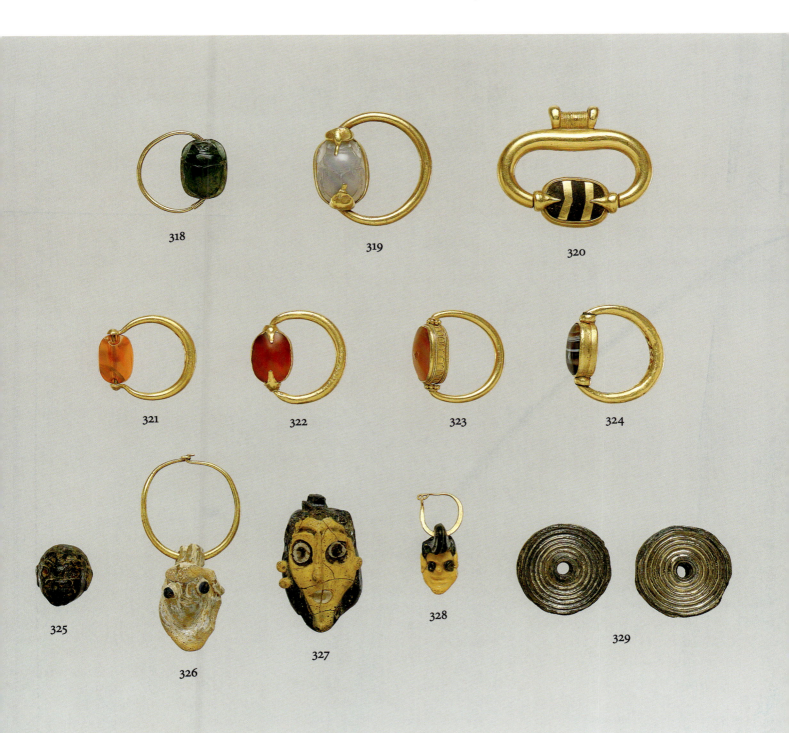

318

319

320

321

322

323

324

325

326

327

328

329

321. Scaraboid ring

Cypro-Phoenician,
6th–5th century B.C.
Gold and sard
Diam. 2.5 cm (1 in.)
74.51.4142 (Myres 4142)

The ring is a characteristic
Phoenician type that is well repre-
sented on Cyprus. J R M

BIBLIOGRAPHY: Quillard 1987,
p. 169.

322. Scaraboid ring

Cypro-Phoenician,
6th–5th century B.C.
Gold and sard
Diam. 2.4 cm (1 in.)
74.51.4155 (Myres 4155)

The thin, pointed extensions pro-
jecting from the gold fittings that
hold the swivel ring are characteris-
tically Cypriot. J R M

BIBLIOGRAPHY: Quillard 1987,
p. 169.

323. Ring

Cypro-Phoenician,
6th–5th century B.C.
Gold and carnelian
Diam. 2.4 cm (1 in.)
74.51.4212 (Myres 4212)

The side of the setting is embel-
lished with delicate filigree work.
 J R M

BIBLIOGRAPHY: Quillard 1987,
p. 169.

324 Scarab ring

Cypro-Phoenician,
6th–5th century B.C.
Gold and agate
Diam. 2.5 cm (1 in.)
74.51.4202 (Myres 4202)

The scarab is not engraved.
 J R M

BIBLIOGRAPHY: Quillard 1987,
p. 169.

325. Pendant

Cypriot, probably
6th–5th century B.C.
Chlorite
Diam. 3.2 cm (1¼ in.)
74.51.3161 (Myres 3161)

Depictions of blacks begin to
occur with some frequency in the
sixth century B.C. Pendants such as
this one are rare, but the articula-
tion of the face has some parallels,
notably on a series of molds in the
Ashmolean Museum, Oxford (Ver-
coutter et al. 1976, p. 140). J R M

BIBLIOGRAPHY: Raeck 1981, p. 210
n. 911.

Vases of variegated glass were pro-
duced in places other than Phoeni-
cia. But it was the Phoenicians who
were originally responsible for a
type of pendant or mask made with
the sand-core technique. These
objects, produced from the sixth
through the second century B.C., are
widespread. They have been found
throughout the Mediterranean and
in Anatolia, the Balkans, transalpine
Europe, and the Punic west. They
represent human faces—bearded
or beardless—and animals. More
than sixty come from Cyprus (See-
fried 1982, p. 87; see also Stern and
Schlick-Nolte 1994, nos. 30–34).

The usual colors are blue and yel-
low. They were made to be worn
and have been found in tombs,
their significance no doubt being
apotropaic.

326. Head pendant

Phoenician or Carthaginian,
Classical, 1st half of the
5th century B.C.
Gold and glass
H. 2.7 cm (1⅛ in.); diam. (of wire
hoop): 2.6 cm (1 in.)
74.51.4031 (Myres 4031)

The head is thought to represent
a bearded demon. Many examples
of this type have been found on
Cyprus; their presence may be
associated with increased Phoeni-
cian influence after the Persian
occupation of the island. For other
demonic-mask pendants, see
Tatton-Brown 1981, pp. 144–46
(type A.I.c), and Seefried 1982,
pp. 74–84 (type A). C L

327. Head pendant

Phoenician or Carthaginian,
Archaic, late 7th–5th century B.C.
Glass
H. 3.5 cm (1⅜ in.)
74.51.4038 (Myres 4038)

The origins of such rod-formed
pendants remain uncertain since
a production center has not yet
been identified. Many examples are
known, however, both from the
eastern Mediterranean and from
Carthage and other sites in the
Punic west. Those shaped as hu-
man heads, demonic masks, and
ram's heads were very popular as
amulets to ward off evil. For similar
head pendants, see Tatton-Brown
1981, pp. 147–49 (type A.II.a), and
Seefried 1982, pp. 89–94 (type B II).

CL

328. Head pendant

Carthaginian or eastern
Mediterranean, Hellenistic,
3rd–1st century B.C.
Gold and glass
H. 2.5 cm (1 in.)
74.51.4029 (Myres 4029)
Said to be from a tomb at Idalion

Glass pendants of this type,
depicting a woman's head, are
mainly found in Carthage, Cyprus,
and western Asia Minor and are
usually described as necklace
ornaments. Here, however, the pen-
dant is attached to a simple gold
hoop earring. For other female-
head pendants, see Tatton-Brown
1981, pp. 151–52 (type A.II.h), and
Seefried 1982, pp. 120–31 (type D II).

CL

329. Pair of reels

Eastern Greek, 6th century B.C.
Silver
Diam. 2.2 cm (⅞ in.)
74.51.3589, .3590 (Myres 3589, 3590)

Cylindrical reels of various sizes
in silver, gold, and electrum are
characteristic of eastern Greece and
adjoining regions, notably Lydia.
Some of these objects contain pel-
lets so that they rattle when moved.
While they have been variously
identified as earspools, sistra, and
rattles, there is no certainty about
their function. JRM

BIBLIOGRAPHY: Özgen et al. 1996,
p. 168.

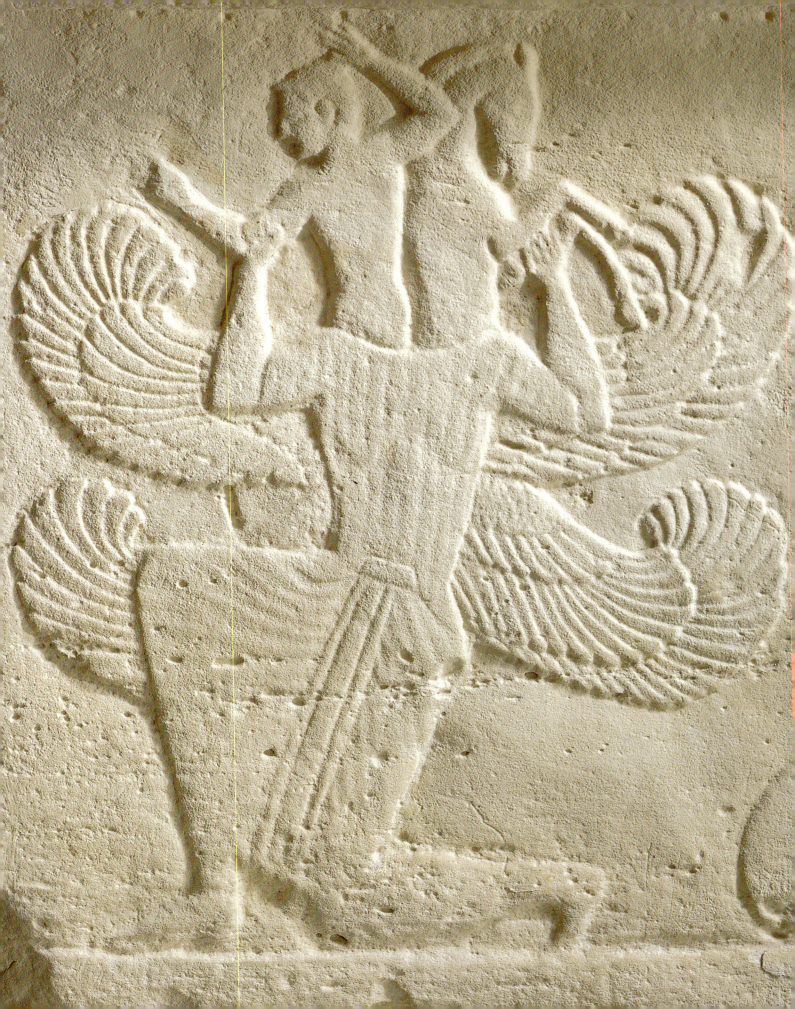

III.

THE CYPRO-
CLASSICAL PERIOD
[CA. 480 – CA. 310 B.C.]

During the Late Cypro-Archaic and Classical periods Cyprus was involved in the conflict between the Greeks and the Persians. The island was occupied by the Persians in about 525 B.C., and for two centuries the Cypriots fought for their independence, often assisted by the Greek army. The Persians, however, exploited the discord among the various independent Cypriot kings. By adopting the principle of divide and conquer, they maintained a firm grip on the island until 333 B.C., when Alexander the Great liberated Cyprus. The Phoenicians, who always sided with those in power, had the Persian kings as allies and thus gained strong economic and political influence in various parts of Cyprus. Three of the island's kingdoms—Salamis, Kition, and Lapithos—had Phoenician kings at times during the fifth century B.C. Amathus was a Phoenician stronghold, and Idalion and Tamassos were under the Phoenician ruler of Kition by the end of the fifth century B.C.

The Phoenicians introduced their own gods and goddesses to Cyprus. Apart from the goddess Astarte, who was assimilated with Aphrodite, the Great Goddess of Cyprus, and was worshipped in monumental temples at Kition, Paphos, Amathus, Golgoi, and elsewhere, other Phoenician gods appear in the Cypriot pantheon. They correspond to Greek gods, for instance, Herakles = Melqart (who was worshipped on Cyprus as a god),

Athena = Anat, and Apollo = Reshef, who were worshipped in temples in urban centers as well as in rural sanctuaries.

The art of the sixth century B.C. is dominated by sculpture, in both limestone and terracotta. Sculptures are found in temples and sanctuaries, several of which Cesnola excavated, notably at Golgoi, where he found some of the fine works illustrated here. By the sixth century B.C., the influence of Archaic Greek sculpture becomes apparent, but from the period when Cyprus was under Egyptian domination, beginning in the second quarter of the sixth century B.C., influence from Assyrian and Egyptian sculpture is also conspicuous. Egyptian influence may have started earlier, however, as a result of Phoenician activities: the Phoenicians traded in works of art throughout the Mediterranean.

The long wars for freedom and the presence of the Greek army on the island (in the joint effort to oust the Persians) aroused the Greek identity of the Cypriots. This is manifested particularly in the adoption of Greek styles in art, especially in sculpture. Greek sculptors were probably working on Cyprus, and thus a small number of Greek marble works, mainly funerary stelai, have

Opposite: Detail, cat. no. 331

[199]

come to light on the island, dating from the very end of the Cypro-Archaic II and the Classical periods. Large quantities of Greek pottery—Attic and eastern Greek—have been found, mainly in tombs at Marion, Amathus, and Salamis, and a few elsewhere on Cyprus.

As early as 530 B.C., the independent Cypriot kingdoms began to mint their own coinage. The repertoire of motifs on these coins was largely inspired by Greek gods and heroes. The end of the Cypro-Archaic II period also witnessed the production of an important series of stamp seals and engraved finger rings that reflect the influence of Greek art. In ceramics, a marked decline started about 500 B.C.; the Cypriot potters could not compete with imported Greek wares. Cypriot art in general declined once native artists started to imitate Greek works.

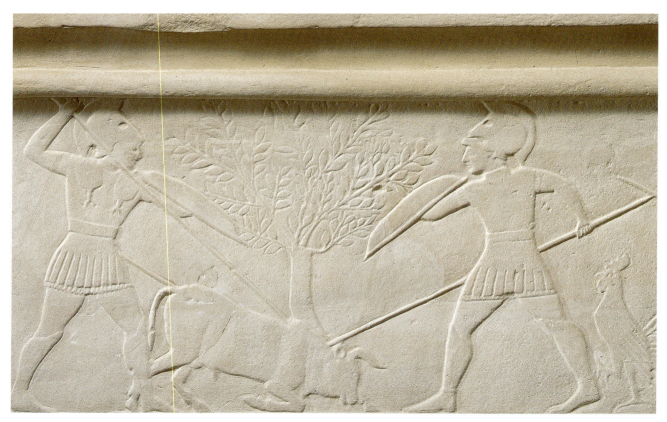

331. DETAIL

STONE SCULPTURE

Sculpture flourished during the Archaic and early Classical periods but declined gradually in the fourth century B.C. The Archaic Greek style of art prevalent in Ionia exercised considerable influence on Cypriot sculpture, and during the sixth century B.C., political developments favored the position of Greek culture on the island. By the end of the Archaic period, the effect of Greek sculptural styles on Cypriot art is undeniable. This change is obvious when one looks at the monumental stone works that adorned the great sanctuaries of Cyprus, where Greek gods, with some Cypriot adaptations, were worshipped.

Although the religious iconography of Cyprus was often based on Greek models, several elements reflect native tastes and idiosyncrasies. From the seventh to the fourth century B.C. Cyprus was under foreign domination. Foreign rule, in addition to the active presence of Phoenicians on the island, considerably influenced artistic development. Among the Cypriot gods that are alien to Greek religion are the Cypriot Herakles, Zeus Ammon, Bes, an oriental Astarte, and other deities that the Phoenicians introduced.

Many of the sculptural works of Cyprus are three-dimensional and freestanding, but Cypriot artists were also fond of carving in relief. The Cesnola Collection possesses some unique examples that betray both Greek and oriental stylistic tendencies. Relief sculptures of particular interest are found on the sarcophagi from Amathus and Golgoi (cat. nos. 330, 331). There is also a series of important dedications, made to hang on the walls of sanctuaries, that date from the fifth, fourth, and third centuries B.C. (e.g., cat. no. 352). These reliefs depict narrative scenes with several figures. Although their sculptural and artistic merit is often limited, they are interesting as expressions of folk art and popular religion. They often include dedicatory inscriptions.

330. **Sarcophagus**
ca. 475 B.C.
Limestone
L. 228.8 cm (90⅛ in.); H. 147.3 cm (58 in.); W. 109.5 cm (43⅛ in.)
74.51.2453 (Myres 1365)
Said to be from Amathus

The Amathus sarcophagus is a unique funerary sculpture; its monumentality is not matched by anything else found on Cyprus. Undoubtedly it was meant to hold the remains of an important person, possibly a king of the city. The exceptionally high relief and its polychrome decoration give this work a particular place in the repertoire of Cypriot sculpture of the fifth century B.C. Much additional polychromy came to light during conservation at the Metropolitan Museum in 1999. Undecorated sarcophagi in wood must have existed. Other examples in stone are known from places such as Amathus and Tamassos (Hermary 1987, p. 69). Similar sarcophagi have also been found in Greece (cf. Tatton-Brown 1981a, p. 82).

The chariot scenes on the two long sides do not have a warlike character. Instead, they show a procession, probably from the life of the deceased (views 1, 3). The dress and general appearance of the human figures give the iconography a strong Cypriot character. The chariots are similar to models in limestone (see cat. no. 353). Some details, such as the parasol, may derive from oriental or eastern Greek representations. The rich decoration of the horses and the chariot poles had a long tradition on Cyprus. These features imitate Assyrian prototypes. Graeco-Persian reliefs

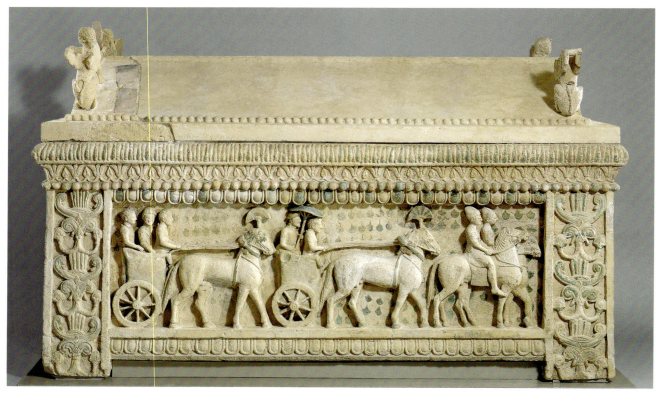

330. VIEW 1

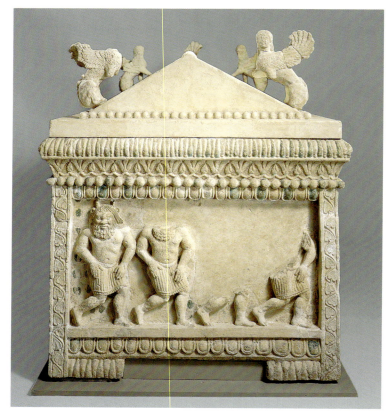

330. VIEW 2

have been suggested as the proto-
types for the Amathus chariot
processions (Tatton-Brown 1981a,
pp. 79–81).

One short side had four figures
of Bes, now damaged or missing
(view 2). The Egyptian god Bes was
popular at Amathus. His favor was
enhanced by the presence of Phoe-
nicians in that city. His *floruit* is the
Cypro-Archaic period, but colossal
statues of the god also appear into
Roman times. The horns on the god
and his placement on one of the
short sides of this sarcophagus re-
veal the influence of Archaic Greek
representations of the Gorgon Me-
dusa (Tatton-Brown 1981a, p. 77).
The function of Bes on this sar-
cophagus is no doubt apotropaic.

The other short side of the sar-
cophagus shows four Astarte fig-
ures standing side by side (view 4).

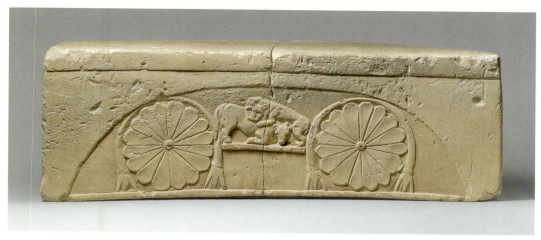

333

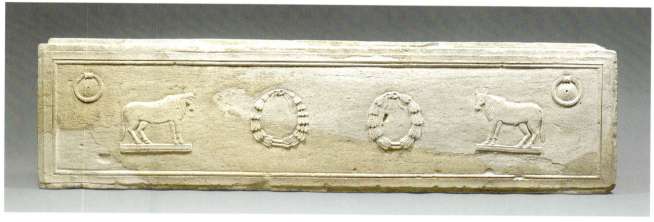

334

333. Votive footstool

1st half of the 5th century B.C.

Limestone

H. 19.7 cm (7¾ in.); L. 58.3 cm
(23 in.); preserved W. 23 cm (9 in.)

74.51.2678 (Myres 1373)

Said to be from the ruins of Golgoi

The front, decorated in low relief,
depicts a lion attacking a bull. A
spray of lotus flowers arches over
each rosette.

BIBLIOGRAPHY: Cesnola 1877, p. 159;
Cesnola 1885, pl. CXXII.906; Masson
1971b, pp. 311, 316; Tatton-Brown
1984, pp. 171–72, pl. XXXIII.6.

**334. Relief from the principal face
of a sarcophagus**

Mid-5th century B.C.

Limestone

H. 45.7 cm (18 in.); L. 175.3 cm
(69 in.); thickness 7.5 cm (3 in.)

74.51.2491 (Myres 1372)

The style of the relief on this
work, especially the rendering of
the loop handles and the wreaths,
betrays the influence of wood carv-
ing. Funerary architecture in stone
often imitated wooden construc-
tions. For example, wooden details
can be seen in the construction of
the roof, the lock, and the relief
decoration inside one of the large
royal tombs at Tamassos (Christou
1996, pls. XLII–XLIV; Buccholz 1974,
fig. 49). There is no independent
evidence for the dating of this
fragment, but the mid-fifth cen-
tury B.C. is appropriate, based on
the style of carving, which recalls
that of the two votive footstools
(cat. nos. 332, 333).

BIBLIOGRAPHY: Doell 1873, p. 58,
pl. XII.10, no. 835; Cesnola 1877,
p. 54.

Cypriot sculptors often imitated Greek statuary, particularly the kouros, represented here by a group of carefully rendered limestone heads of beardless youths that date from the very beginning of the fifth century B.C. (cat. nos. 335, 337, and 338; cf. Hermary 1989, p. 135, nos. 262, 263). From the second quarter of the fifth century B.C. is a group of sculptures from places such as Golgoi and Pyla. Known as Sub-Archaic Cypro-Greek, they have beards with curls and undulating tresses (see cat. nos. 336, 340; cf. Pryce 1931, pp. 61–62, nos. c154–56; for a general account of the style of these sculptures, see Gjerstad 1948, p. 120; Vermeule 1976, p. 21, no. 4, fig. 1–8). The stiffly folded drapery of catalogue number 339 places it last in this series, from the third quarter of the fifth century B.C.

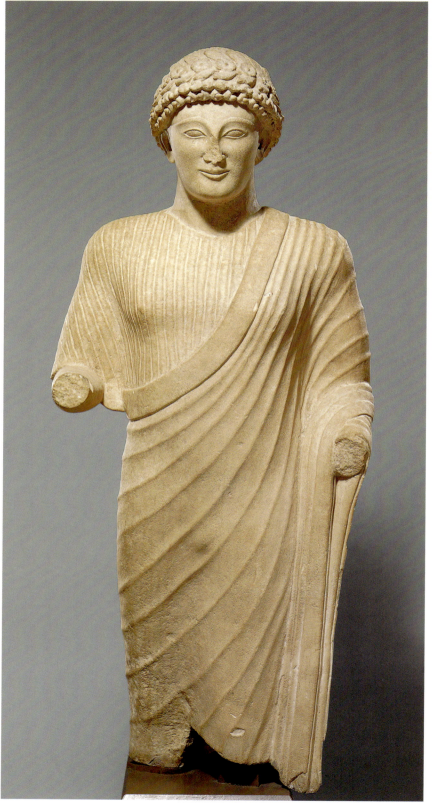

335

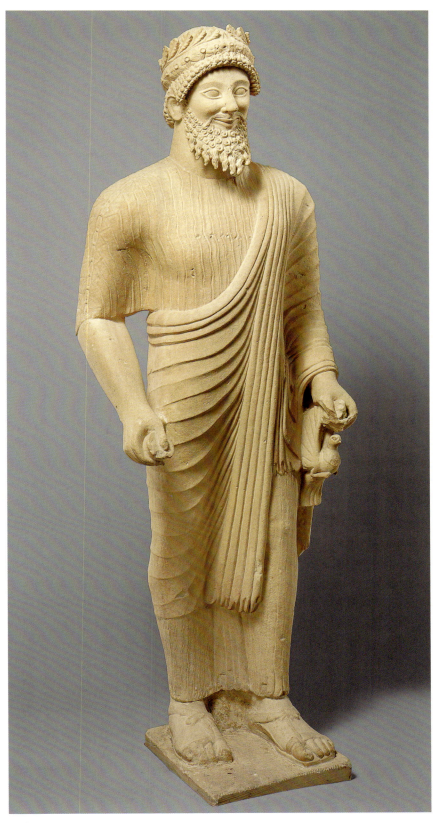

335. Beardless male votary wearing a wreath

Beginning of the 5th century B.C.
Limestone
H. 111.4 cm (43⅞ in.)
74.51.2457 (Myres 1359)
Said to be from the temple at Golgoi

The back is partly carved; there is a tenon behind the right leg and a mortise near the left knee. It is uncertain whether the head belongs to the body.

BIBLIOGRAPHY: Doell 1873, p. 27, pl. IV.8, no. 97; Cesnola 1885, pl. LXIX.454.

336. Bearded male votary wearing a wreath

2nd quarter of the 5th century B.C.
Limestone
H. 164.5 cm (64¾ in.)
74.51.2461 (Myres 1407)
Said to be from the temple at Golgoi

The figure wears a wreath of oak leaves and narcissus. In the right hand he holds a spool-like object often interpreted as a yo-yo, and in the left a dove (held by the wings). The feet are modern.

BIBLIOGRAPHY: Doell 1873, pp. 24–25, pl. IV.9, no. 80; Cesnola 1877, pp. 149–50; Colonna-Ceccaldi 1882, pl. IV.3; Cesnola 1885, pl. LXVIII.453; Senff 1993, p. 36 n. 294.

336

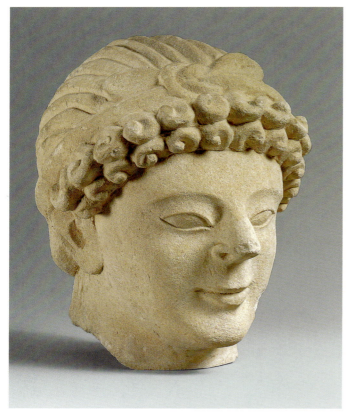

337

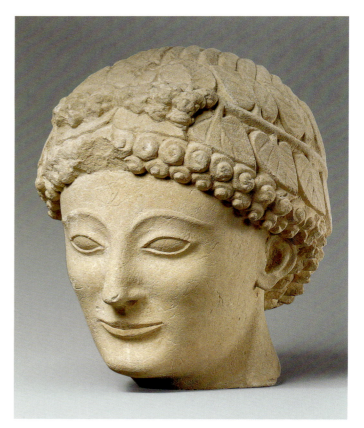

338

337. Beardless male head wearing a wreath
Beginning of the 5th century B.C.
Limestone
H. 17.1 cm (6¾ in.)
74.51.2632 (Myres 1303)
 The wreath is fastened with a Herakles knot.

338. Beardless male head wearing a wreath
Beginning of the 5th century B.C.
Limestone
H. 19.5 cm (7⅝ in.)
74.51.2832 (Myres 1305)
Said to be from the temple at Golgoi

BIBLIOGRAPHY: Cesnola 1885, pl. LXXV.482.

339. Beardless male votary wearing a wreath
3rd quarter of the 5th century B.C.
Limestone
H. 81.9 cm (32¼ in.)
74.51.2482 (Myres 1308)
Said to be from the temple at Golgoi
 The feet are missing. Over the tunic is what appears to be an outer tunic that falls to the waist. In his left hand he holds what may be a trumpet or an alabastron.

BIBLIOGRAPHY: Doell 1873, p. 30, pl. V.12, no. 114; Cesnola 1885, pl. CIII.677; Perrot and Chipiez 1885, pp. 135–36, fig. 88.

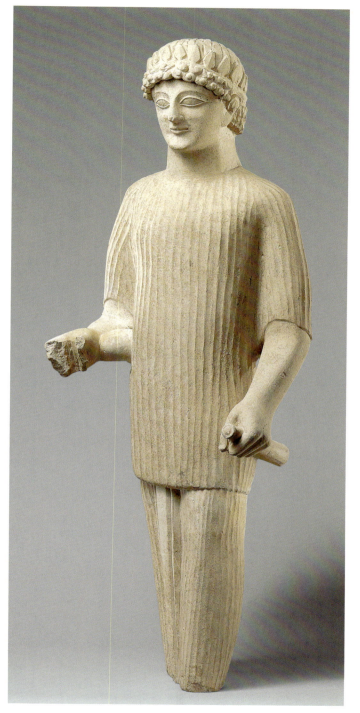

339

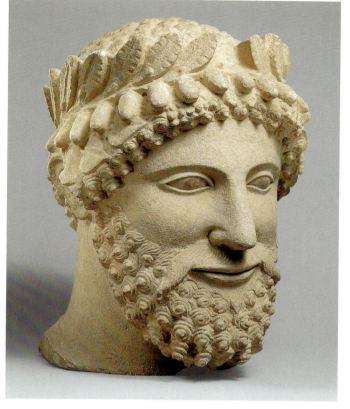

340

340. Bearded male head wearing a wreath

2nd quarter of the 5th century B.C.
Limestone
H. 35.9 cm (14⅛ in.)
74.51.2837 (Myres 1291)
Said to be from the temple at Golgoi

The figure wears a wreath with oak leaves at the top and narcissus below.

BIBLIOGRAPHY: Doell 1873, p. 46, pl. IX.8, no. 346; Cesnola 1877, p. 153; Cesnola 1885, pl. LXXXII.539.

341. Aphrodite and Eros

ca. 330–ca. 320 B.C.
Limestone
H. 126.4 cm (49¾ in.)
74.51.2464 (Myres 1405)
Said to be from the temple at Golgoi

The crown is decorated with anthemia and nude female figures in relief: on the left a figure holds something in her left hand against her chest; on the right a figure holds something in her right hand and extends her left arm to the side, toward what appears to be a large flower. The fragmentary winged Eros places his right hand on Aphrodite's left breast.

The battered condition of Aphrodite's face and of Eros is unfortunate, because this work is important as a Cypriot copy of a Late Classical Greek sculptural type and as a statue that preserves local sculptural traditions such as the crown and the veil (cf. Vermeule 1976, pp. 25–26, fig. 1–14; cf. Vessberg and Westholm 1956, p. 88, pl. IX.1).

BIBLIOGRAPHY: Cesnola 1877, p. 106; Cesnola 1885, pl. CVII.695; Vessberg and Westholm 1956, p. 88, pl. IX.1; Vermeule 1976, pp. 25–26, pl. I.14; Sørensen 1981, pp. 169–77, pl. XXXII.5; Vermeule 1988, p. 139; Connelly 1991, p. 98, pl. XXa; V. Karageorghis 1998a, p. 206, fig. 154.

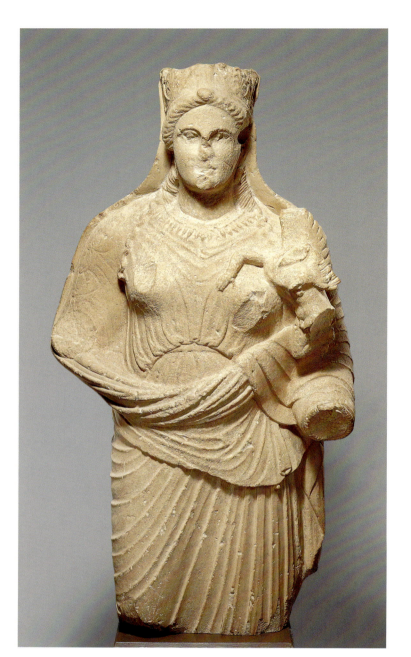

341

342. Female head with elaborate jewelry

Mid-5th century B.C.
Limestone
H. 29 cm (11⅜ in.)
74.51.2820 (Myres 1295)
Said to be from the temple at Golgoi

Female heads wearing elaborate earrings, ear caps, and a necklace with many strings of beads were common from the end of the sixth to the beginning of the fifth century B.C. They wear not a crown but, occasionally (as here), a fillet that holds back the delicately rendered hair. The smiling expression on the face is in the Archaic Cypro-Greek style (cf. Hermary 1989, p. 330, no. 650).

BIBLIOGRAPHY: Doell 1873, p. 46, pl. IX.5, no. 308; Cesnola 1877, p. 141; Cesnola 1885, pl. LXXXII.537; Richter 1949, p. 175, fig. 267.

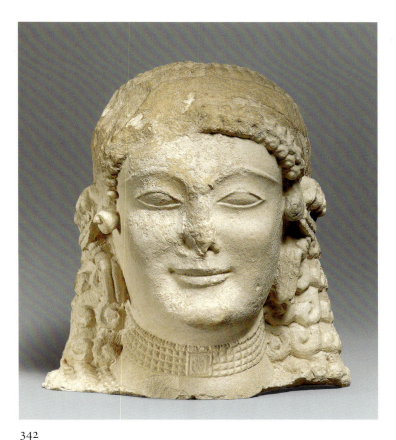

342

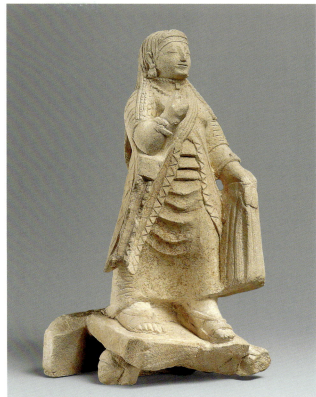

343

343. Draped female figure
Late 6th or early 5th century B.C.
Limestone
H. 20.3 cm (8 in.); H. (with base):
25 cm (9⅞ in.)
74.51.2558 (Myres 1262)
Said to be from the temple at Golgoi

The figure holds the disk and shaft of a mirror in her left hand. The folds of her himation are rendered as triangles, imitating the drapery of Greek korai. Under the flat, rectangular platform on which she stands are two human (female?) Egyptianizing heads looking outward. The platform once had a flat, vertical back that projected above the floor; it is now broken off. The lower part was sawed flat by Cesnola. Near the left corner a grooved,

cylindrical object appears below the floor, but it is broken off. Possibly it was a snake.

This statuette created considerable controversy in the 1880s and was used as an example of Cesnola's deliberate alteration of stone sculptures in his collection. Details of the piece, such as the left hand that holds both a mirror and a fold of the skirt, are peculiar. The drapery is richly folded, but in such a way that it raises doubts as to how much has been recarved in modern times. Since the figure stands on a square bracket that rests on the heads of two human figures, it may have formed part of another object, now broken away.

Myres called her a "lady of rank"

and identified her dress with an Assyrian type (1914, p. 197). Prior to the statuette's recarving, however, it may have looked much like a work now in the Musée du Louvre, Paris (Hermary 1989, p. 343, no. 682), that imitates the Greek kore type and dates from the end of the sixth or beginning of the fifth century B.C. The sculptor here also, no doubt, tried to imitate the drapery and the movement of Greek korai.

BIBLIOGRAPHY: Doell 1873, p. 15, pl. I.2, no. 28; Cesnola 1877, p. 157; Colonna-Ceccaldi 1882, pl. XIII; Cesnola 1885, pl. LVII.365; Myres 1946b, p. 101; Bossert 1951, p. 5, fig. 58, no. 58; Harden 1962, p. 195, pl. 71.

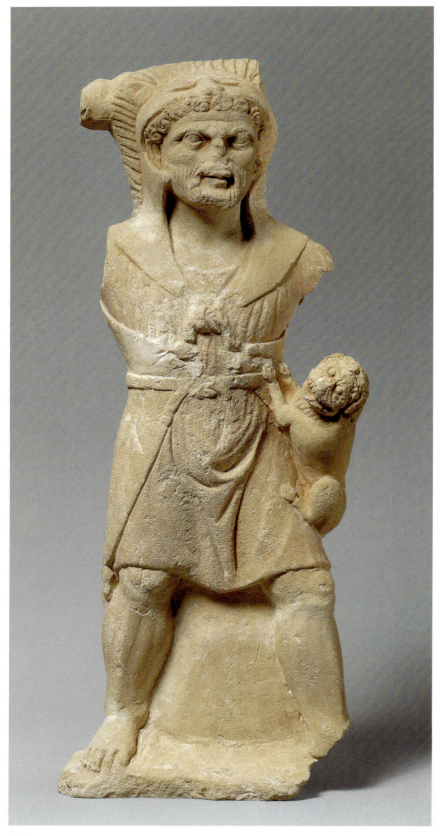

344

344. Herakles holding a miniature lion in his left hand

Early 5th century B.C.
Limestone
H. 54 cm (21¼ in.)
74.51.2660 (Myres 1098)
Said to be from the temple at Golgoi

In the Classical period, King Evagoras of Salamis placed on his coinage images of Herakles as a Panhellenic hero. At the same time, the Phoenician kings assimilated him with their god Melqart, who was worshipped at Kition. Furthermore, Herakles was worshipped, together with Athena, in a sanctuary at Kakopetria (V. Karageorghis 1977a).

The Cypriot Herakles type, bearded or beardless, wearing a lion's skin and a short tunic and holding a miniature lion in his left hand, is represented here. The type may have been oriental in origin, but it was adopted and transformed by Cypriot sculptors at the end of the sixth and during the fifth century B.C. (Yon 1992, p. 150). The expression of the face suggests that it dates from the early fifth century B.C. (cf. Hermary 1989, p. 301, no. 600).

BIBLIOGRAPHY: Cesnola 1877, p. 250; Cesnola 1885, pl. LXXXVII.578; Perrot and Chipiez 1885, p. 175, fig. 113; Myres 1946c, p. 65; Hermary 1990, p. 194, no. 14.

345. **Four-sided altar decorated with scenes in relief**

End of the 5th century B.C.

Limestone

H. 25.7 cm (10⅛ in.)

74.51.2633 (Myres 1109)

Said to be from the temple at Golgoi

The back side is flat and undeco-rated. The top has a hollowed-out rectangular cavity. The base is dec-orated on three sides with relief.

On the front Herakles appears in the nude and advances to the right to attack the Nemean lion. Herakles holds a club in his raised right hand. The lion stands on the ground line of the base, whereas Herakles stands on an upper level. On the two sides of the altar appear representations of votaries. One is a draped female figure moving to the right and look-ing backward, toward the side with Herakles. She raises both of her hands up and forward. Above her, in another smaller register, is what appears to be a lion facing to the left. The votary on the other side is a draped human figure facing fron-tally with the right arm bent against the chest and the left arm placed downward. The carving of the fig-ure is crude, and the head is heavily damaged. The miniature altar most likely dates from the end of the fifth century B.C. because of its shape and its depiction of Herakles fight-ing the Nemean lion (Hermary 1990, pp. 195–96, no. 25).

BIBLIOGRAPHY: Cesnola 1885, pl. XXVII.87; Myres 1946c, p. 65; Sophocleous 1985, pp. 40–41, pl. XLII.4; Hermary 1990, p. 195, no. 25; Senff 1993, p. 75 n. 643; V. Kara-georghis 1998a, pp. 80–81, 83, fig. 36.

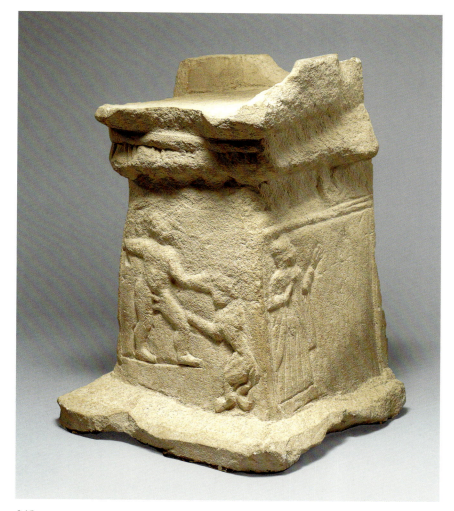

345

346. Funerary stele with sphinxes

Last quarter of the 5th century B.C.

Limestone

H. 88.2 cm (34¾ in.); W. 68.5 cm
(27 in.)

74.51.2499 (Myres 1413)

Said to be from the necropolis
at Golgoi

The influence of Greek sculpture
is obvious. The sphinxes are com-
pletely different from the Cypriot
type of the sixth century B.C. They
are shown with palmettes, an egg-
and-dart motif, and a knotted sash.

The lower part of the piece has
been sawed off. The back of the
piece is crudely carved; the breasts
are covered with a painted scale
pattern.

BIBLIOGRAPHY: Cesnola 1885,
pl. CXXVI.920; Perrot and Chipiez
1885, pp. 221, 223, fig. 151; Myres
1946c, p. 68; Masson 1971b, p. 316;
Tatton-Brown 1986, p. 443,
pl. XLVII.6.

**347. Funerary stele with Cypriot
capital**

5th century B.C.

Limestone

H. 137.1 cm (54 in.); max. W. 81.3 cm
(32 in.)

74.51.2493 (Myres 1418)

Said to be from the necropolis
at Golgoi

The work is a fine example of a
Cypriot capital and was probably
used as a tombstone (Tatton-
Brown 1986, p. 445 n. 58). The type
comes mainly from Idalion and
Golgoi. It was already in use in the
seventh century B.C. and continued
into the fifth century B.C. (Her-
mary 1989, p. 470). This piece,
combining the tree-of-life motif
with two Greek-type sphinxes,
is undoubtedly of the fifth cen-
tury B.C. (Tatton-Brown 1986,
p. 445).

The back side of the stele is flat;
the lower part has been sawed off.

BIBLIOGRAPHY: Cesnola 1877, p. 117;
Colonna-Ceccaldi 1882, p. 67;
Cesnola 1885, pl. XCIX.671; Myres
1946c, p. 68; Harden 1962, pp. 194,
196, pl. 45; Masson 1971b, p. 316;
Tatton-Brown 1986, p. 445; Masson
1989, fig. 2.

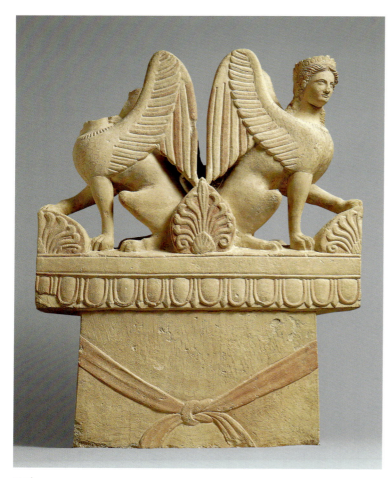

346

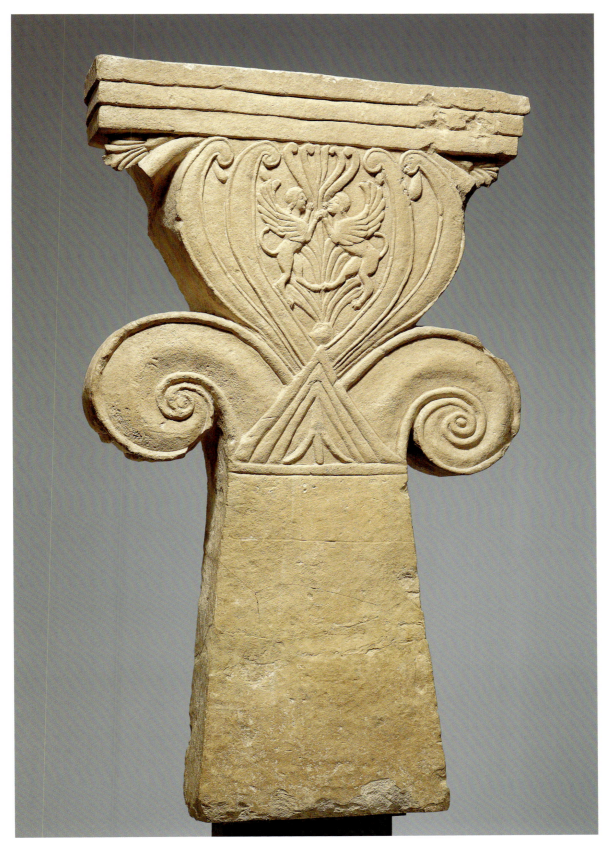

347

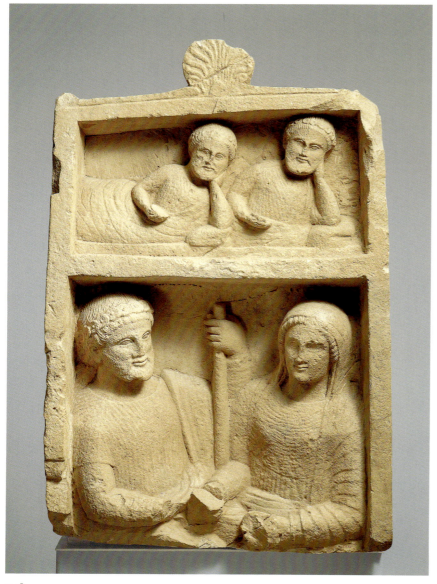

348

349. Funerary stele
2nd half of the 5th century B.C.
Limestone
H. 144.8 cm (57 in.);
max. W. 70.5 cm (27¾ in.)
74.51.2485 (Myres 1400)
Said to be from the necropolis
at Golgoi

The relief stele has a high plinth.
A female figure leans her head
against her right hand and holds
fruit on her lap. The influence of
Greek funerary sculpture is seen
here. Women in similar postures of
mourning appear in both lime-
stone and mold-made terracotta,
particularly in the region of Mar-
ion (cf. Caubet, Hermary, and
Karageorghis 1992, pp. 155–56,
no. 187). Several marble funerary
stelai made in Greece have also
been found at Marion.

BIBLIOGRAPHY: Cesnola 1885,
pl. CXXVIII.922; Vermeule 1976,
p. 61 n. 9.

348. Funerary relief
ca. 400 B.C.
Limestone
H. 124.4 cm (49 in.); max. W. 80 cm
(31½ in.)
74.51.2484 (Myres 1401)
Said to be from the necropolis
at Golgoi

The figures in the upper register
are wreathed with rosettes, and each
holds a phiale, or libation bowl. The
male and female figures in the lower
register are possibly holding hands.
A bracelet encircles the woman's left
wrist, and she probably held a fruit
in her left hand. The entire surface
of the piece is worn.

BIBLIOGRAPHY: Cesnola 1885,
pl. CXLI.1053; Masson 1971b, p. 316,
fig. 8; Dentzer 1982, p. 569, pl. 32,
fig. 197, no. R16.

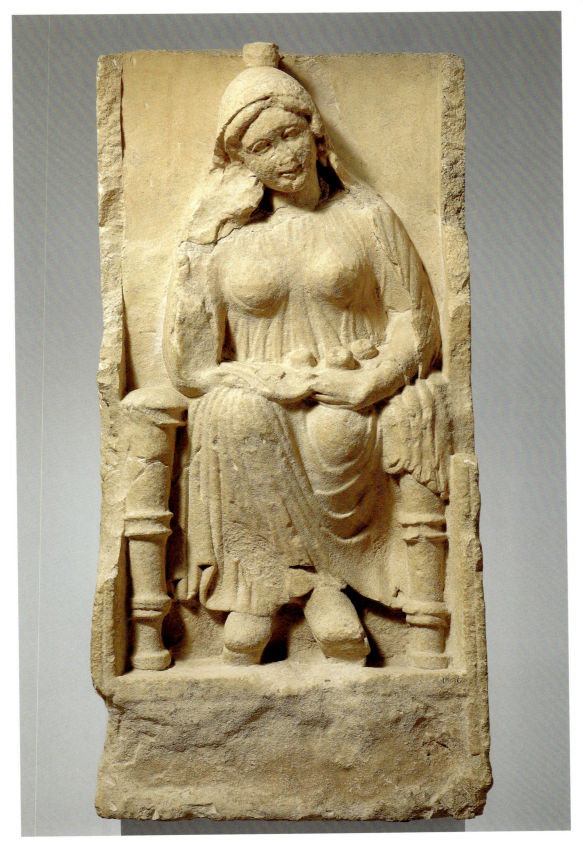

349

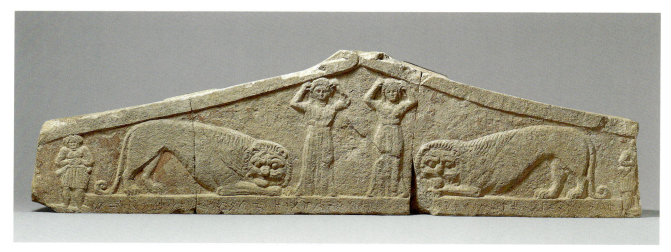

350

350. Funerary pediment

4th century B.C.

Limestone

L. 121.9 cm (48 in.); H. 34.3 cm (13½ in.)

74.51.2317 (Myres 1857)

Said to be from a tomb in the necropolis at Golgoi

Both ends are broken away. A round tenon held an akroterion at the apex. There were also tenons on either end for akroteria, but only the one on the left is preserved. The piece is smooth at the back and increases in depth from top to base. At each extremity is a Master of the Animals or Bes(?) facing frontally. The figure on the right is cut through the middle. The background of the pediment was painted pink. There is an engraved inscription on the frame; red paint fills the lettering. It reads: "I am Aristokretes, my brothers set [this] down in memory of good deeds that I once did well." The top part of the frame probably ended in two antithetical scrolls, now broken.

The guardian lions are strictly stylized, with their heads turned unconvincingly to face outward. The two mourning women, in the center, are rare in Cypriot funerary reliefs, as is the form, which imitates the pediment of a temple. Tatton-Brown considers the piece Hellenistic (1986, p. 449).

BIBLIOGRAPHY: Cesnola 1877, p. 439, no. 37, pl. 6.37; Cesnola 1885, pl. LXXXV.563; Cesnola 1903a, pl. CXXXVII.1–5; Masson 1961, pp. 282–83, pl. 44.1, no. 261; Masson 1971b, p. 316, fig. 6.

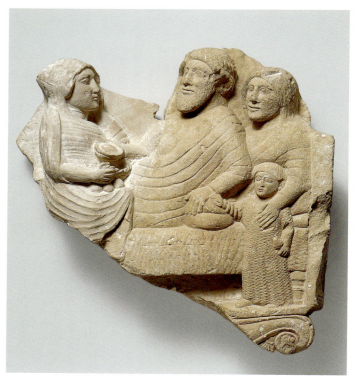

351

351. Banquet scene

Early 4th century B.C.

Limestone

H. 50.8 cm (20 in.); L. 57.2 cm (22½ in.)

74.51.2843 (Myres 1382)

Said to be from the necropolis at Golgoi

The piece once consisted of two reliefs, but of the lower one, only the scroll of a Cypriot capital survives. The bearded man wears a wreath, a long-sleeved chiton, and a himation. In his right hand he holds a phiale. He faces a woman who holds fruit and other objects on her lap.

This banquet scene is part of a funerary stele (Tatton-Brown 1986, p. 444; Dentzer 1982, p. 280, no. R14). Early in the fifth century B.C., well before the Greeks, Cypriots put scenes of banquets on grave stelai. The intent was to comfort the deceased, usually a male, with the presence of family members and to remind him of happy moments that might be repeated in the next life. In addition to the dead man's wife, two other figures are probably family members. The stele had an Ionic or an Aeolic Cypriot capital below the relief. It dates to the early fourth century B.C. (Tatton-Brown 1986, p. 444). Catalogue number 348, a funerary relief showing two well-defined panels with two reclining figures in each, is of a similar date, about 400 B.C.

BIBLIOGRAPHY: Cesnola 1885, pl. CXXI.902; Masson 1971b, p. 316; Dentzer 1982, pp. 280, 569, pl. 32, fig. 196, no. R14; Tatton-Brown 1986, p. 444.

352. Votive relief with a scene of worship and a banquet scene

4th century B.C.

Limestone

H. 31.8 cm (12½ in.); W. 50.5 cm (19⅞ in.); thickness 0.5–2.5 cm (¼–1 in.)

74.51.2338 (Myres 1870)

Said to be from the temple at Golgoi

The slab is roughly rectangular, with two perforations for suspension in the middle at the top. One side is decorated in low relief. The figures are arranged in two registers: the upper register represents a scene of worship and the lower a scene of feasting and dancing.

The extreme right of the upper register is occupied by Apollo, represented as a seated, beardless young male figure, with a wreath around his head. He touches a lyre with his left hand and holds out a phiale in his right. In front of him is a high altar, perhaps made of earth or stones. Seven worshippers advance toward him from the left, up a slope. They are probably a single family. The man leading the group may have held an offering, but his right hand is damaged. The young boy holds a jug in his right hand. Red paint defines details of Apollo's garments, the lyre, and the hair of the other figures. On the altar is a sign of the Cypriot syllabary.

The lower register has two groups of figures, banqueters to the right and dancers, three boys and two women or girls, to the left. The five banqueters, all youthful males, sit in a semicircle facing a flute player. At the feet of the flute player is a large, semiglobular jar with horizontal handles containing a red-painted amphora. The jar may be a psykter, an apparatus for cooling wine. To the right of the amphora are two signs of the Cypriot syllabary, "o-pa." Masson

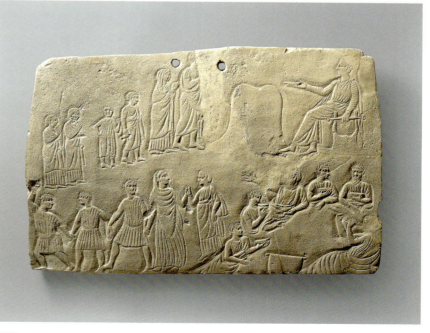

352

has interpreted these signs as
'ο[μ]φά, "oracle."

This low, flat relief resembles
a drawing rather than sculpture.
Its style follows that of the Golgoi
sculptors (see cat. no. 192). The
narrative scene is in two registers
that are not separated or framed.
The composition is lively and well
carved. Greek influence is evident
in the rendering of Apollo, but the
rest of the relief has a Cypriot char-
acter, for it represents a scene from
popular religion and exhibits a
sense of humor in the composition.

The relief dates from the fourth
century B.C. and may have hung on
the wall of the sanctuary of Apollo
at Golgoi. It is improbable that this
Apollo is Apollo Magirios, the god
of banquets, as has been suggested
by Ghedeni (1988). Apollo combined
many qualities, and his worship
was particularly strong on Cyprus
from the sixth century B.C. on.

BIBLIOGRAPHY: Doell 1873, p. 49,
pl. XI.5, no. 766; Cesnola 1877,
pp. 149, 438, pl. 4.21, no. 21;
Colonna-Ceccaldi 1882, pp. 75–76;
Cesnola 1885, pl. LXXXV.553; Cesnola
1903a, pl. CXXXIII.2; Masson 1961,
pp. 280, 287–88, no. 268; Dentzer
1982, pp. 281–82, pl. 34, fig. 208,
no. R27; Ghedeni 1988; Connelly
1989, p. 212; V. Karageorghis n.d.(a).

353. Model of a biga

5th century B.C.
Limestone
H. 15.9 cm (6¼ in.); L. 18.4 cm
(7¼ in.); W. (at the wheels): 15.6 cm
(6⅛ in.)
74.51.2687 (Myres 1017)
Said to be from the ruins of a
temple at Kourion

Several chariot groups in lime-
stone date from the fifth century B.C.
(Crouwel 1987, p. 101), but they
are outnumbered by terracotta
examples, which appeared on Cy-
prus by the end of the seventh cen-
tury B.C. (Crouwel 1987, p. 101). This
biga, or two-horse chariot, is lively
and well carved. It has a Y-shaped
pole, and the harnessing is clearly
indicated by grooves. Unlike the
earlier terracotta examples, this
piece represents not a war chariot
but a processional one. Limestone
chariot models have been found at
Amathus (cf. Hermary 1981, pp. 49–
51), and relief scenes of chariots
appear on the sarcophagus from
Amathus and that from Golgoi (see
cat. nos. 330, 331).

BIBLIOGRAPHY: Cesnola 1885,
pl. LXXX.520; Myres 1933, p. 35 n. 25;
Littauer and Crouwel 1977, p. 2
n. 10, p. 3, fig. 1; Crouwel 1987,
pp. 101 n. 3, 104, 107–8, 111,
pl. XXXVI.1,2.

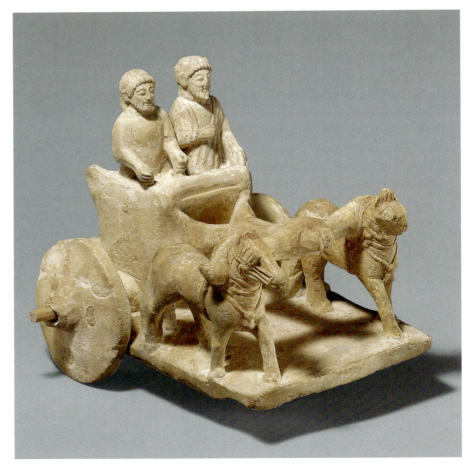

353

The present example is one of two marble anthropoid sarcophagi that have been found at Amathus; the second is published in Hermary 1987. The other marble anthropoid sarcophagus in the Metropolitan Museum was found at Kition (cat. no. 361). Today, there are more than two hundred known anthropoid sarcophagi, many made of local Cypriot stone. Some are mold-made of clay. These were the poor man's version (for general discussions of anthropoid sarcophagi, see Hermary 1987, pp. 59–63, and V. Karageorghis n.d.[b]).

Hermary suggested that sarcophagi of the early fifth century B.C. were made by Greek sculptors, and that those of the second half of the century were made by Phoenician or Cypriot sculptors (1987, pp. 61–62). This may be true for a very small number, but it is difficult to accept that a Greek sculptor would have rendered female hair in the style shown here (e.g., Hermary 1985, pp. 696–97, figs. 40–41).

BIBLIOGRAPHY: Cesnola 1877, p. 288; Cesnola 1885, pl. XCI.590; Kukahn 1955, pp. 23 n. 68, 39–40, 91, pl. 24, no. K19; Teixidor 1977, p. 68, fig. 28, no. 28; Hermary 1981, pp. 85–86, pl. 21, no. 83; Hermary 1987, pp. 59, 62.

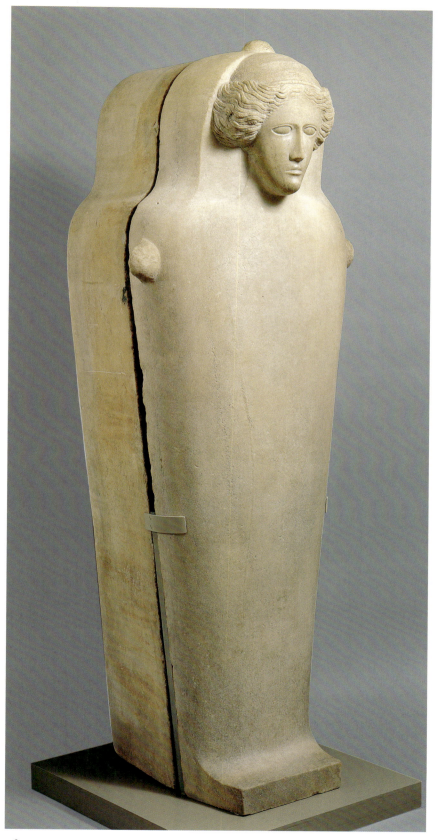

360. VIEW 2

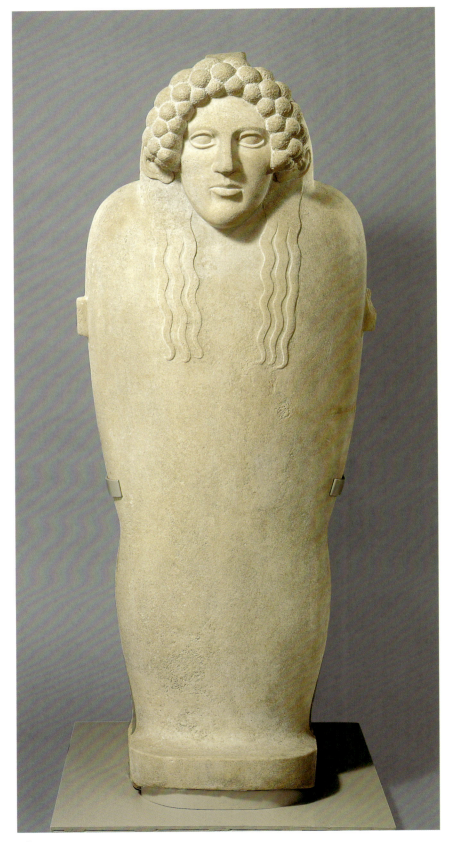

361. VIEW 1

361. Anthropoid sarcophagus
Mid-5th century B.C.
Marble
L. 211.5 cm (83¼ in.)
74.51.2454 (Myres 1367)
Said to be from the necropolis
at Kition

The head of a female figure
adorns one end of the sarcophagus
lid. The remainder of the body is
almost completely undifferentiated,
except for partially modeled legs
and feet. The area below the feet is
roughly chiseled.

BIBLIOGRAPHY: Doell 1873, p. 58,
pl. XII.6, no. 834; Cesnola 1877, p. 53;
Cesnola 1885, pl. XCI.589; Kukahn
1955, pp. 37, 84, 87, pl. 26.2, no. K25;
Hermary 1987, p. 59; Caubet and
Yon 1994, p. 102.

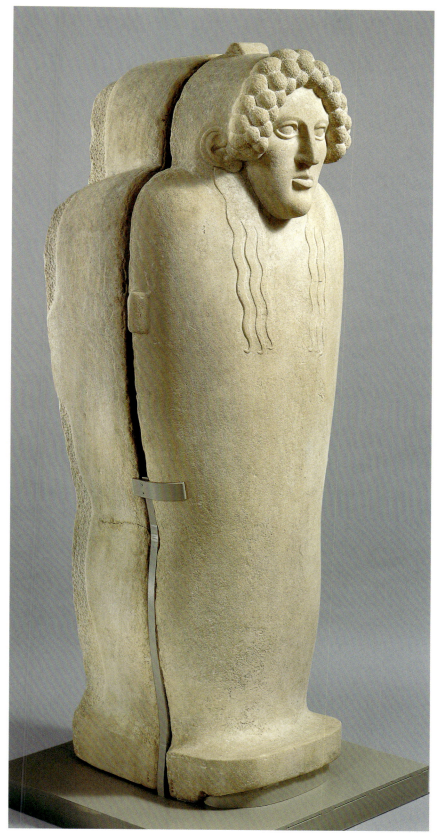

361. VIEW 2

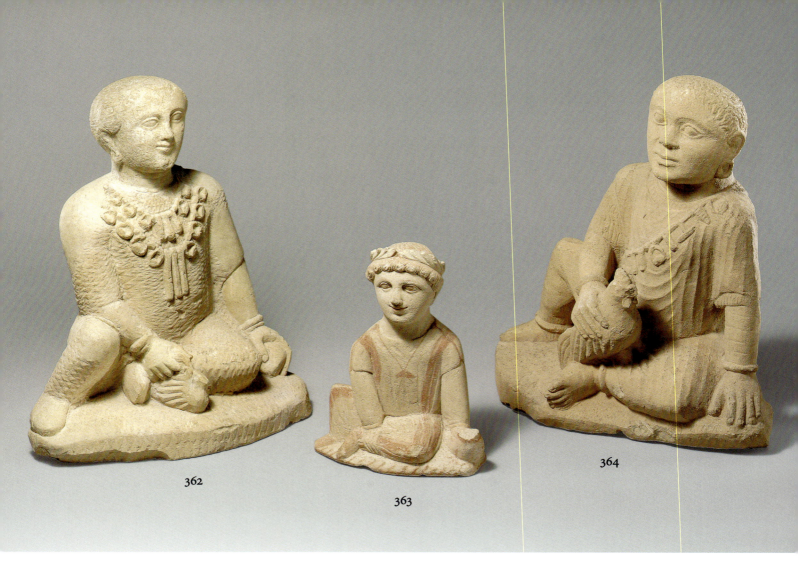

362

363

364

362. **Temple boy**
Late 5th century B.C.
Limestone
H. 38.3 cm (15⅛ in.)
74.51.2764 (Myres 1221)
Said to be from the ruins of a
temple at Kourion

In his right hand he holds a bird
by its wings; the head of the bird is
missing. Around his neck he wears
two strings of seals that flank two
rows of oblong pendants.

BIBLIOGRAPHY: Cesnola 1885,
pl. CXXXII.984; Myres 1946c,
pp. 66–67; Hadzisteliou-Price 1969,
pp. 106 n. 70, 107 n. 79; Beer 1994,
p. 61, pl. 61.a–d, no. 204.

363. **Temple boy**
2nd half of the 4th century B.C.
Limestone
H. 23.8 cm (9⅜ in.)
74.51.2760 (Myres 1205)
Said to be from the ruins of a
temple at Kourion

The back of the flat torso is
plain. The left hand holds a bird,
whose head is missing.

The sculptural type of the
"temple boy" is discussed more
fully in the section on terracottas
in Part IV (see cat. nos. 432, 433).
The Cesnola Collection has several
other fine examples of temple boys
in limestone (see cat. nos. 425, 426).

BIBLIOGRAPHY: Cesnola 1885,
pl. CXXXI.977; Myres 1946c, p. 66;
Hadzisteliou-Price 1969, p. 107
n. 79, pl. 23, no. 25; Beer 1994, p. 60,
pls. 115, 116.a–b, no. 200.

396. ENGRAVING

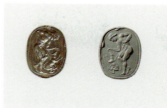

400

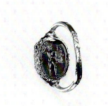

398. ENGRAVING

400. Scaraboid
Greek, early 5th century B.C.
Chalcedony
H. 1.7 cm (⅝ in.)
74.51.4200 (Myres 4200)

In a characteristically Greek representation, a youth leans on a staff and plays with a dog, probably offering it food. The gem is one of a considerable number that are Greek in style and subject but come predominantly from Cyprus.

J R M

BIBLIOGRAPHY: Richter 1956, no. 66; Boardman 1989, p. 45.

401

401. Scaraboid
Greek, early 5th century B.C.
Attributed to the Semon Master
Carnelian
W. 1.9 cm (¾ in.)
74.51.4223 (Myres 4223)

A winged youth carries off a girl who holds on to her lyre. Her right arm raised in a combination of protest and surprise contributes to the spontaneous vitality of the subject. The identity of the youth remains subject to discussion. While Eros as raptor rarely appears at this early date, he is the most likely candidate known by name. The large sickle wings are reminiscent of those of the unnamed Late Archaic youths who occur in works coming from or influenced by the Greek east; the Amasis Painter, for instance, favored them. It is possible that the youth is one of these, who, at a later date, become assimilated with Eros. It is also worth noting that the iconography here is a direct reversal of a representation of Eos carrying off a youth with a lyre (see Weiss 1986, no. 269).

J R M

BIBLIOGRAPHY: Richter 1956, no. 41; Boardman 1968, pp. 94–96.

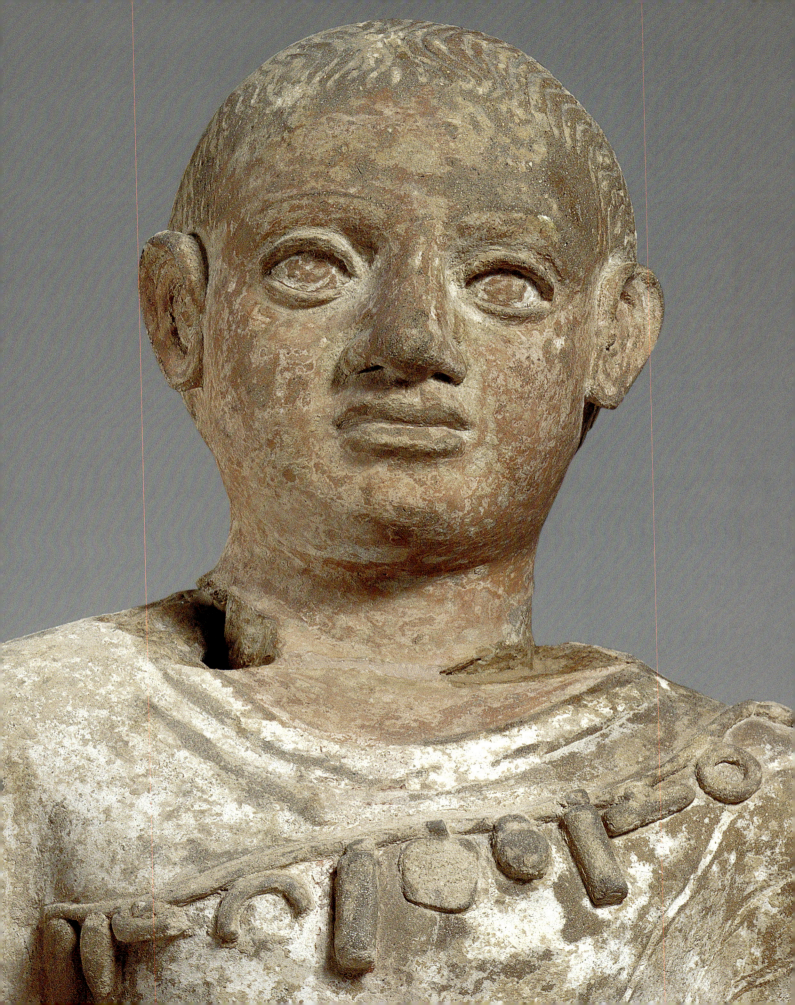

IV.

THE HELLENISTIC AND ROMAN PERIODS

[CA. 310 B.C. — CA. A.D. 330]

Although Cyprus was liberated from the Persians by Alexander the Great in 333 B.C., the island did not enjoy a long period of freedom. After the death of Alexander in 323 B.C., his successors quarreled and Cypriot rulers became entangled in antagonisms, with tragic effects— for example, the annihilation of the royal family of Salamis in 311 B.C. In 300 B.C. the Ptolemys finally became rulers of Cyprus and Alexandria. They introduced the political and cultural institutions of the Hellenistic world to the island, ruling Cyprus from Alexandria through high officials who resided in Paphos, where the capital had been transferred because it was easily accessible from Alexandria. They also abolished the independent kingdoms of Cyprus and established a unified rule and a single currency. The Greek alphabet, which had been introduced to the island in the Classical period— but existed contemporaneously with the syllabic script —was now dominant throughout the island, allowing for more efficiency in administration.

At the beginning of Ptolemaic rule, Macedonian elements were still evident in Cypriot art and funerary architecture, but Egyptian elements gradually prevailed. By the end of Ptolemaic rule, in 58 B.C., when the Romans annexed the island, Egyptian gods and goddesses, such as Serapis and Isis, were worshipped. In other arts, such as ceramics, sculpture, and jewelry, the Cypriots followed the styles of the Hellenistic koine, inspired by the Alexandrian school. Stone sculpture continued to be produced; portraiture, especially depictions of the royal family, became the main form of representation.

The Romans exploited the island by imposing heavy taxes. As in the rest of their eastern empire, they constructed large-scale public buildings (gymnasiums, theaters, bathing establishments) as well as monumental villas for the high officials of the administration. These structures, several of which have been excavated in Paphos, were adorned with sculpture and polychrome mosaic floors. Cesnola did not excavate any Roman public buildings, hence the absence of any Roman marble sculpture in his collection.

From the cultural point of view, the Roman period on Cyprus was a continuation of Hellenistic antecedents. Greek institutions, such as the gymnasiums and the theaters, prevailed, and Greek was the official language. After the division of the Roman Empire into eastern and western entities, Cyprus formed part of the eastern Roman Empire. Christianity, which was first preached on Cyprus by the apostles Paul and Barnabas, became the official religion of the island.

Opposite: Detail, cat. no. 432

STONE SCULPTURE

The importation of bronze and marble sculptures from the Aegean and the ease with which artists could travel eventually undermined the traditions of Cypriot limestone sculpture. There are exceptions, such as portraits of Ptolemaic and Roman rulers, but they are rare.

The Human Form in Hellenistic and Roman Sculpture

The head of the lifesize statue (cat. no. 402) does not belong to the body, which represents a male votary draped in a fashion similar to that of the following figure (cat. no. 403). Both date from the mid-third century B.C. (Connelly 1988, p. 88). Each figure holds a lustral branch; the first carries a pyxis (a circular box with a lid) and the second holds a bull's mask similar to those worn by worshippers in the Cypro-Archaic period, known in both limestone and terracotta (Hermary 1979). It is unlikely that the bull's head is a rhyton, as suggested by Connelly (1988, p. 80).

The Cesnola Collection includes a large number of Hellenistic heads from lifesize or over-lifesize statues of votaries found in the temple at Golgoi. They all appear to be portraits and may be associated with royalty of the Ptolemaic period. There are certain similarities among these heads. It is possible that they are the work of two or more sculptors (or workshops) active in the area (Connelly 1988, p. 81), a region of the island where suitable limestone was readily available (Connelly 1988, p. 3).

402. **Young man holding a pyxis**
Mid-3rd century B.C.
Limestone
H. 161.9 cm (63¾ in.); W. 65.7 cm (25⅞ in.)
74.51.2465 (Myres 1406)
Said to be from the temple at Golgoi

The young man wears a wreath decorated with berries in the front. In his left hand he holds a pyxis with a convex lid. There are traces of paint on the drapery.

BIBLIOGRAPHY: Doell 1873, p. 30, pl. VI.4, no. 123; Cesnola 1877, p. 160; Cesnola 1885, pl. CXXVII.921; Hermary 1979, pp. 735–37, no. 3, fig. 10; Connelly 1988, pp. 3, 4, 80, 84, 88, 101, 112, pl. 32, fig. 116, no. 31.

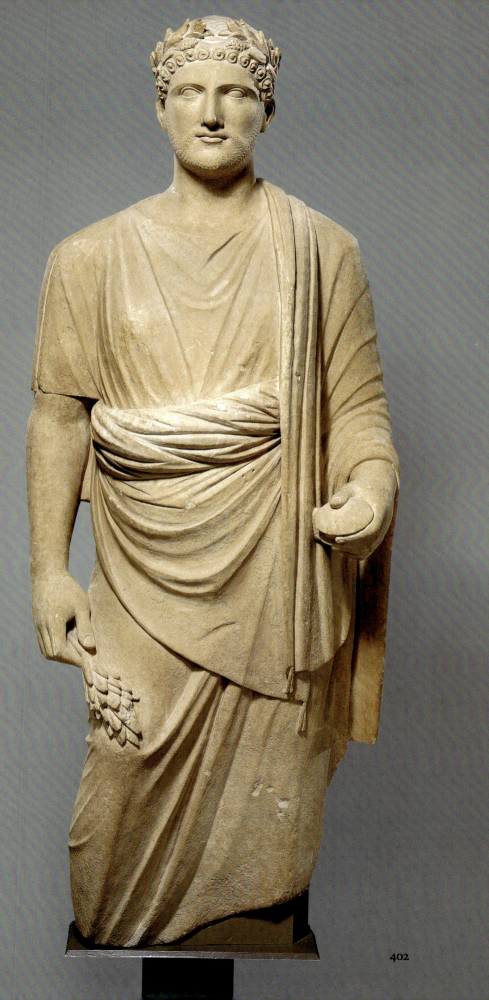

402

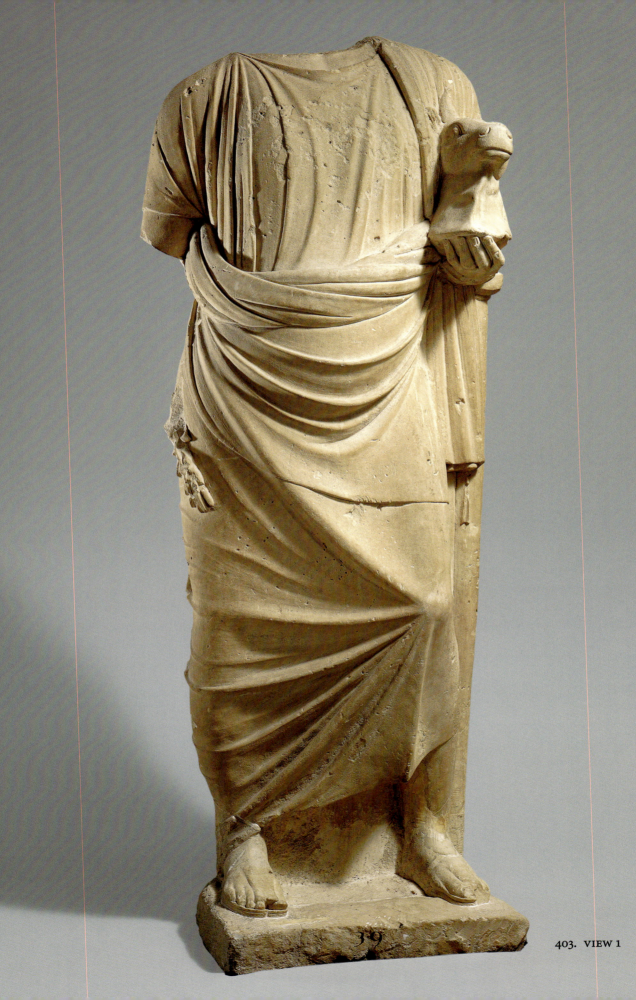

39

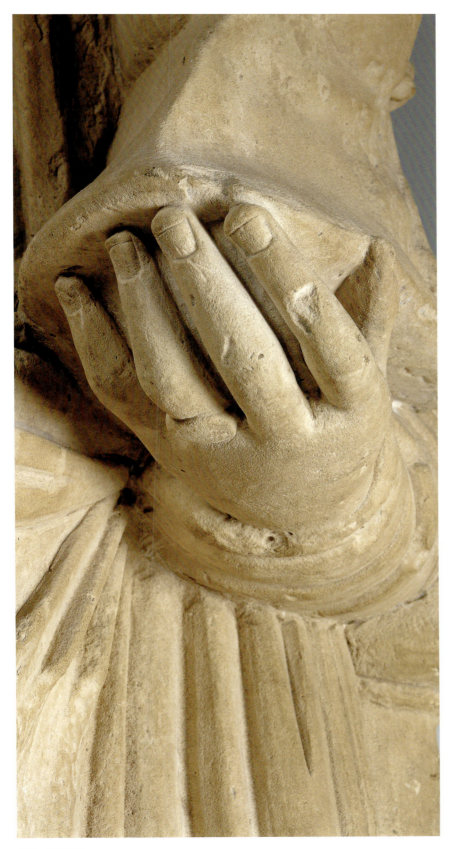

403. Male votary holding a
bull's head
Mid-3rd century B.C.
Limestone
H. 170.2 cm (67 in.)
74.51.2463 (not in Myres)
Said to be from the temple at Golgoi

The feet may not belong to the statue. In his left hand he holds what appears to be a mask in the form of a bull's head. Faintly engraved (now illegible) graffiti appear on the front of the garment.

BIBLIOGRAPHY: Cesnola 1877, pl. XIII; Cesnola 1885, pl. CXXIII.914; Hermary 1979, pp. 735–37, fig. 10, no. 3 (figure reversed); Connelly 1988, p. 80, pl. 31, fig. 115.

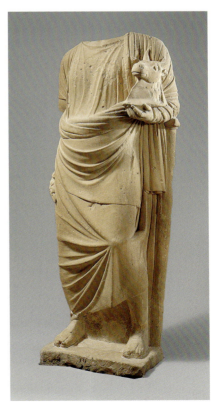

403. DETAIL

403. VIEW 2

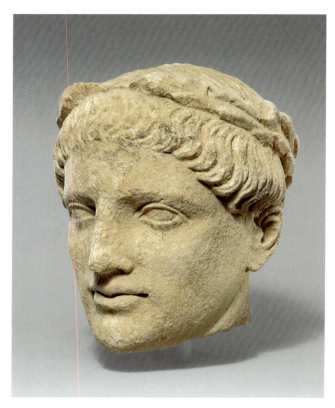

404

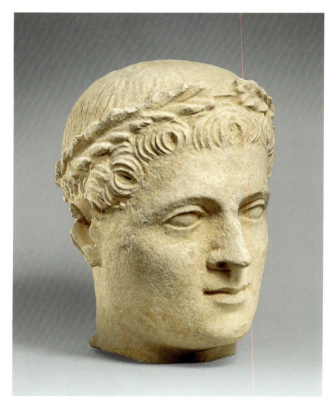

405

404. Male head wearing a wreath
Mid-3rd century B.C.
Limestone
H. 22.9 cm (9 in.)
74.51.2806 (Myres 1314)
Said to be from a ruin at Kythrea

BIBLIOGRAPHY: Cesnola 1885,
pl. CV.685; Connelly 1988, pp. 80,
84, 88–89, 112, pl. 33, figs. 117, 118,
no. 32.

**405. Head of a young votary
wearing a wreath**
Late 2nd century B.C.
Limestone
H. 29.5 cm (11⅝ in.)
74.51.2803 (Myres 1346)
Said to be from the temple at Golgoi

BIBLIOGRAPHY: Doell 1873, p. 47,
pl. X.15, no. 416; Cesnola 1885,
pl. CXXXIX.1042; Connelly 1988,
pp. 82, 95–96, 113, pl. 39, figs. 141,
142, no. 44.

**406. Male head wearing a
double wreath**
Early 2nd century B.C.
Limestone
H. 30.5 cm (12 in.)
74.51.2805 (Myres 1316)
Said to be from the temple at Golgoi

The head is in the style of the
school of Scopas of Paros, one of
the foremost sculptors and archi-
tects of the fourth century B.C.

BIBLIOGRAPHY: Cesnola 1885,
pl. CXXXIX.1035; Connelly 1988,
pp. 12, 82, 85, 91, 102, 103, 112, pl. 35,
figs. 125, 126, no. 36.

413. **Young man seated on a throne (Apollo?)**

3rd century B.C.

Limestone

H. 38.7 cm (15¼ in.)

74.51.2708 (Myres 1233)

Said to be from the ruins of Golgoi

The piece is rough at the back. The left arm is bent slightly forward, holding an animal, possibly a bird, of which only the tail survives; the left forearm is missing. Two stags flank his seat. Red paint colors the throne as well as the hair, lips, eyes, and shoes of the youth. The head may not belong to the body.

This small figure was identified by Myres as a poet. More recently, Connelly has suggested that he is Apollo because of the scroll on his lap, the animals supporting the chair, the effeminate expression, the curly hair, and the laurel wreath. She also notes the bird's tail on the left arm, which may be a remnant of Apollo's raven (Connelly 1988, pp. 79–80).

BIBLIOGRAPHY: Cesnola 1885, pl. CXVI.838; Connelly 1988, pp. 79–80, pl. 30, fig. 114; Cassimatis 1991, p. 104, pl. XXV.a.

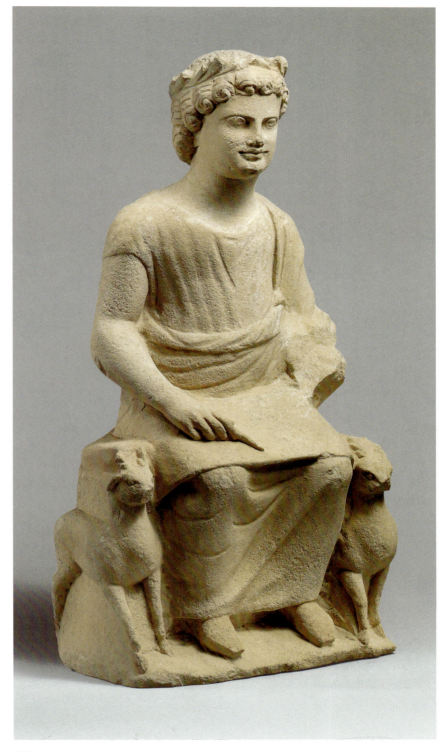

413

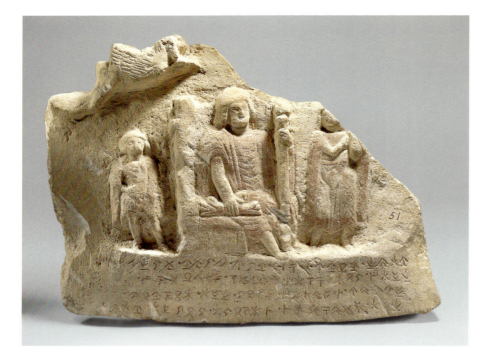

414

and the small figure, four winged horses appear to move to the right. Only the wings and heads are visible. The forelegs, which were probably stretched forward, are partly missing. Behind the horses is a chariot box, but no charioteer. The lower part of the slab is flat and has an inscription of engraved signs, filled with red paint and in four rows, in the Cypriot syllabary. The inscription reads:

> Rejoice. Eat, lord, and drink,
> never speak a boastful word
> Before the immortal gods,
> desiring all in abundance.
> A god takes no consideration
> of a man, but there is the
> hand of fate.
> The gods act as the helmsmen
> for all which men have in
> their thoughts. Rejoice.

BIBLIOGRAPHY: Doell 1873, p. 48, pl. XI.3, no. 764; Cesnola 1877, p. 437, no. 1, pl. XLVIII, 1.1; Cesnola 1885, pl. LXXXV.559; Cesnola 1903a, pl. CXXX.3; Masson 1961, pp. 46, 280 n. 6, 284–86, no. 264, pl. 46; Neumann and Stiewe 1975; V. Karageorghis 1998a, p. 188, fig. 138.

The following works (cat. nos. 414–16) are in the same narrative style as the Golgoi reliefs mentioned in connection with Apollo and Herakles, but the style of their execution is inferior and the reliefs themselves are fragmentary. The engraved inscriptions in the Cypriot syllabary are their most interesting feature. As dedications to an enthroned Apollo, they illustrate aspects of popular religion. On one example (cat. no. 414) Apollo's iconography is confused with that of Zeus. All three pieces date from the Hellenistic period, probably from the third century B.C. (Tatton-Brown 1984, p. 173), and may be from the same workshop.

414. Votive relief dedicated to Apollo

3rd century B.C.
Limestone
H. 30.5 cm (12 in.); W. 41.1 cm (16⅛ in.)
74.51.2370 (Myres 1869)
Said to be from the temple at Golgoi

In the middle of the composition a large, bearded figure (Zeus?) is seated on a throne. In his raised left hand he holds a scepter; his right hand grasps a thunderbolt. He wears a short-sleeved chiton and a mantle with crudely rendered folds. To his left is a second figure who stands with the right arm bent upward to touch something held in the left hand (now chipped off). The face is damaged.

In back of the seated figure is a small standing figure wearing a short chiton and cloak that are painted red. In the upper left-hand corner of the slab, above the throne

415. Votive relief dedicated to Apollo

3rd century B.C.
Limestone
H. 19.1 cm (7½ in.); W. 28.9 cm (11⅜ in.)
74.51.2368 (Myres 1871)
Said to be from the temple at Golgoi

The upper part of the worn and crudely rendered relief is now missing. The scene reads from left to right: a draped male figure wearing a fillet sits on a throne. He holds a scepter in his raised left hand and in

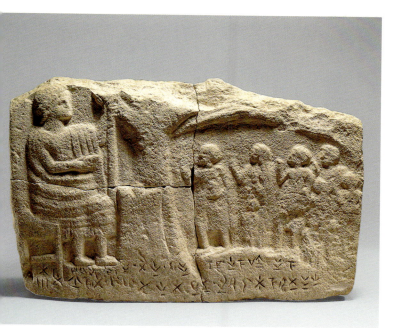

415

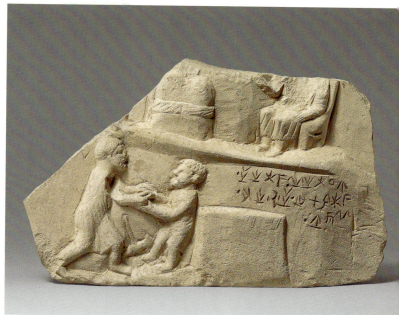

416

his right, a bird. In front of him is a rectangular altar with a horned top. In the background is what Myres thought was the trunk of a tree. Possibly this is the edge of a cavern. If so, it is awkwardly shown, with no regard for perspective or proportion. Perhaps this was a conventional way of representing two caverns or arched recesses. In the compartment of the cavern on the right is a procession of four figures, three of whom appear to be male. Each raises the right arm and holds what is probably a torch. The second figure from the left, with a child in front, is probably female. Along the lower edge of the plaque are two lines of an inscription engraved in the Cypriot syllabary. It reads: "Onasitimos dedicates this votive to the god, the great Apollo, in the temenos [temple precinct], in good fortune. III." The signs are filled with red color. The meaning of the number is unclear.

BIBLIOGRAPHY: Doell 1873, p. 48, pl. XI.1, no. 765; Cesnola 1877, p. 437, no. 2, pl. XLVIII, 1.2; Cesnola 1885, pl.LXXXV.558; Cesnola 1903a, pl. CXXX.2; Masson 1961, pp. 46, 280 n. 6, 286, pl. 47, no. 265; V. Karageorghis 1998a, p. 187, fig. 137.

416. Votive relief dedicated to Apollo

3rd century B.C.
Limestone
H. 20 cm (7⅞ in.); W. 30.5 cm (12 in.)
74.51.2372 (Myres 1873)
Said to be from the temple at Golgoi

The lower border seems to be complete, whereas the other two sides appear to be chipped off. The upper register consists of a seated draped figure who is turned toward an altar that has a horned top and a grooved relief band around the middle. The composition of the lower register consists of two bearded male figures on the left who run toward each other and seize each other's hands. Between them, below their hands, is what appears to be a tool shown in relief. Behind the figure on the right is a rectangular area, possibly a conventional indication of the gallery of a mine.

Above and to its right are two rows of an engraved inscription in the Cypriot syllabary. It reads: "Diaithemis dedicates [this votive] to the god Apollo with fortune." The signs are filled with red paint.

BIBLIOGRAPHY: Doell 1873, p. 49, pl. XI.2, no. 767; Cesnola 1877, p. 437, no. 6, pl. XLVIII, 2.6; Cesnola 1885, pl. LXXXV.556; Cesnola 1903a, pl. CXXXIII.1; Masson 1961, pp. 280 n. 6, 286–87, no. 266, pl. 48.1; Tatton-Brown 1984, p. 173, pl. XXXIII.7; V. Karageorghis 1998a, p. 187, fig. 136.

Objects of limestone—and, occasionally, terracotta—representing parts of the human body are known from antiquity, mainly from the Roman period. Eyes, ears, female breasts, legs, toes, arms, and the face were all represented in works from Etruria, Greece, and, particularly, Cyprus. They were dedicated in sanctuaries of the healing gods by sufferers who wished to invoke the help of the divinity. The site of Golgoi has produced a large number of such objects. Others have been found elsewhere on the island (for a general account and bibliography, see Hermary 1989, p. 449). They are now scattered in various museums, including the Musée du Louvre, Paris; the Pitt Rivers Museum, Oxford; the Cyprus Museum, Nicosia; and The Metropolitan Museum of Art.

Pieces of this type now in the Cesnola Collection were found at Golgoi. Whether they were dedicated to a specific healing god or to the main god of the sanctuary, Apollo, is not easy to determine. Not all of them are of the Roman period. There is another ear in the collection not shown here (74.51.5172 [Myres 1682]; Masson 1961, p. 293, no. 288; for a recent general discussion of these objects, see Masson 1998).

417. Votive face

4th or 3rd century B.C.
Limestone
H. 11 cm (4⅜ in.); max. thickness 2.6 cm (1 in.)
74.51.5171 (Myres 1684)
Said to be from the temple at Golgoi

The reverse of the plaque is flat. This piece, which lacks a nose, was dedicated by a person who had an ailment affecting the eyes and mouth.

BIBLIOGRAPHY: Doell 1873, p. 54, pl. XIII.8, no. 797; Cesnola 1877, pp. 157–58; Cesnola 1885, pl. CXXIX.935.

418. Votive ear

4th or 3rd century B.C.
Limestone
H. 6.4 cm (2½ in.)
74.51.2357 (Myres 1882)
Said to be from the temple at Golgoi

On the lobe are four engraved signs of the Cypriot syllabary, "to-po-to-e[-mi]" (I belong to a deaf [person]) (Masson 1961, pp. 293–94, no. 289).

BIBLIOGRAPHY: Cesnola 1877, p. 438, no. 18, pl. 3.18; Cesnola 1885, pl. CXXIX.933; Cesnola 1894, pl. CXLII.1055; Cesnola 1903a, pl. CXL.15; Masson 1961, pp. 293–94, no. 289; Masson 1998.

419. Votive toe

4th or 3rd century B.C.
Limestone
H. 7.5 cm (3 in.); L. 7.4 cm (2⅞ in.)
74.51.5173 (Myres 1680)
Said to be from the temple at Golgoi

The piece was probably dedicated by someone who lost the other toes in an accident.

BIBLIOGRAPHY: Doell 1873, p. 54, pl. XIII.9, no. 798; Cesnola 1877, pp. 157–58; Cesnola 1885, pl. CXXIX.927.

420. Votive left foot

4th or 3rd century B.C.
Limestone
H. 19.4 cm (7⅝ in.); L. (of foot): 22.7 cm (9 in.)
74.51.5179 (Myres 1678)
Said to be from the temple at Golgoi

BIBLIOGRAPHY: Cesnola 1885, pl. XXVIII.158.

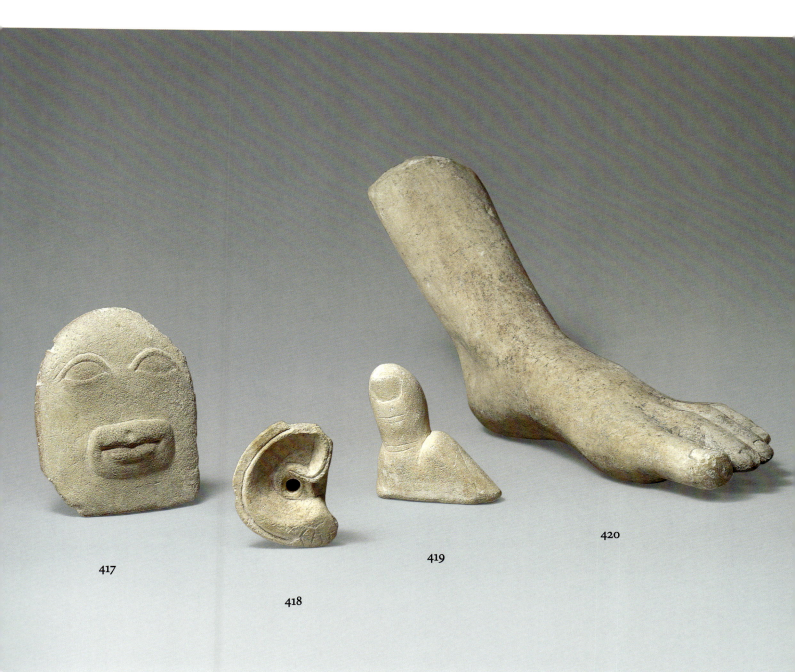

417

418

419

420

The popularity of Apollo on Cyprus may have led to the frequent representation of Artemis (his twin) in the various sanctuaries of the god. In many cases her iconography corresponds to that of Aphrodite. For example, both are shown holding an apple or a pomegranate. The Cesnola Collection includes a number of Artemis images made of limestone. Many of their heads originally belonged to other works. The Artemis-Bendis type (cat. no. 422) is so called after the Thracian goddess who is probably a counterpart of Artemis. There are other such examples from Cyprus (e.g., Pryce 1931, p. 126, C382).

421. Artemis
Hellenistic (ca. 310–ca. 30 B.C.)
Limestone
H. 60.6 cm (23⅞ in.)
74.51.2741 (Myres 1240)
Said to be from the ruins of a temple at Pyla discovered by R. Hamilton Lang

BIBLIOGRAPHY: Cesnola 1885, pl. CXVII.849; Vessberg and Westholm 1956, p. 89.

422. Artemis-Bendis
Hellenistic (ca. 310–ca. 30 B.C.)
Limestone
H. 78.7 cm (31 in.)
74.51.2477 (Myres 1350)
Said to be from the ruins of the temple of Apollo Hylates at Kourion

The head of the figure is not original. The votary stands in oriental dress with a Phrygian cap.

BIBLIOGRAPHY: Cesnola 1885, pl. CII.675; Vermaseren and de Boer 1986, p. 24, no. 2.

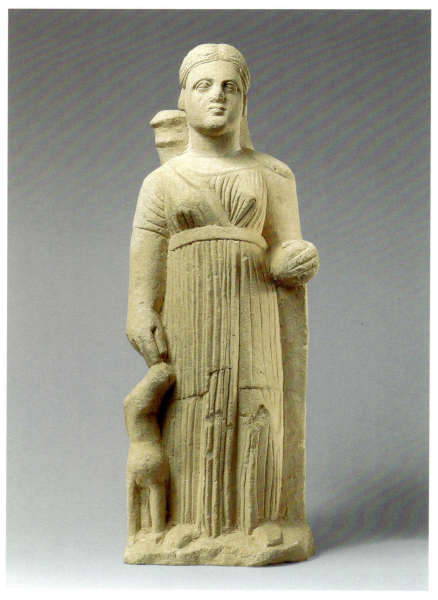

421

423. Pan or Opaon Melanthios
Hellenistic (ca. 310–ca. 30 B.C.)
Limestone
H. 32.3 cm (12¾ in.)
74.51.2735 (Myres 1115)
Said to be from the temple at Golgoi

The figure wears a long chlamys fastened with a knot at the chest. He holds a syrinx in his left hand and a hooked stick in his right. He has goat's ears and horns at the top of his head.

The identification of the figure as Opaon Melanthios is based on epigraphical evidence. The name may have been given to a Hellenized Cypriot god. Most representations of the god lack artistic merit, but some noteworthy Hellenistic examples betray the influence of Greek

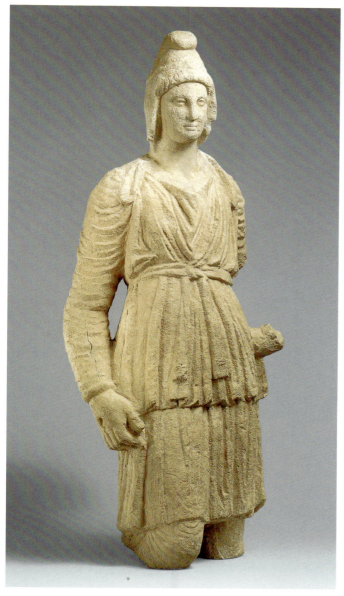

422

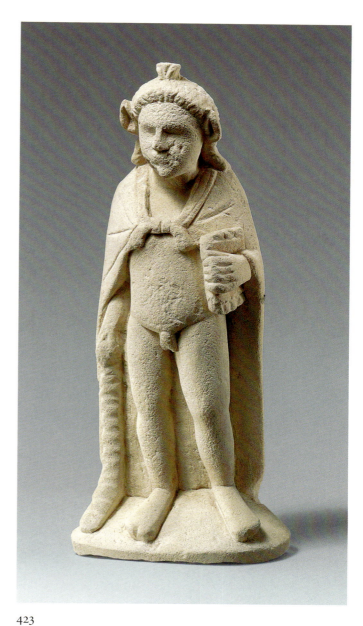

423

sculpture. It is tempting to suggest that the worship of Opaon Melanthios as a fertility god on Cyprus is a survival of the way in which the god Apollo was venerated in Arcadia. But Opaon Melanthios's cult is attested only in the Paphos district, at Amargetti, during the Roman period (Hermary 1994; Masson 1994). He might have been intro-

duced to the island earlier, perhaps in a form similar to the Greek god Pan. He might then have developed locally as a god of shepherds (see cat. no. 358), retaining some of his original qualities as Pan but also taking on other attributes that brought him closer to the ancestral fertility god of the island. Apart from those at Amargetti, inscrip-

tions or representations of Opaon Melanthios have been found throughout Cyprus, for example, at Lefkoniko, in the temple of Apollo at Idalion, in the temple of Aphrodite at Golgoi, and in the sanctuary of Apollo at Voni.

BIBLIOGRAPHY: Cesnola 1885, pl. CXIX.867; Myres 1946c, pp. 65, 67.

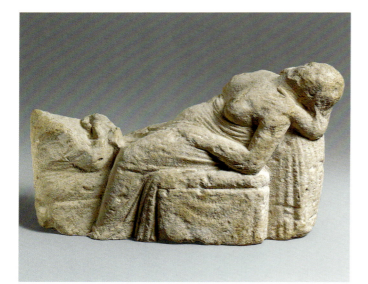

424

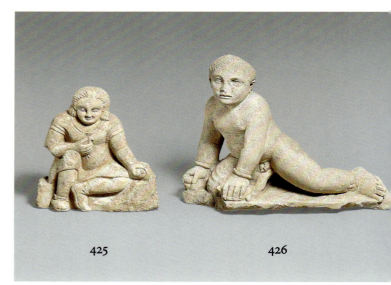

425 426

424. Childbirth scene
Hellenistic (ca. 310–ca. 30 B.C.)
Limestone
H. 16.5 cm (6½ in.); L. 25.1 cm
(9⅞ in.)
74.51.2698 (Myres 1226)
Said to be from the temple at Golgoi

A standing attendant, whose head
is missing, supports the mother
from behind. At the foot of the
couch on the opposite side a seated
attendant holds the child.

There are several childbirth
scenes in Cypriot coroplastic art
of the Late Archaic or Classical
period. This limestone group may
be associated with the myth of
Ariadne's giving birth at Amathus
after having been abandoned
by Theseus (cf. Bernhard and
Daszewski 1986, pp. 1068–69).

BIBLIOGRAPHY: Doell 1873, p. 23,
pl. VI.1, no. 74; Cesnola 1885,
pl. LXVI.435.

425. Temple boy
Hellenistic (ca. 310–ca. 30 B.C.)
Limestone
H. 27.3 cm (10¾ in.)
74.51.2766 (Myres 1222)
Said to be from the ruins of a
temple at Kourion

The temple "boy" is probably a
girl. The lower portion, with the
legs, is flat, as if in a relief.

BIBLIOGRAPHY: Cesnola 1885,
pl. CXXXI.976; Myres 1946c, p. 66;
Beer 1994, p. 83, pl. 196.a.

426. Temple boy
Hellenistic (ca. 310–ca. 30 B.C.)
Limestone
H. 34.6 cm (13⅝ in.); L. (of base):
46 cm (18⅛ in.)
74.51.2784 (Myres 1212)
Said to be from the ruins of a
temple at Kourion

The drapery covers the figure's
buttocks, but his groin is exposed.
He holds a tortoise in his left hand
and an unidentifiable object in
his right.

BIBLIOGRAPHY: Cesnola 1885,
pl. CXXXI.978; Myres 1946c, p. 66;
Hadzisteliou-Price 1969, p. 107
n. 79; Beer 1994, p. 83, pl. 197.a–e,
no. 2.

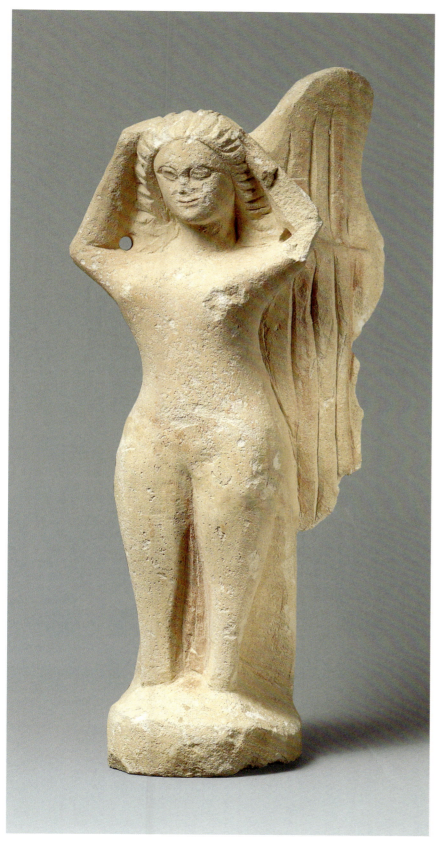

427

427. **Siren**
Hellenistic (ca. 310–ca. 30 B.C.)
Limestone
H. 33.5 cm (13¼ in.)
74.51.2680 (Myres 1090)
Said to be from Salamis

The figure stands on an elliptical plinth. She has a human head, arms, torso, and breasts. The legs are those of a bird. Both arms are raised to her head, probably to tear her hair in mourning. Red colors the lips. There are traces of red paint on the body and between the legs.

Myres identified this figure as a harpy or a siren (1914, p. 170, no. 1090). Harpies are not known in the iconography of Cyprus, but the siren, as a guardian figure, is common on funerary monuments from the Archaic and later periods.

BIBLIOGRAPHY: Cesnola 1885, pl. LVII.368.

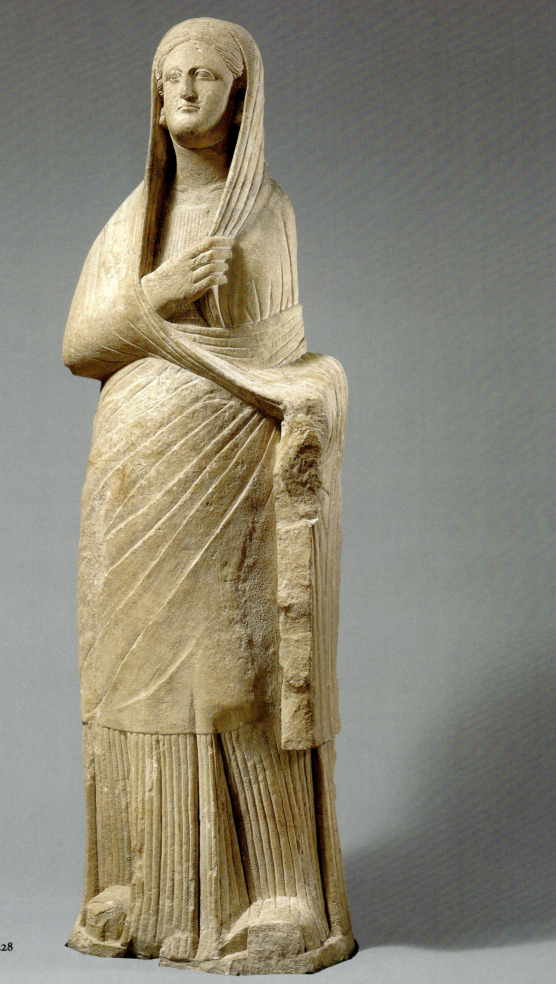

428

428. Veiled lady
1st century B.C.
Limestone
H. 191.8 cm (75½ in.)
74.51.2456 (Myres 1404)
Said to be from the ruins of Golgoi

This votive statue belongs to a group of Late Hellenistic works representing draped female figures, known as the "Herculaneum Maiden" type, after the site where such pieces became known at an early date. They stand imposingly and are dressed, according to Late Classical tradition, in a chiton and a himation (cf. Vessberg and Westholm 1956, pp. 87–88). The body and head of this figure are broken in the back, and the feet are missing.

BIBLIOGRAPHY: Cesnola 1885, pl. CXVIII.855; Vessberg and Westholm 1956, pp. 87–88, pl. IX.3.

Funerary Monuments

429. Cippus
Roman (ca. 30 B.C.–ca. A.D. 330), early 3rd century A.D.
Limestone
H. 107.9 cm (42½ in.)
74.51.2268 (Myres 1952)
Said to be from Larnaca

The cippus has an engraved inscription in Greek capital letters that translates: "Good Olympianos, farewell."

Funerary cippi of this type are common on Cyprus. Each is engraved with a standard farewell message, which gives the name of the deceased and, occasionally, the name of the father or spouse of the person. Sometimes words of encouragement are added, such as "no one is immortal." Cippi were used as funerary markers from the Late Hellenistic until the end of the Roman period.

BIBLIOGRAPHY: Cesnola 1885, pl. CXLVI.1151; Cesnola 1903b, no. 44.

429

430

430. Funerary stele

Roman (ca. 30 B.C.–ca. A.D. 330),
probably 1st century A.D.
Limestone
H. 129.5 cm (51 in.); W. (at the top):
76.2 cm (30 in.)
74.51.2488 (Myres 1397)

The architectural frame and
the pose of the human figure are
characteristic of a small group of
funerary stelai that date from the
beginning of the Roman imperial
period (cf. Hermary 1989, p. 478,
no. 990).

431. Seated woman and her maid

ca. A.D. 100
Limestone
H. of woman (with plinth):
109.2 cm (43 in.); H. of maid (with
plinth): 80 cm (31½ in.)
74.51.2490 (Myres 1381)
Said to be from the necropolis
at Golgoi

The front of the maid's plinth is
inscribed: "Zoilos of Golgoi made
[it]." The maid holds a disk-shaped
object in her left hand, possibly a
mirror. At the front of her drapery
is what appears to be a hieratic tas-
seled band. This piece may imitate
Attic stelai.

The seated woman is obviously
the deceased. Her deeply drilled
honeycomb hairstyle and her side
curls recall Flavian fashion and
indicate that the stele dates from
about A.D. 100. Funerary stelai are
not usually signed, so the inscrip-
tion is rare. This is an example of a
provincial work by a native sculp-
tor who upheld local Hellenistic
traditions at a time when marble
and bronze statuettes were being
imported to the island from Greece

431

(Vermeule 1976, pp. 57–58; Con-
nelly 1988, pp. 9–10).

BIBLIOGRAPHY: Cesnola 1885,
pl. CXXXVIII.1032; Masson 1971b,

pp. 316 n. 54, 330 nn. 113, 115, fig. 18;
Vermeule 1976, pp. 57–58, 69,
fig. 11-24; Connelly 1988, pp. 9–10,
pl. 6, fig. 21.

COROPLASTIC (TERRACOTTA) ART

The term "temple boy" is used for a type of figure most frequently carved from limestone (cf. cat. nos. 362–64 and 425, 426) but also mold-made in terracotta. These sculptures depict boys of about two years, usually seated, with one leg bent, and shown nude or wearing a short tunic that allows the genitalia to be seen. On some, a band with amulets and seals hangs across the chest. Temple boys have been found mainly in sanctuaries in eastern Cyprus but also in the sanctuary of Apollo Hylates at Kourion. Similar figures occur in the Levant, the Aegean, and the Punic world. They date from the fifth to the third century B.C. (cf. Beer 1994).

These figures have been interpreted in several ways. Some propose that parents dedicated them in the sanctuary of a male god, such as Apollo or Eshmun (a Phoenician god of healing), so that the boy would be protected after a certain age. They may also have been dedicated by parents who wished to have a male child. Other hypotheses suggest that the figures represent boys who were servants in a temple—or who were destined to become male prostitutes. Laffineur is probably right in proposing that these sculptures were placed in temples to commemorate a rite of passage in the life of a boy and to place him under the protection of a divinity (Laffineur 1994).

More than two hundred examples of temple boys are known. Several have only the head preserved (for a short discussion, see Hermary 1989, pp. 69–77).

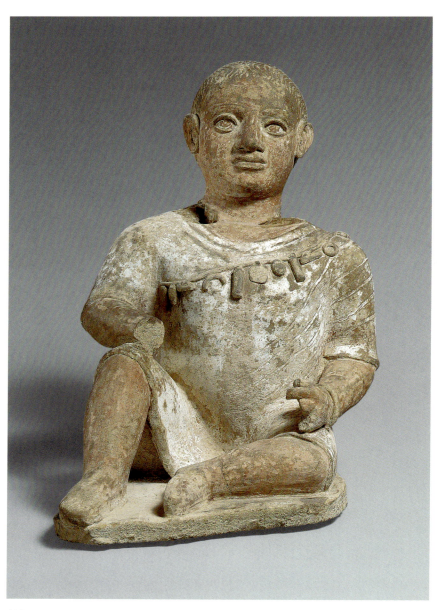

432

432. **Temple boy**
ca. 325–300 B.C.
Terracotta
H. 34.6 cm (13⅝ in.)
74.51.1449 (Myres 1463)
Said to be from the temple of Apollo Hylates at Kourion

The figure is mold-made and hollow. The head, prepared separately, was pressed into a mold that left a hole at the back, which was then filled with coils of clay. A string of seals, amulets, and rings, each made separately out of clay, hangs across the chest. The garment is covered with an undercoat of white paint. The figure was wearing shoes, whose color has now faded.

BIBLIOGRAPHY: Cesnola 1894, pl. XXXVI.297; Beer 1994, p. 55, pls. 92, 93.a,.b, no. 187.

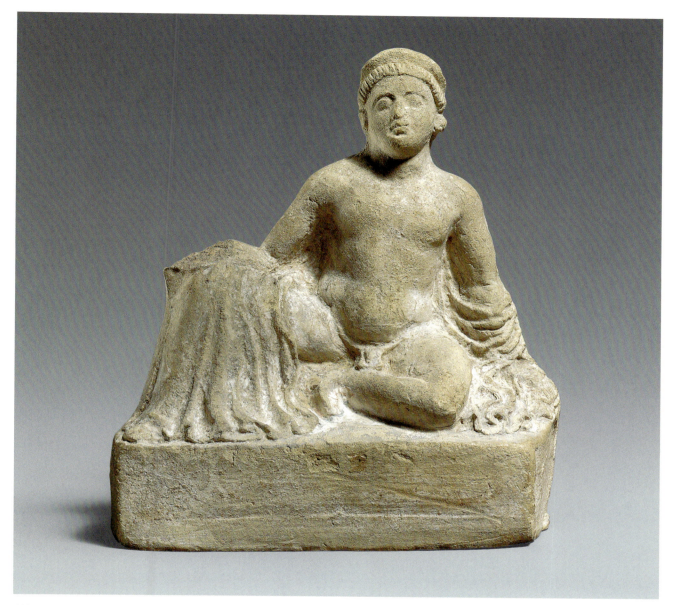

433

433. **Temple boy**
3rd century B.C.
Terracotta
H. 12.1 cm (4¾ in.)
74.51.1607 (Myres 2293)
Said to be from the temple of
Apollo Hylates at Kourion
 The figure is mold-made and
hollow.

BIBLIOGRAPHY: Cesnola 1894,
pl. XLIV.346.

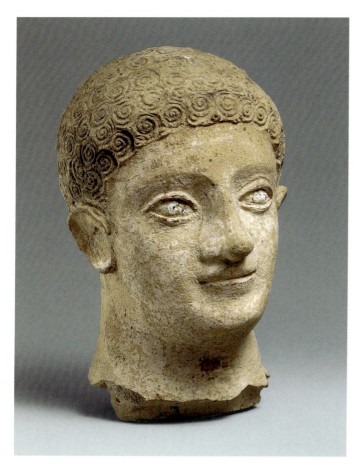

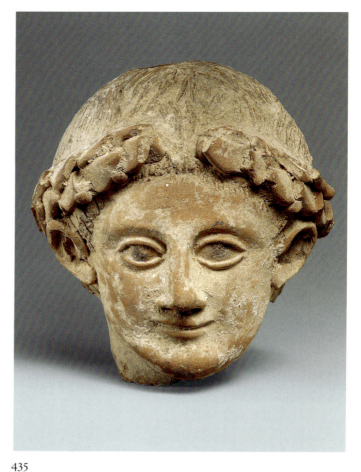

434

435

434. **Head of a youth**
Hellenistic (ca. 310–ca. 30 B.C.)
Terracotta
H. 14.1 cm (5⅝ in.); L. (of face):
7.6 cm (3 in.)
74.51.1457 (Myres 1473)
Said to be from the temple of
Apollo Hylates at Kourion
 The head is mold-made and
hollow.

BIBLIOGRAPHY: Cesnola 1894,
pl. LIX.488.

435. **Head of a youth**
Hellenistic (ca. 310–ca. 30 B.C.)
Terracotta
H. 14.3 cm (5⅝ in.); L. (of face):
9.2 cm (3⅝ in.)
74.51.1454 (Myres 1471)
Said to be from Kythrea
 There is a hole at the top of the
head, which is mold-made and
hollow.

BIBLIOGRAPHY: Cesnola 1894,
pl. XXX.251.

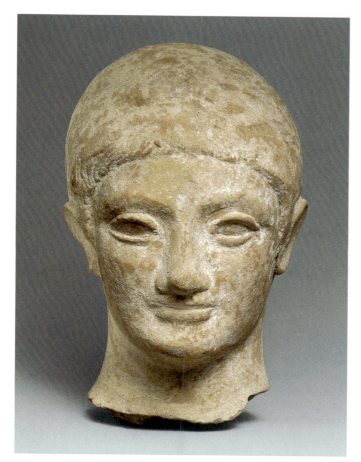

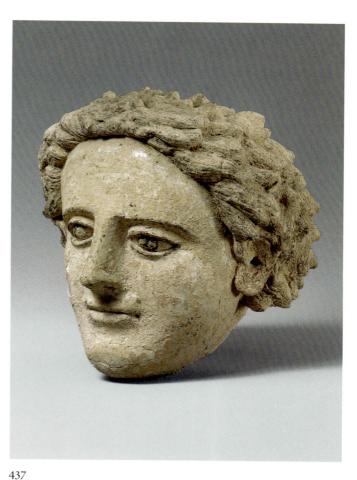

436

437

436. Head of a youth
Hellenistic (ca. 310–ca. 30 B.C.)
Terracotta
H. 19 cm (7½ in.); L. (of face):
9.7 cm (3⅞ in.)
74.51.1453 (Myres 1466)
Said to be from the temple of
Apollo Hylates at Kourion
 The head, which is mold-made,
has a hole at the back.

BIBLIOGRAPHY: Cesnola 1894,
pl. LX.502.

437. Head of a youth
Hellenistic (ca. 310–ca. 30 B.C.)
Terracotta
H. 12.7 cm (5 in.)
74.51.1456 (Myres 1462)
Said to be from Kythrea
 The head is mold-made and
hollow.

BIBLIOGRAPHY: Cesnola 1894,
pl. LIX.494.

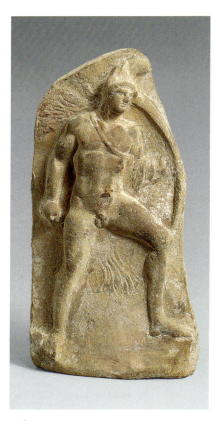

438

439

Figurines

The Hellenistic and Roman periods witnessed an increase in the manufacture of terracotta figurines. Because most were now made in molds, an artist could mass-produce the same composition and could vary a design simply by modifying the mold. Both molds and figurines were objects of trade, and similar subjects treated in similar styles were produced in many locations across the Hellenistic world. It is therefore often difficult to determine the origin of a figurine. The crouching boy (cat. no. 442), for example, was made from the same mold (or a similar one) as a figurine found on the island of Rhodes (Higgins 1954, p. 95, no. 268). Most figurines excavated on Cyprus come from tombs and houses, but they are sometimes found in sanctuaries and temples as well.

Artists drew on a wider variety of subjects than previously. Many of the subjects Cypriot sculptors traditionally preferred were still represented, such as horses and riders (cat. no. 439), musicians (cat. no. 440), and water bearers (cat. no. 446). In addition to these, foreigners, as distinguished by physical features or costume (cat. nos. 438, 439, and 441), and people rarely depicted before, such as children, the elderly, the poor, and slaves, now frequently appeared in terracotta (cat. no. 442). Images of gods from the Greek pantheon were also popular. Aphrodite and her son and servant, Eros, had par-ticular significance on Cyprus, the legendary birthplace of the goddess. In the Hellenistic and Roman periods Eros was most often represented as an infant, or *putto* (cat. nos. 448, 449).

MER

438. **Warrior**
1st century B.C.–1st century A.D.
Terracotta
H. 16.2 cm (6⅜ in.)
74.51.1708 (Myres 2348)
Said to be from Kythrea

The relief depicts a heroic nude warrior who carries a large shield. He wears a Phrygian helmet such as that worn by Alexander the Great's Macedonian soldiers.

MER

BIBLIOGRAPHY: Cesnola 1894, pl. XLIII.340.

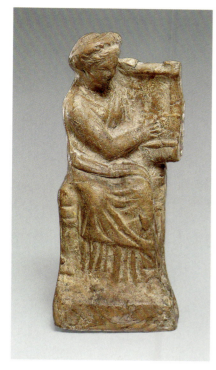

440

439. Horse and rider
3rd century B.C.
Terracotta
H. 18.3 cm (7¼ in.)
74.51.1665 (Myres 2300)
Said to be from Kition

MER

BIBLIOGRAPHY: Cesnola 1894, pl. LXXIII.665; Winter 1903, p. 300, no. 6; McClees 1924, p. 11; Riis 1942, p. 203.

440. Musician
1st century B.C.–1st century A.D.
Terracotta
H. 13.8 cm (5⅜ in.)
74.51.1673 (Myres 2229)
Said to be from Kition

The figure plays a *kithara,* a type of lyre. MER

BIBLIOGRAPHY: Cesnola 1894, pl. XXXIV.283.

441

441. Dancer (Attis?)
3rd century B.C.
Terracotta
H. 18.4 cm (7¼ in.)
74.51.1710 (Myres 2299)
Said to be from Kythrea or Soli

The dancer wears a typically Phrygian costume. He may be Attis, companion of Cybele (the Phrygian mother goddess), or one of his followers. According to legend, Attis went mad after Cybele discovered his infidelity. Cults of Attis and Cybele spread to the Greek world from Asia Minor in the fourth century B.C. This figurine and others of a similar composition may recall ecstatic dances that are thought to have been included in the festival dedicated to Attis each spring. The fabric of the clay indicates that the figurine was made on Cyprus (Connelly 1990, p. 96).

MER

BIBLIOGRAPHY: Cesnola 1894, pl. XXXVIIII.307; Connelly 1990, pp. 96–97.

442

443

442. Crouching boy
Hellenistic (ca. 310–ca. 30 B.C.)
Terracotta
H. 9.2 cm (3⅝ in.)
74.51.1701 (Myres 2320)
Said to be from Kourion

Figurines of seated and crouching black boys were popular and have also been found in Egypt, Rhodes, Corinth, and Sicily.

MER

BIBLIOGRAPHY: Cesnola 1894, pl. LXXXII.739; Beardsley 1929, p. 17, no. 16; V. Karageorghis 1988a, p. 42, no. 34.

443. Vase in the form of a sleeping boy
Hellenistic (ca. 310–ca. 30 B.C.)
Terracotta
H. 20.8 cm (8⅛ in.)
74.51.2263 (not in Myres)

The sleeping boy's nakedness and exhausted state suggest that he is a slave or servant. Vases in the shape of seated or crouching Africans date from the Late Classical through the Hellenistic period. The boy has slight projections on his head that may be horns. Images of black people often were given characteristics of satyrs (woodland creatures associated with Dionysos). Blacks and the mythological satyrs were considered to be on the margins of the Greek world and were therefore exotic and popular subjects for Hellenistic artists. Vases of

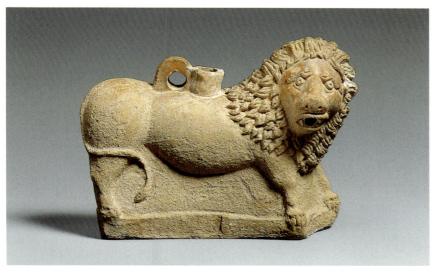

444

this type probably held perfumed oils (Lunsingh Scheurleer 1993).

MER

BIBLIOGRAPHY: Cesnola 1877, p. 456; McClees 1933, p. 123.

444. *Askos* in the shape of a lion
Roman (ca. 30 B.C.–ca. A.D. 330), 2nd century A.D.
Terracotta
H. 11.4 cm (4½ in.); L. 14.9 cm (5⅞ in.)
74.51.1666 (Myres 2349)

MER

BIBLIOGRAPHY: Cesnola 1894, pl. LXXIV.669.

445. Woman with casket
Hellenistic (ca. 310–ca. 30 B.C.), 1st century B.C.
Terracotta
H. 26.2 cm (10¼ in.)
74.51.1583 (Myres 2211)

The small chest that the woman holds is a type of container used to hold objects such as jewelry, toiletries, or scrolls. The box may be a gift for a god.

MER

BIBLIOGRAPHY: Cesnola 1894, pl. XXXIX.315.

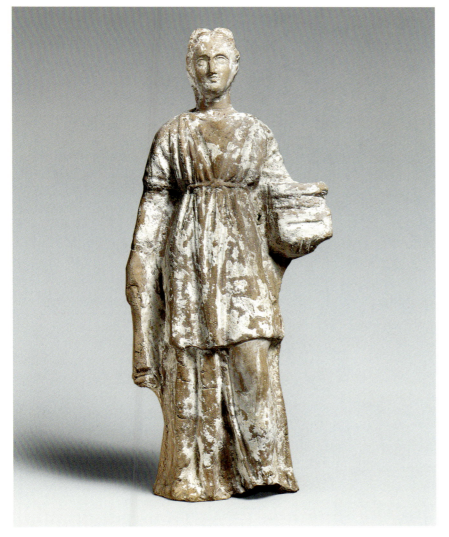

445

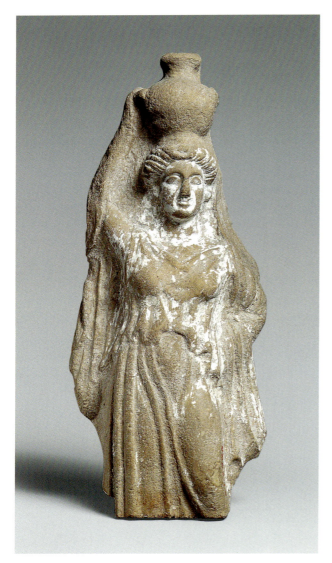

446

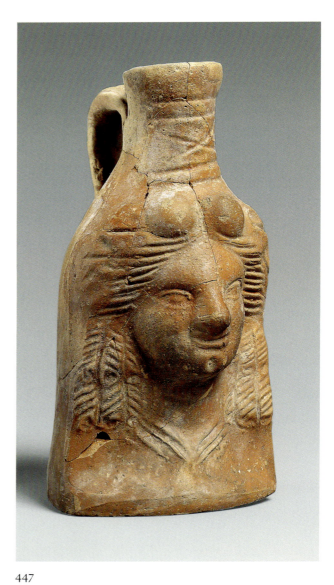

447

446. Water bearer
1st century B.C.–1st century A.D.
Terracotta
H. 15.2 cm (6 in.)
74.51.1720 (Myres 2215)

Water bearers played important roles in the religious ceremonies of ancient cults. The fetching of water was also an essential part of everyday life. Classical *hydriaphorai* were portrayed as young women; this depiction of a mature woman is evidence of Hellenistic interest in the different stages of life.

<div style="text-align: right">MER</div>

BIBLIOGRAPHY: Cesnola 1894, pl. XX.157.

447. Head-shaped jug
Hellenistic (ca. 310–ca. 30 B.C.) or Roman (ca. 30 B.C.–ca. A.D. 330), late 1st century B.C.
Magenta Ware

H. 15.1 cm (6 in.)
74.51.541 (Myres 1728)

Many Magenta Ware flasks in the shape of women's heads, including this example, have been found in Cypriot tombs. The face on the vessel was made in a mold, while the back, base, and neck of the jug were formed by hand. Incised diagonal lines indicate rows of corkscrew curls around the face, a motif that often characterizes Egyptian

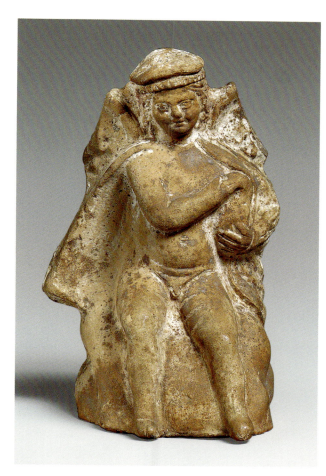

448

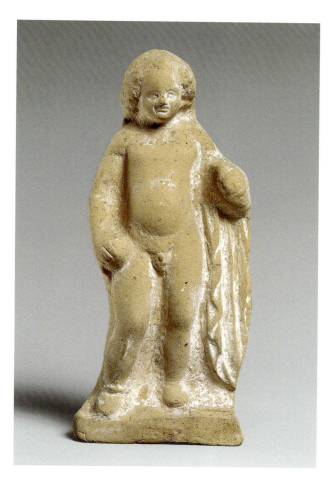

449

subjects such as Isis. Other vases of this type found on Cyprus have additional Egyptian attributes (Michaelides 1997, p. 142).

The hemispherical projections above the forehead appear on related vases, where they are recognizable as the clusters of ivy berries worn by followers of Dionysos. Similar vases (such as one in The Metropolitan Museum of Art, 46.11.46, not illustrated here) have been identified as depicting Dionysos, but those found on Cyprus are usually identified as representations of women.

MER

BIBLIOGRAPHY: Cesnola 1877, p. 402, fig. 13; Michaelides 1997, p. 140, pl. XLVI.C.

448. Eros
1st century B.C.–1st century A.D.
Terracotta
H. 10.6 cm (4⅛ in.)
74.51.1596 (Myres 2303)
Said to be from the temple of Artemis Paralia at Kition

The cap this Eros wears is similar to one called a *causia* that originated in Macedonia. Other examples of the cap are found in Cypriot art, where it is most often worn by votive figures of young boys.

MER

BIBLIOGRAPHY: Cesnola 1894, pl. XLVI.363; Sjöqvist 1955, p. 47, no. 19.

449. Eros
1st century B.C.–1st century A.D.
Terracotta
H. 15.1 cm (6 in.)
74.51.1745 (Myres 2305)
Said to be from the temple of Apollo Hylates at Kourion

Although the figure has no wings and may therefore be identified as a mortal child, he holds an apple and a dove, attributes of Aphrodite that suggest Eros in his role as Aphrodite's attendant.

MER

BIBLIOGRAPHY: Cesnola 1894, pl. XLII.333.

POTTERY

The Cesnola Collection contains examples of pottery types that were popular not only on Cyprus but throughout the Mediterranean. Vessels were traded in great numbers in the post-Classical period. Much of the fine tableware found on Cyprus—such as the Red Slip Ware jug (cat. no. 455), probably made in Tunisia—was imported, along with amphorae that contained products such as olive oil and wine. The amphora to the right (cat. no. 450) carried wine from Rhodes.

The practice of elaborately painting vases lost favor to less time-consuming methods. Red Slip Ware (cat. nos. 454, 455) was often decorated with motifs that were made in molds and pressed onto vases before firing. In the Barbotine technique, soft, wet clay was trailed and pressed onto the cup before firing (cat. no. 457). Mold-made cups (cat. no. 456) were stained with a lead-based glaze that turned green upon firing and was especially common in the eastern Mediterranean. The cups have thin, delicate walls, in imitation of costlier vessels made from glass or metal.

Vases in the shapes of animals are known to have been made on Cyprus from the Bronze Age on (cat. nos. 21, 38, 39, 45, 63, 73, and 126, among others). Examples dating from the Hellenistic and Roman periods were mass-produced from molds (cat. no. 444). Vases in human form also appear frequently at this time and often depict subjects with foreign characteristics (cat. nos. 443, 447). *Lagynoi* are oil flasks characterized by a cylindrical neck placed atop a squat body with a

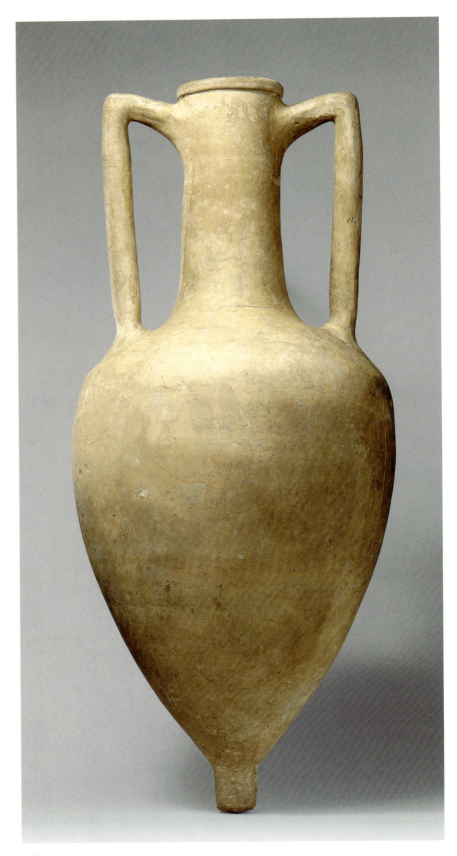

450

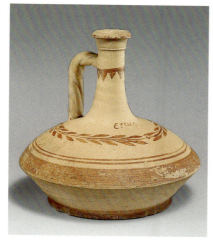

451

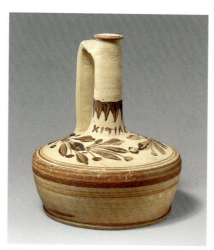

452

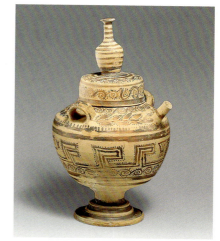

453

pronounced shoulder. They were common throughout the Hellenistic world and may imitate metallic prototypes. The type appears on Cyprus at the beginning of the Hellenistic I period in Plain White, Glazed Painted, and White Painted wares. The two *lagynoi* below (cat. nos. 451, 452) bear inscriptions in the Greek alphabet. Several such inscribed pieces are thought to be of Cypriot origin (cf. V. Karageorghis 1971a, pp. 368 n. 59, 370, fig. 75).

MER and VK

450. Amphora
Hellenistic (ca. 310–ca. 30 B.C.), 300–100 B.C.
Terracotta
H. 81.2 cm (32 in.)
74.51.357 (not in Myres)
From Rhodes, said to be from Idalion
Inscribed left handle:
Ε[πι πυ]θογε νευς Δευτερου Παναμου; right handle: Ηφαιοτι ωνος, caduceus

The amphora's characteristic shape was practical for efficient storage. It would have been stacked

with other vessels in rows, with its pointed end fitting between the necks of the amphorae below. Stamped inscriptions on the amphora's handles reveal the month the amphora was made, the name of the magistrate in office at the time, and the name of the amphora's maker.

MER

BIBLIOGRAPHY: Cesnola 1894, pl. CXLIV, no. 1068.

451. *Lagynos*
Hellenistic (ca. 310–ca. 30 B.C.)
White Painted Ware
H. 19.7 cm (7¾ in.)
74.51.386 (Myres 959)
Said to be from Kiti

On the neck, opposite the handle, is an inscription in Greek capital letters that reads: "ΕΡΩC" (Eros). A horizontal row of solid "flames," or triangles, hangs from a band around the upper part of the neck.

BIBLIOGRAPHY: Cesnola 1894, pl. CXLIII.1066; Cesnola 1903b, no. 10; Vessberg and Westholm 1956, p. 65, fig. 28, no. 10.

452. *Lagynos*
Hellenistic (ca. 310–ca. 30 B.C.)
White Painted Ware
H. 22.5 cm (8⅞ in.)
74.51.390 (Myres 958)
Said to be from Kiti

The decoration is in orange to dark brown semigloss paint. On the neck, opposite the handle, an inscription in Greek capital letters reads: "KITIAC" (Kitias [a proper name]).

BIBLIOGRAPHY: Cesnola 1877, p. 431, no. 42; Cesnola 1894, pl. CXLIII.1067; Cesnola 1903b, no. 11; Vessberg and Westholm 1956, p. 65, fig. 28.6; V. Karageorghis 1962, p. 364 n. 1.

453. Spouted vase with lid
Cypriot, Hellenistic (ca. 310–ca. 30 B.C.)
Terracotta
H. (with lid): 30.8 cm (12⅛ in.)
74.51.375 (Myres 1727)

From earliest times, Cypriot vessels—particularly of clay—show a predilection for spouts. The shape is unusual, but the ornament is even more so.

JRM

454. Bowl
Roman (ca. 30 B.C.–ca. A.D. 330),
1st century A.D.
Red Slip Ware
H. 11.4 cm (4½ in.); diam. 15.9 cm
(6¼ in.)
74.51.385 (Myres 986)
Said to be from Kition

The shape of this bowl is derivative of Italian forms. The twelve dancing and flute-playing nude figures who circle the exterior are caricatures of dwarfs. They are comical in appearance, wearing only Phrygian caps and displaying grossly exaggerated genitals. Dwarfs were popular entertainers in the Hellenistic and Roman periods. Representations of performing dwarfs were used as domestic decoration—as statuettes, on pavement mosaics, on terracotta oil lamps, and on tableware such as this bowl. Their depiction may have been considered protection against the evil eye. MER

BIBLIOGRAPHY: Cesnola 1877, p. 230; Cesnola 1894, pl. CXXXII.979.

455. Jug
Roman (ca. 30 B.C.–ca. A.D. 330),
3rd century A.D.
Red Slip Ware
H. 15.4 cm (6⅛ in.)
74.51.383 (Myres 985)

A vertical palm branch divides the jug into two fields. Within them, the details of the applied motifs are unclear. On one side a crouching figure wearing a Phrygian cap holds a square object. An animal with its head turned backward is on the other side. A leaf spray decorates the handle. MER

BIBLIOGRAPHY: Vessberg and Westholm 1956, p. 71, no. 32.3; Hayes 1972, p. 194, no. 41.

456. Cup
Roman (ca. 30 B.C.–ca. A.D. 330),
late 1st century B.C.–
early 1st century A.D.
Terracotta
H. 6.7 cm (2⅝ in.); diam. 9.7 cm
(3⅞ in.)
74.51.389 (Myres 989)

The cup's shape is based on a silver prototype and is one of the most common among green-glazed vessels. MER

BIBLIOGRAPHY: Richter 1916, p. 65, fig. 4; Hochuli-Gysel 1976, p. 231, no. 2, pl. 37.2.

457. Cup
Roman (ca. 30 B.C.–ca. A.D. 330),
ca. A.D. 100
Terracotta
H. 6.2 cm (2½ in.); diam. 9.9 cm
(3⅞ in.)
74.51.373 (Myres 991)

The cup originally had two handles. MER

BIBLIOGRAPHY: Goldman 1950, fig. 170c; Vessberg and Westholm 1956, pp. 67–68, fig. 30, no. 10.

458. Cup
Late Hellenistic (ca. 310–
ca. 30 B.C.), 200–150 B.C.
Terracotta
H. 6.4 cm (2½ in.); diam. 8.3 cm
(3¼ in.)
74.51.5843 (not in Myres)
MER

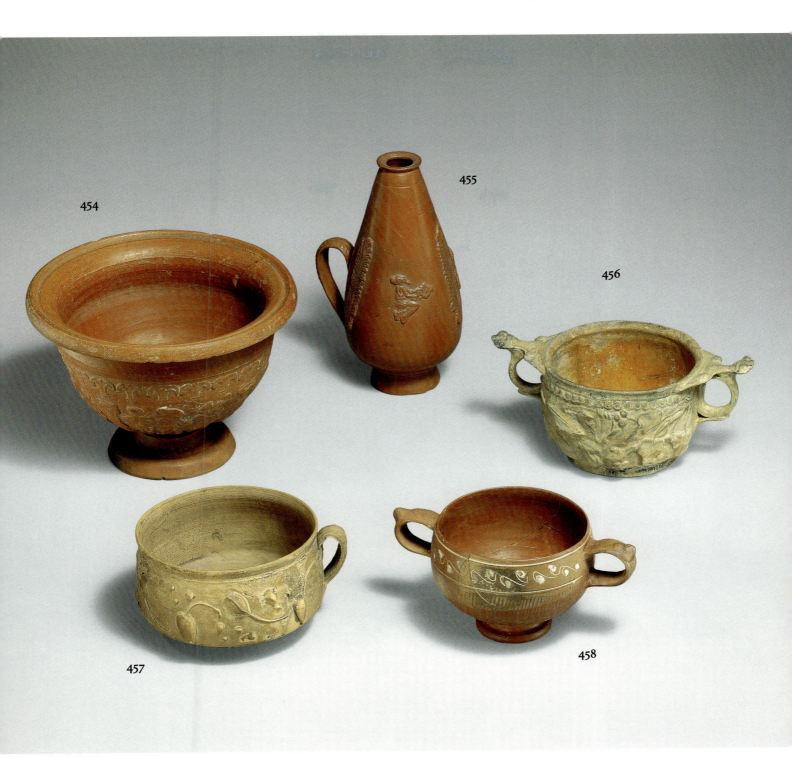

454

455

456

457

458

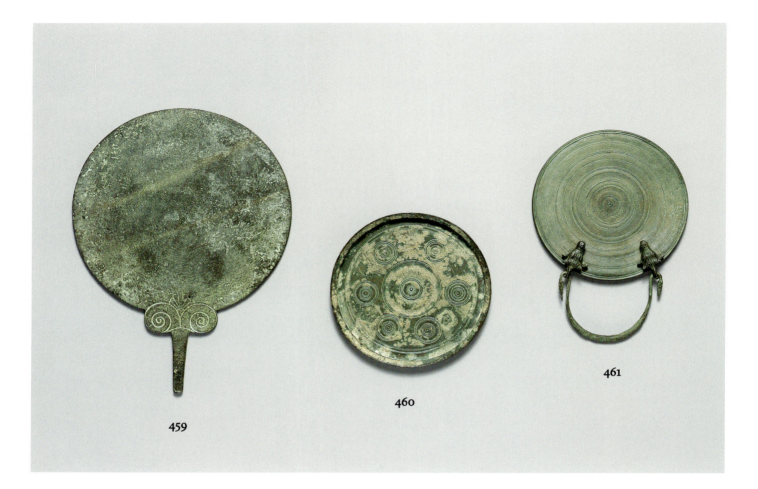

459

460

461

BRONZE AND IRON OBJECTS

Mirrors

Bronze mirrors had a long tradition on Cyprus, beginning in the Late Bronze Age. They were particularly popular from the Late Archaic through the Roman period. A type that dates from the sixth century B.C. (cat. no. 459) is made of cast metal. The tang below a "capital" would have been inserted into a handle of wood or ivory (cf. Gjerstad 1948, pp. 142–43, 215, fig. 25). Box mirrors of the Hellenistic and Roman periods (cat. nos. 460, 461) consist of a pair of disks, hinged together. On the front they are flat,

polished, and often silvered. The back is unpolished and decorated with concentric circles in relief or groups of incised concentric circles. A parallel to catalogue number 461 was found in a Roman tomb in Palaepaphos, but the attachments on the swinging handle are in the form of human busts (V. Karageorghis 1961, pp. 292–93, fig. 45).

459. **Mirror**
6th century B.C.
Bronze
Diam. 15.9 cm (6¼ in.); L. (with tang): 21.6 cm (8½ in.)
74.51.5416 (Myres 4794)

BIBLIOGRAPHY: Richter 1915, p. 254, fig. 740, no. 740.

460. Mirror cover
Hellenistic (ca. 310–ca. 30 B.C.) or
Roman (ca. 30 B.C.–ca. A.D. 330)
Bronze
Diam. 11.6 cm (4⅝ in.)
74.51.5405 (Myres 4806)

BIBLIOGRAPHY: Richter 1915, p. 269,
fig. 784, no. 784; Vessberg and West-
holm 1956, p. 114, fig. 33, no. 16.

461. Mirror cover
Roman (ca. 30 B.C.–ca. A.D. 330)
Bronze
Diam. 11.1 cm (4⅜ in.); L. (with
handle): 15.9 cm (6¼ in.)
74.51.5417 (Myres 4811)
Said to be from Idalion

BIBLIOGRAPHY: Cesnola 1903a,
pl. LXI.1,2; Richter 1915, p. 270,
fig. 789, no. 789; Gjerstad 1948,
p. 143, fig. 25.7 (gives a date of
Cypro-Classical II).

462. Two pairs of waterspouts
Roman (ca. 30 B.C.–ca. A.D. 330)
Bronze
Diam. 9.2 cm (3⅝ in.) (74.51.5675,
.5676), 13 cm (5⅛ in.) (74.51.5677,
.5678)
74.51.5675–.5678 (Myres 5015–18)
Said to be from Kourion

These two pairs of waterspouts
share structural similarities. De-
spite the stylistic differences be-
tween the lion's heads, one must
allow for the possibility that they
originally belonged to one foun-
tain. The two smaller heads are
attached to a bronze tube of about
12 cm (4¾ in.) in length, encased
in lead, while the larger heads are
attached to a tube of about 7 cm
(2¾ in.) in length. J R M

BIBLIOGRAPHY: Richter 1915,
pp. 166–67, nos. 406–9.

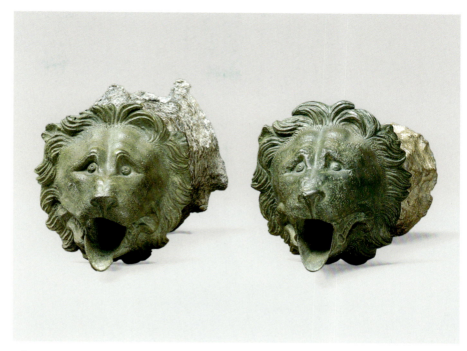

462

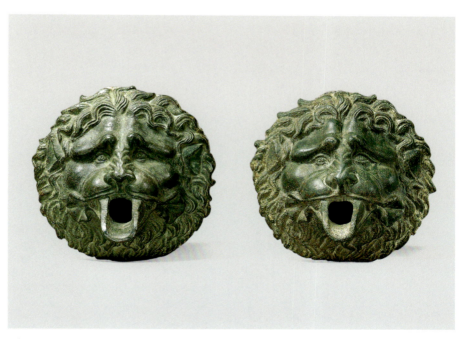

462

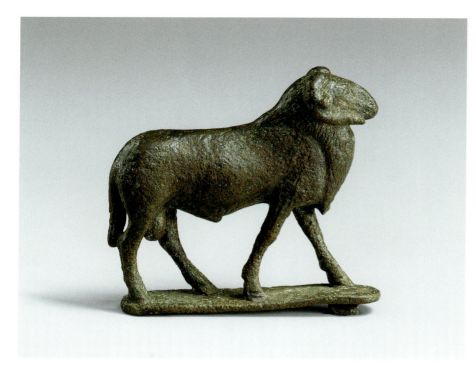

463

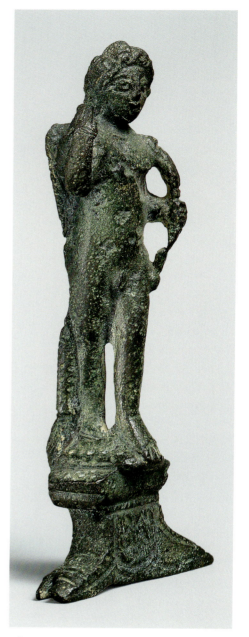

464

463. Ram
Hellenistic (ca. 310–ca. 30 B.C.) or
Roman (ca. 30 B.C.–ca. A.D. 330)
Bronze
H. 5.4 cm (2⅛ in.); L. 6.4 cm
(2½ in.)
74.51.5625 (Myres 5024)

Thick fleece with a lightly punc-
tured surface surrounds the neck.
Myres considered this statuette to
be Egyptian, from the Ptolemaic
or Graeco-Roman period (1914,
p. 499, no. 5024).

464. Eros
Roman (ca. 30 B.C.–ca. A.D. 330)
Bronze
H. 9.7 cm (3⅞ in.)
74.51.5579 (Myres 5029)

Eros is depicted holding his bow
in the left hand and drawing an
arrow from his quiver with the
right hand. The pose is a time-
honored one that probably origi-
nated with the goddess Artemis
and was then applied to other
mythological archers. This variant
of Eros appears in numerous
media in Roman times. JRM

BIBLIOGRAPHY: Richter 1915, p. 120,
no. 229.

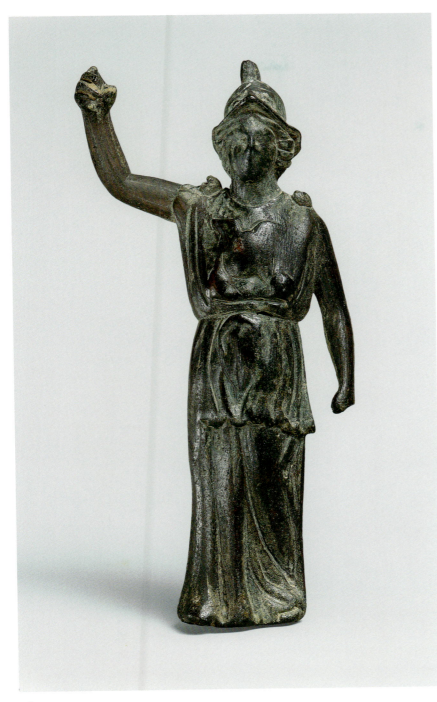

465

465. Athena
Roman (ca. 30 B.C.–ca. A.D. 330),
2nd–3rd century A.D.
Bronze
H. 11 cm (4⅜ in.)
74.51.5578 (Myres 5028)

This slight piece is a distant rem-
iniscence of the Athena Parthenos,
depicted with a helmet, a spear
held vertically in the right hand,
and the garment belted at the waist
with an overfold. Such bronzes cir-
culated widely throughout the
Roman world. JRM

BIBLIOGRAPHY: Richter 1915, p. 115,
no. 215.

GLASS

Objects of glass began to be im-
ported from Egypt into Cyprus
during the Late Bronze Age. The
manufacture of glass on the island
dates from as early as the four-
teenth and thirteenth centuries B.C.
(Seefried 1986, pp. 145–46). Varie-
gated, or polychrome, glass was
probably imported from both
Egypt and Phoenicia. Some schol-
ars have suggested that variegated
glass was produced on Cyprus also,
but there is no archaeological evi-
dence to substantiate the claim. It
is true, however, that some of the
variegated-glass examples from
Cyprus are peculiar to the island
because they differ in their typol-
ogy from those in Egypt and
Phoenicia. This supports the idea
that some variegated glass was pro-
duced on Cyprus (Seefried 1986,
p. 147).

The earliest glass found on Cy-
prus is variegated glass of the type
modeled around a removable sand
core, a technique that appeared
in Egypt during the 17th Dynasty
(second millennium B.C.) and flour-
ished later in the sixth century B.C.
in the Greek colony of Naukratis
(for a general account of glass on
Cyprus, see Seefried 1974, pp. 147–
48, and Seefried 1986). In this sec-
tion, some of the types known
throughout the Mediterranean
are represented.

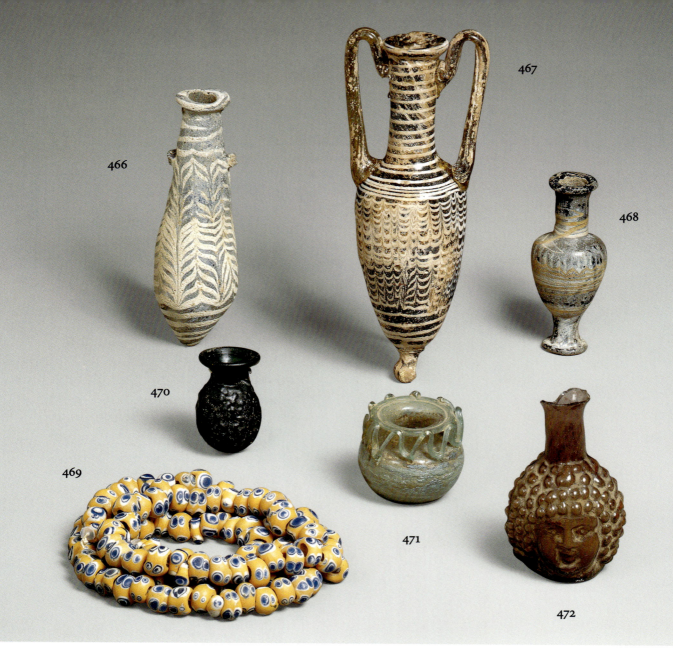

466. **Alabastron**
Cypriot, Hellenistic (ca. 310–
ca. 30 B.C.), Mediterranean
Group III, 2nd–1st century B.C.
Glass
H. 13.7 cm (5⅜ in.)
74.51.319 (Myres 5058)

Most of the known examples of
this type of alabastron have been
found on Cyprus, an indication
that they were made there. They
were, however, widely exported,
reaching as far as Italy. One such
piece, probably intended for the
Roman market, was recovered from
an ancient shipwreck dated to
about 80 B.C., found at Antiky-
thera, off the southern coast of the
Peloponnese. For comparable
examples, see Grose 1989, pp. 123
(class II:E; alabastron form III:5),
168, no. 166; Weinberg 1992, p. 92,
no. 32.

C L

467. **Amphoriskos**
Cypriot, Late Hellenistic,
Mediterranean Group III,
1st century B.C.
Glass
H. 17.2 cm (6¾ in.); diam. 4.9 cm
(1⅞ in.)
74.51.320 (Myres 5054)
Said to be from a tomb at Idalion

Similar vessels have been found
throughout the eastern Mediterra-
nean region, from the Black Sea to
the Syrian coast. Some are thought

to have been made in Cyprus, from which they could easily have been distributed via the maritime trade routes. A distinctive feature of these late examples of core-formed glass is the use of translucent glass for the handles and knob base (cf. Grose 1989, pp. 123–24 [class II:E; amphoriskos form III:2B], 172, no. 172; Weinberg 1992, pp. 92–93, no. 33). CL

BIBLIOGRAPHY: Cesnola 1877, pl. III; Cesnola 1903a, pl. LXXVI.4; Fossing 1940, p. 120 n. 1.

468. Unguentarium
Eastern Mediterranean, Early Hellenistic, Mediterranean Group II, 3rd century B.C.
Glass
H. 8.6 cm (3⅜ in.)
74.51.325 (Myres 5053)

Although examples of this type of core-formed glass are found throughout the eastern Mediterranean and Black Sea area, they are especially common on Cyprus. Whether they were made there or the island was a major stopping point on the trade routes that aided their distribution remains uncertain. For similar unguentaria, or perfume bottles, see Grose 1989, pp. 121–22 (class II:G; unguentarium form II:2), 166, no. 158; Weinberg 1992, p. 93, no. 34. CL

BIBLIOGRAPHY: Cesnola 1877, pl. III; Fossing 1940, p. 117 n. 3.

469. Eye beads
Phoenician, Hellenistic (ca. 310– ca. 30 B.C.), ca. 300–ca. 70 B.C.
Glass
Average diam. 1–1.3 cm (⅜–½ in.)
74.51.316 (Myres 5799)

The beads formed a necklace that probably had an apotropaic as well as a decorative purpose. Beads are some of the earliest objects made in glass, and examples have been found in archaeological contexts dating from the third millennium B.C., long before the first glass vessels were made. Nevertheless, beads remain some of the most difficult objects to date, since the same shapes and types remained in use for long periods. See Stern and Schlick-Nolte 1994, p. 198, no. 41, for comparable beads. CL

The invention of glassblowing in the mid-first century B.C. made glass vessels inexpensive and readily available throughout the Roman world. Cyprus was one of many locales for glass manufacture. Two examples illustrated here are of mold-blown glass. One (cat. no. 472) depicts two heads, and the other (cat. no. 470) a bunch of grapes. Mold-blown glass vessels are particularly attractive and were common from the first century B.C. to the first century A.D. (Vessberg and Westholm 1956, pp. 159, 203). The jar (cat. no. 471) is of free-blown glass and has parallels from the third and fourth centuries A.D.

470. Grape flask
Eastern Mediterranean, Roman (ca. 30 B.C.–ca. A.D. 330), late 1st–2nd century A.D.
Glass
H. 4.6 cm (1¾ in.)
74.51.317 (Myres 5764)

Mold-blown containers in the shape of a dried date or a bunch of grapes were produced in large quantities by Roman glasshouses in Syria. This example, however, is an unusual miniature version for which no exact parallel has been found. For other grape-bunch–shaped bottles, see Stern 1995, p. 180, nos. 109–10. CL

471. Jar
Syro-Palestinian, Roman (ca. 30 B.C.–ca. A.D. 330), 4th–5th century A.D.
Glass
H. 4 cm (1⅝ in.); diam. 4.43 cm (1¾ in.)
74.51.197 (Myres 5745)

Jars with openwork zigzag trails between rim and shoulder are found most commonly in Syria (cf. Hayes 1975, p. 115, no. 443), but the type also appears among Late Roman glassware made in Egypt. This is an unusually small example; it was probably used as a cosmetic jar. CL

472. Double-head–shaped flask
Eastern Mediterranean, Roman (ca. 30 B.C.–ca. A.D. 330), ca. A.D. 200–220
Glass
H. 8 cm (3⅛ in.); diam. 4.46 cm (1¾ in.)
74.51.318 (Myres 5763)

The two similar idealized heads may have been intended to represent Medusa. Mold-blown glass and terracotta plastic vases in the form of human heads were popular throughout the Roman period, but double-head–shaped vessels are restricted to glass and generally represent figures such as Dionysos, Eros, or Medusa (see Stern 1995, pp. 201–46, especially p. 235, no. 152). CL

BIBLIOGRAPHY: Vessberg 1952, p. 136.

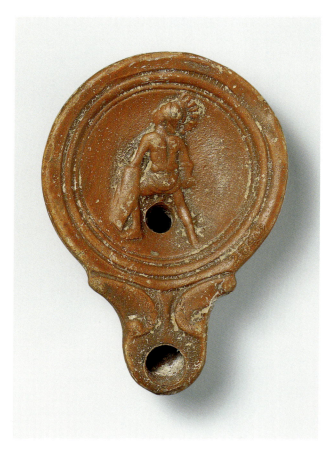

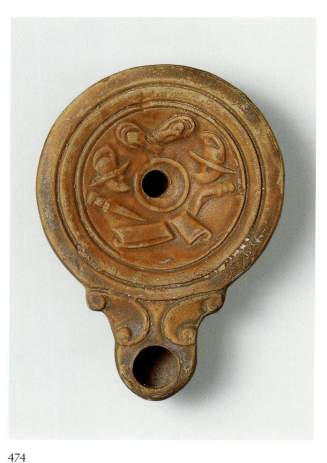

473

474

LAMPS

Three of the lamps that follow belong to a group with pictorially decorated disks. In several cases the relief decoration is blurred, an indication that the disk is a secondary cast of the original lamp. These pieces (cat. nos. 473–75) were probably made on Cyprus; other examples from the same molds have been found on the island. Some lamps having a sharper relief image date from the first century A.D. and may have been imported from Italy (Vessberg and Westholm 1956, p. 188, type 10a). The themes represented here, of gladiators and gladiators' arms, were popular on lamps (cf. Vessberg and Westholm 1956, p. 123, fig. 38.10; Oziol 1977, pp. 122–23, 142–44, pl. 17, nos. 303–11, pl. 22, nos. 402–12). The theme of Herakles (see cat. no. 475) is unusual.

473. Red-glazed lamp
A.D. 40–100
Terracotta
L. 8.7 cm (3⅜ in.); H. 2.4 cm (1 in.)
74.51.1850 (Myres 2642)

The upper disk-shaped section, which was made from a mold, is concave and has a filling hole for oil. Its decoration consists of a gladiator wearing a crested helmet and holding a shield in his left hand (cf. Bailey 1988, pp. 57, 303, pl. 63, fig. 57, no. Q2391).

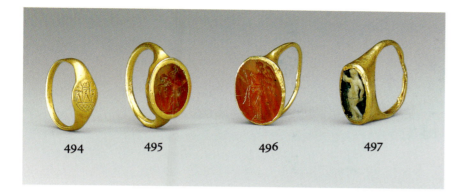

494 495 496 497

the Hellenistic period, particularly from Cyprus. It is not clear whether these objects were for personal use or embellished dedications.

JRM

493. Two pins
Roman (ca. 30 B.C.–ca. A.D. 330), 1st–3rd century A.D. or later
Bone
L. 10.5 cm (4⅛ in.) (74.51.5205), 10.6 cm (4⅛ in.) (74.51.5206)
74.51.5205, .5206 (Myres 5947, 5946)

The bone pins of Roman date found on Cyprus tend to have the head of a piece with the shaft. On these examples, the busts were worked separately and attached.

JRM

BIBLIOGRAPHY: Chavane 1975, pp. 166–72.

494. Finger ring
Roman (ca. 30 B.C.–ca. A.D. 330)
Gold
Diam. 1.7 cm (⅝ in.)
74.51.4088 (Myres 4088)
Said to be from Kourion

The ring is small, with a thin, flat loop and an elliptical, flat bezel on which there is a finely engraved representation of the well-known sanctuary of Aphrodite at Palae-paphos. The sanctuary consists of a tripartite structure with what

appears to be a semicircular front courtyard filled with a lattice pattern; the three compartments may represent the holy of holies of the temple. To either side are high posts topped by what are probably "horns of consecration." Inside each compartment is a conical object with a dot above it, probably aniconic representations of the Great Goddess of Cyprus.

Representations of the sanctuary of Aphrodite at Palaepaphos appear on coins of emperors such as Augustus, Vespasian, and Trajan, as well as on gems, sealings, and finger rings (Westholm 1933, pp. 203–4; Maier and Karageorghis 1984, pp. 85–86, figs. 65–67, 87). They even appear on coins from Asia Minor, an indication that the architectural type of the Paphian sanctuary was well known outside Cyprus.

The temple of Aphrodite at Palaepaphos has been excavated recently. The temple dates from early in the twelfth century B.C. and is referred to by Homer in the *Odyssey* (8.363) (Maier and Karageorghis 1984, p. 81).

BIBLIOGRAPHY: Cesnola 1903a, pl. XXX.16; Richter 1920, p. 148, no. 280.

495. Ring stone
Roman (ca. 30 B.C.–ca. A.D. 330), 2nd half of the 1st century B.C.
Carnelian
H. 1.4 cm (⅝ in.)
74.51.4233 (Myres 4233)

Eros leans to the left, supporting himself on an inverted, flaming torch. The motif is a common one from the third century B.C. on, in all media.

JRM

BIBLIOGRAPHY: Richter 1956, no. 304; Schlüter et al. 1975, no. 265.

496. Ring stone
Roman (ca. 30 B.C.–ca. A.D. 330), latter part of the 1st century B.C.
Carnelian
H. 1.6 cm (⅝ in.)
74.51.4234 (Myres 4234)

Winged Nemesis, the goddess of retribution, stands to the right holding branches in her right hand. From the first century B.C. into the third century A.D. she figured prominently in Roman iconography, particularly in small-scale media such as gems and coins.

JRM

BIBLIOGRAPHY: Richter 1956, no. 370; Schlüter et al. 1975, no. 301.

497. Cameo
Roman (ca. 30 B.C.–ca. A.D. 330), probably 1st century A.D.
Glass
H. 1.5 cm (⅝ in.)
74.51.4244 (Myres 4244)

A nude youth is shown holding a mantle. The gold ring may be original.

JRM

BIBLIOGRAPHY: Richter 1956, no. 641.

BIBLIOGRAPHY
OF WORKS CITED

Adelman, C.
1971 "A Sculpture in Relief from Ama-
 thus." *Report of the Department of
 Antiquities, Cyprus,* pp. 59–64.

Amadasi, M. G., and V. Karageorghis
1977 *Fouilles de Kition III: Inscriptions
 phéniciennes.* Nicosia.

Amandry, P.
1956 "Chaudrons à Protomes de Taureau
 en Orient et en Grèce." In *The
 Aegean and the Near East: Studies
 Presented to Hetty Goldman on
 the Occasion of Her Seventy-Fifth
 Birthday,* edited by S. S. Weinberg,
 pp. 239–61. Locust Valley,
 New York.
1958 "Objets orientaux en Grèce et en
 Italie aux VIIIᵉ et VIIᵉ siècles avant
 J.-C." *Syria* 35, pp. 73–109.
1986 "Sièges mycéniens tripodes et
 trépied pythique." In *Philia epe
 eis Georgion E. Mylonan: Dia
 ta 60 ete tou anaskaphikou tou
 ergou,* pp. 167–84. Athens.

Amiet, P.
1997 *Sceaux-cylindres en hématite et
 pierres diverses.* Ras Shamra-
 Ougarit, 9. Paris.

Aruz, J.
1997 "Cypriot and Cypro-Aegean Seals."
 In *De Chypre à la Bactriane: Les
 sceaux du Proche-Orient Ancien;
 Actes du colloque international
 organisé au Musée du Louvre par le
 Service Culturel, 13–18 mars 1995,*
 pp. 271–88. Paris.

Åström, L.
1972 *The Swedish Cyprus Expedition.*
 Vol. 4, part 1D, *The Late Cypriote
 Bronze Age: Other Arts and Crafts.*
 Contributions by L. Åström,
 V. E. G. Kenna, and M. R. Popham.
 Lund.

Åström, P.
1972 *The Swedish Cyprus Expedition.*
 Vol. 4, part 1B, *The Middle Cypriote
 Bronze Age.* Lund.
1972a *The Swedish Cyprus Expedition.*
 Vol. 4, part 1C, *The Late Cypriote
 Bronze Age: Architecture and Pottery.*
 Lund.

Bailey, D. M.
1988 *A Catalogue of the Lamps in the
 British Museum.* Vol. 3, *Roman
 Provincial Lamps.* London.

Baker, H. S.
1966 *Furniture in the Ancient World:
 Origins and Evolution, 3100–
 475 B.C.* London.

Barnett, R. D.
1958 "Early Shipping in the Near East."
 Antiquity 32, pp. 220–30.

Basch, L.
1987 *Le musée imaginaire de la marine
 antique.* Athens.

Beardsley, G. M. H.
1929 *The Negro in Greek and Roman
 Civilization: A Study of the Ethi-
 opian Type.* Johns Hopkins Univer-
 sity Studies in Archaeology, no. 4.
 Baltimore.

Becatti, G.
1955 *Oreficerie antiche dalle minoiche
 alle barbariche.* Rome.

Beck, H., P. C. Bol, and M. Buckling, eds.
1990 *Polyklet: Der Bildhauer der griech-
 ischen Klassik.* Exh. cat. Frankfurt
 am Main: Liebieghaus, Museum
 Alter Plastik.

Beer, C.
1994 *Temple-Boys: A Study of Cypriote
 Votive Sculpture.* Part 1, *Catalogue.*
 Studies in Mediterranean Archae-
 ology, vol. 113. Jonsered.

Bennett, C. G.
1980 "The Cults of the Ancient Greek
 Cypriotes." 2 vols. Ph.D. disserta-
 tion, University of Pennsylvania,
 Philadelphia.

Benson, J. L.
1975 "Birds on Cypro-Geometric Pot-
 tery." In *The Archaeology of Cyprus:
 Recent Developments,* edited by
 N. Robertson, pp. 129–50. Park
 Ridge, New Jersey.
1984 "A Pilgrim Flask of Cosmopolitan
 Style in the Cesnola Collection."
 Metropolitan Museum Journal 18
 (1983), pp. 5–16.

Bernhard, M.-L., and W. A. Daszewski
1986 "Ariadne." In *Lexicon iconograph-
 icum mythologiae classicae,* vol. 3,
 pp. 1050–70. Zurich and Munich.

1973 *Excavation in the Necropolis of Salamis III.* 3 vols. Nicosia.

1975a *Alaas: A Protogeometric Necropolis in Cyprus.* Nicosia.

1975b "Kypriaka II." *Report of the Department of Antiquities, Cyprus,* pp. 58–68.

1976a "Chronique des fouilles et découvertes archéologiques à Chypre." *Bulletin de correspondance hellénique* 100, pp. 839–906.

1976b *The Civilization of Prehistoric Cyprus.* Athens.

1977a "A 'Favissa' at Kakopetria." *Report of the Department of Antiquities, Cyprus,* pp. 178–201.

1977b *The Goddess with Uplifted Arms in Cyprus.* Scripta minora in honorem Einari Gjerstad, 1977–78, no. 2. Lund.

1977c *Two Cypriote Sanctuaries of the End of the Cypro-Archaic Period.* Rome.

1982 "Black Slip Grooved Ware from Cyprus." *Report of the Department of Antiquities, Cyprus,* pp. 119–22.

1983 *Palaepaphos-Skales: An Iron Age Cemetery in Cyprus.* Ausgrabungen in Alt-Paphos auf Cypern 3. Konstanz.

1987a "The Terracottas." In *La nécropole d'Amathonte: Tombes 113–367,* edited by V. Karageorghis and O. Picard, pp. 1–52. Études chypriotes, vol. 9. Nicosia.

1987b "Varia." In "Enkomi (Fouilles Schaeffer 1934–1966): Inventaire complémentaire," by A. Caubet, J.-C. Courtois, and V. Karageorghis, *Report of the Department of Antiquities, Cyprus,* pp. 44–47.

1988a *Blacks in Ancient Cypriot Art.* Houston.

1988b "A Stone Statuette of a Sphinx and a Note on Small Limestone Thymiateria from Cyprus." *Report of the Department of Antiquities, Cyprus,* part 2, pp. 89–93.

1989 "A New 'Geryon' Terracotta Statuette from Cyprus." *Eretz Israel* 20, pp. 92–97.

1991 *The Coroplastic Art of Ancient Cyprus, I. Chalcolithic–Late Cypriote I.* Nicosia.

1993a *The Coroplastic Art of Ancient Cyprus, II. Late Cypriote II– Cypro-Geometric III.* Nicosia.

1993b *The Coroplastic Art of Ancient Cyprus, III. The Cypro-Archaic Period: Large and Medium Size Sculpture.* Nicosia.

1993c "Erotica from Salamis." *Rivista di studi fenici* 21, supp., pp. 7–13.

1994 "Monkeys and Bears in Cypriote Art." *Opuscula Atheniensia* 20, pp. 63–73.

1995 *The Coroplastic Art of Ancient Cyprus, IV. The Cypro-Archaic Period: Small Male Figurines.* Nicosia.

1996 *The Coroplastic Art of Ancient Cyprus, VI. The Cypro-Archaic Period: Monsters, Animals, and Miscellanea.* Nicosia.

1997 "An Enthroned Astarte on Horseback?" *Report of the Department of Antiquities, Cyprus,* pp. 195–204.

1998 *The Coroplastic Art of Ancient Cyprus, V. The Cypro-Archaic Period: Small Female Figurines. A: Handmade/Wheelmade Figurines.* Nicosia.

1998a *Greek Gods and Heroes in Ancient Cyprus.* Athens.

1999 "A Cypriote Silver Bowl Reconsidered: 1. The Iconography of the Decoration." *Metropolitan Museum Journal* 34, pp. 13–20.

n.d. (a) "A Cypriote Banquet Scene." In *L. Kahil Festschrift.* Forthcoming.

n.d. (b) "Phoenician Marble Anthropoid Sarcophagi and their Parian Connection." Forthcoming.

Karageorghis, V., and J. Des Gagniers

1974a *La céramique chypriote de style figuré: Âge du Fer (1050–500 av. J.-C.).* Vol. 1, *Texte.* Rome.

1974b *La céramique chypriote de style figuré: Âge du Fer (1050–500 av. J.-C.).* Vol. 2, *Illustrations et descriptions des vases.* Rome.

1979 *La céramique chypriote de style figuré: Âge du Fer (1050–500 av. J.-C.): Supplément.* Rome.

Karageorghis, V., and M. Iacovou

1990 "Amathus Tomb 521: A Cypro-Geometric I Group." *Report of the Department of Antiquities, Cyprus,* pp. 75–100.

Karageorghis, V., and J. Karageorghis

1956 "Some Inscribed Iron-Age Vases from Cyprus." *American Journal of Archaeology* 60, pp. 351–59.

Karageorghis, V., and Y. Olenik

1997 *The Potters' Art of Ancient Cyprus in the Collection of the Eretz Israel Museum, Tel Aviv.* Tel Aviv.

Karageorghis, V., F. Risopoulou-Egoumenidou, D. Bakirtzi, and C. Elliott

1985 *Ancient Cypriote Art in the Pierides Foundation Museum.* In Greek and English. Larnaca.

Karo, G.

1930–33 *Die Schachtgräber von Mykenai.* Munich.

Kearsley, R.

1989 *The Pendent Semi-Circle Skyphos: A Study of Its Development and Chronology and an Examination of It as Evidence for Euboean Activity at Al Mina.* London.

Kenna, V. E. G.

1967 "The Seal Use of Cyprus in the Bronze Age." *Bulletin de correspondance hellénique* 91, pp. 255–68.

1971 *Corpus of Cypriote Antiquities.* Vol. 3, *Catalogue of the Cypriote Seals of the Bronze Age in the British Museum.* Studies in Mediterranean Archaeology, vol. 20, no. 3. Göteborg.

Kling, B.

1989 *Mycenaean IIIC:1b and Related Pottery in Cyprus.* Studies in Mediterranean Archaeology, vol. 87. Göteborg.

Knapp, A. B., et al.

1994 "The Prehistory of Cyprus: Problems and Prospects." *Journal of World Prehistory* 8, pp. 377–453.

Kondoleon, N.
1949 In *Ephēmeris Archaiologikē* 1945–47, pp. 11–19.

Kourou, N.
1994 "Sceptres and Maces in Cyprus before, during, and Immediately after the 11th Century." In *Proceedings of the International Symposium "Cyprus in the 11th Century B.C.,"* edited by V. Karageorghis, pp. 203–27. Nicosia.

Kraus, T.
1954– "Antithetische Böcke." *Mitteilungen*
55 *des Deutschen Archäologischen Instituts, Athenische Abteilung* 69–70, pp. 109–24.

Krzyszkowska, O.
1990 *Ivory and Related Materials: An Illustrated Guide.* London.

Kukahn, E.
1955 *Anthropoide Sarkophage in Beyrouth und die Geschichte dieser sidonischen Sarkophagkunst.* Berlin.

Laffineur, R.
1994 "À propos des 'temple boys.'" In *Cypriote Stone Sculpture: Proceedings of the Second International Conference of Cypriote Studies, Brussels-Liège, 17–19 May, 1993,* edited by F. Vandenabeele and R. Laffineur, pp. 141–48. Brussels and Liège.
1997 "The Cypriote Ring-Vases Reconsidered." In *Four Thousand Years of Images on Cypriote Pottery: Proceedings of the Third International Conference of Cypriote Studies, Nicosia, 3–4 May 1996,* edited by V. Karageorghis, R. Laffineur, and F. Vandenabeele, pp. 145–55. Brussels.

Laffineur, R., et al.
1986 *Amathonte III, Testimonia 3.* Études chypriotes, vol. 7. Paris.

Lang, R. H.
1878 "Narrative of Excavation in a Temple at Dali (Idalium) in Cyprus." *Transactions of the Royal Society of Literature* 11, pp. 30–79.

Langdon, Susan, ed.
1993 *From Pasture to Polis: Art in the Age of Homer.* Exh. cat. Columbia: University of Missouri-Columbia, Museum of Art and Archaeology.

Lemos, I.
1994 "'Birds Revisited.'" In *Proceedings of the International Symposium "Cyprus in the 11th Century B.C.,"* edited by V. Karageorghis, pp. 229–37. Nicosia.

Liepmann, U.
1968 "Fragmente eines Dreifußes aus Zypern in New York und Berlin." *Jahrbuch des Deutschen Archäologischen Instituts* 83, pp. 39–57.

Lilyquist, C.
1996 "Stone Vessels at Kāmid el-Lōz: Egyptian, Egyptianizing, or Non-Egyptian? A Question at Sites from the Sudan to Iraq to the Greek Mainland." In *Kāmid el-Lōz 16: 'Schatzhaus'-Studien,* edited by R. Hachmann, pp. 134–73. Bonn.
1997 "Egyptian Stone Vases? Comments on Peter Warren's Paper." In *Texnē [Techne]: Craftsmen, Craftswomen, and Craftsmanship in the Aegean Bronze Age: Proceedings of the 6th International Aegean Conference, Philadelphia, Temple University, 18–21 April 1996,* edited by R. Laffineur and P. P. Betancourt, pp. 224–29. Aegaeum 16. Liège.

Littauer, M. A., and J. Crouwel
1977 "Chariots with Y-Poles in the Ancient Near East." *Archäologischer Anzeiger,* pp. 1–8.

Lorber, F.
1979 *Inschriften auf korinthischen Vasen: Archäologisch-epigraphische Untersuchungen zur korinthischen Vasenmalerei im 7. und 6. Jh. v. Chr.* Archäologische Forschungen, vol. 6. Berlin.

Loud, G.
1948 *Megiddo II: Seasons of 1935–39.* 2 vols. Chicago.

Lunsingh Scheurleer, R. A.
1993 "Finally Awake." *Bulletin Antieke Beschaving* 68, pp. 195–202.

Maier, F. G., and V. Karageorghis
1984 *Paphos: History and Archaeology.* Nicosia.

Manning, S. W., and S. Swiny
1994 "Sotira *Kaminoudhia* and the Chronology of the Early Bronze Age in Cyprus." *Oxford Journal of Archaeology* 13, pp. 149–72.

Markoe, G. E.
1985 *Phoenician Bronze and Silver Bowls from Cyprus and the Mediterranean.* Berkeley.
1987 "A Bearded Head with Conical Cap from Lefkonico: An Examination of a Cypro-Archaic Votary." *Report of the Department of Antiquities, Cyprus,* pp. 119–25.
1990 "Egyptianizing Male Votive Statuary from Cyprus: A Reexamination." *Levant* 22, pp. 111–22.

Markoe, G. E., and N. J. Serwint
1985 *Animal Style on Greek and Etruscan Vases.* Exh. cat. Burlington: Robert Hull Fleming Museum, University of Vermont.

Masson, O.
1957 "Cylindres et cachets chypriotes." *Bulletin de correspondance hellénique* 81, pp. 6–25.
1961 *Les inscriptions chypriotes syllabiques: Recueil critique et commenté.* Études chypriotes, vol. 1. Paris.
1971a "Inscriptions chypriotes retrouvées ou disparues." *Syria* 48, pp. 427–52.
1971b "Kypriaka IX: Recherches sur les antiquités de Golgoi." *Bulletin de correspondance hellénique* 95, pp. 305–34.
1980 "Kypriaka, XIII–XIV." *Bulletin de correspondance hellénique* 104, pp. 225–35.
1983 "Addenda Nova." In *Les inscriptions chypriotes syllabiques,* pp. 407–24. Études chypriotes, vol. 1. Augmented reprint ed. Paris.

1989 "Les frères Palma di Cesnola et leur correspondance." In *Cyprus and the East Mediterranean in the Iron Age: Proceedings of the [Twelfth] British Museum Classical Colloquium, April 1988,* edited by V. Tatton-Brown, pp. 84–89. London.

1994 "Kypriaka XVIII." *Bulletin de correspondance hellénique* 118, pp. 261–75.

1998 "Les ex-voto trouvés par L. Palma di Cesnola à Golgoi en 1870." In *Mélanges Olivier Masson,* by M. Amandry, H. Cassimatis, A. Coubet, and A. Hermary, pp. 25–29. Centre d'Études Chypriotes, cahier 27. Paris.

Masson, O., and A. Hermary
1993 "À propos du 'Prêtre à la colombe' de New York." *Centre d'Études Chypriotes, cahier* 20, pp. 25–34.

Masson, O., and M. Sznycer
1972 *Recherches sur les Phéniciens à Chypre.* Geneva and Paris.

Matthäus, H.
1985 *Metallgefäße und Gefäßuntersätze der Bronzezeit, der geometrischen und archaischen Periode auf Cypern.* Prähistorische Bronzefunde, ser. 2, vol. 8. Munich.

Maximova, M. I.
1927 *Les vases plastiques dans l'antiquité (époque archaïque).* 2 vols. Translated by M. Carsow. Paris.

McClees, H.
1924 *The Daily Life of the Greeks and Romans.* New York: The Metropolitan Museum of Art.

1933 *The Daily Life of the Greeks and Romans, as Illustrated in the Classical Collections.* 5th ed., revised. New York: The Metropolitan Museum of Art.

McClellan, M. C.
1992 "The Core-Formed Vessels." In *Glass Vessels in Ancient Greece: Their History Illustrated from the Collection of the National Archaeological Museum, Athens,* edited by G. D. Weinberg, pp. 80–94. Athens.

McFadden, E.
1971 *The Glitter and the Gold: A Spirited Account of The Metropolitan Museum of Art's First Director, the Audacious and High-Handed Luigi Palma di Cesnola.* New York.

McFadden, G. H.
1954 "A Late Cypriote III Tomb from Kourion Kaloriziki no. 40." *American Journal of Archaeology* 58, pp. 131–42.

Merrillees, R. S.
1986 "A 16th Century B.C. Tomb Group from Central Cyprus with Links Both East and West." In *Acts of the International Archaeological Symposium "Cyprus between the Orient and Occident," Nicosia, 8–14 September 1985,* edited by V. Karageorghis, pp. 114–46. Nicosia.

1988 "Mother and Child: A Late Cypriote Variation on an Eternal Theme." *Mediterranean Archaeology* 1, pp. 42–56.

1989 "Highs and Lows in the Holy Land: Opium in Biblical Times." *Eretz-Israel* 20, pp. 148–54.

Meyers, C. L.
1991 "Of Drums and Damsels: Women's Performance in Ancient Israel." *Biblical Archaeologist* 54, no. 1, pp. 16–27.

Michaelides, D.
1997 "Magenta Ware in Cyprus Once More." In *Four Thousand Years of Images on Cypriote Pottery: Proceedings of the Third International Conference of Cypriote Studies, Nicosia, 3–4 May 1996,* pp. 137–44. Brussels.

Miller, S. G.
1979 *Two Groups of Thessalian Gold.* Berkeley.

Milne, M. J.
1942a "A Corinthian Jar with Inscriptions." *Bulletin of The Metropolitan Museum of Art* 37, no. 2, pp. 36–37.

1942b "Three Names on a Corinthian Jar." *American Journal of Archaeology* 46, pp. 217–22.

Misch, P.
1992 *Die Askoi in der Bronzezeit: Eine typologische Studie zur Entwicklung askoider Gefässformen in der Bronze- und Eisenzeit Griechenlands und angrenzender Gebiete.* Studies in Mediterranean Archaeology and Literature, Pocket-Book 100. Jonsered.

Mitford, T. B.
1963 "Akestor, King of Paphos." *University of London, Institute of Classical Studies, Bulletin* 10, pp. 27–30.

1971 *The Inscriptions of Kourion.* Memoirs of the American Philosophical Society, vol. 83. Philadelphia.

Mogelonsky, M. K.
1996 "Figurines." In *Alambra: A Middle Bronze Age Settlement in Cyprus, Archaeological Investigations by Cornell University, 1974–1985,* by J. E. Coleman, J. A. Barlow, M. K. Mogelonsky, and K. W. Schaar, pp. 199–205. Studies in Mediterranean Archaeology, vol. 118. Jonsered.

Mogelonsky, M. K., and L. B. Bregstein
1996 "Spindle Whorls." In *Alambra: A Middle Bronze Age Settlement in Cyprus, Archaeological Investigations by Cornell University, 1974–1985,* by J. E. Coleman, J. A. Barlow, M. K. Mogelonsky, and K. W. Schaar, pp. 205–17. Studies in Mediterranean Archaeology, vol. 118. Jonsered.

Monloup, T.
1994 *Salamine de Chypre XIV. Les terres cuites classiques: Un sanctuaire de la Grande Déesse.* Paris.

Moore, M. B.
n.d. *Corpus Vasorum Antiquorum. United States of America, Metropolitan Museum of Art, New York. Greek Geometric, and Protoattic Pottery.* New York. Forthcoming.

Moscati, S.
1988 *I Fenici.* Milan.

Mountjoy, P. A.
1986 *Mycenaean Decorated Pottery: A Guide to Identification.* Studies in Mediterranean Archaeology, vol. 73. Göteborg.

Murray, A. S.
1877 "On the Pottery of Cyprus." In *Cyprus: Its Ancient Cities, Tombs and Temples: A Narrative of Researches and Excavations During Ten Years' Residence as American Consul in That Island,* by L. P. di Cesnola, pp. 393–412. London.

Mylonas, G. E.
1956 "Seated and Multiple Figurines in the National Museum of Athens, Greece." In *The Aegean and the Near East: Studies Presented to Hetty Goldman on the Occasion of Her Seventy-fifth Birthday,* edited by S. S. Weinberg, pp. 110–21. Locust Valley, New York.

Myres, J. L.
1914 *Handbook of the Cesnola Collection of Antiquities from Cyprus.* New York.
1933 "The Amathus Bowl: A Long-Lost Masterpiece of Oriental Engraving." *Journal of Hellenic Studies* 53, pp. 25–39.
1946a "The Bamboula Hill at Larnaca." In "Excavations in Cyprus, 1913," *Annual of the British School at Athens* 41 (1940–45), pp. 85–96.
1946b "The Dates and Origins of Cypriote Sculpture." In "Excavations in Cyprus, 1913," *Annual of the British School at Athens* 41 (1940–45), pp. 100–104.
1946c "A Sanctuary Site at Lefkóniko." In "Excavations in Cyprus, 1913," *Annual of the British School at Athens* 41 (1940–45), pp. 54–72.

Neumann, G.
1999 "Beiträge zum kyprischen XVIII." *Kadmos* 38, pp. 167–70.

Neumann, G., and K. Stiewe
1975 "Zu den Hexametern der kyprischen Inschrift ICS 264." *Kadmos* 13, pp. 146–55.

Oliver, A.
1966 "Greek, Roman, and Etruscan Jewelry." *Metropolitan Museum of Art Bulletin* 24 (May), pp. 269–84.
1977 *Silver for the Gods: 800 Years of Greek and Roman Silver.* Exh. cat. Toledo: Toledo Museum of Art.

Oppenheim, A. L., R. H. Brill, D. Barag, and A. von Saldern
1970 *Glass and Glass Making in Ancient Mesopotamia: An Edition of the Cuneiform Texts Which Contain Instructions for Glassmakers with a Catalogue of Surviving Objects.* Corning Museum of Glass Monographs, vol. 3. Corning, New York.

Orphanides, A. G.
1983 *Bronze Age Anthropomorphic Figurines in the Cesnola Collection at The Metropolitan Museum of Art.* Studies in Mediterranean Archaeology, Pocket-Book 20. Göteborg.

Özgen, I., et al.
1996 *The Lydian Treasure: Heritage Recovered.* Istanbul.

Oziol, T.
1977 *Salamine de Chypre VII: Les lampes du musée de Chypre.* Paris.
1993 *Les lampes au Musée de la Fondation Piéridès, Larnaca (Chypre).* Nicosia.

Paoletti, O.
1986 "Una coppa geometrica euboica da Tarquinia." *Archäologischer Anzeiger,* pp. 407–14.

Parlasca, K.
1955 "Das Verhältnis der Megarischen Becher zum alexandrinischen Kunsthandwerk." *Jahrbuch des Deutschen Archäologischen Instituts* 70, pp. 129–54.

Peltenburg, E.
1991 "Kissonerga-Mophilia: A Major Chalcolithic Site in Cyprus." In *Chalcolithic Cyprus,* pp. 17–35. Malibu: J. Paul Getty Museum.

Peltenburg, E., and H. McKerrell
1974 "Appendix I: The Glazed Vases (Including a Polychrome Rhyton)." In *Excavations at Kition.* Vol. 1, *The Tombs,* by V. Karageorghis, pp. 105–44. Nicosia.

Perrot, G., and C. Chipiez
1885 *History of Art in Phoenicia and Its Dependencies.* Vol. 2. Translated and edited by W. Armstrong. London.

Pfeiler, B.
1970 *Römischer Goldschmuck des ersten und zweiten Jahrhunderts n. Chr. nach datierten Funden.* Mainz.

Picard, C. G.
1967 "Sacra Punica: Étude sur les masques et rasoirs de Carthage." *Karthago* 13, pp. 1–116.

Pierides, A.
1971 *Jewellery in the Cyprus Museum.* Nicosia.

Pieridou, A.
1971 "Cypriote Funerary Vases." *Report of the Department of Antiquities, Cyprus,* pp. 18–26.
1973 *Ho protogeometrikos rythmos en Kypro.* Athens.

Pini, I.
1980 "Kypro-ägäische Rollsiegel: Ein Beitrag zur Definition und Ursprung der Gruppe." *Jahrbuch des Deutschen Archäologischen Instituts* 95, pp. 77–108.

Popham, M. R.
1972 "White Slip Ware." In *The Swedish Cyprus Expedition,* vol. 4, part 1C, *The Late Cypriote Bronze Age. Architecture and Pottery,* by P. Åström, pp. 431–71. Lund.
1995 "An Engraved Near Eastern Bronze Bowl from Lefkandi." *Oxford Journal of Archaeology* 14, pp. 103–6.

Porada, E.
1948 "The Cylinder Seals of the Late Cypriote Bronze Age." *American Journal of Archaeology* 52, pp. 178–98.

1971 "Appendix I—Seals." In *Enkomi: Excavations, 1948–58*, by P. Dikaios, vol. 2, pp. 783–810. Mainz.

1973 "On the Complexity of Style and Iconography." In *Acts of the International Archaeological Symposium "The Mycenaeans in the Eastern Mediterranean,"* pp. 260–73. Nicosia.

1983 "A Seal Ring and Two Cylinder Seals from Hala Sultan Tekke." In *Hala Sultan Tekke 8*, by P. Åström et al., pp. 218ff. Göteborg.

1986 "Late Cypriote Seals between East and West." In *Acts of the International Archaeological Symposium "Cyprus between the Orient and Occident," Nicosia, 8–14 September 1985*, edited by V. Karageorghis, pp. 289–99. Nicosia.

1992 "Remarks on Cypriote Cylinders." In *Acta Cypria: Acts of an International Congress on Cypriote Archaeology Held in Göteborg on 22–24 August 1991*, vol. 3, edited by P. Åström, pp. 360–81. Studies in Mediterranean Archaeology and Literature, Pocket-Book 120. Jonsered.

Pryce, F. N.
1931 *Catalogue of Sculpture in the Department of Greek and Roman Antiquities of the British Museum.* Vol. 1, part 2, *Cypriote and Etruscan.* London.

Quillard, B.
1979 *Bijoux carthaginois.* Vol. 1, *Les colliers d'après les collections du Musée National du Bardo et du Musée National de Carthage.* Louvain-la-Neuve.

1987 *Bijoux carthaginois.* Vol. 2. *Porte-amulettes, sceaux-pendentifs, pendants, boucles, anneaux et bagues d'après les collections du Musée National du Bardo et du Musée National de Carthage.* Louvain-la-Neuve.

Raeck, W.
1981 *Zum Barbarenbild in der Kunst Athens im 6. und 5. Jahrhundert v. Chr.* Bonn.

Raubitschek, I. K.
1978 "Cypriot Bronze Lampstands in the Cesnola Collection of the Stanford University Museum of Art." In *The Proceedings of the Xth International Congress of Classical Archaeology*, edited by E. Akurgal, pp. 699–707. Ankara.

Richter, G. M. A.
1915 *The Metropolitan Museum of Art. Greek, Etruscan, and Roman Bronzes.* New York.

1916 "Hellenistic and Roman Glazed Vases." *Bulletin of The Metropolitan Museum of Art* 11 (March), pp. 64–68.

1920 *The Metropolitan Museum of Art. Catalogue of Engraved Gems of the Classical Style.* New York.

1926 *Ancient Furniture: A History of Greek, Etruscan, and Roman Furniture.* Oxford.

1949 *Archaic Greek Art against Its Historical Background: A Survey.* New York.

1950 *The Metropolitan Museum of Art. The Sculpture and Sculptors of the Greeks.* Rev. ed. New Haven.

1953 *The Metropolitan Museum of Art. Handbook of the Greek Collection.* Cambridge, Massachusetts.

1956 *The Metropolitan Museum of Art. Catalogue of Engraved Gems: Greek, Etruscan, and Roman.* Rome.

1960 *Kouroi: Archaic Greek Youths. A Study of the Development of the Kouros Type in Greek Sculpture.* 2d ed. London.

1966 *The Furniture of the Greeks, Etruscans, and Romans.* London.

Riis, P. J.
1942 "A Horseman Figurine from Syria." *Acta Archaeologica* (Copenhagen) 13, pp. 198–203.

Rystedt, E.
1990 "On Distinguishing Hands in Mycenaean Pictorial Vase-Painting." *Opuscula Atheniensia* 18, pp. 168–76.

el Safadi, H.
1974– "Die Entstehung der syrischen
75 Glyptik und ihre Entwicklung in der Zeit von Zimrilim bis Ammitaqumma." *Ugarit Forschungen* 6, pp. 313–52; 7, pp. 433–68.

Sakellariou, A.
1964 *Die minoischen und mykenischen Siegel des Nationalmuseums in Athen.* Vol. 1 of *Corpus der minoischen und mykenischen Siegel*, edited by F. Matz and H. Biesantz. Mainz.

von Saldern, A., B. Nolte, P. La Baume, and T. E. Haevernick
1974 *Gläser der Antike: Sammlung Erwin Oppenländer.* Exh. cat. Hamburg: Museum für Kunst und Gewerbe.

Salje, B.
1990 *Der "Common Style" der Mitanni-Glyptik und die Glyptik der Levante und Zyperns in der späten Bronzezeit.* Baghdader Forschungen, vol. 11. Mainz.

Schaeffer, C. F.-A.
1929 *Les fouilles de Minet-el-Beida et de Ras Shamra.* Paris.

1952 *Enkomi-Alasia: Nouvelles missions en Chypre, 1946–1950.* Vol. 1. Paris.

1956 "Corpus des armes et outils en bronze de Ras Shamra-Ugarit, première partie: Soixante-quatorze armes et outils en bronze dédiés au grand-prêtre d'Ugarit." *Ugaritica* 3, pp. 249–75.

1983 *Corpus des cylindres-sceaux de Ras Shamra-Ugarit et d'Enkomi-Alasia.* Paris.

Schlüter, M., et al.
1975 *Antike Gemmen in deutschen Sammlungen.* Vol. 4, *Hannover, Kestner-Museum; Hamburg, Museum für Kunst und Gewerbe.* 2 vols. Wiesbaden.

Schmidt, G.
1968 *Kyprische Bildwerke aus dem Heraion von Samos.* Samos, vol. 7. Bonn.

Seefried, M.
1974 "Les objets en verre façonnés sur noyau de la collection Pierides à Larnaca (Chypre)." *Report of the Department of Antiquities, Cyprus,* pp. 147–50.
1982 *Les pendentifs en verre sur noyau des pays de la Méditerranée antique.* Collection de l'École française de Rome, vol. 57. Rome.
1986 "Glass in Cyprus from the Late Bronze Age to Roman Times." *Report of the Department of Antiquities, Cyprus,* pp. 145–49.

Senff, R.
1993 *Das Apollonheiligtum von Idalion: Architektur und Statuenausstattung eines zyprischen Heiligtums.* Studies in Mediterranean Archaeology, vol. 94. Jonsered.

Singer, C., E. J. Holmyard, A. R. Hall, and T. I. Williams
1956 *A History of Technology.* Vol. 2, *The Mediterranean Civilizations and the Middle Ages, c. 700 B.C. to c. A.D. 1500.* Oxford.

Sjöqvist, E.
1955 "A Cypriote Temple Attendant." *American Journal of Archaeology* 59, pp. 45–47.

Smith, H. R. W.
1935 "Charles Dugas and Constantin Rhomaios, *École française d'Athènes, Exploration de Delos, no. 15, Les vases préhelléniques et géométriques,*" book review. *American Journal of Archaeology* 39, pp. 414–15.

Sophocleous, S.
1985 *Atlas des représentations Chypro-archaïques des divinités.* Göteborg.

Sørensen, L. W.
1981 "A Female Head from Arsos." *Report of the Department of Antiquities, Cyprus,* pp. 169–77.

Sparkes, B. A.
1962 "The Greek Kitchen." *Journal of Hellenic Studies* 82, pp. 121–37.
1981 "Not Cooking, but Baking." *Greece and Rome* 28, pp. 172–78.

Spiteris, T.
1970 *Art de Chypre: Des origines à l'époque romaine.* Lausanne.

Stampolides, N.
1994 *Euleutherna, tomeas III.* Vol. 2, *Apo te geometrike kai archaike nekropole: Taphikes pyres kai smerika epe.* Rethymno.

Steel, L.
1997 "Pictorial White Slip—the Discovery of a New Ceramic Style in Cyprus." In *Four Thousand Years of Images on Cypriote Pottery: Proceedings of the Third International Conference of Cypriote Studies, Nicosia, 3–4 May 1996,* edited by V. Karageorghis, R. Laffineur, and F. Vandenabeele, pp. 37–48. Brussels.

Stern, E. M.
1995 *The Toledo Museum of Art. Roman Mold-Blown Glass, the First through Sixth Centuries.* Rome.

Stern, E. M., and B. Schlick-Nolte
1994 *Early Glass of the Ancient World, 1600 B.C.–A.D. 50: Ernesto Wolf Collection.* Ostfildern, Germany.

Swiny, S.
1986 *The Kent State University Expedition to Episkopi Phaneromeni.* Studies in Mediterranean Archaeology, vol. 74, no. 2. Nicosia.
1997 "The Early Bronze Age." In *A History of Cyprus,* vol. 1, *Ancient Cyprus,* edited by T. Papadopoullos, pp. 171–212. Nicosia.

Tatton-Brown, V.
1979 "A Terracotta 'Geryon' in the British Museum." *Report of the Department of Antiquities, Cyprus,* pp. 281–88.
1981a "80. Le 'sarcophage d'Amathonte.'" In *Amathonte II. Testimonia 2: La sculpture,* by A. Hermary, pp. 74–83. Paris.

1981b "Rod-Formed Glass Pendants and Beads of the 1st Millennium B.C." In *Catalogue of Greek and Roman Glass in the British Museum,* vol. 1, *Core- and Rod-Formed Vessels and Pendants and Mycenaean Cast Objects,* by D. B. Harden, pp. 143–55. London.
1984 "Sculptors at Golgoi." *Report of the Department of Antiquities, Cyprus,* pp. 169–73.
1986 "Gravestones of the Archaic and Classical Periods: Local Production and Foreign Influences." In *Acts of the International Archaeological Symposium "Cyprus between the Orient and Occident," Nicosia, 8–14 September 1985,* edited by V. Karageorghis, pp. 439–52. Nicosia.
1997 *Ancient Cyprus.* 2d ed., revised. London: British Museum.

Teixidor, J.
1977 "The Phoenician Inscriptions of the Cesnola Collection." *Metropolitan Museum Journal* 11 (1976), pp. 55–70.

Thompson, H. A.
1934 "Two Centuries of Hellenistic Pottery." *Hesperia* 3, pp. 311–480.

Tihn, T. T.
1986 "Bes." In *Lexicon iconographicum mythologiae classicae,* vol. 3, pp. 98–108. Zurich and Munich.

Todd, I. A., D. Pilides, and M. Hadjicosti
1993 "Excavations at Sanida 1992." *Report of the Department of Antiquities, Cyprus,* pp. 97–146.

Vandenabeele, F.
1986 "Bread in the Cypriote Terracotta Production of the Archaic Period." *Medelhavsmuseet Bulletin* 21, pp. 39–43.
1994 "Ohnefalsch-Richter–Cesnola: Ou, la recherche des cruches à terres cuites tenant une oinochoé." *Centre des Études Chypriotes, cahier* 22, pp. 19–31.